THE ARCHITECTURE OF SUSPENSE

Midcentury: Architecture, Landscape, Urbanism, and Design
Richard Longstreth, Editor

THE ARCHITECTURE OF SUSPENSE

The Built World in the Films of Alfred Hitchcock

Christine Madrid French

University of Virginia Press

CHARLOTTESVILLE AND LONDON

University of Virginia Press
© 2022 by the Rector and Visitors of the University of Virginia
All rights reserved
Printed in the United States of America on acid-free paper

First published 2022

9 8 7 6 5 4 3 2 1

Library of Congress Cataloging-in-Publication Data

Names: French, Christine Madrid, author.
Title: The architecture of suspense : the built world in the films of Alfred Hitchcock / Christine Madrid
 French.
Description: Charlottesville : University of Virginia Press, 2022. | Series: Midcentury: architecture,
 landscape, urbanism, and design | Includes bibliographical references and index.
Identifiers: LCCN 2022017086 (print) | LCCN 2022017087 (ebook) | ISBN 9780813947662 (hardcover ; acid-
 free paper) | ISBN 9780813947679 (paperback ; acid-free paper) | ISBN 9780813947686 (ebook)
Subjects: LCHS: Hitchcock, Alfred, 1899–1980—Criticism and interpretation. | Architecture in motion
 pictures.
Classification: LCC PN1998.3. H58 F75 2022 (print) | LCC PN1998.3. H58 (ebook) | DDC 791.4302/33092—
 dc23/eng/20220422
LC record available at https://lccn.loc.gov/2022017086
LC ebook record available at https://lccn.loc.gov/2022017087

Publication of this volume was assisted by a grant from Furthermore: a program of the J. M. Kaplan Fund.

Cover art: Background, proof sheet for *Rear Window,* November 1953. (Photo by Michael Ochs Archives/
Stringer/Getty Images)

To the architects, filmmakers, scholars, scientists, and time travelers of the world, who help us visit strange and beautiful universes. And to my friends and family, who are right beside me on my worldwide adventures.

When making a picture, my ambition is to present a story that never stands still.
—Alfred Hitchcock

CONTENTS

ILLUSTRATIONS

Color Gallery (*following page 118*)

FOREWORD

Film is the primary transformative art and technology of the twentieth century, and Alfred Hitchcock was its master. It altered mankind's comprehension of time, space, perception, and mass communication. Hitchcock understood and exploited these changes, and they can be seen, as Christine Madrid French explains, in the way he used architecture. Through the lens of film, architecture in the real world could be seen in new ways. In the hands of a great visual storyteller filtering these buildings through the new film medium, these architectures are about a great deal more than their firmness, commodity, or delight.

Buildings were often key actors in Hitchcock's films, establishing tone and propelling plots. Consider some of his most famous architectural tropes: the isolated, ominous, yet elegant roost of a villain; the gothic horror of a mansion looming from a hilltop; a rundown roadside motel; the confined courtyards of Greenwich Village apartment houses. These indelible memes are Hitchcock signatures as much as the shrieking violins of Bernard Herrmann's *Psycho* score.

Through the lens of the movies, buildings reveal their multiple lives and cultural dimensions. Note that lairs, gloomy mansions, and motels rarely appear on conventional lists of influential twentieth-century buildings. After reading French's book, however, I think they should. Those lists measure significance by style (e.g., Modern, Brutalist, Deco) or structure (e.g., steel frame, post and beam) or materials

(e.g., glass, steel, concrete). Such categories now seem limited, though, in describing the full range of an architecture's character.

Through the prism of film storytelling, architecture diffracts into deeper, more ambivalent meanings, and mines dimensions far beyond conventional academic or professional measures. What happens when a building brings together its bright past with its decaying present, as the vernacular Bates Motel does? How does morality deal with the optimism and progressivism of Modernism when it reflects the character of the villain Phillip Vandamm? Architecture is a cultural construct, not a scientific equation—even if many early Modern architects thought it was.

And why shouldn't it be a complex construct? The movies are the modern technology of dreams, imagination, the psyche, emotion, and (in Hitchcock's case especially) of fear, queasiness, the unexpected. They work on these levels whether you are a scholar or a child.

Not all buildings are equally evocative, but they will still have their own stories to tell to the people living in and passing by them. This is the dimension of architecture that Hitchcock's films add and French describes. Ever since the movies began to alter our consciousnesses, buildings have straddled the realms of reality and imagination. French alerts us to the fact that this is where architecture now exists. At this point we can never rewind the influence of the movies in the twentieth century.

For example: one of twentieth-century architecture's most famous, coveted, and paradigmatic Modern houses never even existed except in the flickering shadows of a movie screen (or television tube). Yet millions of people worldwide have a vivid image of the cliffside retreat of Cary Grant's nemesis Phillip Vandamm (played by James Mason) in Alfred Hitchcock's *North by Northwest*. The thick timber supports for its daring cantilever jutting out over the valley, the tall living room overlooked by a balcony, the elegantly furnished decor of earth tones and stone framed by tall French doors right out of the pages of *House Beautiful:* these are indelible images that evince desire for or envy of wealth, debates about the decadence or admirable daring of norm-busting Modernism, or awe of sheer beauty at a spectacular natural site.

Given the global ubiquity of midnight TV broadcasts, indie art house retrospectives, VCRs, compact discs, streaming services, and Turner Classic Movie channel marathons over the last seventy years, how many people do you think know the Vandamm House? It's quite possible that at least as many people have seen (and

been impressed by) the image of this nonexistent house as have seen the images of another paradigmatic Modern house, Frank Lloyd Wright's breathtaking Fallingwater in Pennsylvania.

If architecture and movies are at first glance different as art forms—one physical and lasting, one as evanescent as a flicker of light—French invites us to consider that there is more to it than that. Both are, for example, popular mass media. If, for example, five million people have toured Fallingwater since it opened to the public in 1964, then a much larger number of the world's population has experienced that magnificent design only through photography. Logically, *North by Northwest*'s medium of film has allowed at least an equal number of people (and probably many more) to experience the imaginary Vandamm House. The movie has probably conveyed Modern architectural knowledge, imagery, and ideas to a far vaster impressionable audience.

The Vandamm House is understood in academic circles as an example of Organic Modern architecture. But Hitchcock uses it cinematically, via plot, art direction, and acting, to evoke a wider spectrum of meanings. It is a piece of architecture with tangible meaning but no physical reality. Since the advent of photography, architecture doesn't really require physical incarnation to have power or presence. Hitchcock grasped the concept that buildings could exist in a dimension rarely realized before.

So convincing is Hitchcock's and art director Robert Boyle's creation of the Vandamm House out of matte paintings and sound stage sets that to this day people inquire about the location of the house. Its design actually owes more to the service of plot points than to the traditional constraints of site, structure, or program, but the dimension that matters in Hitchcock's insight into twentieth-century architectural design is how it draws on multivalent meanings: the exoticism of Modern, the whiff of luxurious decadence, the maverick persona of Frank Lloyd Wright (Ernest Lehman evoked Wright directly in the screenplay).

Hitchcock's other architectural tropes take on a similar wide range of meanings reflecting culture. *Psycho* evokes the neglect of the people who lived in decaying Victorian mansions in the era of jet planes and transistors, and the psychological damage that might result from that isolation. *North by Northwest*'s Manhattan scenes waver ambivalently between the glassy transparency and the opaque anonymity of glass box skyscrapers. This Hitchcockian ambivalence sets up Cary Grant's character: is Roger Thornhill a boring advertising man or an international spy? *Rear*

Window's densely packed Greenwich Village courtyard both traps Jimmy Stewart and opens him to a cosmopolitan range of Village lifestyles, including a murder.

These multiple meanings have little to do with the crisp theories and confident manifestos that architects themselves offer as the correct way to see their buildings. Once a building has escaped the drafting board for the wilds of cities, society, and media, the culture ingests it and regurgitates it with multiple nuances (often contradictory) that an artist like Hitchcock can use.

This is the lesson that French takes from Hitchcock's understanding of how the movies reshaped the way we see architecture. She explains how this applies to her field of expertise, historic preservation (or the purposeful conservation of cultural memory through physical structures and their nonphysical dimensions.) Traditional architectural preservation turned many Victorian homesteads into house museums for schoolchildren; Hitchcock turned the Bates Mansion into an unexpectedly macabre museum. It seems that architecture has a life of its own beyond its creator's intentions or historians' pigeonholes.

The stories and meanings of architecture, such as those exploited by Hitchcock, are hooks that can be used to relate buildings to the public in meaningful ways. The stories they tell, the emotion, nostalgia, or memory they call forth from a Saturday matinee long ago (or a YouTube clip last night) are how the public relates to architecture these days. The magnificent Gamble House in Pasadena, built for scions of the Procter and Gamble fortune by Charles and Henry Greene in 1908, is attracting visitors today eager to experience Doc Brown's home in director Robert Zemeckis's *Back to the Future* from 1985.

Such is the power of cinema, the twentieth century's most influential art form. Hitchcock, of course, plumbs psychological depths deeper than the appeal of a summer blockbuster. But both examples demonstrate how the movies have served architecture, and architecture has served the movies.

This relationship is underscored by French's valuable original research into the relationship of architects and the movie studios, particularly in the major role played by the University of Southern California (USC) School of Architecture and its alumni. Many critics and historians never took Los Angeles architecture seriously precisely because it was so close to Hollywood. Yet that cultural proximity allowed the movies and Modern architecture to grow together and thrive.

French reveals how USC is culturally significant for the role its students played in art directing, designing sets, and winning Oscars. USC was one of the most impor-

tant architecture schools in the nation to teach Modernism from the 1930s on. It is rightfully known for the role its faculty and students played in the Case Study House Program, which defined one thread of mainstream postwar Modern design, but its role in providing trained architects to the studios may be even more significant. For example, besides USC graduate Robert Boyle's design for the Vandamm House, USC faculty William Pereira (with his brother, art director Hal Pereira) advised Hitchcock on the Greenwich Village apartment courtyard in *Rear Window.*

Further building the case for the argument that Los Angeles's architecture is significant precisely because of, not in spite of, its connection to Hollywood, French spotlights the poet Vachel Lindsay's startlingly early—*1915!*—insight into the power of the movies and Los Angeles's grasp of this emerging visual culture. Lindsay seems a veritable seer when he writes, "It is possible for Los Angeles to lay hold of the motion picture as our national text-book in Art as Boston appropriated to herself the guardianship of the national text-books of Literature."

Hitchcock, of course, preferred visual means whenever possible over written dialogue. His use of architecture is one example. We need this insight into architecture and movies today as the movies' cultural presence transmutes into video games, virtual reality, and beyond.

For the field of historic preservation, Hitchcock also suggests a way to look at buildings that stretches beyond the usual didactic categories. Architecture, like the movies, is a popular art form as well as a fine art. If Hitchcock's career and reputation is any indication, there may not be as sharp a line between the two as is often assumed. That's a good place to start understanding architecture and its value today after a century of filmmaking has trained filmgoers to perceive and assess visual information in a new way.

This dialogue opens up a new way to engage the public in conversations about architecture and media. Perhaps we should be asking not, "What style is it?" but "What movie is it?" Or today, "What video game is it?" where psychologically rich tropes such as noir mansions and futuristic supercities appear for the sake of the interactive story. Hitchcock, it turns out, was well ahead of his time.

In Christine's vision, these multivalent stories have proven useful in interpreting the shifting memories associated with architecture. The public is not primarily made up of historians or theoreticians. The stories of people who created or lived in worthy buildings, the stories of evolving neighborhoods, the stories of buildings seen in popular movies are all meaningful beyond the design and academic

professions. The movies have visually trained the general public for more than a century to respond to such things. Connecting the popular audience to architecture through evocative storytelling as Hitchcock did so effectively in his films may be the way to go.

Alan Hess

ACKNOWLEDGMENTS

As with all long projects, this book has manifested itself in different ways over the last six years. I want to convey my most sincere and loving thanks to my immediate family, including Scot French; my dad, Ruben Madrid; and Margot and Norman French, who have all supported my work for decades. My wicked-smart sons, Gideon and Levi French, were my sounding board and research partners, watching dozens of movies with me and then engaging in lengthy analyses during our two-mile walks every evening during the spring and summer of 2020. I would also like to acknowledge the immense contributions of my mother, Diane Madrid, who passed many years ago but whom I continue to carry with me forever.

Both my mother and father came from families of ten children each; I am grateful for all of the support from my relatives across the country, though I will no doubt miss a few names with more than eighteen aunts and uncles and thirty-plus first cousins. Thanks to my sister Monika Madrid and her son Avery, my aunts, uncles, and cousins on the Robinson side and their families, including Rose, David, Gary, Steve, Bruce, Carol, Patty, Janet, and Dennis, plus Julie, Beverly, Matthew, Sarah, Teresa, Linda, Ben, Gary II, Sean, and Val. Thanks also to my aunts, uncles, and cousins on my Madrid side and their families, including Tencha, David, Stephen, Carmen, Patzi, Juanita, Irma, Denise, Jerry, Stephen II, Vincent, Valerie, Daniel Jr., Jennifer, David II, and many more.

Eternal gratitude to my friends, old and new, my professors, mentors, critics,

and cheerleaders who stuck with me throughout this long and strange process of discovery and adventure, including Shannon Barras, Rachel and Chris Bartlett, Amanda Bearse, Robert Bellissimo, Fred Bernstein, Eric Besner, Peter Blackburn, Daniel Bluestone, Norman Buckley, Elizabeth Bullock, Sheridan Burke, Annalisa Capurro, Anna Chakraborty, Maanvi Chawla, Meghan Leone Cox, Todd Croteau, Adele Cygelman, Christine Dalton, Peter Dessaur, Joy Wallace Dickinson, Gilbert Duran, Nathan Duvall, Nicole and Jeff Elefterion, Adrian Scott Fine, Janene Fontaine, Richard Forbes, Josh Gorrell, Sidney Gottlieb, Bethany Gray, Joel Gunz, Anthea Hartig, Mike Hastings, the Helton Family of Massachusetts, Tom Holland, Sandy Holmes, Lisa Jordan, Sally Julien, Melita Juresa-McDonald, John Kaiser, Julie Koran, Christy LaGuardia, Steven Lee, Ed Lupyak, Leo Marmol, Andrea and David Matousek, Megan Matousek, Sheree Matousek, Kim Mathis, Nickie McLaughlin, Vince Michael, Christina Morris, Paul Neidinger, Raymond and Dion Neutra, Kyle Normandin, Jeannine Oppewall, Kristin and Stephen Pategas, Ambar Payne, Richard Reep, Sonoma Rohrbaugh, Mark Rozzo, the Nils Schweizer family, Susan Skolfield, Dennis Soriano, Elaine Stiles, Natasha and Roger Stone, Marc Strauss, Frederick Taylor, Ken Topper, Anthony Veerkamp, Camille Wells, Victoria Young, Catherine Zipf, and Maude Zopf. I also want to recognize Darren Bradley for the beautiful photographs, Cynthia Cardona for editing and assistance with image acquisitions, and Morris Hylton III for empowering my vision.

I am also grateful to Furthermore: a program of the J. M. Kaplan Fund for supporting the publication of this book.

Thank you to Palm Springs Modernism Week, led by Mark Davis and William Kopelk, for hosting the first public presentation of my research during their annual event in February 2016. Hitchcock scholar Doug Cunningham encouraged me to finish my essay on this topic for inclusion in his book *Critical Insights,* which was published shortly thereafter. More presentations followed, each of which I enjoyed immensely, hosted by Tucson Modernism Week and Demion Clinco, the Sarasota Architectural Foundation, Ringling College of Art + Design, and Janet Minker, US Modernist Radio and George Smart, and the Los Angeles Conservancy. For the "Last Remaining Seats" program hosted by the Conservancy, I was invited by Linda Dishman and Sarah Lann to interview actor Veronica Cartwright on the stage of the elegant 1931 Los Angeles Theatre on Broadway before a screening of *The Birds,* in which she played the character of Cathy Brenner. That incredible evening counts as a glittering highlight in my life.

Doug and I later presented our work together courtesy of Kirk Huffaker, Pres-

ervation Utah, the Salt Lake City Public Library, and the Salt Lake Modern Committee, where I enjoyed a reunion with my undergraduate professors Peter Goss and Tom Carter, who taught me all of the basics about understanding historic architecture and its contextual story during my studies at the University of Utah. Doug and I met again back in Palm Springs for the annual California Preservation Foundation conference, thanks to Cindy Heitzman and Jonathan Haeber, where Doug presented his research about creating a heritage trail in Northern California following the path of *Vertigo*. But the most important presentation of my work was at the University of Virginia School of Architecture in November 2016, when I started my engagement with editors Boyd Zenner and Mark Mones of the University of Virginia Press, who encouraged me throughout this process, as well as Ellen Satrom, managing editor and editorial, design, and production manager. Returning to my school at the invitation of Lisa Reilly and Richard Guy Wilson for this event felt like a completion of the academic circle. My friends and colleagues Alan Hess, Barbara Lamprecht, and Richard Longstreth provided close readings of the initial manuscript and helped keep me on track toward the finish line. Lastly, I acknowledge that I stand on the strong shoulders of my ancestors, including my grandparents, Elizabeth and Raymond Robinson of Fort Wayne, Indiana, and Tomasa and Manuel Madrid, who settled in Los Angeles after arriving from Mexico in the early 1920s. Sincere and gracious thanks from me to all of you.

THE ARCHITECTURE OF SUSPENSE

INTRODUCTION

Every film begins with a blank page and a story to tell. And each building arises from empty land as the structural fulfillment of a dream. The resulting works speak to us intimately as individuals, leveraged on our collection of experiences, interests, and environments. Common feelings and interpretations emerge when the two arts are superimposed, when the language of building design is deliberately manipulated as a character for film. Patterns of representing a building type or style develop into expectations, then morph into general guidelines, and finally become entrenched as narrative rules. In this book, I aim to deconstruct this process by exploring the role of creators behind the scenes and outlining how a new cultural dialogue is created by the cinematic doppelgängers of real buildings. The lens I choose to look through is that of director and storyteller Alfred Hitchcock.

Unraveling the many threads of Hitchcock's impact is, for practical purposes, impossible at this point. Hitchcock is so omnipresent that you do not discover his work as much as realize that he exists in every corner of your life, without your knowledge. There are few movie directors who occupy the rarefied air of Hitchcock, an immersive artist who repeatedly challenged and changed the parameters of the film industry until his death in 1980. I was born the same year that *Torn Curtain* was released and grew up within the immediate ripple effect of Hitchcock's influence and that of the creatives he inspired, including George Lucas, Steven Spielberg, Brian DePalma, Tom Holland, Ridley Scott, and Stanley Kubrick,

among others. My own interest in Hitchcock's movies began in earnest in the late 1980s with annual viewings of *Psycho,* accessible at that time only during late-night television broadcasts and later via VHS tapes rented from Blockbuster. The movie penetrated me with its visual starkness, its vibrant score, and the simple premise of a heroes-and-villains narrative interpreted as a modern tale of deception and murder.

I am still fascinated by this skillful crafting of a film so compelling that it is passed down from generation to generation like a great campfire story, never losing its power over the audience. My mother, Diane, told me about her own experience of seeing the movie in the theater and the immense terror she felt stepping into the shower again many weeks later, connecting personally with the sad fate of the conflicted heroine in that movie. From my first fascinations with *Psycho,* I then moved further into Hitchcock's mid-twentieth-century films, released one after the other during the late 1950s and early 1960s. The more I watched, the more questions I asked. I became a fanatic. Finally, I made the connection: the movies I enjoyed the most were tapping into my concurrent studies of, and passionate admiration for, architectural design and buildings.

As an architectural historian, I reconstruct the story of a building or community from the designer's point of view, the patron's identity, or the people's need for artistic expression or everyday utility in a structure. In this case, I retained the object of my gaze but altered my research methodology to tell the story of architecture from the perspective of directors, screenwriters, production designers, and filmgoers at large. Scholars acknowledge that Hitchcock captured and articulated a "series of lucid interrogations of the totems of American life . . . and the institutions that celebrate, interpret, and patrol our cultural terrain: advertising, the judicial system, psychiatry, the police, [and] the movies themselves."[1] In his works, Hitchcock also dissolved the mental and conceptual boundaries between the audience and the screen by using buildings and landmarks as vehicles to express the characters' innermost thoughts or to represent the increasingly precarious situation of the players. More significantly, Hitchcock and his team wielded the unique power to create monumentality from the vernacular, elevating common American structures into filmic icons. Interpreting his approach to architectural design and the identity of place through the lens of cinema therefore exposes a new direction for understanding cultural values and architectural interpretations in the mid-twentieth century and beyond.

Contemporary scholars tackling the subject of film and architecture include Dietrich Neumann, professor for the history of modern architecture and director

of the Urban Studies Program at Brown University. In 1999, Neumann edited and contributed to a collection of essays covering twenty-four films ranging from the German expressionist piece *Metropolis* (directed by Fritz Lang, 1927) to the cult-futurist epic *Blade Runner* (directed by Ridley Scott, 1982). Neumann identified three "major roles of film architecture" in the text, articulating clear narrative paths for exploring design on film. The first approach examines the topic as "a reflection and commentary on contemporary developments," a method that includes an examination of a film within the cultural context of its release date but also allows for regular revisiting of the material as it ages and is interpreted and understood by succeeding generations. The second approach governs design in film "as a testing ground for innovative visions," acknowledging that cinematic space permits the creation of buildings and structures that transcend both time and space as well as real-life engineering and budgetary limitations. Third, Neumann regards film "as a realm in which a different approach to the art and practice of architecture can be realized," opening new avenues for constructive dialogues and discussions.[2]

Neumann further determined that the "most fascinating cases" to study are those "in which architecture is created for a particular movie and exists only for and through film, but nevertheless reflects and contributes to contemporary architectural debates."[3] The films of Alfred Hitchcock can be examined using all of these criteria. Following Neumann's lead, I engage in a study of the long-term influence and impact of Hitchcock's architectural designs such as the Bates Motel and Bates Mansion in *Psycho,* buildings that cast long shadows and continue to impact filmmakers today. Using Neumann's second approach, I examine the house of the villain in *North by Northwest,* created by production designer Robert Boyle, that built upon and exceeded the work of architects Frank Lloyd Wright and John Lautner by its nature of unbuildable outrageousness. And Neumann's third methodology can be applied to my deeper discussion of architects' impact on film projects and the studio structure in Hollywood, bringing their knowledge of the art of architecture into a new creative field as production designers and art directors.

Reviewing his own legacy, Hitchcock separated his films into two distinct periods, British and American, noting, "For want of a better term, we might label the initial phase the period of the sensation of cinema, and the second phase the period when the ideas were fertilized."[4] Biographer William Rothman described Hitchcock's American films as "profound studies of the conditions of human identity, knowledge, and love, and sustained reflections, at the highest level of seriousness, on the conditions of the art of the film."[5] In this way, film and architecture

are analogous. Rothman's viewpoints align with the words of British architectural critic Reyner Banham, who wrote that architecture "is more than a commentary on the human condition—along with war and peace and love and death and pestilence and birth, abundance, disasters and the air we breathe, it *is* the human condition."[6] In these films, therefore, we can connect the two arts to see how Hitchcock "exploited architectural style to enhance emotional impact" for the audience, as described by fellow architectural critic Paul Goldberger.[7]

The following chapters are divided by specific building types highlighted in Hitchcock films from his mid-twentieth-century American period: the Villain's Lair (modernist houses), the Urban Honeycomb (apartments and skyscrapers), and the American Roadside (motels and mansions). The movies I examine include *Rope* (1948), *Rear Window* (1954), *The Wrong Man* (1956), *Vertigo* (1958), *North by Northwest* (1959), *Psycho* (1960), and *The Birds* (1963), among others. These movies vividly feature structures and landmarks that expose the "complex relation between Hitchcock's movies and American ideology," and illuminate the curated impact of design and the built environment on daily life in the second half of the 1900s.[8] Repeated viewings reveal distinctive patterns; those patterns create a cultural roadmap of interconnected ideas that follow the fluid interpretations of architecture as new filmic archetypes emerged and the very definitions of "home" changed over time. For example, we can observe the transformation of a high-end modernist house into the prototypical home of an evil genius as expressed in *North by Northwest* or look to *Psycho* for fresh evaluations of the American Gothic based on architectural symbolism, a theme explored by Edgar Allan Poe in *The House of Usher* in the nineteenth century but brought shockingly into the modern age by Hitchcock.

Despite the proliferation of texts focused on the director, there is only one book that explores buildings within Hitchcock's films. *The Wrong House: The Architecture of Alfred Hitchcock,* by Steven Jacobs, is an expansive, well-researched, and heavily illustrated text that includes floor plans for twenty-six fictional structures. In this book, the author asserts that "designing architecture is a Hitchcockian activity," critical to the director's exploration of life and the cinematic art. Jacobs applies his keen eye to illuminate patterns in Hitchcock's films, then interprets those patterns to establish the meaning of recurring fetish objects (such as stairways and doorknobs), and the confluence of story line and narrative with distinctive building elements, frames, and camera angles. He posits that Hitchcock "based his screenplays on objects and places" rather than "plot or characters," constructing his story lines

around spaces (both real and as stage sets) that represented a theoretical intersection of place and identity.[9]

My study of this topic began with the goal of leveraging popular cultural touchstones to enhance the interpretation of our built environment, particularly in the service of advocating for historic structures that are often misrepresented or misunderstood. I have since established a methodology to understand and save real buildings by deconstructing the audience enthusiasm for filmic architecture. The practice of historic preservation and heritage conservation can be advanced with these lessons from the film industry, a commercial enterprise whose success is guided by popular opinion. Preservationists and historians overlook the enduring quality and power of human emotion as a critical factor in public outreach with their wholesale rejection of nostalgia countered with a dogmatic embrace of objective analysis. But building on cinematic narrative foundations can be effectively utilized to save endangered structures. The key is storytelling.

In this text, I also explore architects as a creative group and interpret their larger contributions in the history of cinema, including the development of key roles in film production, the creation of visual storytelling methodologies, and the modeling of art departments on the example of architectural studios. I reveal the close relationship between architects and the film industry, both on the screen and behind the scenes (or "above and below the line," to use industry nomenclature). Hitchcock worked with and employed dozens of architects as art directors and production designers on his films—many graduates of the architecture program at the University of Southern California (USC)—a professional relationship that is not yet explored in depth in any publication.

My research was first released in 2016 as an original essay entitled "American Modern Architecture as Frame and Character in Hitchcock's Cinematic Spaces," published in *Critical Insights: Alfred Hitchcock,* a collection of individually authored articles intended for film and cinema studies. *Critical Insights: Alfred Hitchcock* interprets the works of the director through the lens of each contributor's specific field: psychoanalysis, the female gothic, cultural dimensions of adolescence, spectatorship, and architectural history. In the preface, volume editor Douglas Cunningham asserts: "Hitchcock is the type of genius about whom not enough can ever be written or even said. His body of work is so extensive, his quality so consistent, his themes so pervasive, and his style so innovative, that energetic and insightful discourse on his oeuvre can never be exhausted." He states that our interpretations

of Hitchcock's work must be continually revisited as our perspectives and cultural contexts change over time, an examination that can reveal "the very essential ideas about how our world and the people in this world think and operate."[10]

As a guide to the reader, all technical information about the films discussed within this book, including casting, filmmakers, production crew, studios, and year of release, was obtained from the Internet Movie Database (IMDb), a comprehensive online resource for film, television, and other similar creative content.[11] The first reference for each film is followed by the name of the director and the year of release. An abbreviated list of "Fifty Films to Watch" (from comedy to romance to horror, dating from 1925 through 2020) is included not only as a guide for further research but also to encourage your own enjoyment and exploration of cinema.

Understanding the audience reaction to architecture, and the embrace or rejection of certain types of structures in popular culture, can enhance how we interpret and understand buildings and their intersections with the cinematic arts. I am exploring this topic in the spirit of director Stanley Kubrick, who once said, "I don't pretend to have the answers; but the questions are certainly worth considering."[12] Hitchcock was not the only filmmaker who brought architecture to life as a narrative character, but his mastery heightened reality both individually and collectively in the theater audience. That is the true magic of Hitchcock's films: the meaning of his art lies in what each of us brings to the experience.

1

ALFRED HITCHCOCK'S
AMERICAN EXPERIENCE

Alfred Hitchcock swept into New York on March 11, 1939, traveling across the Atlantic via the elegantly appointed RMS *Queen Mary* on his way to Hollywood. Studio head David O. Selznick, riding on the blockbuster success of his 1939 opus *Gone with the Wind,* signed the British director amid great fanfare for three movies after Hitchcock's success with *The 39 Steps* (1935) and *The Lady Vanishes* (1938). With Selznick's offer in hand, Hitchcock completed work on *Jamaica Inn* (1939) in England and steamed off with his family in tow.[1] His first project was a story surrounding the sinking of the *Titanic,* although that project was ultimately shelved and replaced with the film *Rebecca* (1940).[2]

He jumped into American culture upon his arrival, delivering a lecture at both Yale and Columbia Universities on the "History of Motion Pictures."[3] He then traveled to Florida and Cuba "for a sight of white houses in the sunshine, blue skies and palm trees" before setting out for the golden hills of California.[4] Later that year, *Life* magazine published a seven-page illustrated celebratory spread entitled "England's Best and Biggest Director Goes to Hollywood." Hitchcock reported to the Selznick International Studios headquarters in Culver City, California, accompanied by his assistant and Academy Award–nominated screenwriter Joan Harrison. She began working for him in 1933 and emigrated to the United States to continue in his employ. She co-wrote the screenplays for the British productions *Jamaica Inn* and *Foreign Correspondent* (1940), as well as the American-made *Rebecca, Suspicion*

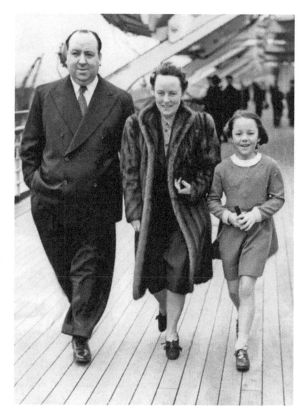

Figure 1. Alfred Hitchcock, his wife, Alma Reville, and their daughter, Pat, on the deck of the *Queen Mary*, at Southampton, Great Britain, on March 4, 1939, on their way to the United States to start a new life in Hollywood. (AFP/Stringer/Getty Images)

(1941), and *Saboteur* (1942). The article also noted his idiosyncrasies, noting that he "baffled the Selznick office" by interviewing a dozen writers for *Rebecca,* then rejected many of the candidates "because he didn't care for their voices, or the way they parted their hair."[5]

The magic coupling of a quirky British gentleman with a newly emerging creative industry could only happen in a freethinking western outpost of experimentation like Los Angeles. Hitchcock declared that he was not "in the least interested in Hollywood as a place. The only thing I cared about was to get into a studio to work."[6] Nonetheless, he did enjoy the unrestricted access and daily interactions with the creative film community that Southern California provided. The region had long promoted an innovative atmosphere that allowed free rein to explore new ideas, no matter how improbable or impractical. As early as 1915, the American poet Vachel

Lindsay predicted the upward momentum of this starstruck city, writing, "It is possible for Los Angeles to lay hold of the motion picture as our national text-book in Art as Boston appropriated to herself the guardianship of the national text-books of Literature."[7] In Lindsay's mind, the very essence of film arose from the landscape surrounding its creation. He acknowledged that "if the photoplay is the consistent utterance of its scenes, if the actors are incarnations of the land they walk upon, as they should be, California indeed stands a chance to achieve through the films an utterance of her own."[8] Almost a century later, the landscape, the industry, and Hitchcock's impact in Hollywood are now inseparable.

Alfred Joseph Hitchcock began his life on August 13, 1899, the son of William and Emma Hitchcock. His parents ran a local grocery store in Leytonstone, northeast of London; the family resided in the living areas and bedrooms above the shop.[9] He was raised a middle-class Catholic and grew up along with the British movie industry, a rising commercial interest that led the world in cinematic innovations at that time. He recalled attending films as early as 1907, including *A Ride on a Runaway Train* (directed by Lyman H. Howe, 1921), which was known to thrill

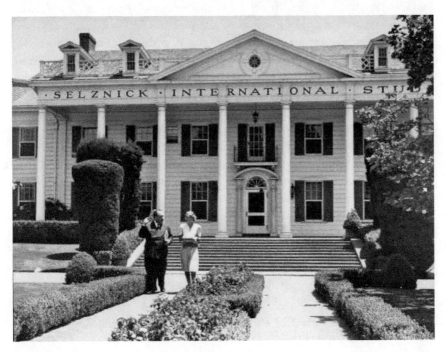

Figure 2. Alfred Hitchcock walking with his assistant and Academy Award–nominated screenwriter Joan Harrison in front of the Selznick International Studios headquarters in Culver City, California, ca. 1939. (Peter Stackpole/The LIFE Picture Collection via Getty Images)

and terrify audiences with its dynamic realism and perspectival scenes created by mounting the camera on the cowcatcher of a running locomotive.[10]

Historians note that Hitchcock began to read "screen trade papers," such as *Kinematograph and Lantern Weekly*, before he reached his teenage years.[11] He himself recalled that even at that age he was "deeply entrenched in American cinema," comparing "the photography of the English and American films" both in the theater and in the pages of the film journals.[12] In 1913, he attended the London County Council School of Engineering and Navigation. He then secured a position with W. T. Henley's Telegraph Works, employed on the technical side of this early communications industry, tracking the sizes and voltages of cables. Hitchcock eventually edged his way into a new position as founding editor of the *Henley Telegraph* in 1919, an internal magazine for the company, where he honed his writing and illustrating skills.[13]

His storytelling vision blossomed after he ventured into courses at Goldsmiths' College, a branch of the University of London.[14] He became an avid patron of plays, the cinema, and museums, each promoting its own specialized form of narrative and interpretation. In 1920, Hitchcock formally began his film career at Famous Players-Lasky, an American studio with a branch in Islington. Famous Players-Lasky was created by the merger of multiple film companies; it became Paramount Pictures by the end of the decade. At the studio, he lettered and illustrated the "title cards," or frames of text inserted to explain actions and dialogue between the pantomime scenes in silent films; he then moved up to the position of art director before setting his hand to screenwriting.[15]

At Famous Players-Lasky, Hitchcock met his lifetime personal and creative partner, Alma Reville, who contributed immensely to his success and art for the rest of their conjoined careers. They worked together on set for a few years, but Hitchcock delayed the courtship. According to him, "it was unthinkable for a British male to admit that a woman has a more important job than his, and I waited until I had the higher position [of] assistant director" before proceeding in the relationship.[16] Hitchcock, as assistant director, co-screenwriter, and art director, then invited her to work as a "cutter" on the film *Woman to Woman* for the production company Balcon, Freedman & Saville (directed by Graham Cutts, 1923). They worked "side by side" on five Cutts-directed films, an alliance that fortified the base for their long relationship.[17]

Hitchcock began to direct films on his own with *The Pleasure Garden* (1925), followed by *The Lodger* (1927).[18] The couple married in 1926. Alma was a filmmaker

in her own right when she met Hitchcock and was "always the last pair of eyes on every finished production" for her husband. She was both a trusted confidante and co-collaborator. He said that "she tries to be on the set the first day we begin shooting a film, sometimes goes to rushes, and always gives me her criticism [which is] invariably sound." Over her long career, Alma earned more than a dozen credits in her own name, a number that reveals only a portion of her significant contributions to film history.[19] Between 1927 and 1939 (when they left for the United States), Hitchcock and Alma worked on another twenty-five "pictures," as he liked to call his films.

As a pioneer in the industry, Hitchcock strived to keep one step ahead of the popular-culture curve by embracing new technologies for storytelling, including synchronized sound. The "talkies," or movies with a vocal track, broke with a long-standing tradition in which a film portrayed voiceless actors and was accompanied by live music in the theater. Theater owners did not initially embrace the new sound technology with enthusiasm; the advent of audio systems promised to cost millions of dollars in upgrades and improvements. But there was no stopping progress. In the last days of 1927, the *Los Angeles Times* reviewed *The Jazz Singer* (directed by Alan Crosland), the first feature to blend spoken dialogue with music and a recorded soundtrack using Vitaphone technology. Star Al Jolson, who appears in blackface in a musical scene, was a popular stage actor of the period before moving into film. The *Times* heralded this "landmark in screen theater history," stating that "to miss it would be like failing to catch a glimpse of [Charles] Lindbergh," the handsome and charismatic pilot who completed the first nonstop transatlantic flight earlier that year. The movie won "ovation upon ovation," as "one of the greatest events in the world of entertainment in years."[20] Columnist Louella Parsons defended the movie against "strong protests uttered against the Vitaphone as a destroyer of the peaceful silence of the motion picture," and celebrated the "glorious defeat" of outdated customs, evidenced by the immense audiences attending the film nationwide.[21] The *Baltimore Sun* concluded that the movie was a "grand orgy of sentimentality" that would be "punk" without Vitaphone.[22] Crosland predicted a coming revolution after the success of the picture, which marked the beginning of monumental changes in cinema.[23]

Hitchcock took notice and immediately began experimenting with integrated sound technology. In 1929, he released two versions of *Blackmail*, one silent and the other a hybrid, with a transition to modern sound in the second reel. The director "planned the sound version even while he was working on the silent alternative; he

imagined dialog even before the first words were spoken" on-screen. The film was the first British "100% talking picture."[24] Hitchcock followed up with other films utilizing sound, including *Juno and the Paycock* (1930), also for British International Pictures, which incorporated a full-length audio dialogue and a scenario by Alma. This pioneering concept opened up a new world of film that was "doubtless both unsettling and exciting" for contemporary audiences.[25]

Despite his status as England's "most acclaimed, most famous film director," Hitchcock suffered many defeats as he learned to negotiate the complexities of the motion picture industry. His own ambition to constantly push the boundaries of art and technology put his work, and reputation, on the line with each film. Critics gleefully declared his career dead on multiple occasions. The history of Hitchcock's work is littered with bad ideas, mishaps, mistakes, and firings. For example, Hitch worked as a producer on the crime-drama *Lord Camber's Ladies* (1932), with actor-manager Gerald du Maurier, a longtime friend and fellow prankster. Their personal relationship later provided new creative material for the director, who adapted three stories written by du Maurier's novelist daughter Daphne, including *Jamaica Inn, Rebecca,* and *The Birds.* But *Lord Camber's Ladies* flopped at the box office in part due to simmering conflicts between Hitchcock and director Benn W. Levy (who had worked for Hitchcock as a writer on *Blackmail*). The studio terminated Hitchcock's contract and released him from further films.[26]

By that time, Hitchcock and Alma were "already dreaming of America."[27] Hollywood had surpassed European film centers in England and Germany as the best place to launch a production, in part by tapping into the talents of an active and engaged creative community. In a 1933 article, the *Los Angeles Times* crowed that "World Celebrities Start New Surge to Southland." The lack of cultural inhibitions and abundance of networking opportunities, paired with the mild climate, began a "new pioneer trek, the celebrity trek," in a golden age of "arrivals, sojourns, vacations, [and] visits" to the western coast. Creatives moved from New York in droves to seek work in Hollywood, as it was "easier even to starve as a thespian in sunshine than it is in foul weather."[28] The paper noted that "the newcomers are scattered all over the State, in canyons and on mountain tops: there are highbrows and lowbrows, scholars and shilling shockers" and that if New York was "destroyed tomorrow, we have enough writers now living and working in California to keep the reading public quite busily engaged, thank you."[29] Hitchcock longed to make the switch overseas and tried to seal a deal with Carl Laemmle Jr., head of Universal Pictures, for a one- or two-film commitment. But negotiations failed, and he

continued his career in Britain for another seven years with the Gaumont British Picture Association.[30]

Once they arrived, Hitchcock and his entourage (including his wife, daughter, cook, secretary, and maid) initially lived in a high-rise apartment at the Wilshire Palms "directly above [Academy Award–nominated actor] Franchot Tone and one of the Ritz Brothers" while searching for more permanent lodging in Los Angeles. His house-hunting process revealed a bit about his views on contemporary architecture and the residential landscape of Southern California in the late 1930s. In a press interview, Hitchcock noted: "What I want is a home, not a movie set with a heating plant added. All I I need is a snug little house, with a good kitchen, and the devil with a swimming pool. Only try to find one here. First thing the real estate agents start talking about is the pool. Then they discuss the tennis court. Finally they get around to talking about the barbecue arrangements in back of the rose garden. They never do talk about the house. Maybe they're ashamed of it." Nonetheless, the family found a place and quickly settled into their new lives. Hitchcock and his wife became regulars at the Hollywood restaurant Chasen's and indulged in a great deal of high-quality food and drink, including a gin and orange juice mix that was one of the director's favorites.[31]

Hitchcock's power over people's imaginations and over his own works is due in part to his methodical approach toward the promotion of self and art to the point of caricature. When Hitchcock arrived in the United States, he was a forty-year-old man embarking on the second phase of his career in the often-unfriendly territory of Hollywood. He determined that the best way to fit in was by standing out, crafting his own distinctive cult of personality. Hitchcock courted the public and charmed the press by openly displaying his generous attributes and quirky shortcomings, satirizing his own style, habits, looks, and even the semantics of his name. "It's Hitch," he would begin, "without the cock."[32]

Life magazine once described Hitchcock as "a small, overstuffed, pouter pigeon of an Englishman with a genial exterior."[33] Reporters frequently jabbed at his rotund figure. Rather than resist their scolding, Hitchcock joined in and mocked his eating habits and size to the entertainment of the public. Interviewed in New York during his first few days in the United States, he promoted his own version of a daily menu: "My diet takes in all the available enjoyable foods, without stint. Eat as much as you like, as often as you like. It puts on weight, but it makes for good living."[34] His stout facial profile became famous, stylized as a signature element for autographs and as the opening image for his later television series. Hitchcock was

also careful to speak in carefully curated sound bites and comedic takes during his many interviews, creating a character that was irresistible to the Hollywood-hungry public and the press.

In the mundane daily habit of other notable geniuses, from Albert Einstein to Steve Jobs, Hitchcock's simplified wardrobe consisted of multiples of the same item, with "six dark suits" matched with "six identical pairs of shoes, ten identical ties, and fifteen identical pairs of socks and underwear."[35] This outfit, resembling that of a mortician, became an integral part of his character. He maintained the look without interruption for decades in his public appearances, cameos on film, and hosting duties on television. He did, however, indulge in dressing up on occasion, for the sake of theater. In 1957, he posed for photographer Maxwell Coplan as eight different people for "The Great Hitchcock Murder Mystery." This comic piece, a take on his reputation as a storyteller, included photographs of Hitchcock costumed as a gentleman, gardener, constable, maid, butler, inspector, victim and (most famously) Lady Agatha.[36]

Hitchcock was never captured on film in an undressed state, with one notable exception. In 1960, he was photographed with chest bared while peering from a screen of bamboo, strangling a red rose in his right fist (see color plate 1). The picture, by Gordon Parks, was the basis of a promotional piece for the movie *Psycho* in *Life* magazine. Parks was the first African American staff photographer to work for *Life* and was considered "one of the most powerful photographers" of the era by the Chicago Art Institute.[37] He was noted for both his "intimate portraits of celebrities" and for his work as a social documentarian presenting meaningful images of "poverty and powerlessness" in the United States and around the world.[38]

Parks's picture of the director was altered for publication by the photographer with a screen vignette of dark leaves to hide Hitchcock's body and dramatic shadowing of his eyes. The image is accompanied by the title "Phantom Face in the Foliage." A portion of the copy reads: "Here [Hitchcock] drops his attitude of roguish innocence and permits Photographer Gordon Parks, with the help of some botanical props, to take a peek at the diabolical movie-making mind that has scared the daylights out of three decades of delighted moviegoers."[39] This is the only known photograph of Hitchcock giving the shirt off his back, so to speak. Parks later pursued a successful career in cinema himself, becoming the first African American to direct a major studio film with credits as writer, director, producer, and composer for *The Learning Tree* (1969), and as a director for the film *Shaft* (1971), among other cinematic and television ventures.

The Hitchcock family eventually landed for the long term in the high-end private enclave of the Bel Air Country Club, first renting a home from actress Carole Lombard at 609 St. Cloud Road, and then purchasing a new rambling California Ranch–style house at 10957 Bellagio Road. The family home in Los Angeles did not resemble the "Charles Addams house in a grove of melancholy pines" that might be expected from a master of horror. Instead, the "sun-drenched" one-story, stone house with paneled walls was filled with art and the sundry collections of Hitchcock and his wife, Alma. The property faced the golf course and was described in a news story as "comfortable and easy to maintain," with only two bedrooms and no swimming pool. A reporter sarcastically noted that there were no "outward signs of murder, mayhem, or devilry" on the property.[40] The couple resided in this contemporary home for nearly forty years. Images from the period show a modernist-style, streamlined kitchen and traditionally comfortable furnishings. They both died in the house from natural causes: Alfred in 1980 and Alma in 1982. During this time, Hitchcock formalized his relationship with his adopted country, becoming a naturalized U.S. citizen in 1955 and receiving a knighthood from Queen Elizabeth II in 1979 on his native soil.[41]

HITCHCOCK DIRECTS AMERICA

In the late 1930s, the U.S. film industry was "dominated by producers, not directors," as well as "stars under studio contract who reigned at the box office."[42] Hitchcock aimed to disrupt the established system and recast his title of director as the creative head of a film. To that end, he carefully honed an image of the director as a solitary genius, at one point boldly pronouncing that "in the documentary the basic material has been created by God, whereas in the fiction film the director is the god; he must create life."[43] Hitchcock infrequently acknowledged the large team of people who helped him create his masterpieces in order to build and maintain this public persona of the "Film Director" as singular auteur. Even if creating a film was, and remains, "a fundamentally collaborative enterprise," the success of Hitchcock's public profile depended on presenting himself as the sole creator.[44]

Not coincidentally, this approach is also utilized by the principals of large architectural firms, from Frank Lloyd Wright to Frank Gehry, who project themselves, for better or worse, as singularly responsible for the success or failure of the landmark designs created in their studios. Luis Buñuel argued against the auteur position within both fields, writing that a film, "like a cathedral, should remain anon-

ymous, because people of all classes, artists in most different fields, have worked hard to erect this most massive structure, all the industries, all kinds of technicians, masses of extras, actors, set and costume designers."[45] Yet while Hitchcock presented himself as solitary in front of the camera and in the popular press, he acknowledged and admired the work of his collaborators behind the scenes. Robert Boyle, an accomplished production designer on Hitchcock's films, noted: "I avoid anybody who says they're the auteur. The director I would consider in some ways an auteur would be Hitchcock, but he availed himself of all the best help he could get.... He would listen to his chauffeur; it never bothered him."[46]

In *Casting a Shadow: Creating the Alfred Hitchcock Film,* editors Will Schmenner and Corinne Granof agreed, asserting that Hitchcock relied on "accident, improvisation, and collaboration" with others to create his works and enjoyed employing the team's "technical, problem-solving expertise" in addressing the many unplanned variables inherent in the process of filmmaking.[47] Hitchcock was indebted to dozens of talented creatives, including graphic designers such as Saul Bass, composers such as Bernard Herrmann, editors such as George Tomasini, cinematographers such as Robert Burks, costume designers such as Edith Head, and writers such as Robert Sherwood, Thornton Wilder, Dorothy Parker, Ben Hecht, John Michael Hayes, and Raymond Chandler.[48] Nearly all of the stories he selected for dramatization arose first in the minds of others, including Cornell Woolrich (*Rear Window*), Robert Bloch (*Psycho*), and Patrick Hamilton (*Rope*).

Scholar Sidney Gottlieb, editor of *Hitchcock on Hitchcock,* explores the complicated question of film authorship in the introduction to his book on the director's own writings and interviews. Gottlieb asks, "Was *Vertigo,* for example, authored by Hitchcock or the Hollywood studio system, within which Hitchcock might play a contributing but not determining role?"[49] The ratings and censorship boards had a heavy hand in the final outcome of any work during Hitchcock's career, even going so far as to call for changes in the script, dialogue alterations, dubbing of offensive words, and the editing of character development. In speaking of Hitchcock's writings, Gottlieb asserted that "the romantic emphasis on the individual as the sole agent of creativity has . . . given way to an emphasis on art as a mode of social production" that relies on a "context of collaboration and editorial intervention" involving the efforts of many individuals.[50]

Despite these examples of intellectual collaborations, Hitchcock kept tight control of the comprehensive vision seen in his finished films. Without a doubt, his "carefully constructed voice and persona" were strongly expressed in any work

released under the Hitchcock brand.[51] No part in the production process escaped his review, a method bordering on the maniacal and gained from years of bitter experience. For example, he wrested power from the editors, and the cutting room, by shooting a minimum of footage. Hitchcock used this method to ensure continuity in his oeuvre. "Working as I do," he mused, "you're sure that no one in the studio is going to take over and ruin your film."[52] Actor Henry Fonda, star of *The Wrong Man,* said that Hitchcock "plotted his pictures so thoroughly that the assistant directors and script supervisor knew exactly what was going to be before the shot. Not only was he a great director in every way, but in the other way that so many directors don't excel—that is in use of camera and the concept of using film."[53] Designer Boyle mentioned that Hitchcock often had specific colors in mind to portray tones and shifts in the narrative, impacting the work of the art directors. He requested the color red, for instance, as a vibrant trigger for reactions from the "psychologically disturbed young woman" in *Marnie* (1964).[54] Costume designer Rita Riggs recalled that Hitchcock insisted that *Psycho* star Janet Leigh wear a white bra and slip for the sexy opening and "black for after she steals the money," a move made "strictly [as a] character statement." She astutely noted that "he had an obsession for the 'good girl,' or the 'bad' girl" and wanted that character graphically represented by the colors she wore.[55]

Hitchcock's tenacious hold on the position of director, and as the ultimate curator of his own stories, arose from personal experiences in the studios. His biographer François Truffaut (a fellow filmmaker and director who famously conducted a fifty-hour-long interview composed of five hundred questions with Hitchcock in 1962) wrote: "To a director, the greatest danger of all is that in the course of making his film he may lose control of it. Indeed, this is the most common cause of all fatalities."[56] Reminiscing about the critical failure of his film *Rich and Strange* (1931), Hitchcock noted that "with a story that good, I should not have allowed indifferent casting."[57] Both directors believed there was a need to protect the work from "the actors, producers, and technicians . . . insofar as their slightest lapse or whim may jeopardize the integrity of [the] work." So, Truffaut asked of Hitchcock, "how better to defend oneself than to become the director no actor will question, to become one's own producer, and to know more about techniques than the technicians?"[58]

This sea change in the Hollywood hierarchy, a passing of power from the producer to the director, was cemented in place by the late 1960s. Director and noted perfectionist Stanley Kubrick said: "I feel that the director, or the filmmaker as I prefer to think of him, is wholly responsible for the film in its completed form. . . .

The old-fashioned major-studio concept of a director made him just another color on the producer's palette," along with people on the creative and business team. "Formerly it was the producer who dipped into all the colors and blended the 'masterpiece.' I don't think it is so surprising that it should now fall to the director," according to Kubrick.[59]

In spite of his perfectionism, or maybe because of it, Hitchcock went on to become one of the most highly regarded film creators in history. His arrival in the United States was heralded as a great victory for Hollywood and studio head David O. Selznick. Hitchcock completed thirty feature films in his three American decades, beginning with the release of *Rebecca* under Selznick (which replaced the defunct *Titanic* movie and won an Academy Award for Best Picture) through his last film, *Family Plot* (1976). He worked with a stunning array of talent for a variety of studios, including the Selznick Studio, RKO Radio Pictures, Universal, Transatlantic Pictures, Paramount, MGM, and Warner Brothers.[60] A large measure of his worldwide popularity relied upon interpreting a series of persistent and prevailing memes that crossed cultural boundaries. An Australian writer summed up this appeal by noting that Hitchcock's "best line is the sudden shock, the unusual existing behind the usual, truth that is garnished, fun that is chilled, contrast that is ironic. Thrillers for thrillers' sake."[61] Hitchcock earned dozens of awards, including a star on the Walk of Fame at 6506 Hollywood Boulevard, the Irving G. Thalberg Memorial Award in 1968 from the Academy of Motion Picture Arts and Sciences, and the American Film Institute's Lifetime Achievement Award in 1979. He never received an Oscar, although he was nominated five times as a director for *Rebecca, Lifeboat* (1944), *Spellbound* (1945), *Rear Window,* and *Psycho.*[62]

HITCHCOCK'S STORYTELLING METHODS AND FETISHES

In Hollywood Hitchcock built on his reputation as a pioneer, one willing to push established boundaries and veer daringly into zones of discomfort and awkwardness. Many of his works functioned as a cultural "tuning fork," finding "the hidden fears and anxieties of his audience," with an artist's access to the public's "collective unconscious."[63] Despite the levity in his interviews, he had serious goals for his American chapter in cinema, with aspirations to change the very nature of storytelling and film. He mourned the demise of "honest-to-God plot-telling," which led "cinema to emasculate itself, to lose its greatest asset—telling a story in action and movement."[64] On some level, he also lamented the advent of sound, believing

that filmmakers should "resort to dialogue only when it's impossible to do otherwise."[65] Working in the realm of silent films, he was forced to establish a distinction between the stage, where words rule, and the screen, where more splendor and setting were necessary to creatively tell the story in pantomime and story cards. Vachel Lindsay synopsized this exchange during the silent-film era, noting that "moving objects, not moving lips, make the words of the photoplay."[66]

Hitchcock was a rare director who envisioned film as an art form and the camera as the metaphorical brush of creation. William Rothman, in his frame-by-frame analysis of five pivotal Hitchcock works, noted that "if there is a modernist cinema . . . it begins with Hitchcock, in whose work film attains a modern self-consciousness." Rothman stated that "one of [Hitchcock's] deepest insights is that no moment in any film can be fully comprehended without accounting for the camera." The camera was both "the instrument of our gaze" as well as a manifestation of "his godlike power over the world of the film." In other words, this director was one of the first to acknowledge the power and presence of the technology used to capture the moving image.[67]

In Hollywood, Hitchcock changed the very act of filming with his intense focus on preproduction, with the picture "edited before it is taken." Once a theme was selected, Alfred, Alma, an assistant, and a selected writer would produce a detailed outline, or treatment, ranging up to ninety pages and containing hundreds of scenes with "precise specifications as to grouping, action and position of camera." At that time, other directors divided scripts into about fifty scenes with several takes. Hitchcock's approach saved money, with expenses generally half or less of the usual $700,000 cost of a "Hollywood Class A" film of the late 1930s.[68] A 1943 *Life* magazine piece illustrated just how far he could cut, with "more than one trick up his sleeve," to hit a tight budget. During World War II, the War Production Board placed a "ceiling on new materials used for sets." Faced with filming *Shadow of a Doubt* (1943) under these restrictions, Hitchcock reverted to location shooting and recycling materials and sets to stay within the rock-bottom $5,000 limit. The director and his team took over the city of Santa Rosa for four weeks for most of the exterior shots. Extras were townspeople hired through the Chamber of Commerce for five dollars per day. The family house where much of the action takes place was owned by a Dr. C. M. Carlson. A portion of that house was built on a Universal sound stage, using "old lumber and nails," and garden decor from the "lattice morgue" backstage, for a total cost of only $217 for new materials to create the set.[69]

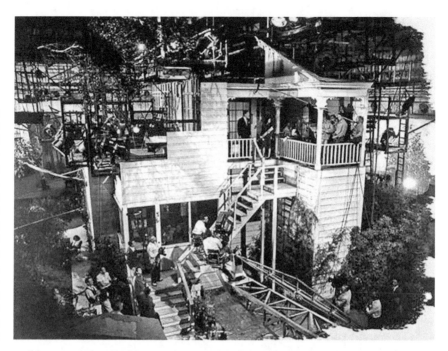

Figure 3. Santa Rosa house set at Universal created from recycled materials for scenes in *Shadow of a Doubt*. Alfred Hitchcock (*top center*) leans over the porch railing to direct actors Joseph Cotten and Teresa Wright (*top left*), Los Angeles, 1942. (Photograph by Gjon Mili/The LIFE Picture Collection via Getty Images)

The camera angles and filmic manipulations Hitchcock employed brought the individual into the cinematic space while also elevating the buildings into dominant and sentient characters in his stories. Hitchcock utilized long-tracking shots, and subjective viewer angles, wielding the camera itself as the source of the point of view. This observational approach, which puts the audience member inside the camera eye and within the action of the scene, is different than the objective viewer camera angle, filmed from a neutral or detached point. Hitchcock noted: "Subjective treatment is the close-up of the person and what they see. You see I use it a lot. . . . *Rear Window* is purely subjective treatment—what Jimmy Stewart sees all the time. And how he reacts to it."[70] In this way, Hitchcock formed an intimate relationship between himself, the camera, the audience, and the frame, a method that brought the prevailing characteristics of actors and architecture to the forefront. The camera claimed "the power to see through" the literal and metaphorical facade of buildings and people and created a relationship that crossed the two-dimensional boundary of the screen. The finished effect is immersive and engulfs the viewer in

THE ARCHITECTURE OF SUSPENSE

the story.[71] The pairing of film editor George Tomasini and cinematographer Robert Burks contributed to the successful results of this visionary approach, working with the director not only on *Rear Window* but also *To Catch a Thief, The Man Who Knew Too Much, The Wrong Man, Vertigo, North by Northwest, The Birds,* and *Marnie.* Tomasini, an expert of forced perspective techniques, also worked as an editor on *Psycho* while Burks had additional credits as director of photography for *Strangers on a Train, I Confess, Dial M for Murder,* and *The Trouble with Harry.*[72]

Hitchcock unashamedly tackled humanity's eternal themes of conflict—such as sexuality, jealousy, hate, power, and love—within the filmic universes he created.[73] During his peak period of production, films were regarded as "America's principal forum for dialogues on sexuality, romance, marriage, the family and other 'private' matters of public concern in an era of social change."[74] He exploited the medium as a way to shine a light on moral dilemmas, nighttime anxieties, and existential questions of identity as well as the "daytime pre-occupations" (as categorized by Truffaut), such as "unemployment, racism, poverty . . . or everyday love conflicts between men and women."[75] Underneath the confident sarcasm he projected to the public, Hitchcock harbored a fear of the world. Through film, Hitchcock was free to expose himself as a "deeply vulnerable, sensitive, and emotional man who feels with particular intensity the sensations he communicates to his audience."[76] To compensate for his fear, he noted that he did his best "to avoid difficulties and any kind of complications. I like everything around me to be clear as crystal and completely calm."[77] He is also one of the first American directors to specialize in modern terror and the macabre, creating a new genre of psychological horror that takes place in ordinary environments and exposes the murderous intentions of everyday people.

The enormous body of work that Hitchcock created during his career allows for the identification of patterns, themes, and "private symbols" that validate "signatures of Hitchcock's authorship" within his oeuvre.[78] In terms of his architectural vocabulary, there are a number of totems that convey double meanings or generate certain tones in his pictures, such as lamp poles, doorknobs, and staircases, each repeatedly used as narrative structures implying masculinity, entrapment, and fear of the unknown. Hitchcock was known as one of the "artists of anxiety" of his time and maintained a long list of personal quirks.[79] Various biographers claim he "suffered from vertigo and the fear of falling," evidenced by his repeated use of steep stairways and dizzying shots in *Vertigo* and *Psycho.*[80] Hitchcock frequently grappled with sexuality and masculinity, portrayed in films such as *The Lodger,* where the

lamppost's "phallic shape" and placement in the frame offer "mute testimony to the powerful, irrational force of male sexuality," which achieves culmination in this film about a male serial killer.[81] Impressions of voyeurism and the male gaze were indulged by the camera and characters peering boldly through open windows or peeking surreptitiously through a hole in the wall as in *Psycho*. Pathologies such as acrophobia, claustrophobia, and agoraphobia are demonstrated in many of his films, including *The Birds, North by Northwest,* and *Saboteur.* He also maintained controversial love-hate relationships with blonde leading ladies and dashingly handsome male actors. Last, he spoke often of a fear of the police and incarceration originating in an unfortunate childhood incident, revealed in *The Wrong Man* and *Psycho*.

Hitchcock famously devised methods of inserting himself into each of his movies, a filmic variation on a long-standing artistic tradition. This self-indulgent trope began early in his career when he played an extra in his film *The Lodger.* However, Hitchcock acknowledged that his "momentary flash appearances" were rather "inspired by his admiration" for the work of both D. W. Griffith and Charlie Chaplin, who also cameoed in films that they directed.[82] He admitted that "later on [the cameos] became a superstition and eventually a gag." The audience began to search out his distinctive and familiar face on-screen rather than watch the film, delaying the all-critical process of immersion in the story. As a result, he emphasized that he was "very careful to show up in the first five minutes so as to let the people look at the rest of the movie with no further distraction."[83] Hitchcock appeared in thirty-nine of his own features, including every picture from his American period.

In each of the quick cameos, Hitchcock is always portrayed as an outsider or an anonymous observer of the action. His deadpan face with lower lip extended in a permanent pucker is unmistakable, however, whether as a bystander in a crowd, as a shadow profile, or as a wayward man walking across the street. His mute character is alternately window-shopping in *Psycho,* rushing to catch a bus in *North by Northwest,* bearing silent witness to a rally in *Frenzy* (1972), or holding all the cards at a communal dining table on a train in *Shadow of a Doubt.* He went to great lengths to incorporate his own image into each film, even placing himself within a class reunion photograph examined by the characters in *Dial M for Murder* (1954), and as the advertising model in before-and-after photographs for the imaginary "obesity slayer" drug Reduco, on a newspaper being read by a shipwreck survivor in the film *Lifeboat.*[84] Hitchcock appeared early in *Marnie,* emerging from a hotel room after actress Tippi Hedren (as a brunette) walks down the hallway. The cameos are

quirky and amusing but also expose his omnipresent identity as Director-Creator-God within his works. He's always there, watching the action and participating in the film universe with you, the audience member.

Not content with dominating the box office, Hitchcock cleverly expanded his work beyond the movie theater and lodged himself firmly in Americans' living rooms by the middle of the twentieth century. Hitchcock said that the new media's "greatest contribution" is "that it brought murder back into the home where it belongs. Seeing a murder on television can be good therapy. It can help work off one's antagonisms."[85] His popular anthology series *Alfred Hitchcock Presents* debuted on the network channel for Columbia Broadcasting System (CBS) on October 2, 1955. He wrangled "one of the best contracts in entertainment history," earning $129,000 per episode with all rights of sale and rebroadcast.[86] He again played into his own typecasting, portraying himself on the screen as a character resembling a "macabre cherub."[87] During the series' run he "explored the dark side of the American Dream—the artificiality, hypocrisy, neuroses, violence, and evil that lurked in boardrooms and bedrooms across the United States."[88]

Hitchcock's movies, television series, and press personality eventually merged in the public eye to create a distinct cultural persona. He leveraged his British formality and acerbic irony as a counterpoint to the idealized stars and oversaturated Americana of the era. Hitchcock's show began with a line drawing of the director's

Figure 4. Alfred Hitchcock appears in the hallway during his cameo in *Marnie*, 1964. (Universal Pictures)

knife-edge profile, filled in black as his shadow stepped into the form accompanied by an off-kilter, discordant soundtrack, an interpretation of the tune "Funeral March of a Marionette," by composer Charles Gounod, written in 1872.[89] Themes and motifs of Hitchcock's television stories included "punishment . . . terror of enclosure, immobility, and madness," which also appeared throughout his films of the same period.[90] His opening appearance was accompanied by bits of dry humor and graveside wit: Hitch began with the greeting "Good evening" in his best mortician's tone and dressed the part in his trademark dark suit and tie with white dress shirt. A few of the opening scenarios included bricking up Santa Claus in a fireplace while mentioning that "he's not a bad chap, but his taste in ties is terrible," for a Christmastime episode, or standing next to a stretching-style torture rack and referring to it as a "medieval chaise lounge." The half-hour episodes, expanded to an hour-length format in late 1962, moved back and forth between CBS and the National Broadcasting Channel (NBC), until the series' cancellation in 1965.[91] Hitchcock's "pouting profile" became "instantly recognizable to millions of Americans" over the long run of the show.[92]

CRITICAL RECEPTION OF HITCHCOCK'S WORK

Hitchcock "delighted [in] presenting himself to the moviegoing public as irreverent and a master provocateur," a persona that helped him achieve unprecedented star status for a director in the entertainment industry. Nonetheless, his work was frequently met with critical derision. His tenuous relationship with critics and the press was due, in part, to his "facetious response[s] to interviewers and his deliberate practice of deriding their questions," a practice that led to his being "victimized in American intellectual circles" as a lesser artist.[93] Any perceived failure on his part was celebrated as the inevitable end of his career. In 1959 (the year before *Psycho* premiered), *New Republic* film critic Stanley Kauffmann stated it quite plainly: "The decline of Alfred Hitchcock is no longer news," he asserted. "Like an old whore struggling desperately for remembered rapture, Hitchcock fumble[s] for his early ability to render familiar scenes and objects scary."[94] He declared the recently released *North by Northwest* as the "low point in Hitchcock's career—pure comic book stuff."[95] The *New Yorker* critic agreed, citing the film as a "bloated" exercise in which the director explored "the vagaries of the nervous system under pressure" and realized "a feat he has unintentionally been moving toward for more than a decade—a perfect parody of his own work."[96] Other critics crudely compared the

director's poor physical condition with the perceived crash-and-burn disaster of his career. In 1971, independent curmudgeon and film expert Vernon Young wrote that "'Tubby' Hitchcock" was "cinematic lard ages ago," with the status of a "deck steward among the diabolists."[97]

Movies and scenes that contemporary audiences regard as high art were initially greeted with skepticism and outright hostility. Actress Vera Miles, who played the character of Lila Crane in *Psycho* and Rose Balestrero in *The Wrong Man,* said: "I don't think 'Psycho' was Hitchcock's best work. He did so much better work." *New York Times* film critic Bosley Crowther wrote that the black-and-white horror film was "a blot on an honorable career." Notably, within six months Crowther had changed his mind and listed the film as one of the ten best movies of the year.[98] Now classic features such as *Vertigo* also received mixed reviews, even from its creator. In their 1962 interview, Truffaut came right to the point, stating, "I understand that [*Vertigo*] was neither a hit nor a failure." Hitchcock responded with, "It has made money by now." To which Truffaut noted, "In your terms, wouldn't that be considered a flop?"[99] Hitchcock's films undoubtedly improve with age. In 2012, that brooding and mysterious film knocked Orson Welles's *Citizen Kane* (1941) from its fifty-year-long reign at number one on the British Film Institute poll of the "Top 50 Greatest Films of All Time."[100]

In any case, Hitchcock's cultural memory and the longevity of his work far exceed the limited reach of cranky news writers and even his own critical self-examinations. Hitchcock manufactured a filmic facade of realism by creating an immersive universe specific to each story and then inviting his willing audiences to enter. Each film in his substantial oeuvre thereby represents a unique place-making venture, promoting above all "audience identification," a component he considered "vital to a film."[101] This "lifelong concern for manipulating audiences" allowed Hitchcock to tap directly into a community psyche, one that penetrated deeply and promoted the director to the status of puppet master, incorporating "his awareness of how this manipulation is accomplished both inside and outside a film, via cinematic structure and style and also carefully calculated publicity, advertising, marketing, and self-promotion."[102]

His talent for capturing and leveraging issues that people grapple with on a daily basis—nostalgia, fear, insecurity, and ambition—set the tone for thrillers and horror films for generations. As author Stephen King noted, this type of visceral screen connection allows the audience to boldly cross over taboo lines and "touch the unknown in a simple, uncomplicated way" while safely seated within the theater, a

gesture and entertainment that is as welcome today as it was in the past.[103] During Hitchcock's career, he was described as "one of the greatest inventors of form in the history of cinema," pursuing a vision that "does not merely embellish content, but actually creates it."[104] He himself compared filmmaking to building construction, saying: "You have to see the steel structure first. I'm not talking about the story structure, but about the concept of the film as a whole. If the basic concept is solid, things will work out."[105] His words approximate the tone and intent of architects when he stated, "The beauty of the image and movement, the rhythm and the effect—everything must be subordinated to the purpose" of the final project, whether speaking of films or buildings.[106]

2

THE VILLAIN'S LAIR

Modernist Houses

Today's movie audiences readily indulge in the Hollywood trope that murderers, spies, and monsters hide out in high-style modernist homes that embody a sense of elevated separateness. Evil adversaries, from Dr. No in the James Bond series to the vampires in *Twilight* (directed by Catherine Hardwicke, 2008), spurned the idea of cobwebbed mansions and took up residence in glass-walled, minimalist buildings. These cinematic structures, whether cantilevered confidently over a precipice, standing in isolation on an open landscape, or hiding within a dense forest, are cast as incredibly beautiful characters on film. The accompanying screen sensation generated by these houses is cold and unyielding, a physical manifestation of the inhabitant's psyche. How did modernist designs, intended as comfortable spaces for contemporary families, translate into an icon of villainy on-screen?

Alfred Hitchcock was one of the first major American directors to leverage this architectural zeitgeist, co-opting the essential features of modernist design and turning those characteristics into totems representing the calculated fervor of a malevolent genius. Inspired by early works such as *Metropolis*, Hitchcock also reconstructed the essential character of the screen villain, abandoning the crazed henchmen of the 1920s and instead casting dashing, charismatic men who wielded wit and charm as their weapons. In *North by Northwest,* Hitchcock's team revealed these two new archetypes fully fledged for contemporary moviegoers, pairing a modern villain with a mid-twentieth-century modern building (see color plate 2).

This cinematic-architectural marriage of patron and design was so successful that it has since been fully typecast as a storytelling device. In the years afterward, production designers, screenwriters, and directors recruited actual houses to play the part of the Villain's Lair, drawing from a proliferation of modern designs in Southern California created by architects such as John Lautner, Richard Neutra, and Frank Lloyd Wright. Other creators designed fantastical modernist-inspired hideaways that existed only on film and in matte paintings. And, in one case, a patron turned the tables on Hollywood and commissioned an actual house based on the fictional building created for *North by Northwest.*

MODERNIZING THE VILLAIN'S LAIR

For decades, many filmmakers followed literary traditions in which the architectural environment matched the desired disposition of the character. In early cinematic productions a dysfunctional mastermind inhabited a ruined home on the moors, a lunatic doctor resided in an isolated mansion outside the city, or an evil agent of the undead hunkered down in his stone-walled castle on the hill. This convention for architectural metaphor perfectly fit the visual nature of film narratives, creating an intellectual shortcut within the mind of the viewer: bad things happen in scary places. Universal Studios pioneered the horror genre and cemented this connection in the public eye with more than a dozen movies released in the 1930s, many featuring iconic film villains Bela Lugosi and Boris Karloff. Universal's resident art director, Daniel Hall (also credited as Charles D. Hall), created "an endless variety of cobwebbed halls, frightening stairs, and creepy cemeteries" for *The Phantom of the Opera* (directed by Rupert Julian, 1925), *Dracula* (directed by Tod Browning, 1931), *Frankenstein* (directed by James Whale, 1931), *Murders in the Rue Morgue* (directed by Robert Florey, 1932), and the original *The Invisible Man* (directed by James Whale, 1933).[1] Hall, a mastermind of monster homes, also worked as art director on *The Black Cat* (directed by Edgar G. Ulmer, 1934), notable for the inaugural screen pairing of horror stars Lugosi and Karloff.[2]

The Black Cat stands out not only for this genius co-billing but also as one the first films to feature modernism as the home of the villain, a devious and deadly architect no less. The immaculately clean, polished, and pristine art deco/modernist-style building effectively transformed the "stranded couple–haunted house cliché into one of the most memorable sequences in the history of the cinema."[3] The movie was "suggested by the immortal Edgar Allan Poe classic," according to the

opening credits, but the only apparent relation is the random appearance of a wayward feline at critical moments and one of the main characters' paralyzing fear of cats. A modern reviewer wrote that this film may be the first "American psychological horror film, with dark sexual repression . . . necrophilia, pedophilia, sadistic murder and incest," all set within "fantastic architectural settings" that contribute to the richness of the story.[4]

The film follows newlyweds Joan and Peter Alison heading to a honeymoon in Budapest via the Orient Express one dark and stormy night. They meet Dr. Vitus Werdegast (Lugosi) on the train, who is heading to the home of his old friend, renowned Austrian engineer and architect Hjalmar Poelzig (Karloff). They share a bus when they arrive, but the vehicle crashes in the heavy rain, killing the driver. The threesome then struggle to Poelzig's house to find medical care for Jane, who was injured in the accident. Werdegast leads them to the architect's isolated modernist mansion perched high above the road. The house is surrounded by traditional landscape cues of villainy and horror to prepare the audience for the story to come; it was built on the remains of Fort Marmorus (dating from World War I) and overlooks an enormous cemetery, "the greatest graveyard in the world," according to the now-dead driver.

Once he arrives, Werdegast confronts Poelzig about his devious behavior during the war as commander of the fort and connects the record of the man with the history of the site, saying: "Is it any wonder that you should choose this place to build your house? A masterpiece of construction built upon the ruins of the masterpiece of destruction. A masterpiece of murder. The murderer of 10,000 men returns to the place of his crime." Interrupted by the other guests discussing the "atmosphere" of the house, Dr. Werdegast admits that "as far as the house being interesting and architectural, it could not be otherwise. Engineer Poelzig is one of Austria's greatest architects." Later, in private, Peter confides to Werdegast: "This is a very tricky house . . . If I wanted to build a nice, cozy unpretentious insane asylum [Poelzig] would be the man for it." But trouble is brewing in the big house, marked by the repeated appearance of Poelzig's pet, the black cat.

Poelzig soon reveals his dark secret to the audience while making his nightly rounds: he entombed at least seven women, each one preserved and displayed inside glass cases arranged in his basement. Poelzig later discloses that he lied to Werdegast's wife while he was away at war, telling her that Werdegast had died and would not be returning. Poelzig then married Werdegast's wife. When she died, he put her into one of his glass cases. The architect is eventually revealed as a Satanist and serial

philanderer who proceeded to marry Werdegast's daughter after the death of her mother. Werdegast later finds his daughter dead after one of Poelzig's black magic rituals and vows revenge, flaying and killing Poelzig before exploding the building with munitions left in the basement from the war.

In *The Black Cat,* art director Daniel Hall and director Edgar Ulmer introduced an entirely new character to horror cinema: the modernist house. Ulmer is also credited with the story, along with screenwriter Peter Uric. For the evil character of Poelzig, Hall created a hotel-scale residence outfitted with sleek finishes, glass-block walls, neon-tube accents, and bent-steel chairs, a marked departure from earlier Universal films in the horror genre. The flat exterior facades and polished interior materials recall the streamlined work of designer Raymond Loewy or the futuristic visions of Norman Bel Geddes (the father of *Vertigo* star Barbara Bel Geddes) that were popular during the 1920s and 1930s. The standard filmic visual cues indicating danger and villainy, such as gargoyles, turrets, and towers, are nowhere to be found. In *Dracula,* for example, the Gothic-style castle created by Hall projects an "overwhelming impression of evil" and a "suffocating feeling of decay," with a crumbling stairway, cobwebs, and tree branches punching through the windows.[5] By contrast, the villain's home in *The Black Cat* conveys the same sentiments but

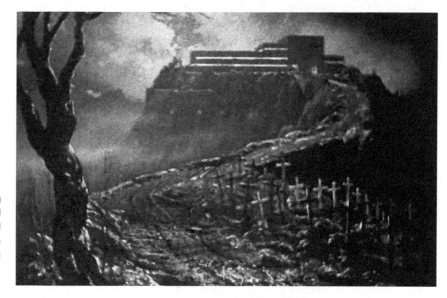

Figure 5. The Poelzig Mansion atop a World War I fortification and cemetery, home of a villainous architect in *The Black Cat,* 1934. (Universal Pictures)

THE ARCHITECTURE OF SUSPENSE

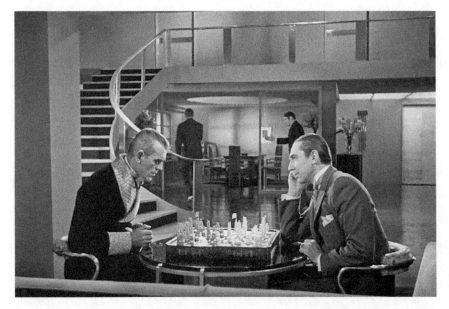

Figure 6. Interior of the Poelzig Mansion, with actors Boris Karloff (*left*) and Bela Lugosi (*right*) playing the dueling villains. (Universal Pictures)

within a completely different architectural vocabulary. Here, the film team "replaced standard Expressionist ingredients—the creaking doors and dark brooding shadows that were de rigueur for the genre—with modernism."[6] Nonetheless, the designers surrounded the modern palace with lopsided gravestones and a neglected landscape to promote the impression of danger and impending terror just in case the audience missed this connection of a modern building as a home for the evil inhabitant.

Although Hall and Ulmer "share the credit for this architectural tour de force," the appearance of the building was no doubt inspired by the director's background in Austria, an area renowned for experiments in modern design. Ulmer was born in Vienna in 1904, also the birthplace of modernist architects and groundbreaking Los Angeles transplants Richard Neutra and Rudolph Schindler. He later revealed in an interview with director Peter Bogdanovich that the architect's home in *The Black Cat* was "very, very much out of my Bauhaus period," referring to the avant-garde, modernist art and architecture school founded in Germany in 1919.[7] Ulmer even conceived the name of the character as a nod toward architecture, referring to German architect Hans Poelzig, who mentored Ulmer as a set designer for the

silent film *Der Golem, wie er in die Welt kam,* or *The Golem: How He Came into This World* (directed by Carl Boese and Paul Wegener, 1920).[8]

NORTH BY NORTHWEST: FROM NEW YORK TO MOUNT RUSHMORE

After its momentous debut in *The Black Cat,* modernism did not appear as a villain's lair again until Hitchcock brought it back in the mid-twentieth century with *North by Northwest.* The return of high-end modern designs on film corresponded with a critical shift in the portrayal of evil characters, morphing from a frazzled Dr. Frankenstein into a handsome Captain Nemo. Using cultivated gentility to cover evil intentions required an equally sophisticated architectural expression. One of Hitchcock's first experiments with this portrayal is seen in *The Secret Agent* (1936), where he unveiled a villain who was "attractive, distinguished," and "very appealing" to audiences.[9] Hitchcock moved forward from there with the belief that "the best way" to make a thriller work was to "keep your villains suave and clever—the kind that wouldn't dirty their hands with ordinary gun play."[10]

The shooting script for *North by Northwest,* written by Ernest Lehman, reveals a refined and dignified villain, with the murderous spy Phillip Vandamm described as "about forty, slightly professional in manner but definitely sexually attractive."[11] This paradoxical lead character was created as a figure who was both "smooth and distinguished," and "threatening at the same time."[12] A new host of questions faced the screenwriters, production designers, and art directors in the visual articulation of this character. What type of building would this person inhabit? What would his private lair look like? How would the character be conveyed in architectural terms? Hitchcock ultimately selected James Mason for the part, noting that the actor was proficient as a debonair leading man yet could also play "creepy as a villain."[13] A richly developed character as striking as Vandamm, played by the elegantly confident Mason, called for something new in the cinematic experience.

The story of *North by Northwest* begins in Manhattan, when advertising executive Roger Thornhill (Cary Grant) is kidnapped during a visit to the Plaza Hotel (designed by Henry J. Hardenbergh, 1907) after he is wrongly identified as George Kaplan, a spy who exists only as a fiction created by government agents. Thornhill is dragged to meet the tyrannical spy Phillip Vandamm (Mason) at his Long Island manor. But this first stop, a traditional twenty-three-room mansion, is merely the public face for the villain, who is hiding his true nature behind traditional notions of respectability. The real Phipps Estate, known as Old Westbury Gardens,

played the part of the lair. The architect George A. Crawley created the sprawling house in the seventeenth-century style of Charles II as a love nest for John Shaffer Phipps, heir to a U.S. steel fortune, and his fiancée, Margarita, in 1906. The house was opened as a public museum in 1959 (about the same time as *North by Northwest* was filming) and has hosted many film crews for movies including *Love Story* (directed by Arthur Hiller, 1970), *The Manchurian Candidate* (directed by Jonathan Demme, 2004), and *American Gangster* (directed by Ridley Scott, 2007).

Thornhill is eventually released from Vandamm's New York home but is then framed for murder in an incident at the newly completed United Nations Secretariat tower and building complex in Manhattan. Thornhill then engages in a cross-country adventure to prove his real identity and his innocence. He travels by train, automobile, and bus across the country, survives a death-defying encounter with a murderous crop duster, and eventually finds his way 1,700 miles north by northwest to Mount Rushmore. Thornhill confronts Vandamm and his lover, Eve (a double agent who has befriended Thornhill, played by Eva Marie Saint), at the villain's secret hideaway, a home that gloriously reveals the personal attributes of an evil double-crosser as visualized in architecture: a glass-and-redwood modernist structure improbably cantilevered off the cliffside behind the presidential sculpture. Thornhill must penetrate this transparent building without being caught and successfully warn Eve of the danger that awaits her from inside the house. Eventually, the two make their escape, but not before being chased by Vandamm's henchmen across the stone heads, a scene that inspired the title for an early version of the screenplay (written by Otis Guernsey), "The Man in Lincoln's Nose."[14]

In Hitchcock's mind, Mount Rushmore characterized American nationalism and communal identity, the perfect place to stage a spy-caper and murder. The stone-faced tourist attraction was created by American artists and father-and-son team Gutzon and Lincoln Borglum, who blasted 60-foot-high granite faces of U.S. presidents George Washington, Thomas Jefferson, Theodore Roosevelt, and Abraham Lincoln into the side of a steep mountain. The sculpting project was intended to attract roadside travelers to the Black Hills area of South Dakota; the process of creating it, however, destroyed a sacred Indigenous site known as the Six Grandfathers. Construction began in 1927 and was not completed until late 1941; the oversize sculpture immediately became a site of reverence and a symbol of democracy for middle America. Hitchcock talked about producing a story at Mount Rushmore as early as 1956, while filming *The Wrong Man* in New York City. He told a reporter that he envisioned a picture starting at the United Nations and then shifting to the

stone monument, with "a fugitive [hiding] in the nostril of Teddy Roosevelt, and another chap is sliding down the nose trying to reach him."[15] Hence the initial title for the film. Hitchcock later joked about the final screen name, saying: "I always figure my pictures by the directions I take. In *39 Steps,* I went north. In this one, I go north by northwest—from New York to Chicago to the Black Hills."[16]

Despite his jovial tone, the movie fulfilled the director's longtime aspiration to film a chase scene over and on top of the national landmark. Hitchcock had expressed a fascination with gigantic or oversized sculptures in a number of his previous works, including *Blackmail*. In that picture, the final sequence depicts a man "wrongly suspected" of murder escaping into the Reading Room of the British Museum. The building, with its magnificent dome, is "itself filmed as a work of mystery." A man hangs tightly to a rope next to the oversized face of Ramses the Great, a "monstrous image of imperturbability and indifference," which also acts as witness to the last moments of the escapee's life before he falls to his death.[17] Similarly, in *Saboteur,* the stern face and upheld torch of the Statue of Liberty serves a similar deadly purpose. Filming at Mount Rushmore fulfilled both Hitchcock's desire "to cover various parts of America" and to place another action shot among the heads, as he noted that "I'd been wanting to do that for years."[18]

Hitchcock's plan to have the main characters scramble over the faces of the presidents did not meet with universal approval, however. The U.S. Department of the Interior (DOI), which operated the federally owned site as the Mount Rushmore National Memorial, complained about the finished film, stating that "Hitchcock allowed acts of violence to be filmed around the sculptures and especially around a studio mock-up which shows in detail the features of Teddy Roosevelt, thereby 'desecrating' the monument." Rather than engage in a lengthy argument with the DOI, Hitchcock and Metro-Goldwyn-Mayer agreed to the agency's demand that they remove a "co-operation" credit from the introduction.[19] When news of the planned filming leaked, even the public asked, "Is anything sacred anymore?" A letter to the editor of the *Chicago Daily Tribune,* signed "Incensed," queried, "I wonder how Hitchcock or [Cary] Grant, both born in England, would feel if a grown man were to play hide and seek on the statue of Queen Victoria?"[20] No doubt Hitchcock would have enjoyed filming a scene there as well if given the opportunity.

No such criticisms were aimed at the filming of a murder scene in the national memorial's actual cafeteria and adjacent visitor center, where Thornhill pretends to be shot dead by leading lady Eve in a setup intended to distract the villainous Vandamm. The Mount Rushmore visitor services complex was designed by architect

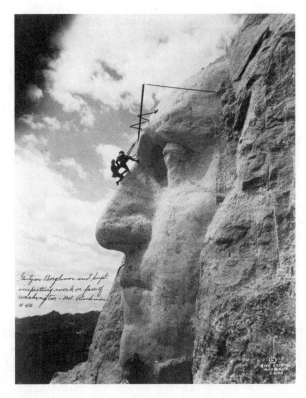

Figure 7. Sculptor Gutzon Borglum and a superintendent inspecting work on the face of George Washington, Mount Rushmore, Keystone, South Dakota, 1932. (Library of Congress Prints and Photographs Division)

Cecil Doty with Harold Spitznagel and Associates in 1963, completed for the National Park Service (NPS) under a massive improvement program. That effort, called "Mission 66" and approved by President Eisenhower, ran for a decade in preparation for the fiftieth anniversary of the founding of the NPS in 1966. After World War II, the national parks were overwhelmed with millions of car-bound tourists, who arrived to find outdated facilities, poorly planned roads, cramped parking areas, and no place to eat. To solve these pervasive nationwide problems, the NPS built more than one hundred visitor centers (introduced as a new concept) and other facilities as part of the ten-year, billion-dollar program. Mission 66 architects abandoned the rustic boulder-and-log aesthetic and embraced modernism in every aspect of the project, effectively capturing America's ambitious spirit at midcentury and promising a new era for the national parks. The visitor centers were promoted as flagship structures for the program, designed in a style that com-

plemented the mission, history, or context of each park site but also as a deliberately stark contrast to the ranger stations of the past.[21] The complex at Mount Rushmore also included a one-thousand-seat amphitheater, intended to present "a tremendously moving patriotic experience" and educate the one million tourists to the park who had "patriotism thrown at them . . . [and] love[d] it."[22] Unbridled devotion to flag and country was a promotional tool for the NPS and helped the agency cobble together a big budget for the new buildings.

At Mount Rushmore, Hitchcock challenged these notions of nationalism, safety, and security. The family-friendly confines of the park cafeteria and gift shop are penetrated by deception and violence during the blatant and publicly staged murder, creating chaos among the patrons. The disorder takes place beneath the stony gaze of the country's most notable presidents, framed precisely within the modernist lines of the 20-foot-high window walls. Aesthetically and structurally, there is a connection between this actual building and the fictional Vandamm House. Both buildings feature a modernist mix of wood, stacked-stone walls, and enormous windows, drawing from an architectural identity of rising from and connecting to the landscape. Luckily for architecture fans, Hitchcock perfectly captured the visual

Figure 8. The visitor center and cafeteria at Mount Rushmore National Memorial, South Dakota, designed by architect Cecil Doty with Harold Spitznagel and Associates, as featured in *North by Northwest*, 1959. (Metro-Goldwyn-Mayer)

THE ARCHITECTURE OF SUSPENSE

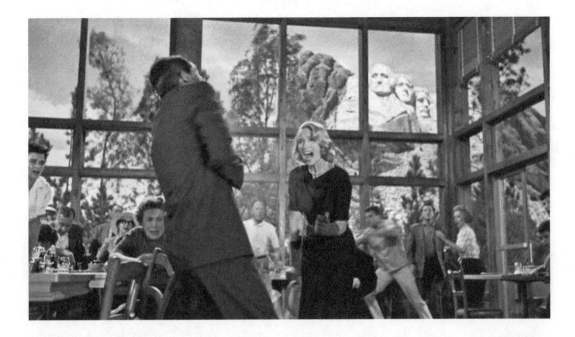

and contextual relationship between the building and the monument; in 1994, the NPS demolished the complex and constructed a larger museum facility on the same site.

ARCHITECTURAL ORIGINS OF THE VANDAMM HOUSE

The building that changed movies forever makes its first appearance on film almost two hours into *North by Northwest* and is on-screen for a mere fourteen minutes. Nonetheless, the design had a penetrating and lasting effect in the public consciousness. The Vandamm House itself is now a movie star, with its own dedicated legion of fans who post on an array of social media accounts and create websites dedicated both to the structure and its place within Hitchcock's work. The high-quality production design of the film, and perhaps the hybrid mixing of recognizable locations with studio sets, has led to many inquiries as to the "real" location of the home. Explorations in the area behind Mount Rushmore would prove futile, however, as the building is entirely conjectural, a set created by production designer Robert Boyle at the Metro-Goldwyn-Mayer studios in Culver City, near Los Angeles. The long

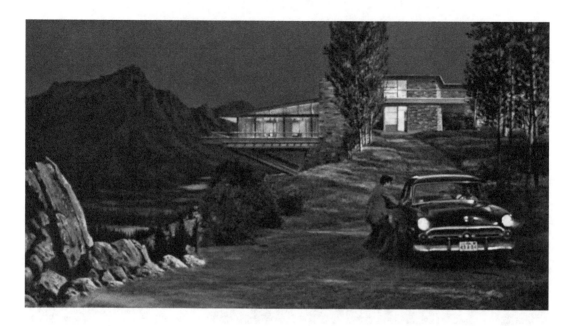

shots of Cary Grant walking up to the house were filmed on the back lot with a
road leading into a matte painting of the building completed by special-effects artist
Matthew Yuricich.[23]

Filmic constructions such as the Vandamm House draw from actual design prec-
edents set by prominent architects of the twentieth century, including Philip John-
son, Richard Neutra, and John Lautner, among others, who were themselves led
by the Four Horsemen of Modernism: Mies van der Rohe, Frank Lloyd Wright,
Walter Gropius, and Le Corbusier. Critic Reyner Banham described these "Masters
of the Modern Movement" as "father-figures who commanded awe and suspicion,
affection, [and] respect."[24] Each of these designers employed their own distinctive
methodologies within the modernist canon, including a relationship with nature
and material experimentation. But, above all, these architects emphasized site-
specific designs developed in close consultation with the client and their needs.
Buildings on film are perhaps no different, designed with intention to express the
character who inhabits the environment.

The pioneering decision to feature a modern house as the villain's lair in *North
by Northwest* arose from both the practical needs of the script and the desire to
explore innovation in cinematic representation. In short, the building had to frame

key story elements while visually articulating the villain's character. Boyle's sketches for the overall look of the Vandamm House demonstrate a well-developed modernist sensibility, with an emphasis on horizontality and an intimate relationship between the building and the natural site. The house is created from stone, wood, and glass, much like the nearby visitor center at the national park monument. The house plan is asymmetrical, expressed on multiple levels, and accented by a series of interpenetrating roof planes. The entryway is more formal, rectilinear, and enclosed, whereas the interior living area is expansive and transparent, contained in a glass box balanced on structural beams over the valley below. This combination of spaces is in line with the physical sensation of compression and release first articulated by the architect Frank Lloyd Wright. In his work, he promoted designs that pushed people through a constricted transitional space to heighten the effect of entering the larger interior volumes of the living area.[25] Even on film, this feeling of movement translates to the audience.

Screenwriter Ernest Lehman confirmed this architectural legacy, describing the Vandamm House as a "sprawling modern structure in the Frank Lloyd Wright tradition set on a rise in the land at the end of a long driveway. Lights are ablaze. There is evidence of activity within." The house, although rendered as a contemporary structure, is nonetheless presented in the tradition of a filmic villain's lair, placed fortress-like on a promontory above the surrounding landscape. The overall atmosphere around the house is dark and foreboding with the exception of a few brightly illuminated windows. Lehman describes the environment as "rocky and [sloping] sharply down to a level field," as the house itself "juts out over the slope, cantilever style."[26] In the film, Thornhill hides behind the rocks below, spying on Eve through the windows as she closes the drapes. The scene nods toward Hitchcock's manic obsession with voyeurism and acts of surreptitious observation.

The interior of the Vandamm House is far more traditional than the exterior and is consistent with a well-dressed American home of the late 1950s. In the script, Lehman describes the interior as "a large room, strikingly furnished; and dominated by a great chandelier which hangs suspended from the two-story-high beamed ceiling. A stairway at the far end leads to a balcony which runs the length of the room. Off this balcony are bedrooms."[27] The chandelier did not make it into the film, perhaps considered too incongruous with the modernist style of the building or cut out due to budget issues. The centerpiece of the living room is a towering, two-sided stone fireplace composed of horizontal courses of rough-faced stone. The house interior represents "the utopia of the modern movement with the

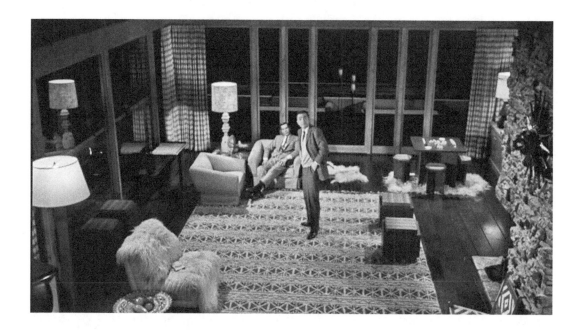

Figure 11. Interior of the Vandamm House, a well-designed modern space perfectly suited to the suave and cultured villains of *North by Northwest.* (Metro-Goldwyn-Mayer)

cornucopia of postwar consumer culture."[28] Vandamm is presented as a collector of the finer things in life, with oversized lamps, stacks of books, and statuary carefully curated on side tables, accented by fur rugs and throws. The overall effect is one of organic minimalism rendered in tones of brown and gray.

As a piece of movie architecture, the Vandamm House was not created to accommodate the daily lives of the residents but instead crafted as a set piece to emphasize the scripted actions of the character Thornhill, who has arrived at the remote home to rescue Eve before her cover is blown. In the film, the remote house was accessed via a dirt road that hugs the edge of the cliff, passes by the building, runs through a porte cochere beneath the bedroom wing, and leads back down the mountain on the other side. According to Lehman's script, Thornhill arrives at the house and climbs "up one of the cantilevers" to hide from the henchmen. He then begins "groping his way up the diagonal beam of the cantilever and . . . climbing up onto the horizontal beam" to find himself "outside one of the large windows of the living room."[29] The question of exactly who introduced this modernist architectural imagery into the scene cannot be definitively answered. The production designer,

screenwriter, and director worked closely together to edit the script, from first draft to shooting copy, and all had a hand in the creative process.

For his part, Boyle noted that "I knew we had to have a house where Cary Grant would be in a precarious position if he was discovered," with clarity and transparency so "he could see everything in the house" at one time. The pivotal scene called for both large glass windows and heavy supporting beams, features only found in high-end modernist residences. Boyle dismissed the notion of trying to identify an existing building that could fit the particularities of filming while suiting the needs of the script. "This was not a house we could find" in the field, he observed. Using Fallingwater as the inspiration, Boyle admitted that the "horizontal striated stone" of the fireplace would be "perfect for somebody to get a handhold and climb up; that's why I selected it. I was really influenced by the handholds." The stone fireplace at the Vandamm House was never used for that purpose in the film, although the supporting beams were. Boyle noted that he "really jutted it out" and rendered the house "more extravagant" than its real-life exemplar to provide a "kind of jungle gym for Cary Grant."[30]

Figure 12. Roger Thornhill (Cary Grant) climbing the beams of the Vandamm House to save the heroine in *North by Northwest*. (Metro-Goldwyn-Mayer)

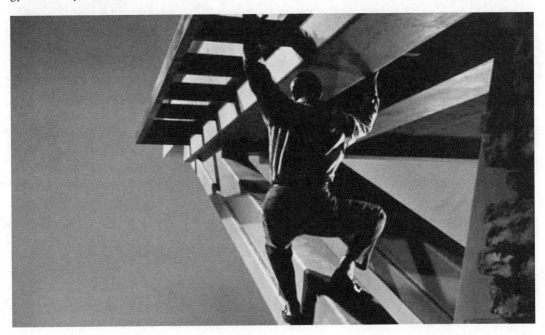

VILLAIN'S LAIR TYPECASTING

Creatives in the film community enthusiastically adopted Hitchcock's architectural precedent established in *North by Northwest*, crafting fictional modernist structures and rediscovering designs in Southern California that could host a score of film villains introduced in the 1960s and 1970s. This architectural typecasting is now so ingrained in popular culture that Lisa Rosen, a writer in Los Angeles, was compelled to ask, "Why are some of the best modern houses called home by some of the worst characters in film?" She remarked that "it makes one wonder if the homeowner's application has space for past offenses."[31]

When defining the elements of a Villain's Lair in the modernist idiom, it is perhaps easier to start with what is missing than what is included. There are no cobwebs, no creaky wooden steps, and no dark corners. Modernism is more than an architectural style; to its adherents it is an immersive lifestyle of buildings, interior furnishings, fashion, food, and art. The movement is minimalist in spirit but maximalist in experience. These straightforward designs emphasize sensory indulgences of light, sound, texture, and temperature rather than decorative embellishments. The expression of a modern building is deceivingly simple, marked by flat roofs, wide glass windows and doors, open interior spaces, and an indoor-outdoor connection with the natural world that is lacking in most other styles of architecture.

Modernism as a design movement began in the early twentieth century worldwide. The early tenets of modernism emphasized an entirely new approach to architecture "deriving form from productive method, material constraint, and programmatic necessity."[32] The focus of the design is on volume rather than decoration, on structurally articulating "a quantity of air caught between a floor and a roof," as noted by historian Arthur Drexler.[33] This idea of a simplistic expression of both the building elements and their role was captured in the statement "form ever follows function," coined by American architect Louis Sullivan decades earlier.[34] European architects translated the simplicity of modernism into a pursuit of "social rather than aesthetic considerations" in an effort to bring well-designed, machine-made environments to the masses and improve daily life, whether in factories, at home, or in the functioning of government.[35]

In America, that impulse for design as a social cure was translated into a capitalist expression as the style morphed into a brand and spread across the country. The new buildings signaled a cultural shift as well as an architectural sea change, presenting startling, energetic forms never seen before and replacing older structures

that had stood for a century. The public subsequently tagged modernism with the names of bold and assertive personas, both architects and patrons, further associating the buildings with perceptions of power, control, and discipline. On film, production designers adopted these impressions and anthropomorphized architectural features to visually connote the identity of the villain residing within the building: daredevilry is represented by cantilevered decks, elevated walkways, and suspended stairways; bold vision is epitomized by expansive glazing and panoramic views; unchecked ambition is symbolized by soaring rooflines; and disciplined self-control is signified by the minimalism and rigid geometry of modernist design. All of these elements are now solidly encoded in cinematic vocabulary as distinguishing characteristics of the iconic "archetypal dwelling of a rogue," or a classic Villain's Lair.[36]

DESIGN IMPACT OF ARCHITECT FRANK LLOYD WRIGHT

Inspiration for the style and form of the Vandamm House traces directly back to the work of Wright, one of the most accomplished and popular American architects of the twentieth century. Wright, like Hitchcock, challenged the standards of his profession, breaking the bounds of design in residential, commercial, and museum architecture repeatedly over his seventy-year career. He was also notorious for dismissing moral limits, leading a profligate and frequently shocking private life. Wright began his career in Chicago, where he worked as an apprentice to Louis Sullivan before setting out on his own in the late nineteenth century.[37] He first arrived in California from his Wisconsin design studio in 1917 to work with Aline Barnsdall on a theater and art center on top of a hill near Hollywood, as well as three other masterpiece houses composed of hollow block, an innovative but problematic building material. He kept an office on Broadway in the bustling center of downtown Los Angeles and brought in Austrian architect Rudolph Schindler, who worked for Wright in Wisconsin, to assist him. But after four years, the big commissions continued to elude Wright, and he decided to return to the Midwest. At his departure, he reportedly told his architect son Lloyd Wright (who stayed behind): "You're young enough, you can take it. I'm going back to Chicago."[38] In later years, one of Frank's grandchildren (by first wife Catherine) did succeed in Hollywood and starred in a Hitchcock movie: Anne Baxter who played Ruth Grandfort in *I Confess* (1953). She also won an Academy Award for a supporting role in *The Razor's Edge* (directed by Edmund Goulding, 1946) and was nominated for her lead role in *All About Eve* (directed by Joseph L. Mankiewicz, 1950).[39]

Wright never stopped trying to change his world. His works were noted as the "products of an imaginative temperament, romantic and robust." The press described the "layman" as "either charmed by the poetic qualities of the completed work or repelled by the strangeness of something so different."[40] Architectural critic Lewis Mumford, writing for the *New Yorker,* described Wright as an "inexhaustible creator, whose formal structures and images, far from shrinking into a convention, were unfolding until the very moment of his death." Mumford called out a direct relationship between the character of the buildings and charisma of the man, noting that his drawings and designs showed "the combination of formal discipline and effulgent feeling, the union of the mechanical and the romantic, the union of the audacious engineer, enthralled by the possibilities of technology, and the highly individualized artist that were the man himself."[41] Wright's most famous works include Fallingwater (1935) in Bear Run, Pennsylvania; the Guggenheim Museum (1959) in New York City; his two residential design studios and schools known as Taliesin (1911) and Taliesin West (1937), located in Wisconsin and Arizona, respectively; and a series of simple houses designed for middle-class families in the 1930s, dubbed "Usonian," a contraction referring to the built environment of the United States. According to the architectural curators at the New York Museum of Modern Art, Wright "grounded" his buildings "in the emotional experience of space, light, and materials . . . a resourcefulness that transcends the merely imaginative."[42] Wright's designs were cinematic in the extreme, perfectly suited for interpretation by the creative minds of the movie business.

Wright's work appeared in at least one film before the creation of *North by Northwest.* In 1951, director Arch Oboler filmed the movie *Five* in his own house, located in the Santa Monica mountains outside of Los Angeles. The complex of buildings was designed by Wright in 1940 as "Eaglefeather" and featured rustic stone-and-wood construction similar to Wright's own 1937 home Taliesin West in Scottsdale, Arizona. In this obscure film, a neo-Nazi and four survivors take up residence in the gatehouse after a nuclear holocaust destroys the world. The real Oboler House was gutted by a wildfire in 2018 and essentially destroyed, according to the Frank Lloyd Wright Foundation.[43]

Boyle and Hitchcock both referred directly to Wright's work as the architectural prototype for the Vandamm House. The movie home, like Wright's designs, combines natural materials with modern forms: coursed, rugged limestone attaches the building firmly to the earth while heavy beams support the glass-walled living room over thin air. A popular anecdote holds that Alfred Hitchcock first inquired with

Wright about designing the fictional house, but the director could not afford the master architect's costs of design and construction. References to Wright's design aesthetic in association with the Vandamm House are evidenced, however, in Lehman's script and in Hitchcock's own words. In a lengthy series of interviews with fellow filmmaker François Truffaut, Hitchcock mentioned that the building was "a miniature of a house by Frank Lloyd Wright that's shown from a distance," with the production designers building a life-size portion "for the scene in which Cary Grant circles around it."[44]

The director also mentioned the architectural connection in a 1958 memo, now held in the Alfred Hitchcock collection at the Margaret Herrick Library of the Academy of Motion Picture Arts and Sciences, in which he articulated the value associated with the exclusivity of his sets and of this design in particular. In short, he wanted to take steps to ensure no other productions would utilize the custom-designed Vandamm House; sharing the set would dilute the visual power of the house on-screen. In an interoffice memo to Sol Siegel, vice president in charge of production at MGM Studios, Hitchcock conveyed his concerns about "rumors to the effect that the big Frank Lloyd Wright Home Set, on Stage 6, might be used for television." In his typical dry manner, he continued, "I presume that this is not so, as I imagine it would be bad from a company standpoint." He signed the memo, "Happy Christmas." Sol returned the memo the next day with a handwritten addendum, "Dear Hitch, No truth to this at all—Sol."[45]

For *North by Northwest,* Boyle worked with William A. Horning and Merrill Pye (credited as art directors) as well as Henry Grace and Frank McKelvey (credited as set decorators) to create the Vandamm House.[46] Horning and Boyle both attended the University of Southern California (USC) and graduated from the School of Architecture at a pivotal time. In one of his many interviews, Boyle recognized that his career in design and film coincided with a "threshold of change" from traditional styles to modernism. He began his studies at USC during "the classic period," examining the traditions of the Paris Beaux-Arts, but discovered modernism as interest grew in the International Style as developed by Irving Gill, Walter Gropius, and the Bauhaus design school in Germany. Boyle felt that this unusually eclectic approach to design was especially valuable to architects who "went into movies," because film sets were "inclined to use a mix of traditional and modern backgrounds."[47] Headquartered in Los Angeles, Boyle was also surrounded by iconic works in every imaginable style, such as the stark-white modernist Lovell "Health" House completed by Richard Neutra in 1929; cinematic art deco monu-

ments like the Los Angeles City Hall, designed by John Parkinson, John C. Austin, and Albert C. Martin Sr. in 1928; and grandiose Egyptian and Mediterranean Revival styles as seen at the Los Angeles Public Library, designed by Bertram Goodhue in 1926. Nonetheless, America's master designer undoubtedly impacted Boyle's method, a fact revealed when he acknowledged that "every architect is influenced by Frank Lloyd Wright."[48]

The Vandamm House is clearly inspired by Wright's iconic Fallingwater, a very unusual home at that time and still a standout piece of architecture. Fallingwater is best known for its astonishing projected porches cantilevered over a running stream. Despite its rectilinear forms, the building maintains an intimate connection to nature, appearing to emerge fully formed from the surrounding southeastern Pennsylvania landscape. Designed in 1935 for businessman and philanthropist Edgar J. Kaufmann and his wife, Liliane, the house revolutionized American domestic architecture by combining a high-end modernist approach (no applied decoration and a display of technical prowess) with other Wrightian conventions, such as the amalgamation of natural materials with man-made structural elements and a liberal interpretation of traditional features like the fireplace. Peter Blake, a noted architect and architectural curator, recognized Fallingwater as one of Wright's "most poetic statements" and hailed it as "a structure of startling modernity."[49] Later critics concurred with this assessment, citing the bold design strokes and daring material juxtapositions, fundamentals that later became character-defining features of modernist villain's lairs (see color plate 3).

Kenneth Frampton, an architectural historian, observed that Wright's "cantilevering gesture" at Fallingwater was considered "extravagant to the point of folly." He concluded that the whole design effected the character of an "agglomeration of planes miraculously suspended in place" with an interior that evoked "the atmosphere of a cave rather than that of a house in the traditional sense."[50] National Park Service photographer Jack Boucher, working for the Historic American Buildings Survey in 1985, captured the stacked stone wall, multiple projecting roofs, and a three-story-tall, segmented, corner window with the cut-back edges of the bedrooms visible through the glass. This corner of the home was reproduced in spirit for the scenes of Roger climbing toward Eve's bedroom window at Hitchcock's Vandamm House in *North by Northwest*.

By coincidence, Wright had visited the Mount Rushmore area at the invitation of local promoter Paul Bellamy and wrote his thoughts on the landscape in a 1952 essay entitled "Nature as Architect." Impressed with the grandiosity and scale of

nature in South Dakota, Wright noted that the landscape stirred "a different region of the soul; we call it the heart probably. . . . [I]t seems fitting that some hand of man should brush aside the realistic veil of a stained weathered rock and let the mind of man himself envision his own greatness and his fate alongside the titanic handiwork of nature." But he hoped that the area would not "be marred by the nature imitator with his 'rustic' effects, piled boulders, peeled logs, and imitation of camp style primitive gabled buildings," further asserting the modernist doctrine that "Nature needs from man not imitation but interpretation."[51] Boyle successfully employed the thrust of Wright's design methodology at the Vandamm House, creating a home that incorporated features of the natural environment while standing boldly apart from it.

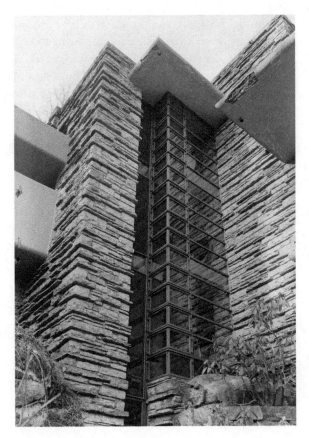

Figure 13. Detail of the three-story window at Fallingwater, designed by Frank Lloyd Wright in Bear Run, Pennsylvania, 1936–39. (Photograph by Jack E. Boucher, 1985, Historic American Buildings Survey, Library of Congress Prints and Photographs Division)

There are a number of other works in the Wright oeuvre that may have served as inspiration for the Vandamm House. In 1939, Wright returned to Los Angeles to complete a design in the Hollywood Hills with the assistance of his protégé John Lautner. The George and Selma Sturges House, a Usonian design, carries the strong lines and bold cliffside profile appropriated by Boyle for the house in *North by Northwest*. The concrete, brick, and redwood structure, measuring only 870 square feet, was described by the *Los Angeles Times* as "rakishly-cantilevered" from a central shaft.[52] Although the house appears windowless from the street, all of the rooms open onto a sun-filled terrace for light and air. Photographer Pedro E. Guerrero, who worked closely with Wright, captured the dramatic angles of the new house and the extremely private nature of the facade in a positional frame that closely resembles the atmosphere that Hitchcock adopted for his iconic villain's lair. The interior arrangement of the spaces in the Vandamm House, with a row of up-stairs private rooms overlooking an open living room, also follow a pattern found at the Wright-designed Spring House, outside of Tallahassee, Florida. Designed in 1952 for the Lewis family, the pod-shaped house was built by regionally significant architect Nils Schweizer, who worked with Wright to develop Florida Southern

Figure 14. The dramatically cantilevered George and Selma Sturges House in Los Angeles, designed by Frank Lloyd Wright, 1939. (Photograph by Pedro E. Guerrero, copyright Estate of Pedro E. Guerrero)

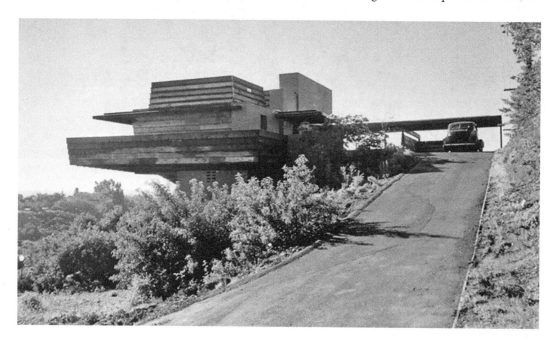

THE ARCHITECTURE OF SUSPENSE

College in Lakeland (now the single largest collection of Wright buildings in the world). Schweizer later developed his own successful firm in Florida, specializing in modern works.[53]

The Ennis House, designed by Wright in 1924 for Charles and Mabel Ennis in Los Angeles, has taken its own star turn in a number of films. The house most famously appeared as a dark and dreary mansion hosting a spooky psychological experiment run by a villainous millionaire (played by Vincent Price) in *House on Haunted Hill* (directed by William Castle, 1959) and as the futuristic apartment house of character Rick Deckard (played by Harrison Ford) in the original *Blade Runner* (directed by Ridley Scott, 1982). Interestingly, the script for *Blade Runner* authored by Hampton Fancher and David Peoples had no description of the locations of the scenes in the film and did not even identify Los Angeles as the city. Without direction from the script, production designer Lawrence G. Paull leveraged real-life architecture in Los Angeles as the "starting-off point" for his work, including the iconic Bradbury Building in downtown, designed by Sumner Hunt and George Wayman in 1893.[54] And, although *Blade Runner* ultimately featured the Ennis House on-screen, Paull said that he based the set piece on the interior of Lloyd (architect son of Frank) Wright's own home and studio on nearby Doheny Drive. According to Paull, that home more successfully incorporated spaces reminiscent of a "womb," or a cave, appropriate for the brooding Deckard to find refuge from the urban apocalypse outside his doors.[55]

VILLAIN'S LAIRS IN THE MOVIES: REAL AND IMAGINED

Ken Adam & James Bond

Ken Adam, an architect and production designer, cemented the filmic Villain's Lair character with a series of architectural creations for the James Bond series of movies. Adam (born Klaus Adam in 1921 in Berlin, Germany) intended to work as a designer in theater or film. A chance meeting with art director Vincent Korda led him on a detour into architecture. Korda advised Adam to "get a grounding in the history of styles and period" through the study of buildings in order to develop a personal approach based on wider contexts. Adam followed this advice and entered architecture studies at the Bartlett School of the University of London for two years.[56] He asserted, "I never wanted to be an architect," and disliked the "fussy Beaux-Arts classicism" taught at Bartlett, preferring the clean lines of the Bauhaus

and straightforward approach of German expressionism.[57] After graduation, Adam began his career at the firm of C. W. Glover & Partners, under the visionary architect Charles Glover, but the onset of World War II interrupted his plans. He served with the Royal Air Force as a fighter pilot from 1941 to 1946, then returned to England with the aim of getting into film.[58]

Adam is credited as production designer on seven James Bond movies. Each film features leading men Sean Connery or Roger Moore as the dapper and masculine British spy vying against a parade of megalomaniacs, each more incredible than the one before and each requiring ever more fantastic set pieces to express the characters of the story. Adam's movies include *Dr. No* (directed by Terence Young, 1962), *Goldfinger* (directed by Guy Hamilton, 1964), *Thunderball* (directed by Terence Young, 1965), *You Only Live Twice* (directed by Lewis Gilbert, 1967), *Diamonds Are Forever* (directed by Guy Hamilton, 1971), *The Spy Who Loved Me* (directed by Lewis Gilbert, 1977), and *Moonraker* (directed by Lewis Gilbert, 1979). Adam projected a "distinctive and architecturally bold," cinematic style in these films, featuring buildings with "angled ceilings, jutting support beams, and immense scale" that transported the audience "into a world of heightened reality," according to director Vincent LoBrutto, who interviewed Adam for his study of production designers.

Designing for "heightened reality" ended up being Adam's specialty. For the set of *You Only Live Twice* (1967), he supervised the building of "the largest set ever built for a European film," a $1 million project measuring more than 400 feet long by 120 feet high and requiring 700 tons of steel. This extreme villain's lair featured a lake on top and a convertible roof. Adam acknowledged his multiple roles on the movie, acting as "production designer, engineer, quantity surveyor and, yes, also architect." No surprise, then, that he was also associated with the Modern Architectural Research Group, known as the MARS Group, a think tank catering to innovative design and designers.[59] Adam's professional accolades included an Academy Award nomination for Best Art Direction–Set Decoration with James W. Sullivan and Ross Dowd in *Around the World in 80 Days* (directed by Michael Anderson, 1956) working with producer William Cameron Menzies. He later won two more Oscars and received two nominations for art direction, including a nod for his work on the James Bond thriller *The Spy Who Loved Me* (with Peter Lamont and Hugh Scaife).[60]

Throughout his career, Adam set "the standards of futuristic style and perpetual imagination" that eventually became the trademark of Bond films and promoted the role of modernism as signaling sites of danger.[61] Adam was also a production

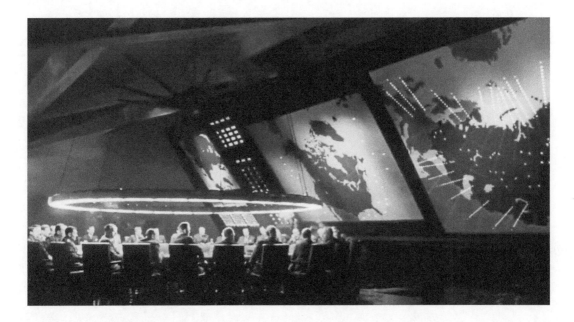

designer for the Stanley Kubrick–directed *Dr. Strangelove, Or: How I Learned to Stop Worrying and Love the Bomb* (1964). His set for the famous "War Room" at the Pentagon, where leaders of the world positioned themselves at an oversized yet spare circular table beneath a space-age light ring, chilled audience's hearts with its absence of traditional context or emotional connections.[62]

Figure 15. The "War Room" at the Pentagon, by production designer Ken Adam for director Stanley Kubrick in *Dr. Strangelove*, 1964. (Columbia Pictures)

John Lautner's Hollywood Concrete Houses

Most of Adam's filmic buildings were sets, matte paintings, and backlot creations, similar to Boyle's work on *North by Northwest*. However, Adam did use an existing modernist house as the highlight for a scene in *Diamonds Are Forever*. In the film, Bond (played by Connery) wrestles two bikini-clad guardians (known as "Bambi" and "Thumper") in the rock-strewn living room before being thrown into the indoor-outdoor pool, where he wrestles both women while taking in views of the desert oasis of Palm Springs. The otherworldly structure was designed by John Lautner, a protégé of Frank Lloyd Wright, for the interior designer Arthur Elrod in 1968, and it fits all the criteria for a villain's lair. At its unveiling, the *Chicago Tribune* described the futuristic, all-concrete Elrod House as "A house that needs

no words, this one speaks for itself." Elrod, an outsized personality who created works for Bob Hope and Walt Disney, noted, "I'm extremely simple . . . separate . . . away from people . . . private . . . you could say I'm somewhat anti-social." But his house is hardly a retiring space; the dramatically curved roofline projects boldly off a promontory and is visible from all points across the valley below. Elrod said that "living in it is better than living in a piece of sculpture."[63] The house featured a 60-foot-diameter, round living room worked around boulders natural to the site, and enclosed by floor-to-ceiling (and pool-to-ceiling) retractable glass walls. The remarkable space is covered by a concrete dome laid in flower-petal-shaped sections with clerestory windows set between the layers.

John Lautner designed many houses that later found fame as villain's lairs on film, perhaps more than any other single architect. In the movies, his tactile, sensuously curved, concrete spaces exude sexuality in their boldness and unorthodox approach. Yet most of his houses were originally created for occupation by families, despite the precipitous drops, elevated walkways, unfenced swimming pools, and indoor-outdoor fishponds that pass beneath glass walls. For the theater audience, Lautner's Hollywood-style spectacle homes best symbolized not domestic life but

the eroticism of modernist design. Author Richard J. Williams created the term "pornomodernism" to describe this combination of style and character, explored in his book *Sex and Buildings*. Williams noted that Lautner's designed spaces have "specifically erotic connotations," which developed "almost entirely through visual representation (in films, magazines, photographs), rather than by design."

Pornomodernism, as expressed in the movies, is a "debased, mannered, baroque variant that challenges all the usual assumptions about modernism's purity."[64] This sexualization, and attachment to villains, happened "retrospectively, and via third parties" rather than from any intention by the "puritanical," real-life architect. Lautner's motivations were not guided by libido but by function, joy, and beauty. He was "an artist whose work speaks of sensitivity to nature, moral integrity and emotional restraint."[65] Despite his beautiful additions to the Southern California landscape, Lautner reportedly despised his adopted home of Los Angeles, calling it "too rotten" and a forsaken "Junkland" of "indescribable ugliness."[66] But it was the very nature of this imaginative, unreal cultural landscape that permitted him to create the modernist landmarks that made him famous. Despite his aims, Lautner's works defined "home" for the typical Hollywood villain, transforming his oeuvre from "the architect of nature to the architect of porn."[67]

The proliferation of Lautner's work near the studios of Hollywood did not go unnoticed by production designers. Filmic creators appreciated the cinematic scale of the houses and the ambitiousness and improbability of the designs. A Lautner design was selected by Brian De Palma for *Body Double* (1984), a murderous homage to both *Vertigo* and *Rear Window* that draws upon the prevailing narratives of voyeurism, identity, and shame explored by Hitchcock. In *Body Double,* the main characters live in a pair of posh modernist works located on opposite sides of a valley in the Hollywood Hills. The main structure is Lautner's space-age-style Chemosphere, also known as the Malin House, completed in 1960, about the same time that *North by Northwest* hit the screen. The Chemosphere is an extraterrestrial structure resembling a glass-and-wood saucer perched on a toothpick: the house is balanced on a single supporting pier projecting from the hillside and accessible only by a funicular that runs up the slope. The building is currently owned by publishing mogul Benedikt Taschen, whose own "treatment of architecture is highly selective, and sexualized" in his many books on architects and modernism.[68] The Chemosphere has since appeared in multiple films, including an animated satirization in the television comedy *The Simpsons*.[69] The building was re-created magnificently

by production designer J. Michael Riva as the home of the villain in *Charlie's Angels* (directed by McG, 2000), with heroine Dylan (played by Drew Barrymore) being blasted through the glass windows and plunging into the valley below.

Riva featured another Lautner house for the follow-up to this all-women private-detective film, with Alex (played by Lucy Liu) inhabiting the Sheats-Goldstein House in *Charlie's Angels: Full Throttle* (directed by McG, 2003). The home was designed for Helen and Paul Sheats and their children in 1963 and sold to real estate investor and basketball superfan James Goldstein in 1972. This stunning structure also had a starring appearance in *The Big Lebowski* (directed by Joel Coen, 1998), as the home of character Jackie Treehorn, a rich pornographer and loan shark. "The Dude" (played by Jeff Bridges) famously lounged on one of the Lautner-designed, full-length, brown leather couches permanently installed in the living room beneath the coffered concrete ceiling (see color plate 4). Popular on-site tours allow visitors to take in the expanse of the house and pose on the couches while overlooking the city of Los Angeles below the cantilevered pool. In 2016, Goldstein promised the house, its contents, the land, and his car (a 1961 Rolls Royce Silver Cloud) to the Los Angeles County Museum of Art.[70]

A model of Lautner's Garcia House, designed in 1962 in Los Angeles, was completely destroyed on film in *Lethal Weapon 2* (directed by Richard Donner, 1987), when an unhinged undercover policeman (played by Mel Gibson) ties a cable between his truck and the slender stilts that support the elegantly balanced house and pulls the structure to the ground to foil a group of gangsters. That same year, Barbara Ling, production designer, featured the 1963 Lautner-designed Reiner-Burchill Residence in Los Angeles, also known as Silvertop, as the parents' home for a Brat Pack teen in *Less Than Zero* (directed by Marek Kanievska, 1987).

Richard Neutra's Hillside House in *L.A. Confidential*

Lautner was not the only Los Angeles architect taken to the movies. Richard Neutra's Health House is more recognizable for its appearance in *L.A. Confidential* (directed by Curtis Hanson, 1997), as the home for Pierce Patchett, a pimp, drug dealer, and blackmailer, than it is as the real-life home of Dr. Philip and Leah Lovell. Philip, born in New York as Morris Saperstein, moved to California in the 1920s and retooled himself as a health expert and writer of the popular "Care of the Body" series that appeared in the *Los Angeles Times*. In his advice column he promoted nude sunbathing, cold showers, and vigorous exercise but frowned on

masturbation, loose literature, and "salacious moving pictures."[71] The successful couple hired the relatively unknown modernist Neutra, newly arrived in Southern California after a stint at Frank Lloyd Wright's Wisconsin studio. He came of age in Austria surrounded by revolutionary architects such as Adolf Loos but had only completed one freestanding design in Los Angeles—a bare-faced apartment building on Marathon Street that flouted tradition with its total lack of ornamentation paired with cantilevered balconies and corner windows.

The Lovells worked with Neutra for three years to create a landmark structure that incorporated "more designs of household efficiency, social and private welfare, physical and cultural development, than any house known" in the United States. The couple already owned a concrete-frame modern house designed by Neutra's fellow Austrian and partner Rudolph Schindler in 1926 at Huntington Beach a few hours south. For this "city house," however, Lovell and Neutra pursued the lofty goal of changing the built landscape overall, to "introduce a modern type of architecture and establish it firmly in California, where new and individualistic architecture is necessary."[72] The unorthodox building is made of a Bethlehem Steel–produced frame covered with sprayed concrete, a technological achievement in residential construction. The multistory, blazing-white house is perched at the top of a green valley like a sentinel, with ribbons of glistening glass windows engaging views of the city below.[73] The shadowy villain's lair in *The Black Cat* bears an eerie resemblance to this actual building. Ironically, in that film actor Boris Karloff played the role of a murderous architect from Austria, which is also Neutra's country of origin.

This newcomer design by Neutra stood out from the Southern California crowd, distinguishing both building and architect for decades afterward. In 1929, Lovell published a two-page spread in the *Los Angeles Times* announcing the opening: "At last the day has arrived. We have built . . . a home premised on the fundamental health principles and construction ideas which I have presented in my writing in the past," including natural and artificial lighting, hydrotherapy equipment, labor-saving devices, sleeping porches, and modern construction materials. In a bold public-relations move, Lovell invited his readers to visit his so-called Health House on two consecutive weekends that December. He provided both a map and directions for parking on the steep, narrow road: all cars facing downhill on the right side of the street "to avoid confusion" and crowding (which is still a notable problem during events and tours).

Architect Neutra was at the opening himself, enthusiastically lecturing once each day and providing a personalized tour of the hillside property, in which he

conducted "the audience from room to room and place to place, describing in detail the purposes of each innovation." By throwing open the doors on this one-of-a-kind house, Lovell and Neutra shared their design dreams with the public and widely promoted a new style of living in the twentieth century. Lovell wrote, "The entire home should be considered from a social sense rather than from a restricted private family residence—a place where friends and kin can gather—where children of the neighborhood will prolong their stay voluntarily." And, despite the oversized nature of his house, the proud owner boasted that "there are dozens and dozens of features in this home which can be included in the average five or six-thousand-dollar cottage" and the typical American home.[74]

Arthur Millier, writing for the *Los Angeles Times,* articulated the enormous impact that Neutra had on the architectural climate of the era and how shocking his ideas of incorporating industrial building techniques into residential buildings were at the time:

He negates entirely the age-old instinct of man to decorate everything he uses. His passion is reason. His ideas are genuinely modern in their insistence on the maximum of light and air. His buildings are rationalistic experiments in structural engineering. They are blank spaces on which the occupant must write whatever charm or wayward fancy he can. Perhaps in their bald spacing, their stark puritanism, they utter the alphabet of the new esthetic. Certainly they are intelligent.... Structure and space are everything. In him the engineer triumphs, the artist-craftsman dies; reason defeats imagination.[75]

Today the Health House is recognized as one of the most significant residential structures in the United States, listed on both the National Register of Historic Places and as a Los Angeles Historic Cultural Monument under the long-term stewardship of the subsequent owners, Betty Topper and her family. The house changed hands in 2021 after her death and is facing a new future. Neutra went on to change the identity of modern architecture worldwide with his ideas promoting

Figure 18. Lovell "Health" House, designed by architect Richard Neutra (*pictured*), Los Angeles, ca. 1931. (Photographer unknown, Security Pacific National Bank Collection, Los Angeles Public Library)

material transparency, connecting indoor and outdoor environments, and harnessing the power of design to improve people's lives, whether at a house in the country or an office building in a busy downtown. In a 1949 cover story featuring architect Richard Neutra, *Time* magazine asked, "What will the neighbors think?" of the new modernist lifestyle, stating that, "Like them or not, modern houses are here to stay."[76] Over his long career, Neutra completed landmark commissions for buildings across the country, including the 1946 Desert House in Palm Springs for business scion Edgar J. Kaufmann (a bookend to the Frank Lloyd Wright–designed Fallingwater in Pennsylvania for the same family), and received the Gold Medal from the American Institute of Architects posthumously in 1977.[77]

Despite this notable historic pedigree, the Lovell House remains better known in the public eye for its brief star appearance on film. Neutra never expected that his technologically and ideologically groundbreaking design would be publicly identified as the home of a villainous character, and a fictional one at that. He spoke with disdain about the cinematic mind-set of Hollywood and the larger impact on design in Southern California, a view also shared by Neutra's architect colleague John Lautner. In Los Angeles, Neutra found himself surrounded with an eclectic collection of buildings as varied as on any studio backlot. He despaired that "motion picture sets have undoubtedly confused architectural tastes. They may be blamed for many phenomena in this landscape such as: Half-timber English peasant cottages, French provincial and 'mission-bell' type abodes. Arabian minarets, Georgian mansions on 50 by 120 foot lots with 'Mexican Ranchos' adjoining them on site of the same size."[78] Interestingly, the Lovell House designed by Schindler has yet to make an appearance in the movies. Millier, the press writer who lauded Neutra's design, did not appreciate Schindler's undressed expression of bare materials at the shore. He described the exposed concrete frame of Lovell's Beach House, the fraternal twin of the Health House, as "like a man who struts about displaying his huge muscles," not unlike the patron himself.[79]

In 1997, production designer Jeannine Oppewall, working with director Curtis Hanson, selected the Lovell "Health" House as the residence for the heartless character Pierce Patchett, a brilliant pairing of villain and architectural character. Oppewall, recipient of the Lifetime Achievement Award from the Art Directors Guild, believes that the production designer's role is akin to a "cultural shaman, in that you have to react to architecture and the environment in an intuitive, more emotional, rather than a rational, way."[80] *L.A. Confidential* highlighted the city at

a peak moment in the 1950s, yet she notes with irony that in the film "some of the best architecture went to the film's worst characters."[81]

During an interview with the California Preservation Foundation in 2020, Oppewall recalled the process of selecting key locations for *L.A. Confidential:*

> Curtis and I did have discussions about whether we should use traditional LA architecture for the villains. But because we knew that the high-class call girls would need architecture that was more easily understandable to everyone, especially to their clients, we decided that it might not be a bad idea to move in a different direction for the villains. In film, it's important to differentiate characters by the buildings they inhabit. So if Lynn Bracken, the call girl, lived in a familiar and traditional LA Spanish style house, then Pierce Patchett, the wealthy pimp, should live in a modernist structure. In this way, the audience is given some clues about how different the characters are from each other. The master manipulator, Patchett, is placing his Veronica Lake look-alike call girl in a familiar theatrical lair that would easily appeal to the creatures he wants her to catch.[82]

In selecting the Health House, Oppewall noted that she was looking for "places that satisfied the action requirements but brought emotion to the scenes as well, in terms of what baggage a piece of architecture carries with it," similar to the motivation cited by Boyle in the creation of the Vandamm House.[83]

A Real-Life Vandamm House

In an architectural twist worthy of Hitchcock, the Vandamm House inspired at least one person to ask for the plans from the director with the intention of recreating the residence. The house, named Mirrabooka, was built in the Castle Hill neighborhood of Sydney, Australia, in 1963. The home made the local news when it was selected as the setting for the television biopic *Dynasty: The Making of a Guilty Pleasure* (directed by Matthew Miller, 2005), with the house playing the "Hollywood Hills home of the couple who created the 1980s soap classic." The owners, who wished to remain anonymous, according to a local newspaper article, told actor Ritchie Singer the story of the home. Singer said: "The owner had been a huge fan of Hitchcock, particularly *North by Northwest,* and when Hitchcock came to

Sydney to promote [the movie,] he was staying at the Intercontinental Hotel. So this man went down there and pestered and pestered until he finally got to speak to [the director]. He said 'I have to have that house that Cary Grant goes to in *North by Northwest.*" According to the story, "Hitchcock was so impressed with the Syd-neysider's vision that set plans were handed over to him."[84]

The home was designed by architect Bruce Rickard "in the Usonian manner," as he was "one of the leading Australian proponents of Frank Lloyd Wright's concept of dynamic, organic space and his method of carefully integrating buildings with their site." Not surprisingly, Rickard had studied architecture under a fellowship at the University of Pennsylvania in 1955 (within driving distance of Wright's Fall-ingwater) before returning to Australia to practice. An Australian National Trust Register report noted that materials at Mirrabooka were similar to those used by Wright, as well as the fictional building created by Boyle: "Rickard utilized local equivalents to the Usonian palette . . . natural timber, glass, and stone." The inte-riors do indeed resemble the house from the film, including the "open plan living areas . . . anchored by a massive stone fireplace." The house pushed the boundar-ies of practical construction at the time, as the first domestic residence to utilize a "pre-tensioned concrete floor slab, cantilevered three metres from the balcony."[85] The newspaper summarized the completion of this filmic design circle, noting that "Hollywood has come to Castle Hill to pay homage to a house originally built in homage to Hollywood."[86]

The Merging of Character and Building

In *North by Northwest,* the multiple personalities of modernist design played per-fectly when presented as the home of a classic two-faced character. The move was so successful that the identities of the structure and the villain merged. Film crit-ics such as Raymond Durgnat interpreted the Vandamm House as a sentient being when he described the building as "an alien, malign, disaffected intelligence." Like-wise, he interpreted the position of the home, on a plateau above the carved stone faces of Mount Rushmore, as one that "expresses visual domination and panoptic control" over the nearby "devotional shrine of American democracy." Author and art historian Steven Jacobs, who created a set of blueprints of the house after re-peated viewings of the movie and extensive archival research, observed that "both love of the arts and a predilection for modern architecture are persistent Holly-wood signifiers of menace and malice."[87] Jacobs conflated the style and location of

the building with the power of the villain within. He posited that this iconic residence ultimately represented a "progressive quest for power and wealth," a quality often attributed to capitalists, and likewise to criminals.[88]

Architectural critic Paul Goldberger agreed, writing that the Vandamm House's "very existence suggests tension and improbability." He noted that the glass walls imply a transparency, "but of course there is nothing but duplicity within—a lovely tweak at modernism's own duplicity." Goldberger further linked modernism and villainy in his observation that "the stark modernity of the structure, and indeed the fact that it is itself so visibly a work of structure, underscores a sense of modern architecture as thrilling, dangerous, and exotic." The powerful design of the house not only changed architectural interpretations in film but affirmed the logic of the *North by Northwest* narrative that ultimately exposed Vandamm as a cold-blooded and deceitful killer. Goldberger believed that this climactic reveal "would have not been the same had the mountaintop contained a rustic cabin instead of this modernist extravaganza."[89]

Filmmakers leverage the character of modern architecture to forward the story, but many no doubt also find it convenient that the buildings incorporate features properly fitted for cliff-hanging murders. Screenwriter Lem Dobbs discussed the process of casting a villain's house for *The Limey* (directed by Steven Soderbergh, 1999), a story of an off-kilter Brit traveling to Los Angeles to find his daughter's murderer. The killer, Terry Valentine (played by Peter Fonda), a hedonist, money-launderer, and music executive, lives in an all-white modernist temple: the Astral House by architect Brent Saville, hanging off the cliffside in the Hollywood Hills area of Los Angeles. The house "was cast even before the script was finished," according to Dobbs. While in the process of writing, he had attended a party at the house and then created pivotal moments in the film around the distinctive features of the building: "It was mainly that pool hanging over that horrendous, dangerous-looking drop that occurred to me practically in terms of the scene and knowing that I wanted to have someone flung off it."[90]

The public at large maintains a love-hate relationship with modernism. Perhaps it is because architects of the modern age, beginning in the early twentieth century, dispensed with any type of nostalgic longing for the past. A person who intentionally sought an environment unmoored from the comforts of cultural and historical foundations translated in the public hive-mind to a coldhearted narcissist who lacked respect or regard for the past. This impression is not too far from the truth in some cases. Filmmakers today could legitimately argue that the modern-

ists deserved the title of villain. Architects like Frank Lloyd Wright, John Lautner, and Richard Neutra were openly disdainful of public tastes in architecture and dismissed widely accepted traditions in design. Barbara Lamprecht, an architectural historian and noted scholar of Neutra's works, believed that the architect and his heady compatriots of the time were all "involved in exposing and uprooting what they believed to be a decadent culture riddled with a myriad of middle-class hypocrisies," with a dialogue that was "daily, fierce, and intimate." She concluded that "the atmosphere of cultural upheaval was the air Neutra breathed and moved in," qualities essential to the art of architectural disruption.[91]

Today, many of the most significant residential designs of the American modernists are held tightly in private hands, completely inaccessible to the public and impenetrable from the outside world. The blank street-side facades are deliberately hostile to protect the privacy of the inhabitants, a separation reinforced by gated driveways with only slight glimpses of an angled roof or windowed balcony available through the trees. In short, the perfect hideaway for a villain.

3

URBAN HONEYCOMBS
Skyscrapers and Apartments

The monumental form of the skyscraper inspires a sense of optimism and desire. These lofty buildings represent efficiency, ambition, and technological victory for millions of people around the world. But the skyscraper's soaring architectural spirit and masculine scale is countered by the inhumanity of capturing human souls within its tightly regulated and mechanistic boundary. The structures portray the character of an impenetrable fortress, one that dominates by its inherent density with sheer walls hiding layer upon layer of spaces enclosed within a rigid pattern of masonry or steel. There are direct physical and environmental impacts as well: tall buildings throw entire neighborhoods into shadow as the sun passes and create soldierly rows that generate powerful urban wind canyons. The manifold levels and meanings of this modern building type, populated by people both commonplace and extraordinary, attracted Hitchcock's attention as a premiere storytelling device in a number of his films, including *Rope* (1948), *Dial M for Murder, Rear Window, Vertigo, North by Northwest,* and *Psycho* (see color plate 5).

Hitchcock identified and exploited existential questions of identity in the modern age in the cubist-like forms of the tall office building and the human honeycomb of the apartment house. Within this structural identity, Hitchcock also explored the unique irony of urban environments, places that are at one moment quietly intimate and the next filled with nameless, and possibly dangerous, inhabitants. He also tapped directly into widespread public perceptions of the skyscraper or tower

as "the most shamelessly sexual building form," which are "invariably, inescapably phallic symbols, standing proud, firm, erect," representing power and domination, as historian Richard J. Williams noted in his analysis of sex and buildings.[1] The director further taunted the pure, modernist ideal of streamlined perfection in the modern skyscraper by emphasizing the essential flaws and individuality of the people behind the glass curtain.

In architectural terms there are legible, connective relationships between the multistory buildings starring in Hitchcock's movies and the cinematic vocabulary he employed. The American skyline, filled with "monolithic, disornamented, impersonal, straight-up-and-down" tall buildings reflected not only the community but a vision of ourselves, represented as a series of "faceless boxes" that were "going to take over everything, and they almost did so," according to popular critics.[2] Photographers captured this urban intensity in the endless wall of buildings lining the

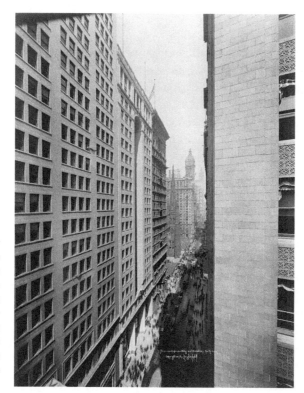

Figure 19. Skyscraper canyon in New York City with a view down Broadway toward the American Express Building, 1917. (Photograph by Irving Underhill, Library of Congress Prints and Photographs Division)

streets of American cities in the early twentieth century. Similar themes of identity and the loss of individualism within the modern world were explored in *Metropolis,* visualized by Austrian director Fritz Lang in 1927 with Otto Hunte, Erich Kettelhut, and Karl Vollbrecht credited with art direction. In this German expressionist silent film, a dictatorial entrepreneur runs the "Wonder City of the Future" from the heights of his skyscraper office while the industrial proletariat labors underground, living below street level. A duplicitous automaton starts a worker's rebellion against the machines that run the city, leading to catastrophe and ultimately salvation. A promotional piece for the film identified the urban landscape as "a modern Tower of Babel, where the different elements are fighting under different conditions for their existence, or their indulgence in pleasure."[3] Similarly within Hitchcock's oeuvre, skyscrapers and apartments clearly expressed society's own distorted and tangled perspective of itself and the endless search for identity.

HISTORY OF THE AMERICAN SKYSCRAPER

In the early 1880s, the term "skyscraper" was primarily used in reference to baseball swings, celebrities, politicians, and a style of lady's bonnet.[4] Identifying the first skyscraper in the world and the qualities and characteristics of a true member of the type continues to be a subject of dispute and debate, depending on whether the argument relies on the height of the building or technological and material achievement. Contenders for the earliest high-rise structure in the world might include one of the first buildings to rely on a steel-frame structure beneath a reinforced masonry curtain wall, most often cited as the ten-story-tall Home Insurance Building designed by William LeBaron Jenney (1884–85) in Chicago. This modern triumph, along with the introduction of the mechanized elevator, allowed for the immense heights achieved in skyscrapers today. Others point to the Montauk Building in the same city, designed slightly earlier by the architectural firm Burnham and Root (1881–82), but the same height as Jenney's structure. Yet other scholars point to New York City as the origin of this American building type, citing the Tower Building by Bradford Gilbert (1888–89), the first in that city with a "skeleton frame," or even earlier examples such as the Western Union Telegraph Building by George B. Post or the Tribune Building by Richard M. Hunt, both built between 1873 and 1875.[5]

Despite this origin-story identity crisis, the term "skyscraper" had firmly entered the architectural vernacular by 1884. The unusual stature of the buildings immedi-

ately generated metaphors for strength and masculinity. "Colossal Architecture," read an 1885 headline in a Stockton, California, newspaper, describing New York's "business palaces" as both "attractive" and "massive," which provided "evidence of the wealth and stability of the business enterprises centred [*sic*] therein." Builders sought to go "higher, still higher," a trend that was predicted to continue until "possibly a two-minute earthquake shock will bring the aspirations of architects to a lower level."[6] Instead of being cowed, however, architects themselves adopted the imagery of structural muscle and believed their designs held a special power over their patrons and the public.

Louis Sullivan, an architect in late nineteenth-century Chicago and cofounder of the landmark firm Adler & Sullivan, is now widely acknowledged as the "father" of the skyscraper. A man of outsized ideas with a spectacular imagination, Sullivan outpaced everyone in his realm. Notably, a young apprentice named Frank Lloyd Wright joined the firm in 1887 but departed only six years later, when Sullivan refused to allow Wright to design "boot-legged houses" on his own time.[7] Historian Albert Bush-Brown lyrically wrote that "only the heroic scale measures Louis Sullivan," an individual who embodied the character of the architect as a "prophet" with a "grandiose vision" to "shape his society through architecture."[8]

Adler & Sullivan's ten-story-tall Wainwright Building, opened in 1891 in downtown St. Louis, Missouri, set the tone for American high-rises as architects explored the unlimited possibilities of designing upward rather than outward. In a 1930s lecture at Princeton University entitled "The Tyranny of the Skyscraper," the by-then-famous Wright described the moment of that building's conception:

> Our peculiar invention, the skyscraper, began on our soil when Louis H. Sullivan came through the door that connected my little cubicle with his room in the Auditorium Tower, pushed a drawing-board with a stretch of manila paper upon it over onto my draughting-table, and, without a word, went back again into his own room and closed the door behind him. There it was, in delicately pencilled elevation. I stared at it and sensed what had happened. It was the Wainwright Building—and there was the very first human expression of a tall steel office-building as Architecture. It was tall and consistently so—a unit, where all before had been one cornice building on top of another cornice building. This was a greater achievement than the Papal Dome, I believe, because here was utility become beauty by sheer triumph of imaginative vision.[9]

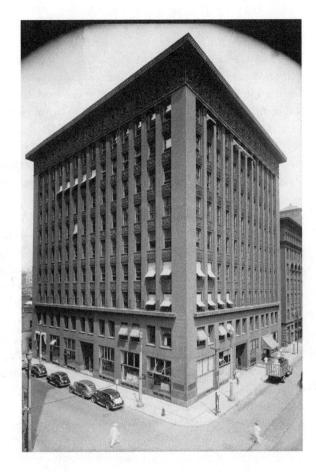

Figure 20. The Wainwright Building, St. Louis, Missouri, designed by architect Louis Sullivan, 1891. (Photo by Lester Jones, 1940, Historic American Buildings Survey, Library of Congress Prints and Photographs Division, HABS MO-1140)

In an 1896 article entitled "A Tall Office Building Artistically Considered," Sullivan enthusiastically described the potency of modern skyscrapers. These elevated structures, reaching for the clouds, were a "joint product of the speculator, the engineer, the builder," a trinity of deities whose fertile minds were capable of creating this unique soaring edifice.[10] But, he questioned, "What is the chief characteristic of the tall office building?" The answer, he wrote, was blatantly clear: "It must be tall, every inch of it tall. The force and power of altitude must be in it, the glory and pride of exaltation must be in it. It must be every inch a proud and soaring thing,

rising in sheer exultation that from bottom to top it is a unit without a single dissenting line—that it is the new, the unexpected, the eloquent peroration of most bald, most sinister, most forbidding conditions." For the community to erect such a structure, Sullivan asserted, the "man who designs in this spirit . . . must be no coward" but live "his life in the fullest, most consummate sense" and grasp upon the "problem of the tall office building [as] one of the most stupendous, most magnificent opportunities that the Lord of Nature in His beneficence has ever offered to the proud spirit of man." The public took notice, elevating the architects, developers, and creators of this new building type to star status in the press.

Despite this call to greatness, there remained the problem of beauty in design. Sullivan pondered the challenge of applying the current architectural design vocabulary to an entirely new building form, asking: "How to impart to this sterile pile, this crude, harsh, brutal agglomeration, this stark, staring exclamation of eternal strife, the graciousness of those higher forms of sensibility and culture. . . . How shall we proclaim from the dizzy height of this strange, weird, modern housetop the peaceful evangel of sentiment, of beauty, the cult of a higher life?"[11] The answer, he resolved, lay in pulling from ancient architectural traditions, separating the tall structure into three sections equivalent to the base, shaft, and capital of a classical column. Within this structure, Sullivan prophesied, the modern office worker or apartment dweller could be accommodated in "an indefinite number of stories . . . piled tier upon tier, one tier just like another tier, one office just like all the other offices, an office being similar to a cell in a honey-comb, merely a compartment, nothing more."[12] Art history professor Juan Antonio Ramírez has since noted that the "beehive metaphor" in architecture presciently referred to by Sullivan represented "a stimulus to imagine a society in which human life was transparent and in which there is no privacy." This movement represented a terrifying by-product of modernity for a community more familiar with life on the ground.[13]

MODERNIST ARCHITECTURAL IDENTITIES IN THE UNITED STATES

In Europe, modernist architects advocated turning away from traditional designs of the past as part of a larger effort to stabilize and equalize social disparities through carefully articulated architectural environments. Many of those same architects found refuge in the United Sates during the tumultuous years of the early twentieth century, a prolonged period marked by wars across the globe and widespread oppression. Once modernism took hold in America, a transformation began. Cor-

porate and moneyed interests co-opted the stylistic and technical prowess of the movement to create high-end buildings that celebrated wealth. At that point, architects moved away from the socialist ideals of the first generation of designers and into a period of stunning economic growth and creative activity. The modernists' unflinching design vision heralded a nationwide building boom, resulting in the development of new materials, more efficient methods of demolition and construction, and the generation of a large labor pool. As the movement progressed and grew, traditionalists began to foment a fear of this new future vision. Popular culture captured the social unease with this new architecture, a typology that did not rely on the past to inform its shape or purpose. As monolithic skyscrapers loomed ever taller and daily life became increasingly possessed by machines, there was an attendant rise in anxiety about "people's control over their own inventions."[14]

As early as 1930, architects such as Wright bemoaned this "dull craze for verticality and vertigo" that guided the upward mobility of landlords and property owners while diminishing the importance of human scale and the "freedom" to roam.[15] He mourned the loss of opportunity for creating inspired monumentalism and declared: "Today all skyscrapers have been whittled to a point. . . . [T]hey whistle, they steam, they moor dirigibles, they wave flags, or they merely aspire, and nevertheless very much resemble each other at all points. . . . [S]omething like paralysis seems to stultify them."[16] He concluded that the whole enterprise was "utterly barbaric."[17]

Nonetheless, skyscrapers blossomed everywhere in 1949, powered by post–World War II economic prosperity. That year, the monumental United Nations Secretariat Building in New York City was completed, and, not by coincidence, Warner Brothers released *The Fountainhead,* a passionate film about architects and architecture. The film was directed by King Vidor and based on an oversized novel by author Ayn Rand (published in 1943), who also wrote the screenplay for the film. Robert Burks (a Hitchcock collaborator on twelve films) had an early credit as director of photography. The themes in both the novel and movie had not changed much since the nineteenth-century interpretations of the tall building by Sullivan. Here, architecture is a metaphor for manhood, the future, and self-identity. In Rand's story, a modernist architect, Howard Roark, and his lover (played by Gary Cooper and Patricia Neal) tangle repeatedly over the design, completion, destruction, and rebirth of a series of buildings and skyscrapers while simultaneously engaging in "episodes of cruelty, sadism and finally, domination."[18]

The character of Roark is generally interpreted as a fictionalization of Frank Lloyd Wright but is more likely a cinematic amalgamation of many architects of

the age who were known for their outsized personalities and outrageous designs. Roark's buildings as represented in the film, however, unequivocally resemble Wright's mid-twentieth-century works. The creative team for the movie included Edward Carrere as art director, who later worked with Alfred Hitchcock on *Dial M for Murder*. According to Steven Jacobs, Wright was asked to create the illustrations used throughout the movie to demonstrate the rise of Roark's skyrocketing career, but he dropped out due to "financial disagreements."[19] Carrere completed the drawings and sets himself. The public conflict between modernism and traditionalism within the form of the skyscraper is explained in detail in the dialogue of the film. The movie is also acutely expressive of the public attitude toward modern architecture and the architectural profession at the time.

The film captures the prevailing mood of distrust toward architects and their work along with an overall impression of the modernist architect as a lone wolf pursuing his own goals to the disadvantage of the public good. Upon Roark's presenting his work for the Security Bank Building to the board, the committee requests changes to the groundbreaking design, adding a neoclassical facade to the ground floor and a primary elevation, hiding the pure rectilinear form of the structure. Proud of their additions, the chairman states: "Now there's a touch of the new and a touch of the old, so it's sure to please everybody. . . . Why take chances when you can stay in the middle?" Roark refuses, arguing, "A building has integrity just like a man, and just as seldom." An architectural critic later argues with the patron (a newspaper mogul), aghast at the idea of departing from the traditional styles, even for a purely modern form such as the urban high-rise. "But surely you are not in favor of so-called modern architecture?," he asked. "It's worthless because it is merely the work of a few unbridled individualists. Artistic value is achieved collectively, by each man subordinating himself to the standards of the majority." The patron retorts, with an ironic barb aimed squarely at an architecturally uninformed audience: "You wouldn't expect me to pick a man of merit, would you? I've never hired a good architect for the banks, hotels, or other commercial structures I've built. I've given the public what it wants." At the climax of the movie, the single-minded modernist—who stayed true to his design principles—vanquishes all naysayers and emerges victorious atop the windy heights of his landmark skyscraper with his reputation, and his relationship with his woman, intact.[20]

By the early 1950s, contemporary architect and curator Philip Johnson declared, "The battle of modern architecture has long been won."[21] But his victorious stance, posited from the halls of the Museum of Modern Art (MOMA) in New York, was

still not an opinion shared by the general public. Although modern architecture entered a renaissance period during this era, a "great post-war flowering," according to Johnson, the burst of creativity was paired with distrust and a fear of the unknown, particularly as the country entered the Cold War era. Traditionalists felt alienated by rapid changes in society, now paired with a new architectural discourse that disposed of cultural memory and dismissed old buildings as irrelevant. Henry-Russell Hitchcock, architectural curator at MOMA (no relation to Alfred), put the nail in the coffin, so to speak, when he proclaimed the "obvious fact" that "what used to be called 'traditional' architecture is dead if not buried."[22] But the modernists themselves cautioned the public to rein in their excitement for the new movement and support of the burst of construction. "Booms are not always conducive to good building," he noted, "and memories of excessive production in the twenties should warn us to view with a wary eye such construction as is prepared and executed under conditions of maniac haste and rising costs."[23] Patrons and designers eagerly latched onto modernism as the new style while often waiving away larger sociocultural and existential concerns about urban development and architectural identity.

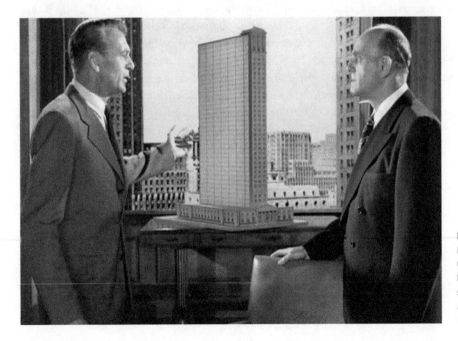

Figure 21. Architect Howard Roark (Gary Cooper) defending his modern skyscraper design in *The Fountainhead*, 1949. (Warner Brothers)

ROPE

In *Rope,* Hitchcock exposed audience unease with modern art, homosexuals, and educated lifestyles through the story of an unabashed urban murder at the top of a skyscraper. The entire film takes place within a penthouse suite, with most of the action set in the open-plan living area marked by a distinctive wall-length window that curves up toward the ceiling, providing expansive views of the city. This sophisticated home is occupied by two champagne-guzzling immoral men who strangle their classmate with a rope (hence the title) as a personal challenge and hide his body in a wooden chest while his father, college friends, and professor enjoy an elegant dinner in the same room. The 1948 screenplay is an adaptation written by Arthur Laurents, based on a play by Patrick Hamilton authored in 1929 in London. Hume Cronyn translated the story for Hitchcock's American-centric approach by placing the action in New York City.

This film stands out in the Hitchcock oeuvre as a demonstration of his cinematic capabilities. *Rope* was the first movie that he shot in Technicolor, a film process developed in the late 1910s by three scientists in Boston that projected "motion pictures in actual natural colors," without added tints or tones.[24] The film is also renowned for Hitchcock's deliberate filming of long takes to capture continuous action and the creation of a customized set with movable walls that would swing away as the camera passed by on a dolly, the "only instance in which an entire film has been shot with no interruption for the different camera setups."[25] This "stunt" (as Hitchcock himself called it) was his homage to the stage-produced plays of the past, with "no break in the telling of a story that begins at seven-thirty and ends at nine-fifteen." Despite the use of Technicolor, Hitchcock was determined to keep "color to a minimum" in the setting, creating a monochromatic scheme that highlighted the characters and the apartment itself.[26]

In 1948, a two-page spread in the magazine *Look* detailed the "roving camera, sliding walls and long takes." The writer noted that this self-indulgent cinematic "experiment" elevated the director into another realm. Within the small cast of nine, the "real star is Hitchcock himself." The *Look* illustration is signed "Karoly" and is likely authored by the film artist Karoly Grosz, an art director at Universal Pictures in the 1930s known for his monster-movie posters. The diagram depicts eight pivotal scenes in the movie, punctuated with photographs and a bold arrow denoting the singular movement of the camera.[27] The movable walls were called "wild walls"

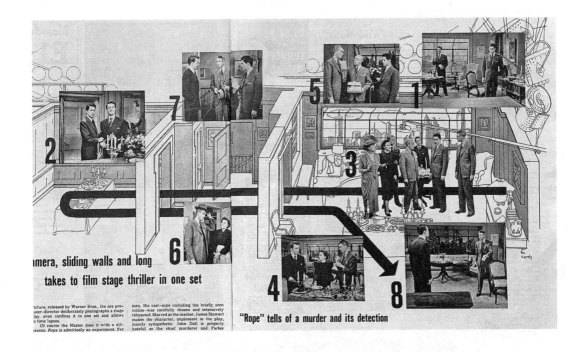

camera, sliding walls and long
takes to film stage thriller in one set

icture, released by Warner Bros., the ace pro-
ucer-director deliberately photographs a stage
lay, even confines it to one set and allows
o time lapses.
 Of course the Master does it with a dif-
erence. Rope is admittedly an experiment. For

men. His cast—nine including the briefly seen
victim—was carefully chosen and intensively
rehearsed. Starred as the teacher, James Stewart
makes the character, unpleasant in the play,
mainly sympathetic. John Dall is properly
hateful as the chief murderer and Farley

"Rope" tells of a murder and its detection

and were hung on overhead tracks. The film team slid each wall out of the scene as the camera moved through the space, and then returned the walls to position for the following takes.[28] In fact, nearly the entire set was movable with furniture, plates, and drinking glasses "moved on cue" as the actors walked through the scenes.[29]

The opening page of the *Rope* screenplay lays out the tone for the film: "The setting of the story is in an apartment high up in the East Fifties. The action of the story is continuous; there are no time lapses of any kind." Laurents describes both the characters and their surroundings with veiled references to homosexuality. The main room is described as "expensively furnished in unorthodox but extremely good taste. . . . A big window takes most of one wall, beyond it, a panorama of midtown Manhattan."[30] In that era, the term "unorthodox" in design referenced modernist art, furniture, and architecture. Brandon Shaw (played by John Dall) wielded the stronger personality of the killers; he is described as a "glib, cultured egomaniac [and] psychopathic." His friend Phillip Morgan (played by Farley Granger) is "neurotic and thus, weaker . . . naturally more boyish [and] given to quick and

Figure 22. Diagram detailing the penthouse scenes in *Rope*, 1948. (Illustration by Karoly, *Look*, Cowles Magazines, Inc.)

extreme changes of mood—up and down, volatile and withdrawn, sensitive and sarcastic."[31] The "sophisticated but eccentric" pair of men are referenced in terms that hint at their sexuality but do not overtly address it. Film censors of the day rejected outright portrayals of gay men; hence the characters are referred to as closeted homosexuals in analyses of the film and story. This portrayal also happened to fit neatly with the public interpretation of penthouse dwellers as portrayed in film: a high-living, skyrise-inhabiting community composed of "wealthy, well educated, and unsentimental" people far removed from the everyday, ordinary experience of the general audience.

Hitchcock historian Steven Jacobs wrote that the penthouse "became a standard for an elegant, modern, metropolitan way of life," as portrayed on film.[32] Within this movie and others, Hollywood promoted the "modern mystique" of the penthouse as the "quintessential residence of the rich and powerful," drawing its power "from the verticality that was New York's special trademark."[33] Yet throughout the film *Rope*, there is a persistent "feeling of confinement and claustrophobia," here achieved through Hitchcock's use of a single set and his storytelling showmanship, which entrapped and engaged the audience as "complicit in the murder," according to Jacobs.[34]

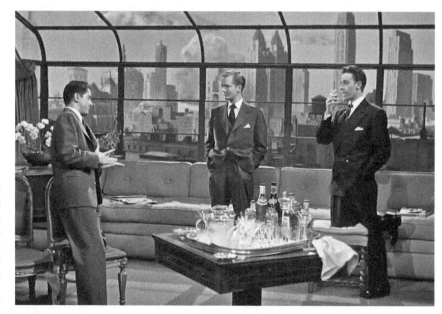

Figure 23. The penthouse murderers host a party for the dead man's friends and relatives, serving dinner on top of a chest holding his body in *Rope*. (Warner Brothers)

THE ARCHITECTURE OF SUSPENSE

In a screenwriter's nod toward the status of the architect and the filmmaker as gods (a term Hitchcock used), the lead killer, Brandon, proclaims that "murder can be an art, too. The power to kill can be as satisfying as the power to create."[35] In the end, the murder is revealed, and the men are confronted by their professor, Rupert Cadell (played by James Stewart). His final monologue as he faces the killers emphasizes the unsteady relationship between modernity and fears of anonymity: "Now I know the truth, and the truth is that humanity cannot be divided into categories to suit our own ends. We are each of us a human being . . . with the right to live and work and think as individuals."[36] With that, he fires the gun from the window, alerting the public and the police below to the skyscraper crime.

Because the film takes place in real time, the skyline of the city changed from early evening to sunset to the darkness of night. A semi-circular cyclorama 80 feet long was constructed by the production team, with "each building individually wired and connected to a 'light organ,' that allowed for the gradual activation of the skyline's thousands of lights and hundreds of neon signs."[37] These living skyscrapers are present as silent sentinels throughout the film and serve as vertical counterpoints to the actors. Both the buildings and the human figures are continually framed by the architecture of the penthouse and the geometric lines of the modern floor-to-ceiling windows.

The penthouse design for *Rope* was the brainchild of art director Perry Ferguson, who also worked on *Citizen Kane* (directed by Orson Welles, 1941), assisted by a team of set decorators and illustrators. Dorothea Holt, a graduate of USC in 1933 and contemporary of Robert Boyle, was an uncredited illustrator on the film.[38] Together the team interpreted Hume Cronyn's script in the most Hitchcockian manner, hiding a murder within the dense urbanity high above the streets of New York: a "Chinese-box [of] confinement . . . a cinematic space created in a sound studio, inside of which is an artificial cyclorama of the New York skyline, inside of which is an oppressively close apartment set, inside of which is a wooden chest, inside of which is a corpse," as so eloquently synopsized by Jacobs.[39] A similar film is *Dial M for Murder,* which was also produced and filmed with a stunt in mind: three-dimensional viewing with the audience wearing "Polaroid spectacles."[40] Not surprisingly for this director, the film also involved a murder in an urban apartment. During the filming of that movie, Hitchcock revealed his predilection for glamorous deaths on film. "This is nicely done," he said before requesting a second take, "but there wasn't enough gleam in the scissors, and a murder without gleaming scissors is like asparagus without the hollandaise sauce—tasteless."[41]

REAR WINDOW

Hitchcock explored themes of voyeurism throughout his career, a fascination that became a defining feature of his work. The mental break of Norman Bates that occurs in *Psycho,* for instance, is preceded by his sexually motivated peeping at Marion disrobing through a hole in the wall of his motel office. The director had tapped into a similar sensibility in *Rear Window,* released six years before, where he indulged more fully in his fascination with the act of conscious observation, also known as scopophilia. Based on the short story "It Had to Be Murder," by author Cornell Woolrich, and adapted by screenwriter John Michael Hayes, the movie explored questions of identity, sexuality, and autonomy, fixed within the urban jungles of the U.S. metropolis at midcentury.[42] The film is regarded as his "most uncompromising attempt to imprison us, not only within a limited space, but within a single consciousness," according to biographers.[43] Hitchcock admitted to "feeling very creative at the time, the batteries were well charged."[44] *Rear Window* presented an unprecedented technical and filmic challenge to the director: the entire narrative is envisioned from "the viewpoint of one man, and embodied in a single, large set."[45]

In *Rear Window* the architectural environment was secondary to Hitchcock's pursuit of creating an overscaled exploration of the concept of pure cinema. His biographer Truffaut (of French nationality) once hotly debated an American film critic who countered his praise for the movie. The critic admonished, "You love *Rear Window* because, as a stranger to New York, you know nothing about Greenwich Village." Truffaut recalled, "To this absurd statement, I replied '*Rear Window* is not about Greenwich Village, it is a film about cinema, and I *do* know cinema.'"[46] Truffaut is here referring to Hitchcock's creative goal, which focused on multiple scenes incorporating a montage protocol that had fascinated the director since his early career days in Britain. For these directorial geniuses, the set was a device to push the boundaries of the cinematic art form.

As Truffaut asserted, *Rear Window* permitted Hitchcock to indulge in a feature-length exploration of the "Kuleshov effect." Introduced by Russian filmmaker Lev Kuleshov in the early twentieth century, the experimental effect encouraged the audience to create and impose their own meaning onto a sequence of quick shots or intercuts. Using this method, the filmmaker could manipulate audience engagement to create the sensation of horror, gratification, hunger, lust, or any other human emotion or visceral sensation. Kuleshov demonstrated the effect in a series of film clips that show an actor's face, then cuts to the object or scene he is looking

at, then cuts again back to the same view of the actor's face. The meaning of this triangle of scene changes depends on the order of the intercuts; the editing itself implies the emotions that the viewer should take from the scene. Applying two variations of the Kuleshov effect with an architectural twist might look like this, for example, by quickly cutting the following shots together: Smiling Woman, Baby, Hospital Building or, alternatively, Smiling Woman, Corpse, Hospital Building. In both examples only the middle shot is different, but the context of the scene (and the interpretation of the building) differs significantly: the audience could be witness to a birth or a murder. This type of violent "fragmentation . . . of the sequence and the spatial temporal disorientation" created by intercut scenes can "actually increase the spectator's sense of confusion and panic."[47] The architecture of *Rear Window,* with its many windows positioned linearly around a garden courtyard, provided the director with multiple opportunities to cut back and forth between a number of simultaneously occurring scenarios as seen from the eyes of the main characters secluded in their apartment.

In this case, again, the architecture is equated with fear, as promoted in movie posters for the rerelease of the film in the late 1960s. One colorful version featuring Hitchcock's familiar face trumpeted: "See it! If your nerves can stand it after *Psycho!*" Voyeuristic apprehension and titillation were increased by a peeping man spying on his neighbors through a long-lens camera. These private views into the lives of any number of individuals, each with their own mysterious stories, promised to reveal "The most UNUSUAL and INTIMATE journey into human emotions ever filmed!!!" One space in particular, the home of the murderer, was labeled with the warning, "YOU won't be able to tear your eyes away from this window!" as a temptation to see the upcoming film on its return to the theater (see color plate 6).

The story of *Rear Window* follows famed photographer L. B. "Jeff" Jeffries (played by James Stewart), who is rendered immobile after being hit by debris while working on a shoot at an automobile racetrack. He is confined for six weeks in his urban, two-room apartment, his broken leg and cast rendering him incapable of leaving the building. He and his beautiful girlfriend, Lisa (played by Grace Kelly), entertain themselves by tracking the stories of the people surrounding the garden courtyard. They peer both openly and surreptitiously into the apartments across the way, each window providing a view, literally, into others' lives. Jeff furthers the game, edging ever more intrusively into their private spaces with binoculars and his professional camera by way of its penetrating zoom lens.

According to the script, each of the neighbors presented "a reflection of the rela-

tionship between the principal [characters]" of Jeff and Lisa.[48] Stewart and Kelly played into their real-life personalities, with Kelly known for her "natural beauty, quiet elegance, endless enthusiasm, and appreciation for bawdy humor,"[49] and Stewart, known as an affable yet slightly cranky good guy with modest confidence and quiet strength. The other main character in the film—Greenwich Village—was apparently chosen by the filmmakers not only for its architectural composition of courtyards surrounded by eye-like windows but also because the murderer's address of 125 West Ninth Street was in close proximity to the Sixth Police Precinct in Manhattan, which makes "their speedy arrival on the scene entirely plausible."[50] The set was based on an actual courtyard apartment located at 125 Christopher Street, as Ninth Street is called west of Sixth Avenue. The building wraps around the corner and is also known as 502 Hudson Street.[51] Built in 1944, the structure was designed by H. I. (Hyman Isaac) Feldman and is listed as a contributing building in the Greenwich Village Historic District. Feldman was a naturalized citizen from Austria; he served in the U.S. Army in World War I and later graduated from the Yale School of Architecture in 1919. He designed more than 2,500 apartment houses in the New York area and developed a "hallmark" of designing buildings with corners "beveled at a 45-degree angle," as seen at Christopher Street.[52] The continued existence of this filmic icon is due at least in part to the groundbreaking advocacy of Jane Jacobs, who lived down the road at 555 Hudson Street. An editor at *Architectural Forum* magazine and author of *The Death and Life of Great American Cities* (1961), Jacobs came forward as a leader in a successful movement to preserve the Greenwich Village area from redevelopment and misguided urban renewal efforts in the 1960s.[53]

In the film, Lisa and Jeff are not known by and do not know any of their compatriots in the garden court. Instead, they indulge in a personal game by inventing names that coordinate with the activities and perceived dispositions of the people around them: Miss Lonely Hearts for the depressed single woman looking for love, Miss Torso for the aspiring dancer, and The Newlyweds, who only appear briefly in the film before drawing their window blinds. One wonders how the residents might have referred to Lisa and Jeff if they played this game themselves. *Life* magazine described the assembled characters as an "amusingly corny though typically Hitchcockian collection of neighbors."[54] At one point, the creative minds of Jeff and Lisa put together disparate facts to arrive at the conclusion that Lars Thorwald (villainously played by a bespectacled Raymond Burr) has murdered his wife, buried her head in the garden, and taken her body away in a suitcase. The inquisitive

couple then endangers their own lives in the process of trying to prove their theory of the killing. The story is based in part on a real murder that occurred in England in 1924, when Patrick Mahon "killed and dismembered his mistress in a seaside bungalow," disassembled the corpse, and stored her body parts in her own trunk before trying to burn the evidence.[55] According to Truffaut, the movie demonstrated that the people in the film, even the crime itself, are "not horrible but simply a display of human weaknesses and people in pursuit of happiness."[56]

Using the Kuleshov effect in this picture, Hitchcock employed the "possibilities of editing for deceiving the spectator."[57] The audience is never certain of exactly what they are looking at, and what it ultimately means, until the last scenes in the film. Despite Truffaut's assertions, the building set and location were critical to the cinematic process. Only in a complex, layered urban environment, such as Greenwich Village, could Hitchcock analyze multiple stories from one vantage point. The movie explores an existential concept of frames: as filmic devices, constructed as windows, and as delineators of our own reality. Like the skyscraper, the windows of

the courtyard apartments represent a microcosmic "image of the world." Hitchcock agreed that the building "shows every kind of human behavior [and is] a real index of individual behavior." Similar to Sullivan's honeycomb, Hitchcock asserted that within the cells, or apartments in this case, "What you see . . . is a group of little stories that . . . mirror a small universe." Each of the windows indeed resembles its own filmic opening, in the quality of illumination and in a similar aspect ratio. Even Stewart himself is "exactly in the position of a spectator looking at a movie."[58] Screenwriter Hayes described the courtyard and "precise architectural details" in his initial treatment for the film, writing the scene as a "Greenwich Village kind of neighborhood, as seen through the picture window of a studio apartment."[59] Curiously, the killer never closes his curtains, perhaps relying on the sense of anonymity in the complex to keep himself, and his crime, hidden from view (see color plate 7).

Rear Window premiered on August 4, 1954, at the Rivoli Theater in New York. The film was nominated for Academy Awards in Drama, Direction, Screenplay, Color Cinematography, and Sound Recording. Although the movie did not win in any of those categories, it did rank as the "fifth-highest-grossing film of 1954," with a $5.3 million box office return that year.[60] Again, despite public success, the critics found pleasure in taking down this now-classic Hitchcock effort. The *New Yorker* critic John McCarten wrote: "I fear that 'Rear Window' must be taken as another example of [Hitchcock's] footless ambition to make a movie that stands absolutely still. In 'Rope' and 'Dial M for Murder,' he worked . . . in one room, and in the current foolishness, he is confined to an implausible back yard." The only benefit to the movie was the presence of the magnanimous and gorgeous Grace Kelly, a leading star whose "very presence in this film brings on an uncritical tolerance of the thing."[61] The *Boston Daily Globe* had a different view, stating that "the story is told with tricks and intricate technique, but the mystery magician, Mr. Hitchcock, never forgets that what people want most is a spine-chilling climax. He gives it them."[62]

Designing and building the urban set for *Rear Window* was an enormous accomplishment. Although nearly the entire film takes place in a single space, the "ostensibly one-room set turned out to be almost the biggest one ever made at Paramount," to accommodate the objects of Jeff's and Lisa's gaze.[63] According to Kelly, Hitchcock relished the act of creation, planning the complexities of the set while completing filming on *Dial M for Murder:* "He was very enthusiastic as he described all the details of a fabulous set while we were waiting for the camera to be pushed around. He talked to me about the people who would be seen in other apartments opposite the rear window, and their little stories, and how they would emerge as

characters and what would be revealed. I could see him thinking all the time, and when he had a moment alone he would go off and discuss the building of that fantastic set. That was really his delight."[64]

Under Hitchcock's eye, art directors Hal Pereira (head of Paramount's art department) and Joseph McMillan Johnson re-created an entire Greenwich Village complex of buildings on Stage 18, complete with "multileveled apartments, gardens, trees, fire escapes, smoking chimneys, and an alley leading to a street with a bar, pedestrians, moving traffic—all of it capped by a Manhattan skyline." Together they created the "largest indoor set ever built at Paramount," up to that time. A list of statistics circulated by the Paramount Advance Campaign noted that building the set "consumed 25,000 man-hours," with a hefty load of materials including "175,000 board-feet of lumber, 200 sacks of plaster, 750 gallons of paint, and 12 tons of structural steel for flooring and for eye-beams from which to hang balconies. Steel was also used for roof vents, down-spouts, chimneys and fire-escapes, all of which were 'practical,' which is the film term for usable, as opposed to plainly ornamental. More than 20,000 square feet of imitation brick was cast-staff, in a new method

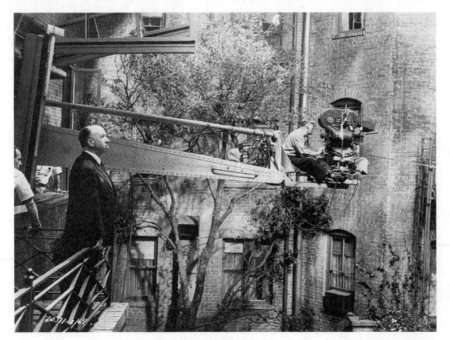

Figure 25. Director Alfred Hitchcock observes the action from a balcony as a cameraman films a scene from a boom on the massive set of *Rear Window.* (Photograph by John Springer/John Springer Collection/ CORBIS/Corbis via Getty Images)

introduced solely for this film."[65] The $100,000 set included thirty-one individual apartments, twelve of which were fully furnished.[66] A few of the units even featured working plumbing.[67] Sam Comer and Ray Moyer furnished each apartment "to match the character of their occupants," a creative move that also helped the audience keep track of what story they were following in each "window" of this multilayered narrative.[68] Cameramen were positioned on extended boom arms to photograph the action in each apartment, supervised by Hitchcock, who directed from an adjacent balcony.

VERTIGO

By contrast, the film *Vertigo* relied heavily on the real-life natural and cultural landscapes of California to establish its tone of disaffected encounters within a timeless, yet familiar, environment. From the Golden Gate Bridge to the redwood forests of Big Basin State Park, the film is a veritable love letter to the northern area of the state and San Francisco, in particular. According to Jeff Kraft and Aaron Leventhal, authors of *Footsteps in the Fog: Alfred Hitchcock's San Francisco,* the movie "captured the romance, mystery, and elegance of the city," with its "tall buildings, twisting staircases, and dramatic bridges." Like many urban environments, they note that San Francisco was "constantly reinventing itself as its architecture, industry, population, culture, and spiritual energy evolve with the times."[69] This California city is a multilayered environment, with contemporary developments and skyscrapers nestled next to preserved historic sites, public squares, and a wide variety of architectural styles, from original Spanish adobe missions to modernist glass skyscrapers. This dimensional multiplicity led the progress of the narrative in the film, energizing the cinematic presentation of Hitchcock's intriguing story of identity, obsessions, and the power of the past. The resulting movie so effectively morphed the story with the landscape that Hitchcock scholar Douglas A. Cunningham has proposed a *Vertigo*-inspired heritage trail, which would incorporate historic sites such as the Mission San Juan Bautista, founded in 1797, to accommodate for "cinephilic pilgrimages" to these sites.[70]

Vertigo was based on a source novel by Pierre Boileau–Thomas Narcejac, with the story set in Paris during World War II. The lead characters and plot points follow essentially the same story as the movie, including a detective, a woman named Madeleine, a curse, and a murderous deception. Screenwriters Alec Coppel and Samuel A. Taylor altered the overall landscape of the screenplay for Hitchcock, who

wanted an American twist. The film transports the action to the city of San Francisco in the mid-twentieth century, key to both setting and character development and consistent with Hitchcock's emphasis on American landscapes during his U.S. period. Hal Pereira and Henry Bumstead are credited with the art direction. Filming began on September 30, 1957, and wrapped a week before Christmas (with two weeks dedicated to on-location shooting and two months in the studio at Paramount), culminating two years of screenwriting and preproduction.[71]

From the opening scenes, and following the theme of the movie, the skyscraper is equated with wide-eyed terror, death, and persistent fear in both the main character and in the audience. Graphic designer Saul Bass designed the title sequence, which begins with an uncomfortably close view of a woman's face. As the credits roll, the audience breaks through her private boundaries by entering her startled eye in a cinematic penetration that is similar to the flying-in-through-the-hotel-window scene that begins the movie *Psycho,* released two years later. The audience then journeys deeper and deeper into her mind and internal psyche, represented by a series of multicolored graphic whirlpools, hypotrochoids, and epitrochoids. The widely praised designer was one of the first to introduce kinetic, or moving, titles in cinema. Bass (inspired by the nineteenth century French mathematician Lissajous), created the forms with a custom-made device consisting of two pendulums, one "free-swinging" and "eccentric," to introduce "variables into the motion of the recording pendulum" which supported a "tiny brush with an ink reservoir."[72] He worked with Hitchcock on the high-contrast promotional posters for the film as well, featuring outlines of a man and woman against the same swirling forms.

After these establishing images, the film opens with a dramatic rooftop chase in downtown San Francisco. Police officer John "Scottie" Ferguson (played by James Stewart) and a fellow officer are in pursuit of an escaping suspect. Scottie loses his grip after a leap between two buildings but saves himself by clinging to the metal gutter with his bare hands. As he fights for survival, a fellow police officer tries to save him before slipping off the roof and plunging to his death. During this scene, Hitchcock's framing of the vanishing points between the closely positioned buildings highlights the sensation of height. The inevitability of tragic destinies at the base of towering structures is vividly expressed by the terror in Scottie's eyes as he hangs in the air and then watches as his colleague plunges to the ground in the alleyway (see color plate 8). The traumatic event creates a fear of heights, or acrophobia, marked by the disabling sensation of vertigo for Scottie. The moving, spinning world he encountered haunts him and forces him to leave the police force.

Scottie's former college fiancée and close friend Marjorie "Midge" Wood (played by Barbara Bel Geddes) helps him to recuperate from the traumatic event. Relegated to desk work, Scottie accepts a position as a private investigator with an old friend, who wants his wife, Madeleine, followed on her mysterious pilgrimages to random landmarks. The wife and the investigator become close after he saves her from the cold waters of San Francisco Bay when she attempts to drown herself. Despite his efforts to track and protect her, the "wife" tragically falls to her death from a mission tower while Scottie watches helplessly, paralyzed by his own fear of heights. But the woman whom he was in love with was an impersonator named Judy, hired to cover the death of the real wife, who was killed and pushed from the tower at the same moment by Scottie's old friend. Scottie is set up as a witness, prevented from climbing to the top of the tower by his paralyzing acrophobia and vertigo. He watches in terror as the body of a woman falls past the window, crashing on the terra-cotta tiled roof below. Sometime later, Scottie randomly crosses paths with Judy on the streets of San Francisco and is instantly possessed by her striking resemblance to Madeleine. He compels her to transform into his departed love, forcing her to change her manner of dress, her hair, and her makeup until his

Figure 26. A bereft John "Scottie" Ferguson (James Stewart) navigates a dizzying tower stairway in *Vertigo*, 1958. (Paramount Pictures)

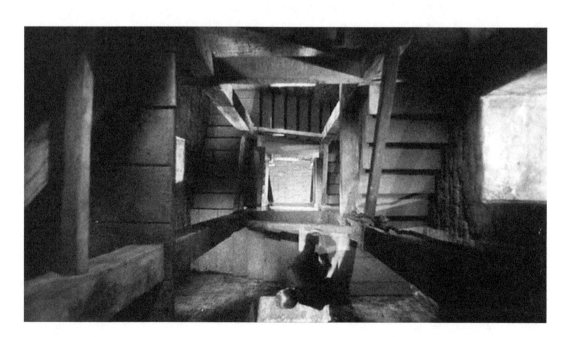

THE ARCHITECTURE OF SUSPENSE

vision is complete. In the end, Judy dies in a fall from the same tower where the death of Madeleine was staged, stumbling off the edge at the sudden appearance of a menacing cloaked figure, who turns out to be a nun in full habit.

The film can be regarded as an accurate screen capture of daily life in and around San Francisco in the late 1950s, marked with Hitchcock's cheeky references to gender and sexuality. Both Scottie and Midge live near downtown San Francisco in trendy apartments. Masculine and feminine sensibilities are deployed throughout their lodgings to distinguish the occupants by their furnishings, decor, and even the context of the location. At her creatively cluttered home near Union Street, Midge is busily illustrating a new type of woman's brassiere employing engineering concepts inspired by cantilevered bridges. Relaxing in his friend's feminine lair, Scottie examines the pink bra closely (which he refers to as a "doohickey"). Her oversized, second-story windows, equipped with freestyle bamboo blinds, embrace the tightly clustered buildings on nearby Telegraph Hill, but the height of her place exacerbates Scottie's vertigo when he tests his limits by stepping on gradually taller stools while gazing at the ceiling and out the window (see color plate 9). By contrast, Scottie's ground-level apartment on Russian Hill is a modernist interpretation of the bachelor life, simple and direct, emphasizing the horizontal through the linear alignment of the blinds and the scored grouting of the Roman brick fireplace surround. The environment is deliberately cast as male, with the view out the window punctuated by the phallic and omnipresent Coit Tower (built in 1933) in the distance, visible through his living room window (see color plate 10).[73] Madeleine refers to the tower in a sexual innuendo when she returns to Scottie's apartment to deliver a thank-you note, saying she remembered the hillside landmark that "led me straight to you." He responds, "Well, that's the first time I've been grateful for Coit Tower," as they exchange sly looks. The exterior shots of Scottie's apartment, marked by a red door and an Asian-inspired metal porch railing, were filmed at 900 Lombard Street in San Francisco. Plagued by fans of the film, in 2012 the owners dismembered the entry and buried the short row of steps where Madeleine and Scottie met behind a high, impenetrable wall.[74]

Scottie's best friend, Midge, mysteriously disappears from the film after ninety minutes. Her last scene with Scottie takes place in a sanitorium, where he is hospitalized for "acute melancholia together with a guilt complex" after the shock of Madeleine's death. After assuring him that she will be there for him, she speaks to the doctor and then departs forlornly after realizing he will always be in love with the ghost of Madeline. Midge's return to anonymity in his life is marked by her

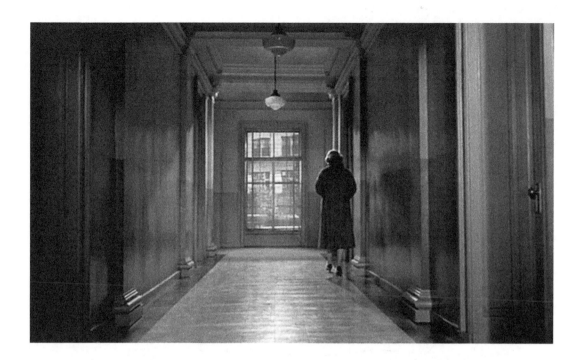

Figure 27. Marjorie "Midge" Wood (Barbara Bel Geddes) walks down a transformative hallway in *Vertigo.* (Paramount Pictures)

lonely departure down an empty hallway, heading nowhere. A similar view of a hallway in *Vertigo* takes place in a downtown hotel, where Scottie finally tracks down the impersonator Judy and confronts her in her room. Hitchcock then reveals her duplicity in a flashback where she recalls her participation in Madeleine's murder. The hallway scenes are evidence of Hitchcock's repeated use of architectural elements (including doors and stairways) as passages to mark the transformative journeys of the characters and their metamorphosis into new identities.

The final revelatory scene of the film takes place in a no-frills establishment called the Hotel Empire. Judy's room is visually filled with the toxicity of distrust, a sickly green atmosphere generated by a neon blade sign hanging outside her window. Within this environment, Scottie pieces together Judy's duplicity, revealed by the presence of a significant piece of jewelry once worn and owned by Madeleine. Like Scottie's apartment, the exteriors of the hotel were filmed in San Francisco. The studio set of Judy's room was based on actual rooms on the fourth floor of the hotel, identifiable by the proximity and placement of the neon sign.[75] This real six-story hotel, located at 940 Sutter Street, opened as the Hotel Glen Royal in 1925.

The building was designed and built by William Helbing of the Helbing Company. Helbing was a prominent developer in San Francisco at the time and constructed at least seven other hotels in the area.[76] In an unusual arrangement, this prolific entrepreneur assumed three different roles at his properties: owner, designer/architect, and builder.[77] The building is typical of the style during that period, with four arched openings at the street level (two doors and two large windows), with the main entrance near the center of the structure. The base is accentuated with decorative block masonry that supports four bays of windows illuminating the guest rooms above. The cornice line is simply articulated; the most accurate style description of the structure would be "Italian Renaissance Revival" with an urban twist.

The Hotel Glen Royal announced its debut in the *San Francisco Examiner* with an advertisement for the "Opening Dinner," in the "beautifully furnished and up to date" building.[78] Later advertisements in the same newspaper promoted the hotel as "San Francisco's Newest Hostelry," which was "Built and furnished for comfort as a first-class family hotel. It has an atmosphere of refinement accentuated throughout and caters particularly to refined out-of-town visitors. Large rooms, gorgeously furnished; spacious closets and dressing rooms. Every room with bath and shower. Running ice water."[79] The hotel was purchased by Sacramento banker

Figure 28. Judy Barton (Kim Novak) reveals herself at the window of the Hotel Empire in San Francisco in *Vertigo*. (Paramount Pictures)

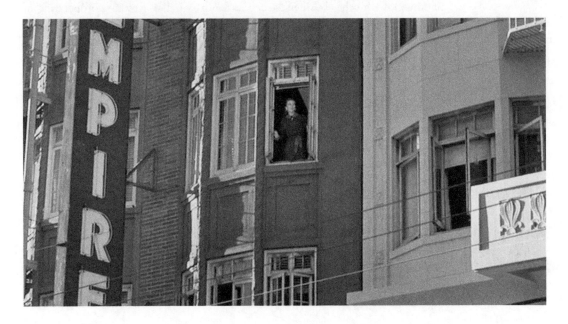

Harry C. Muddox in 1927 and sold to Eugene N. Fritz in 1938, a "capitalist" who maintained a chain of properties in San Francisco, including Hotel Sutter, Park Lane, Herald Hotel, Hotel Cecil, Hotel Spaulding, and El Cortez Hotel.[80] By the 1940s, the hotel was known alternatively as the "Empire Lodge," and the "Empire Hotel," with rooms "including private bath, shower, and telephone" advertised at $17.50 a week in 1957.[81] During World War II, the hotel filled with ladies when the Coast Guard leased the hotel as a "SPAR barracks" to house between "100 and 140 . . . women, on duty in San Francisco," with plans to expand further with more recruits arriving from Palm Beach, Florida.[82] SPAR is an acronym representing the Coast Guard motto, "*Semper Paratus*—Always Ready," and was used to denote the U.S. Coast Guard Women's Reserve established by Franklin D. Roosevelt in 1942.[83] The *San Francisco Examiner* noted the change from private hotel to military housing, reporting that "where maids once went from room to room making beds and sweeping carpets. SPARS will arrange their own bunks and fan down the deck" with officers' quarters in the eighth-floor penthouse.[84]

In 1959, owners Ethel and Anna Ross sold the hotel for $400,000 to an undisclosed buyer.[85] Sid Goldie and Mary Jenkins ran the popular "Plush Room" in the hotel in this era, featuring singers such as Tiny Watson ("300 pounds of Dynamite!"), with other businesses such as Sandro's Italian Restaurant operating in adjacent spaces.[86] The hotel was later known as the York Hotel and had an entertainment space named the "Empire Plush Room," reflecting the long history of the building.[87] In a case of real-life tragedy, an unmarried forty-five-year-old department store clerk jumped to her death from the roof of the hotel only a month before location shooting began for *Vertigo.* The newspaper printed a graphic of the "Path of Death," in which a "dotted line traces the death plunge Helen Zurflua took from her hotel," a drop that passed directly by the blade sign highlighted in the scenes of Judy's room. Apparently despondent "over failure to find work," Helen departed from her second-floor room, "took the elevator to the roof, then simply stepped off. She left no note."[88] There is no evidence that the crew or stars of *Vertigo* knew about the gruesome fatality on the sidewalk where they filmed the Hitchcock thriller shortly thereafter. In a merging of fact and fiction, the *Vertigo* character Judy worked at I. Magnin & Company (a luxury department store in San Francisco), lived in the Hotel Empire, and plunged to her death in a tragic fall.

The continued legacy of the movie compelled the current operators of the hotel to rename the venture (briefly called the York Hotel) as the Hotel Vertigo, to capitalize on its fame within Hitchcock's notable oeuvre. The lobby has since been

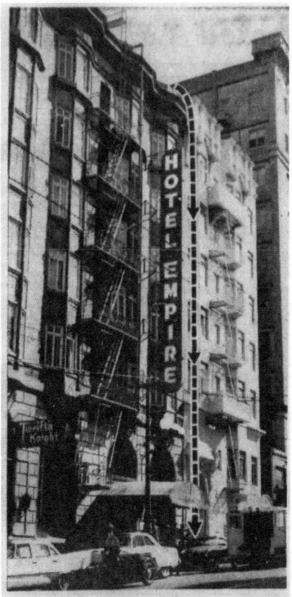

PATH OF DEATH—Dotted line traces the death plunge Helen Zurflua took from her hotel.

6-Story Leap Kills Woman

Figure 29. The "Path of Death" of Helen Zurflua's suicide at the Hotel Empire, a month before *Vertigo* started filming at the building, 1957. (*San Francisco Examiner*)

"decked out in a stark orange and white '60s décor that invokes the film's famous movie poster," with Hitchcock's movie "on a loop in the lobby at all times." One visitor remarked that the number of "references to the film that briefly used the space is enough to make one's head spin."[89] But you can rest easy at night. Promotional copy for the hotel mentions that each guest room maintains only one subtle reference to Hitchcock's film: framed wall art featuring a swirling icon inspired by the work of Saul Bass.

In the 1958 review of *Vertigo,* the film-trade magazine *Variety* mentioned the city as a critical character in the film: "Unbilled, but certainly a prime factor in whatever success [the] film may have, is the city of San Francisco, which has never been photographed so extensively and in such exquisite color as [cinematographer] Robert Burks and his crew have here achieved." But the review was mixed, as the writer noted that the mastery of Hitchcock's directorial hand could not overcome the film's "too slow and too long" first half, perhaps because he "became overly enamored with the vertiginous beauty of Frisco." A fine balance must be achieved, or the places that lend authenticity to the film can "intrude on the story line too heavily" and turn into a touristy travelogue, according to critics. Despite any limitations, the film was later noted as a "work of maturity and lyrical commentary on the relation between love and death" and is now widely considered one of the most significant cinematic works in history.[90]

NORTH BY NORTHWEST

By 1959, the year that *North by Northwest* debuted, one of every ten employed American worker bees reported to the honeycomb of an office building, with New York City alone hosting more than 75 million square feet of office space.[91] The city became so crowded that one urban native observed that "the only way to cross the street in New York City now is to be born on the other side."[92] Despite the efficiencies achieved by this density, design critics such as Reyner Banham maintained that the "conscious manipulation of space" employed by modernist architects within the skyscraper form conveyed a "powerful sense of being caged in a pervasive geometry."[93] In presenting his suspenseful narratives, Hitchcock relied on this popular interpretation of modernism as rigidly disciplined, depicting the buildings as tight, rectilinear enclosures in which human characters tried desperately to maintain autonomy and individualism against twentieth-century, machine-age compartmentalization.

In this film, a premiere Hitchcockian-style spy caper, the lead characters are mistaken for other people, assume secondary personalities, and purposefully double-cross each other to achieve their own ends. The movie, produced from an original script by screenwriter Ernest Lehman and featuring the work of production designer Robert Boyle, relies on themes of duality and deception throughout, further highlighted by key scenes at iconic American buildings, landscapes, and structures, each site with its own complicated and multitextured history. The filmic travelogue of bright and beautiful locations, including Mount Rushmore in South Dakota, is purposefully duplicitous. Hitchcock here crafted a clever narrative in which he is "cheerfully warning" the public "that no one is ever safe from violent death, whether in a crowded station or an uninhabited desert," according to biographer Colin Bennett.[94]

The anonymity of urban habitation is introduced in the first few minutes of the film, in the title sequence by Saul Bass and immediately followed by a montage of scenes showing the scurrying crowds of Manhattan. Hitchcock made his cameo appearance during this opener, missing the bus by a hair as it closes its doors and pulls away from the curb. These scenes establish the entire tone of the film by capturing the multiplicity of layers, the skyscraper as a mirror for modern life, and the tall building as a tool to render the human population into a nameless herd. The Commercial Investment Trust Building (also known as the CIT Building), designed by Harrison and Abramovitz, is the central player as the framework for the titles. At its opening in 1957, that building was described as "a decorous, smooth-faced structure of polished black granite, stainless steel, and green glass," replicated famously in the "promising, green-tinted credits," of the film.[95] The original title sequence called for a series of office vignettes showing advertising executive Roger Thornhill at work. Hitchcock rejected that opening, and Bass was called in to rework the title graphics. He described his approach to film design in a 1958 interview with the *Los Angeles Times:* "I create a symbol for [the movie], one that can be used in every possible way from title to campaign and that can become a key to the film itself. This is my real concern: to give each film a unique individuality."[96]

For *North by Northwest,* Bass based his design on the skyscraper's essential linearity, utilizing the layered ribbons of windows as the foundation for the moving credits, which snap into place on the slanted grid as the words enter and exit the screen. The graphic green field punctuated by blue lines fades and transitions into an architectural view of the building, reflecting the busy movement of the city in its mirrored surface. This imagery reinforces Hitchcock's cinematic vision by fusing

the story being told with the character of the setting. An orchestral soundtrack by Bernard Herrmann accompanies the opening and further sets the tone for the audience to enter the narrative space.

The loss of identity central to the film is further captured in the mirrored facade of the United Nations Secretariat in New York City, which plays itself in the movie and is the location of a key murder as the plot unfolds. This modern fortress was designed by Wallace Harrison, his firm Harrison and Abramovitz, and a stellar team of modernist architects including Le Corbusier and Oscar Niemeyer. Here, the streamlined nature of the structure and the absence of decoration was dictated by the pursuit of political and cultural neutrality at the site, which is independently administered by an extraterritorial treaty. Rather than the elaborate columns, sculptures, and domes representative of specific governments and unique traditions, the linear, modernist design of the United Nations instead emphasizes "light, location, and atmosphere" to generate "emotional overtones as insistent as the hum of a dynamo," within the informed opinion of Henry-Russell Hitchcock and his colleague Arthur Drexler of the New York Museum of Modern Art (MOMA).[97]

The architectural program of the United Nations represented monumentality, its "tremendous architectural impact," based in part on the innate character of the glass curtain wall. At that time, such large expanses of mirrored surfaces perplexed and captivated the public. Drexler, director of the department of architecture and design at MOMA, described the structure poetically, writing that "the glass facades absorb their surroundings and, in a way, merge with them." He noted that the reflections were "indeed the very point of the building," with the tower acting as "an enormous vertical mirror in a white marble frame, set at the edge of a city stuffed like an arsenal with buildings never more appealing than when their chaos is converted by reflections to a casual and harmless decoration." The Secretariat Tower was "criticized because it enshrines mere office workers in a monument," yet Drexler considered it the most "logical and convenient accommodation for the 3,400 office employees." He admitted that "even if one might prefer a more spiritualized symbol of constructive international accord," the design succeeded with its "uncompromising, aggressively scaled geometry" that gave the towering structure its urban power.[98] Filmmakers, including Hitchcock, drew on that power to add dimension to their characters and stories.

Despite public appreciation for the buildings, the United Nations complex did not open to universal admiration. Architect Frank Lloyd Wright unsurprisingly dismissed it as "a glorification of negation." Or, in other words, a "deadpan box with no

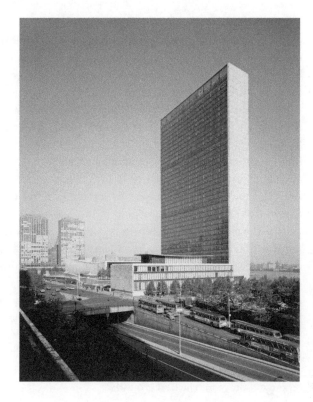

Figure 30. The United Nations headquarters in New York City, designed by the architectural firm Harrison & Abramovitz (and others) in 1951. (Photograph by George Eisenman, 1966, Historic American Buildings Survey, Library of Congress Prints and Photographs Division, HABS NY-6076)

expression of the nature of what transpires within the building." Yet, it was this very idea of cloistered interior spaces cloaked in an unsentimental shell that appealed to a visual artist such as Hitchcock, who imagined any number of scenarios taking place inside the mysterious box filled with individual destinies.[99] Architectural historian and critic Lewis Mumford, not one to praise easily, noted distinguishing features that hinted at the visual mystery of the structure: "No building in the city is more responsive to the constant play of light and shadow in the world beyond it; none varies more subtly with the time of day and the way the light strikes, now emphasizing the vertical metal window bars, now emphasizing the dark green of the spandrels and underlining the horizontality of the composition. No one had ever conceived of building a mirror on this scale before, and perhaps no one guessed what an endless series of pictures that mirror would reveal."[100] This skyscraper characteristic of multiplicity represented a vision of the metropolis at large. The essen-

tial hierarchy of the form attracted Hitchcock, who "was fascinated by systematic efforts to impose regularity upon the irregular . . . and the tendency of such systems to collapse," as noted by historian Dana Brand.[101] Despite his enthusiasm for the building, Mumford also "derided [the structure] as a symbol 'that the managerial revolution has taken place and that bureaucracy rules the world.'"[102]

Before *North by Northwest,* only one fictional movie was filmed in the Secretariat Building, a work called *The Glass Wall* (directed by Maxwell Shane, 1953), released by Columbia Pictures with production designer George Van Marter.[103] The teaser for the film reads: "The 10-Hour Manhunt That Tore New York Apart!" This movie also played upon fears of anonymity and the concept of individuality, with the key line, "As long as there is one man who can't walk free where he wants, as long as there is one displaced person without a home, there won't be peace!"[104] The film is perhaps the only feature to get permission to shoot inside the building until *The Interpreter* filmed there more than fifty years later (directed by Sydney Pollack, 2005), as Hitchcock did not have approvals.[105] To complete his picture, Hitchcock and his team created an "exact copy" of rooms in the United Nations for key sequences with a matte painting standing in for the interior lobby. Filming at the building itself was forbidden. Engaging in his naughty side, Hitchcock shot a few scenes surreptitiously, one with Cary Grant walking deliberately into the building (see color plate 11). Guards prevented the film crew from even taking photographs, so Hitchcock admitted that he "concealed the camera in the back of a truck" to capture "enough footage for the background."[106]

A 1959 *New Yorker* review by of *North by Northwest,* authored by Whitney Balliett, bemoaned Hitchcock's obsession with filming at grand locations, stating that "so much of the film has been photographed in familiar places—the streets of New York and Chicago, the lobby of the Plaza Hotel, inside Grand Central Station, at Mount Rushmore National Memorial—that one tends, because of the effect of innumerable shocks of recognition, to forget the story for its background." Balliett must have failed to get the point of conveying danger in safe spaces, bemoaning Hitchcock's "love of planting the grotesque in a commonplace setting, as if he were dropping water bombs out of a hotel window on a crowded sidewalk." Despite the audience's appreciation for the multiple locations, Balliett felt that this technique was "relied upon with such frequency . . . that by the time the climax of the film is reached, atop Mount Rushmore, one is actually gratified when someone hurtles off George Washington's nose to his death." Nonetheless, he did conclude with the note that "Everyone keeps a remarkably straight face throughout" the film.[107]

THE ARCHITECTURE OF SUSPENSE

PSYCHO

Hotel rooms in Hitchcock's films are cubic stages that provided the occupants with the impression of privacy but not the reality of it. That impression, key to tolerating the density of city living, also plays into the conjured atmosphere of intimacy. In *Psycho,* Hitchcock opened with an illicit postcoital scene in a downtown highrise, an appropriate prelude to a story centered on the psychosexual relationship between a man and the strong women who haunt his mind. As historian Richard Williams noted, "Of all the architectural types . . . it is probably the hotel that most readily connotes sex." The hotel is a place often selected for the size of the bed rather than the amenities available and, he observed, as a "space where marriages are traditionally consummated, where extramarital affairs take place, where old sexual relationships are rekindled and where new ones may be formed." In each room of a hotel building, one can imagine any number of these scenarios happening at the same time, night after night, year after year. But these buildings also hold a sense of morality as the sex is hidden and undiscoverable behind the "anonymity of the space," which itself speaks to society's conception of where, and how, to exercise your sexual freedom.[108]

Graphic artist Saul Bass again designed the opening credits, a rhythmic, monochromatic rectilinear parade of words and forms slashing horizontally and vertically across the screen, accompanied by the jarring violins of Bernard Hermann's score. The audience is immediately put off balance by the concatenation of visual and audio input. As the violins fade, the graphics fall in line with the background buildings, then transition into an establishing shot of the city of "Phoenix, Arizona" on "Friday, December the Eleventh" at "Two Forty-Three P.M." Here, with a series of title cards, Hitchcock provides a precise temporal and geographic frame to ground the audience in the universe of *Psycho,* with the ultimate intention of introducing terror into the safety of the known. The scene also plays into the director's identification principle as applied to architecture. The unfortunate story of the heroine, Marion Crane, is repeatedly jolted askew by decisive events in commonplace spaces, representing sexuality (the downtown hotel), business (the real estate office), home (her apartment), and death (the roadside motel).

Screenwriter Joseph Stefano captured the architectural intent of the movie in the first lines of the script, in which he describes the opening scene: "Above Midtown section of the city. It is early afternoon, a hot mid-summer day. . . . As we approach downtown section, the character of the city begins to change. It is darker and shabby

with age and industry. We see railroad tracks, smokestacks, wholesale fruit-and-vegetable markets, old municipal buildings, empty lots. The very geography seems to give us a climate of nefariousness, of back-doorness, dark and shadowy. And secret."[109] The point-of-view camera (guided by cinematographer John L. Russell) then indulges our inner voyeur. The viewer deliberately shifts from a Peter Pan–like flight over the rooftops and aims for an anonymous open window within an otherwise undistinguished early twentieth-century building, described by Stefano as "a skinny, high old hotel," with "great painted letters," advertising "Transients—Low Weekly Rates—Radio in Every Room." The action pauses "long enough to establish the shoddy character of this hotel. Its open, curtainless windows, its silent

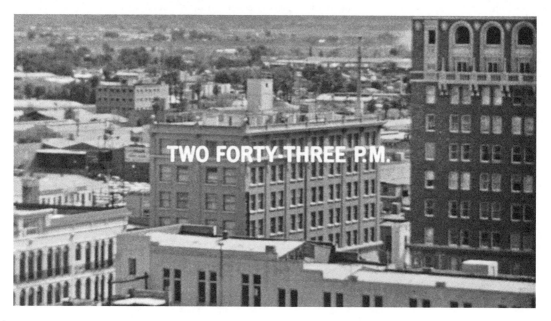

Figure 31. Title card from *Psycho*, putting the audience in the action at precisely 2:43 p.m. on December 11 at the Jefferson Hotel in downtown Phoenix, Arizona, 1960. (Paramount Pictures)

resigned look so characteristic of such hold-and-corner hotels."[110] Rather than turn away, the camera moves toward one window in the checkerboard of anonymous openings. The camera-cum-audience member then enters the seedy hotel room without the knowledge of the occupants, violating the privacy of Marion, who is enjoying a brief postcoital reverie while lying on the bed in her underwear. The "descent and penetration" through the window imbues the camera and the viewer with a "corporeal presence" in the scene. This transference of identity acknowledges that the world we are entering is happening in real time and that we, the audience, are

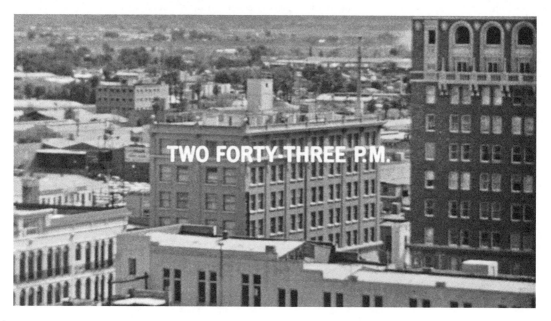

TWO FORTY-THREE P.M.

THE ARCHITECTURE OF SUSPENSE

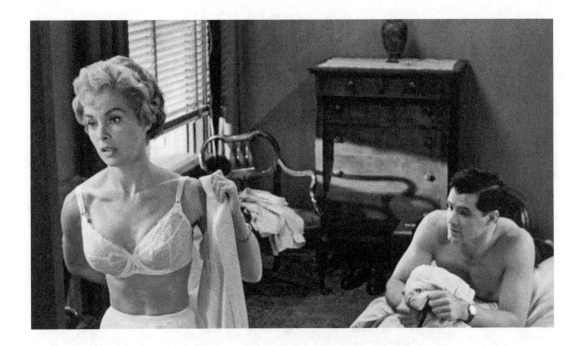

Figure 32. Marion Crane (Janet Leigh) and Sam Loomis (John Gavin) captured during a postcoital conversation at their Phoenix hotel room in *Psycho*. (Paramount Pictures)

active participants in the events, surpassing the status of mute witnesses.[111] Hitchcock used a similar technique to introduce the viewer to *I Confess,* which opened on scenes of Quebec, Canada, followed by a camera entry through a window into a room housing a corpse.

In a draft version of Stefano's script, the character Mary (her name later changed to Marion after fact checking revealed an actual Mary Crane living in Phoenix) reinforces the connection between both her relationship with Sam Loomis (played by John Gavin) and the level of lodging they choose for their illicit lovemaking: "Checking out time is 3 p.m. Hotels of this sort aren't interested in you when you come in, but when your time's up," as she hints at their impending exit. The script continues with a scene that was changed in the final draft. Sam, standing near the open window, tries to open the shade, which jams up and falls to the floor. Stefano describes the scene with direct reference to the connections between the surroundings and the mental state of the protagonist: "the hot sun glares into the room, revealing it in all its shabbiness and sordidness as if corroborating Mary's words and attitude."[112]

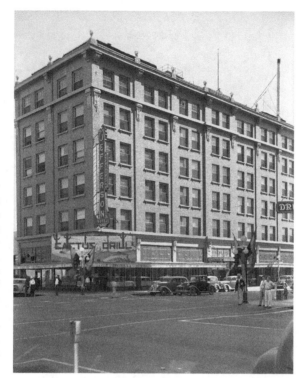

Figure 33. The Jefferson Hotel, Phoenix Arizona, designed by architect F. C. Hurst for entrepreneur Salim Ackel in 1914, featured in the opening scenes of *Psycho*. (Photograph by George H. N. Luhrs, Luhrs Family Photographs, Arizona State University Library)

Hitchcock requested extensive research in preparation for the filming of *Psycho*. Location scouts traveled to Phoenix and Fresno, fulfilling "detailed requests for photos of a 'shoddy hotel exterior, with the street outside with taxis and passerby,'" featured in the opening scene.[113] The down-and-out building they selected is the Jefferson Hotel, once the tallest building in Arizona at a towering six stories. Built in 1915 and located at 101 South Central Avenue in downtown Phoenix, the original hotel featured 150 rooms and was noted as one of the most remarkable and elegant buildings in the area. The hotel is part of the Ackel Building, named for its founder, Salim Ackel, a self-made man who became one of the "wealthiest men in Arizona."[114] The building was designed by architect F. C. Hurst, to be occupied by a hotel corporation considered "just as classy as the edifice," according to a news article announcing the opening.

A lobby decorated with tile floors, marble wainscoting, and mahogany furnishings welcomed visitors on the ground floor, and a palm garden on the rooftop (accessed by an elevator) provided a shaded retreat for guests.[115] The new hotel was known for large guest rooms with "exceptionally big windows." Local news stories reported the material details of the construction: 192 tons of steel, 13,000 sacks of El Toro cement, and 4,200 square feet of marble. The building construction embodied a principle of design espoused by some architects (or maybe the developers were just practical): the structure literally rose from the landscape surrounding it. According to the press, "every bit of the rock and sand of the entire structure was from the basement of the building," which was excavated and then used to create the materials for construction (such as concrete). The elegant hotel was "pronounced one of the strongest in the southwest" and "the tallest and most expensive building in three states."[116]

However, by 1959 (the year of the story in *Psycho*) the forty-four-year-old hotel had fallen on hard times like so many inner-city, downtown establishments in the mid-twentieth century. That year, the local paper reported that police interrupted a "strong-arm robbery" in the rear parking lot, when two "transients" stole seventeen dollars from a local businessman and started assaulting the victim.[117] The City of Phoenix bought the hotel in 1990; the property later housed the Phoenix Police Museum. The hotel was listed as an individually designated property on the City of Phoenix Historic Property Register in 2005. After six years of vacancy, the city sold the building to preservation-minded developers in 2016 as part of a larger condominium and retail project.[118] Now called the Barrister Place Building, or, more popularly, the "Psycho Building," the structure is still primarily known for its brief cameo appearance in Hitchcock's movie rather than its architecturally significant status. Ironically, it is likely due to its star turn in the movies that the building remains standing rather than succumbing to the wrecking ball, the fate of many downtown hotels of that era across the United States.

4

AMERICAN ROADSIDE

Mansions and Motels

Alfred Hitchcock pursued the art of moviemaking as a creative challenge, seeking out new techniques, innovative ideas, and unexpected methods of storytelling that kept the industry, and the audience, on the edge of their seats. In the late 1950s, he was widely known for his big-budget cinematic productions filmed in glorious full-color, starring glamourous actors such as Grace Kelly, Jimmy Stewart, and Cary Grant. But he also entered directly into American living rooms with his dark and moody *Twilight Zone*–type television anthology series entitled *Alfred Hitchcock Presents,* recorded simply in stark black-and-white. In both the series, which ran under various titles from 1955 through 1965, and in the film *Psycho,* released theatrically in 1960, Hitchcock employed concepts of artistic minimalism to strip away all unnecessary elements. The spare sets, short character lists, and straightforward filming techniques were aimed squarely at conveying only the focus of the story to the audience. Despite appearances, this simplistic approach carried an enormous amount of meaning and subtext, as proven by the powerful success and continued relevance of his film *Psycho.*

The long-standing public fascination with this landmark film elevated two American vernacular structures into enduring architectural symbols: the Mansion and the Motel. The striking image of the dilapidated Victorian house towering above a low-slung, outdated motel is recognizable worldwide to this day. In *Psycho,* Hitchcock's team played with the cultural subtexts of these two buildings to create sen-

tient structures that spoke to the audience. Author Steven Jacobs asserted that the buildings conveyed the "feel of the once familiar that has been extracted from the flow of life—both the house and the motel, the ancient setting and contemporary road culture, breathe the atmosphere of an uncanny ruin."[1] The completed movie has since become "the definitive horror film of the period," according to Stephen King, author and creator of a number of widely popular novels focused on terror as a personal experience.[2]

The longevity of this architectural imagery can be attributed to Hitchcock's precise capture of a unique turning point in the history of mid-twentieth-century American cultural landscapes. Both the Victorian mansion and the roadside motel forms had, in the past, represented the height of "modernity" when introduced and popularized in the late nineteenth and early twentieth centuries, respectively. Co-incidentally, both building forms also crashed into disuse and abandonment at the same moment amid a nationwide tsunami of design innovation and construction propelled by post–World War II economic prosperity. At that point, the cultural impression of the motel and the mansion changed from ideal representations of modernity to symbols of a disowned past. The buildings in *Psycho* are depicted as derelict and in disrepair, surrounded by bleak vegetation. The two dead structures stand on land bypassed by the new interstate and face an isolated future. The quest for improvement, for technology, and for greater convenience—the very ideas that spawned the rise of the motel and the mansion—were responsible for their down-fall in the steady and deliberate march toward innovation.

Pulling from that context, Hitchcock created a palpable sense of dead-end de-spair for the audience by highlighting the dismal but inevitable end of these two fading architectural types, overlaid with a shocking story of theft, betrayal, and murder. This cycle of birth and death—for both buildings and the people who inhabited them—highlighted the narrative tones of the story, which relied upon twisted interpretations of who a person is and what havoc time and experience can wreak on an individual's inner constitution. And perhaps audiences felt a little gleeful at the structural state of disrepair, as if the buildings—and the unfortunate protagonists—deserved their fate, the result of trying to hide on a "private island" away from progress.[3] In addition, widespread public indifference to the deteriora-tion and loss of these important architectural types reinforced the futility of pre-serving an idealized moment in time and generated a disorienting ripple effect of insecurity. In the film, the two primary buildings are not regarded as historic sites awaiting restoration. Instead, each of the structures was portrayed as an unfortunate

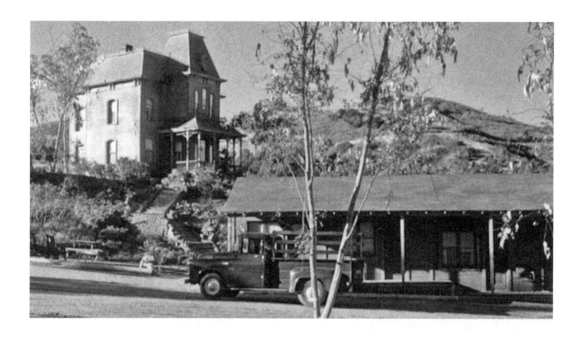

Figure 34. The Bates family buildings (the mansion and the motel) create a discordant and dominating atmosphere in *Psycho*. (Paramount Pictures, 1960)

victim on a path toward inevitable demolition, a journey expressed as well by the lead character of Norman Bates, who runs headlong into a Freudian dead-end and ultimate psychotic breakdown.

With *Psycho,* Hitchcock proved that he could still step boldly into relatively unexplored cinematic territories. Rather than following on the success of *North by Northwest* with another expansive murder-mystery travelogue, Hitchcock went back to his roots, shooting an inexpensive bitonal piece with his small television crew doing the filming. Hitchcock biographer Patrick McGilligan noted: "From his first day in Hollywood, Hitchcock had sought to bring an American authenticity to certain films. . . . From his writers and stories to his stars and settings . . . the director proved increasingly adept at conveying a trenchant vision of his adopted homeland. By the end of the 1950s the soaking-up process was complete—and no film would be more quintessentially American, or Hitchcockian, than *Psycho.*"[4] The director gloried in the challenge of a pared-down picture, noting that there was "nothing about it to distract from the telling of the tale, just like in the old days." He described the story in short terms: "It takes place near Sacramento, California, at a dark and gloomy motel. Some very ordinary people meet other ordinary people

and horror and death ensue in a manner that can't be unraveled unless you have the book as a guide," referring to the original fiction novel by Robert Bloch.[5]

THE MAKING AND RELEASE OF *PSYCHO*

The science-fiction writer Robert Bloch, living in Weyauwega, Wisconsin, wrote the fiction book *Psycho* in only six weeks after reading news coverage about the morbid and murderous activities of a fifty-one-year-old bachelor farmer, Edward Theodore Gein, in nearby Plainfield (population 700) in November 1957.[6] Stephen Rebello, *Psycho* historian and scholar, pinpointed the dark appeal of the source novel for Hitchcock's film, writing that "Robert Bloch had sexed-up and Freudianized the Gothic, revitalizing such creaky elements as the rattletrap Old Dark House, the stormy night, and the crackpot madwoman locked in the dank basement. Into the brew, Bloch stirred a motel on the skids and a randy, alcoholic, mama's boy whose scrambled psyche and way with taxidermy could keep several shrinks in summer houses in the Hamptons for years."[7]

These essential story elements appealed to Hitchcock's sense of black humor, irony, and outright horror. Shortly after publication, Hitchcock purchased the screen rights for nine thousand dollars.[8] Making the film was another story entirely; he had to execute a controversial and bold set of maneuvers to get the picture off the ground, including working for free (with a back-end ownership and revenue agreement) and consenting to film at Universal, which then leased the soundstages and equipment to Paramount. The kickback rental scheme was later investigated by the Justice Department, but no wrongdoing was proven.[9] The film was the last that Hitchcock made for Paramount Pictures, but it is most closely associated with Universal, where the movie was filmed and which later featured the mansion and motel set on its tram-guided public studio tours for decades.

After shelving a first draft by another writer, Hitchcock brought on Joseph Stefano to author the screenplay. Stefano was a "thirty-year-old former actor" who had never written a feature film.[10] However, he was by coincidence "undergoing regular psychoanalysis" during the writing and development of the movie.[11] Stefano completed a first-draft screenplay in three weeks, a work that follows the source story with great similarity. Rebello noted that "despite the screenwriter's cavils about the original novel, he clearly helped himself to the best of Bloch—structure, characters, atmosphere, tone—while enlivening the dialogue with gallows wit and deepening the characterization."[12]

During the completion of a book about her experiences on the set of *Psycho,* actor Janet Leigh interviewed Stefano and asked him to outline his creative method. He described the process of imagining and articulating a convincing cinematic space:

> I think the screenplay I wrote was just about exactly right. . . . I was a young Italian-American man, born in south Philadelphia, went into show business as a singer and dancer, then began to write . . . and suddenly I'm sitting in a room with Alfred Hitchcock. And I know nothing about motels, that kind of life. I'd never even been to Arizona. So I was kind of like I had to find where to set this movie in my own consciousness, in my own experience, and I think that what I did was to create a universe for it. So I could tell you what was going on in other houses nearby, the people who had been at the motel yesterday who didn't get killed. I knew all that . . . I felt that the extraordinary thing about *Psycho* was that I had hit almost a visual nerve.[13]

In the late 1950s, films were subjected to heavy-handed censorship via the Production Code Administration and the aptly named "Legion of Decency," operated by the Catholic Church. It was not unusual for censors to call for changes in dialogue, editing, scene cuts, and even alterations to the story itself. On November 24, 1959, Hitchcock received a two-page memo of suggested changes to Stefano's script. The task of telling the master director to adapt his screenplay or risk ending the production fell to studio executive Luigi Luraschi of Paramount Pictures. In the letter, Luraschi requests that the seductive relationships be toned down and the "discussion of transvestitism . . . be eliminated." Furthermore, "due to the serious rising tide of complaints against profanity on the screen," he threatened to "apply stringently" the banning of words "such as 'hell' and 'damn'" and then helpfully noted the five instances of these words appearing in the script. Lastly, he urged "the utmost care" in the filming of the shower scenes, insisting that this sequence would "have to be handled with the utmost discretion and good taste."[14] Hitchcock was able to satisfy the censor boards and even managed to include the bathroom scene of Marion flushing her notes down the toilet; a flushing toilet had never appeared on-screen before *Psycho.*[15]

The low-budget film opened nationally on June 16, 1960. The cultural impact was immediate, enormous, and lasting. Hitchcock and his black-and-white horror movie disrupted the film industry, broke tradition, challenged film censorship codes, and upset social mores with its "nudity, violence, transvestism, and bathroom

scenes."[16] Scholars note that *Psycho* "yank[ed] the rug out from under every sacred moviegoing expectation" that existed. No detailed information about the story was released beforehand, and there were no advance screenings for critics. Additionally, Hitchcock imposed his considerable power on theater owners, demanding that no audience member be admitted after the film began. At the time it was common practice to arrive at any point during a movie and sit through into the next screening.[17] In the year of its release, *Psycho* broke attendance records and grossed more than $9 million in the United States and another $6 million overseas, coming in right behind the more traditional, and much more costly to produce, *Ben Hur* starring Charlton Heston (directed by William Wyler, 1959).[18]

In an attempt to keep the thrust of the shocking story a secret, Hitchcock prepared a new type of movie trailer. Rather than presenting a quick cut of actual scenes from the film, the director compiled a six-minute-long, travelogue-style preview, based on his television character role as host, in which he walked among and described the buildings and story. This type of trailer, emphasizing the location instead of the actors, initiated an early relationship between the audience and the two lead buildings. The title cards, written with the director's trademark false modesty, read: "The fabulous Mr. Alfred Hitchcock is about to escort you . . . on a tour of the location of his new motion picture, 'PSYCHO.'" He opens with "Good Afternoon," spoken in the same manner that he used to open each episode of his television series. But in this case, he is standing in front of the motel and the mansion. He continues his narrative direct to camera:

> Here we have a quiet little motel, tucked away off the main highway. And as you see perfectly harmless looking, when in fact, it has now become known as "the scene of the crime." This motel also has, as an adjunct, an old house, which is, if I may say so, a little more sinister looking. Less innocent than the motel itself. And in this house, the most dire, horrible events took place. I think we can go inside because the place is up for sale, though I don't know who is going to buy it now.

Hitchcock then walks up the wide stairs to the front door of the mansion, pointing to the facade: "In that window on the second floor, the single one in front, that's where the woman was first seen. Let's go inside." We the audience enter the mansion along with Hitch. "You see even in daylight this place looks a bit sinister," he notes. He leads the audience on a tour of the house, before descending back to the motel

to continue the tour of Norman's taxidermy-filled private parlor behind the office, noting in particular the framed art on the walls (without revealing the presence of the peephole into the next room hiding beneath one picture).

Departing that room, he urges us along to join him in the bathroom of Cabin 1, where the murder occurred: "Well they cleaned all this up now. Big difference. You should have seen the blood. The whole place was . . . well it's too horrible to describe. Dreadful." Quivering with disgust, he continues his descriptive story until he quickly pulls back the shower curtain to reveal a nude, screaming woman. The woman is not lead actress Janet Leigh, but Vera Miles, who plays the sister of Marion Crane in the film. The title cards at the end warn: "The picture you MUST see from the beginning . . . Or not at all! . . . for no one will be seated after the start of Alfred Hitchcock's Greatest Shocker 'PSYCHO.'"[19]

The movie killed it, so to speak, worldwide. An Australian newspaper referred to the movie as a "kind of Charles Addams horror comic, definitely not for the young, the fainthearted or the sensitive and—despite the cleverly devised visual shock—unworthy of the master who made it."[20] "'Alfie' Goes Berserk with His Newest Film," announced another critic, calling *Psycho* "a source of homicidal joy" for Hitchcock's fans.[21] The *Des Moines (IA) Tribune* called the film as "a splendid opportunity to use all the shocking tricks of his gore-and-tension trade," but "humorless—unless you consider the whole thing as a long sick joke. Sick, sick, sick. . . . His camera peers into bathtub drains, eyeballs and swamps while the film as a whole is probing a fantastic mind."[22] *The Daily News* in New York reported that Hitchcock, "the wag," was planning the first screening of the film "in an allegedly haunted house near a cemetery in Brooklyn with TV's Zacherly and Charles Addams hosting the party," although there is no evidence that this event actually took place.[23] The movie was also described as "deliberately sadistic and a product of a 'sick civilization,'" or, in other words, "a macabre prank" and a sort of "Charles Addams joke."[24] The repeated references to Charles Addams, a popular cartoonist and illustrator at the time and creator of *The Addams Family* characters, is important in tracing the cultural and architectural inspirations for the Bates Mansion.

Public outrage followed the release of the film, with angry parents, conservatives, and religious leaders calling for a nationwide ban. The deluge of fan mail no doubt thrilled Hitchcock, as viewers confirmed he had brilliantly hit the mark he was aiming for. Mrs. R. W. Collins wrote to Hitchcock on September 27, 1960, with these words: "I am not writing this letter as a crank. . . . My husband and I recently saw your movie 'Psycho', and I would like to say that it was the most gruesome, morbid,

REALISTIC movie I have ever seen. . . . To be perfectly frank—it made me sick at my stomach and weak in the knees! . . . I wonder what kind of a person you must be to be a party to putting something so grisly as this before the unsuspecting public."[25] Hitchcock did receive "congratulations on your interesting picture" from the American Medical Association (AMA) in Chicago, although the writer took the opportunity to chastise him for the inaccurate "pupillary reaction" in actress Janet Leigh's eyes as she lay "dead" on the bathroom floor. He assured the director that the AMA's Physicians Advisory Committee stood "ready and willing to give technical advice on such medical scenes and this is a good example wherein we could have advised you."[26]

Journalists both appreciated and defended Hitchcock's return to pure horror. Mildred Martin of the *Philadelphia Inquirer* lauded the shower scene, calling it as "brilliant a piece of movie killing as Hitch has ever offered." She continued: "Lightning speed in cutting, from knife to body to bloody water gurgling down the drain to horrified eyes and desperate hand clutching the shower curtain and tearing it loose, gives this sequence the effect of Grand Guignol montage. For sheer dazzling technique, it, rather than the finale, is the high point of the picture." She noted that it was as though Hitchcock "joined hands with Edgar Allan Poe, [and] decided to perform a jig in a cemetery, tossing into the grisly brew fresh as well as quite ripe corpses, building up to effects derived from visual and mental shock."[27] Rather than a traditional film review, Bosley Crowther wrote a lengthy piece in the *New York Times* entitled "An Answer to Those Filmgoers Who Think *Psycho* Should Be Banned":

> Sensitive souls have been outraged by the candor of its stark morbidity, and agonized victims of its refrigerating process have howled for the protection of censorship. Psychiatrists have mumbled that it is liable to induce a state of shock (which is precisely what Mr. Hitchcock intended), and fearful parents have shuddered for their young. On the other hand, thousands of people— maybe millions by now—have come away deliciously coated with goose-pimples and happily trailing their tattered nerves, satisfied that this time they have got a good solid boot out of a film.[28]

In an interview, Hitch later acknowledged that it "was the suddenness of the murder in the shower, coming as it were, out of the blue" in Bloch's story that "made me decide to do the picture."[29] In any case, Hitchcock, like Poe, captured the "deep

conflict between the play of fear and desire that lies at the heart of the American experience," and he translated it to the film screen more effectively than had any other director before him.[30]

This powerful story originated in a rural true crime that was translated into a novel and then visualized by the director and his team for a global audience. The entire timeline—from the discovery of the murder to the opening of the feature film—remarkably spanned a little less than three years. Who, then, is the visionary architect behind the creation of these iconic structures in *Psycho*? Is it Hitchcock himself? The completion of a film is a team effort, similar to the design and construction of a building, with many people contributing to the ideation of the finished product, and both buildings are undoubtedly an amalgam of many structural and design precedents. Nonetheless, there is an architectural ancestry for both the filmic creations and the real-life buildings that inspired the mansion and the motel, in both their visual form and their deeper literary and historical contexts.

THE REAL STORY OF *PSYCHO* AND THE NOVEL

The story of *Psycho* is based on the real life of Ed Gein, one of the most notorious serial killers in American history. Both of his parents and his brother died separately in the 1930s. Gein continued to live on their isolated farm by himself for more than twenty years. He "always liked to talk about women" but had "no close friends or cronies and no known relatives." The family deaths were later deemed suspicious in light of Gein's reputation for killing and his fascination with corpses. In 1957, Gein was implicated in the death of Bernice Worden, fifty-eight, who operated the Worden Hardware & Implement store located between an unoccupied building and a vacant home in downtown Plainfield, Wisconsin. Her son reported her missing; witnesses observed her truck driving away from the store on the morning of her disappearance. Gein's name was on a receipt in the store. Following that clue, police later discovered Worden's cash register at Gein's farm, located about seven miles away.[31]

After further investigation, police uncovered far more than they bargained for. Gein lived within a "gruesome, mass death-house" containing a large collection of body parts obtained from multiple grave-digging expeditions at local cemeteries. Worden was there, in pieces, decapitated and "trussed up by the feet and dressed out like a deer in the summer kitchen." The head lay on the floor and a bucket nearby held the internal organs. Gein's assemblage included five human heads in plastic

bags, four skulls, ten "death masks" made from the skin of human faces (some wearing lipstick), boxes of bones, and skin pieces. Gein fashioned household items from other body parts, including a chair seat made of human skin, a skull bowl, and skin belts.[32] Cannibalism was inferred, but he denied it. In conclusion, authorities determined that Gein had a "strange sex complex that motivated his sadistic rampage," due in part to his unhealthy, codependent relationship with his mother. Gein admitted that he "wanted to be a woman," and he would "don one of the masks, slip into the torso skin vest, and attach to himself other parts he had removed from a woman's body and parade around by himself in his lonely farm house." The press reported that these rituals "gave him great satisfaction."[33]

The horrific details were widely featured both in the local press and national magazines. His Luddite home, described by the *Milwaukee Journal* as "a rundown two story, once white frame building," did not have electricity or telephone service. The L-shaped, eight-room structure had a new roof, but Gein used only the kitchen, an attached bedroom, and the summer kitchen, a porch structure that enclosed the back door. The interior was ramshackle and in disarray with the exception of one space: his mother's bedroom, which was nailed shut and preserved just as she had left it at her death twenty years previously. Gein kept his mother's bedroom as a

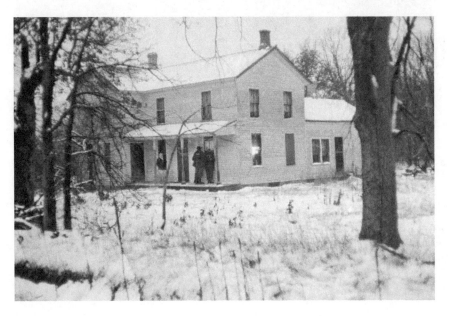

Figure 35. Neighbors peering into the window of the Ed Gein "House of Horror," in Plainfield, Wisconsin, after police uncovered his murderous rampage in 1957. (Photograph by Frank Scherschel, LIFE Picture Collection/ Getty Images)

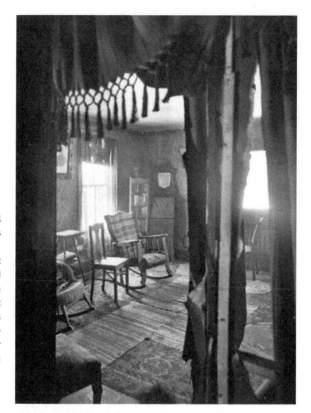

tidy shrine to her memory, as opposed to the hoarder-style mess in the rooms he otherwise occupied.

The disarray of Gein's house and grisly assemblage of body parts was featured in a six-page illustrated story in *Life* magazine. The family-friendly publication did not shy away from the content, titling the December 1957 story "House of Horror Stuns the Nation." Photographs of the farmhouse and the local cast of community characters were accompanied with personal interviews detailing Gein's reclusive ways.[34] The house burned to the ground on March 27, 1958, three days before a property auction, scheduled for Palm Sunday. Locals speculated that prospective purchasers of the home intended to convert it into a grisly tourist site.[35] Gein died in 1984 in prison after being convicted of two murders, although authorities suspected that he had committed a much larger number of crimes.[36]

Bloch asserted that his book, released on April 10, 1959, was based on the idea of Ed Gein but was not a literal recounting of his crimes. Bloch's own recollections, however, are inconsistent and disingenuous about the origin story of what is arguably his greatest work. He reported that "facts were sparse, since the news didn't care to play up unsavory local happenings. All I could learn was that a man had been arrested after murdering the proprietress of a local hardware store. . . . Then, the police found other, 'unspecified' evidence which led one to believe he had not only committed previous crimes but perhaps dug up some graves." He continued, "it wasn't considered exactly polite to discuss those sorts of things in newspapers, not to mention fifties mystery fiction."[37] To the contrary, the public consumed these salacious stories voraciously, as evidenced by the proliferation of headlines dedicated to the discovery of Gein's handiwork at the time and by the continued fascination with his grisly legacy.

Interestingly, Gein's wooden farmhouse, the location of the true crime, bears no resemblance to the buildings depicted in the fictional novel and later cinematic interpretation. Bloch cleverly translated the story to a setting more familiar to his audience: the roadside motel and the Victorian-era mansion, a quirky pairing of buildings that was common along American highways in the late 1950s. During the first half of the twentieth century, mom-and-pop motels sprang up essentially in the front yard of older family homes, with the newer tourist-oriented lodging located adjacent to the blacktop and the proprietors residing in the larger residence set further back on the same lot. Differing from his source material and the life of Gein, Bloch stated, "I came up with his being a motel keeper because of easy access to strangers" who then became his victims.[38]

In the novel (and the movie to follow), the main character is Norman Bates, the manager of a motel his widowed mother owns. The quiet location was left in an economic lurch after the highway was abandoned by tourists in deference to the faster interstate nearby. At one point, she voices regret that the two of them never took "that advance tip that they were moving the highway. . . . We'd have had a new motel, a new house."[39] Norman operates the business on principle and to keep himself occupied as few visitors stop by. A beautiful woman named Mary Crane (renamed Marion in the final version of the screenplay) arrives one dark and rainy night, running away from a crime she committed in order to fund what she believes is a more fulfilling future with her lover. Her sexuality sets off the killer instinct in Norman, who surprises and murders Mary in the shower while dressed in his mother's clothes. He hides the body, but the mental fracturing cannot be undone.

He veers down a steep path toward psychosis, stabbing a detective who is following Mary's trail and attempting to kill the woman's sister and the lover when they arrive to investigate. Finally, it is revealed that Norman had also poisoned his own mother and her lover previously; to compensate for this heinous act of matricide he dug up her body, preserved the corpse, and took on her personality, so that he could once again "speak" with her and share their home together.

The unfortunate Mary stumbled upon the motel and the mansion when she took a wrong turn off the new highway and into the dark, quiet realm of Norman. The book describes her first views of the two buildings: "The entire motel was dark, including the glass-front cubicle on the end which undoubtedly served as an office. . . . She slowed down and peered in, then felt her tires roll over one of those electric signal cables. Now she could see the house on the hillside behind the motel; its front windows were lighted, and probably the proprietor was up there."[40] Bloch further explores the spatial relationship of the two key buildings, with the house and its garage located "up the slope behind the motel," accessed by a gravel driveway. Most importantly, Bloch identifies the period of the motel when Norman refers to his twenty years there, with the date of construction established as 1939.[41]

The essential character of the Bates Mansion is well described in Bloch's novel. Mary first visits the house when Norman invited her to come up for sandwiches. She knocked on the door of a "big frame house on the hillside," and then described what she saw when she peeked through the parlor window: "At first glance she couldn't quite believe what she saw; she hadn't dreamed that such places still existed in this day and age . . . the parlor she peered at had never been 'modernized'; the floral wallpaper, the dark, heavy, ornately scrolled mahogany woodwork, the turkey-red carpet, the high-backed, over-stuffed furniture and the paneled fireplace were straight out of the Gay Nineties. There wasn't even a television set to intrude its incongruity in the scene."[42] Her sister, Lila, who arrives at the Bates property while frantically searching for the now-missing Mary, articulated the decrepit condition further: "the house was old, its frame siding gray and ugly . . . porch boards creaked under her feet, and she could hear the wind rattling the casements of the upstairs windows." Her overall impression was "Ghastly!," the house filled with "antique horrors," and, in her opinion, "the house belonged in a museum." But, as she wandered about and discovered Ms. Bates's room, she realizes that the house was "still alive . . . composed, consistent, coherent; a vital, functioning entity complete unto itself." In the last chapter of the novel *Psycho,* after Norman's ghastly string of crimes is uncovered, the narrator mentions "the Gein affair up north, a few years

back," even referring to the Bates Mansion as a "house of horror," the same moniker the press and *Life* magazine coined for Gein's home.[43]

Bloch may have found inspiration for the mansion from a league of writers before him, and he obviously draws heavily on a well-established haunted house identity. Bloch's book was published in the summer of 1959, less than two years after the discoveries at Gein's farmhouse. The *New York Times* noted that Bloch's novel demonstrated "that a believable history of mental illness can be more icily terrifying than all the arcane horrors summoned up by a collaboration of Poe and Lovecraft."[44] Exploration of the American Gothic and the sentience of structures was in the air at the time. Shirley Jackson also published her novel *The Haunting of Hill House* in 1959, a story that "like 'Usher' . . . begins with a journey that brings an unstable narrator to a remote and disturbing house that seems alive, and which becomes a virtual, but mysterious character in the story." In her novel, she writes of the home in anthropomorphic terms: "No human eye can isolate the unhappy coincidence of line and place which suggests evil in the face of a house."[45]

Both Bloch and Jackson breathed life into the architectural lead character and drew parallels to the dual yet deranged mental state of the occupant in the same way that Edgar Allan Poe depicts the home in his story "The Fall of the House of Usher," published in 1837. Bloch was a "devoted and enthusiastic fan" of Poe (as was Hitchcock), utilizing his classic stories as "an important source of images and ideas."[46] Poe created the first American interpretation of the Gothic house possessed by deranged spirits. His work in "Usher" is widely regarded as "one of the primary foundational texts of modern horror, haunted house, and ghost stories."[47] The connection between these narratives is the sentient house as a centerpiece. The house, in Poe's tale, is a character that represents the body and mind of Roderick Usher, a gentleman who has buried his sister alive in the basement of the home. As Usher's state of mind deteriorates, so does the structure. The story is begun from the point of view of a visitor, who ponders his first experience with the house: "I know now how it was, but with the first glimpse of the building a sense of insufferable gloom pervaded my spirit. . . . I looked upon the scene before me . . . upon the bleak walls and the vacant eyelike windows. . . . I can compare it to no earthly sensation more properly than to the after-dream of the reveler of opium—the bitter lapse into everyday life, the hideous dropping off of the veil."[48] Poe's description of the house brings to mind many familiar scenes constructed since in both literature and film, particularly relevant to a study of *Psycho*. Poe's narrator continues in his description of the home, noting that the absence of Usher heirs has created a phys-

ical and mental merging of "the family and the family mansion."[49] In theory, the building would outlive the family; in practice, both are torn asunder and destroyed by the end of the story.

Both Hitchcock and Bloch use Poe's work and haunted house iconography as a platform for their own stories, leveraging symbols that represent the "Gothic entrapment [of] a suffocating past," according to Hitchcock author R. Barton Palmer.[50] In the novel, Norman refers to the stability represented by the big house and the old-fashioned furnishings that his mother refused to get rid of. He is comforted by the isolated environment, his own private island, that he has created for himself: "He had lived in this house for all of the forty years of his life, and there was something quite pleasant and reassuring about being surrounded by familiar things. Here everything was orderly and ordained; it was only there, outside, that the changes took place."[51] Again, there is precedent for both Bloch and Hitchcock in Poe's story of Roderick Usher. Scholars assert that the ultimate meaning of the *Psycho* narrative "lies in its perception of the dangers of divorcement from reality and the attempt to live in an unreal world of the past, or in any private and abstract world of thought."[52]

In *Psycho,* the ruinous state of the buildings is boldly emblematic of the disorder of Norman's mind. Palmer notes that Norman's mother, a "truly monstrous" character, is represented as the center of the "house's destructive agent." Her relationship with her son is "symbolized by the jarring juxtaposition of the motel" and the mansion, the "family home, [an] index of the unshakable, regressive past."[53] The cellar, where he eventually hides his mother's preserved body and the scene of the final climax in the movie, represented the unfinished states of his subconscious. Yet is the condition of the house the cause of Norman's madness, or the result of it? Norman (played by Anthony Perkins) seemed to embody the very nature of the motel and the mansion in the intimate way that he referred to the buildings in his dialogue as well as his physical attachment to the structures. This unusual relationship was emphasized by multiple scenes capturing him peering through and touching or leaning against the "eyes" (windows) of the buildings along with scene transitions that overlaid images of his face against structural elements.

Ultimately, the danger resides not in the haunted mansion but in the self, which is perhaps the scariest place of all. Poe scholars Dennis Perry and Carl Sederholm note that the character of Norman Bates, and his companion buildings, brings the "sense of awe and wonder that monsters generate" to movie audiences. They also acknowledge Hitchcock's creative debt to one of America's greatest authors, as the director was known to credit his readings of Poe for teaching him that "fear is an

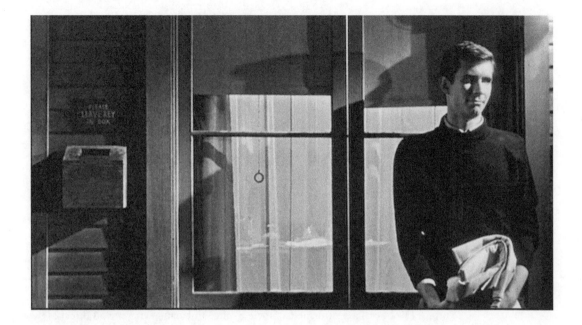

emotion that is fun to experience when you know you are safe." But Perry and Se-
derholm are quick to add that these types of movies and books succeed in part
because "facing the inexplicably horrible, especially when safe, if also fun—for its
own sake."[54]

The full irony of that statement was captured in a period photo shoot for *Sev-
enteen,* a full-color glossy magazine that promoted an American lifestyle ideal for
teenaged women. The May 1960 issue, with heartthrob Rock Hudson on the cover,
promoted "The Kings of Hollywood" splashed across the fashion pages. Photogra-
pher Francesco Scavullo captured actor Anthony Perkins (at that point considered
a heartthrob rather than a serial killer) perched at the top of a ladder in front of the
Bates Mansion, with mother's bedroom window in view just over his shoulder (see
color plate 12). The caption for the photo reads, "Tony cottons white pique and
white pique lights up the somewhat spooky set of Tony Perkins' coming movie, *Psy-
cho,* an Alfred Hitchcock thriller for Paramount. The weathered tree and haunted-
looking house symbolize the eerily exciting fun he had while shooting. But he read-
ily admits that the only spirits possessed by these fashions are gay ones, definitely
of the here-and-now." Two girls-in-waiting with blue headscarves frolic from the

Figure 37. The
moment that Norman
Bates (Anthony
Perkins) switches to
his mother's identity,
a duality signified
by his framing in
the twin windows of
the motel office in
Psycho. (Paramount
Pictures)

ladder on either side of Tony. Picturing a murderer playing with two potential victims seems a bit off-color for a teen magazine. However, to be fair, the editors were likely unaware of the full measure of the story, as the shocking film had not yet been released when the magazine hit the shelves, and Hitchcock had famously kept the story line a secret from the public.[55]

IN COLD BLOOD: ON LOCATION

Coincidentally, another shocking true crime hit the headlines in the year between the release of the book and film versions of *Psycho,* one that also inspired both a literary and cinematic interpretation. In November 1959, two men broke into the Clutter family home in Holcomb, Kansas, slaying four people, including two teenagers and their parents, in the basement playroom of their rural "modern, two-story brick farm home."[56] The horrible incident proved Hitchcock's thrust in *Psycho:* no place is safe from unexpected violence and brutality. Social observer and gadfly Truman Capote (accompanied by author Harper Lee, his childhood friend) investigated the events as the basis for Capote's pivotal American novel *In Cold Blood* (1966). His book later informed a movie by the same name written and directed by Richard Brooks (1967).

For the film version, the actors played out the crime in the exact location in which it occurred: the basement of the original house. Real friends and acquaintances of the family, and even the deceased daughter's horse Babe, were employed as extras in the movie. Hitchcock had performed a similar feat with *The Wrong Man.* That production, filmed in the actual locations of the true crime in New York City and starring people from the neighborhood, was an homage of sorts to the Italian neorealism movement, which sought a confluence of story, place, and character.[57] Hitchcock recalled that "for the sake of authenticity everything was minutely reconstructed with the people who were actually involved in that drama." The crew shot scenes at the actual locations and in some cases, instead of professional actors, had "actual doctors playing themselves."[58] The director could have followed this realist approach in *Psycho,* as the real-life locations were well known to the public, although the book differed in geography.

For *In Cold Blood,* lead actor Robert Blake, who played murderer Perry Smith, notably said he felt "so squirrely" working in the house and engaging in this horrific reenactment. The film was shot in black-and-white in part because the house had since been painted a "gay pink," and director Brooks said, "Technicolor and famous

　　　　　THE ARCHITECTURE OF SUSPENSE

faces would completely destroy the mood we're after." Capote, recollecting on his unusual friendship with the murderers, told this story during the filming: "It isn't funny, really, but I can't help thinking how amused Perry would be if he were here now. . . . Well, one day when I was visiting him in Death Row, reminiscing about the day he and Dick were brought back to the Garden City courthouse to be tried, I told him how big the crowds were outside waiting for him. You know what he wanted to know? He asked me 'Were any representatives of the cinema there?'"

The filming of *In Cold Blood* in the town where the murders occurred felt "like a nightmare revived, affecting both the people who lived through the events and the actors." Yet the townspeople "were disturbed that the aftermath of the tragedy was so profitable—motel revenues . . . were up one-third" in the area due to visitors to the scene of the crime, according to *Life* magazine.[59] The Clutter Home, built in 1948, remains intact today with few changes since the time of the tragedy. The house is now considered an attraction for fans on "dark history" pilgrimages.[60] Despite this film precedent, the Gein House, which was destroyed by fire before filming began,

Figure 38. American novelist Truman Capote (*left*) with actors Scott Wilson (*center*) and Robert Blake (*right*), both dressed in character while on location making the film adaptation of Capote's book *In Cold Blood* at the Kansas house where the murders of the Clutter family occurred, 1967. (Photograph by Hulton Archive/Getty Images)

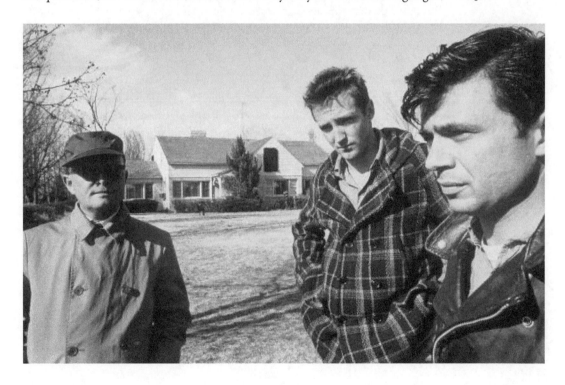

was not considered for *Psycho*. In any case, the director was known to prefer the predictability of the controlled studio environment. The authentic approach, utilizing a documentarian style, was just not "my kind of picture," he maintained.[61]

THE LIVING, BREATHING MANSION

The darkened family mansion on the hill above the motel cultivates emotions of apprehension in the public realm, drawing upon more than a century of haunted house lore and a sense of geographical isolation. Hitchcock had played upon these contexts in his first American film, *Rebecca,* and later again with the remote farmhouse featured in *The Birds*. He noted that "the fear would be greater if the house was so isolated that the people in it would have no one to turn to."[62] This theme began during his American period in part because of the scale of the Great American Landscape. If the scenes of *Rebecca* had been filmed in England, Hitchcock said, he would have been "tempted to show the countryside and the lanes leading to the house," thereby eliminating the sense of lostness he was seeking.[63] By no coincidence, this isolation is both part of the appeal of and the danger inherent in traveling the American roadside, itself a "product of the spatial organization of modern society."[64]

The Bates Mansion is now iconic, functioning for all intents and purposes as a textbook haunted house. But what are the character-defining features of this landmark building? The overall features of the Bates Mansion were rendered within the Second Empire Revival style, loosely based on buildings constructed during the Second Empire of Napoleon, when France was reigned by Emperor Napoleon III (1852–70). The American revival of this style is most readily identifiable by the mansard roof, rising from the cornice line and consisting of a steep lower slope meeting a flat surface above to create an elevated attic space. The Bates Mansion had a rectangular main body set transverse to the highway, with a central projecting tower and a second projection at the rear implying a later addition to the structure. An oval dormer window was set into the attic of the tower. The roof was covered in fish scale shingles with simple eave brackets paired intermittently along the cornice line. The main windows of the house were one-over-one, round arched with no shutters. The tower had a tripartite series of slim, one-over-one, round arched windows set over the entry porch roof. A cast-iron widow's walk lined the roof, and more decorative brackets framed the porch columns.[65]

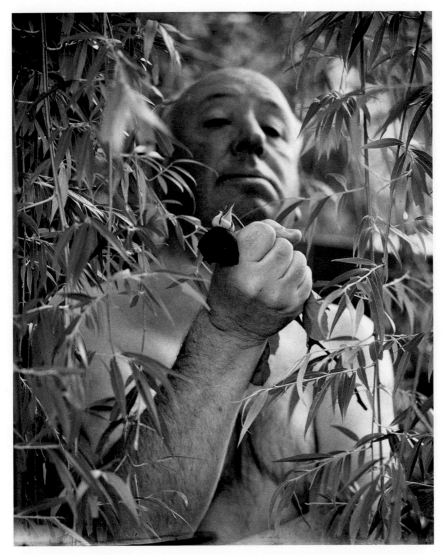

Plate 1. "A blooming flower of cinematic evil, Alfred Hitchcock peers malignantly out from under the garden shrubbery and strangles a rose." This photograph was the foundation for a processed image promoting *Psycho* in *Life* magazine, 1960. (Photograph by Gordon Parks, courtesy of and copyright The Gordon Parks Foundation)

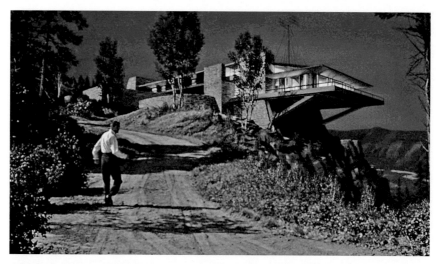

Plate 2. Roger Thornhill (Cary Grant) sneaking up to the Vandamm House, one of the first modernist villain's lairs in the movies, as featured in *North by Northwest*. (Metro-Goldwyn-Mayer)

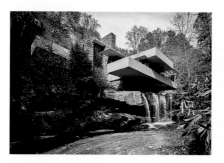

Plate 3. Fallingwater cantilevered over Bear Run Creek, Pennsylvania, designed by Frank Lloyd Wright in 1936, an architectural inspiration for the Vandamm House in *North by Northwest*. (Photograph by Darren Bradley, 2021)

Plate 4. The Sheats-Goldstein House, Los Angeles, designed by John Lautner in 1963, which plays an iconic villain's lair in the movies. (Photograph by Darren Bradley, 2021)

Plate 5. Dizzying view of the United Nations headquarters in a matte-painted scene from *North by Northwest*. (Metro-Goldwyn-Mayer)

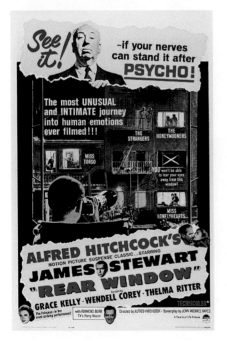

Plate 6. Architecture-centric promotional poster for a rerelease of the film *Rear Window*, 1968. (Photograph by LMPC via Getty Images/Paramount Pictures)

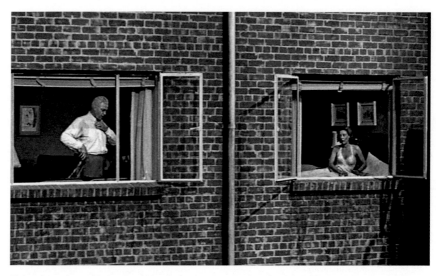

Plate 7. A murderous husband and his wife (the soon-to-be victim) strategically framed by the architecture in *Rear Window*. (Paramount Pictures)

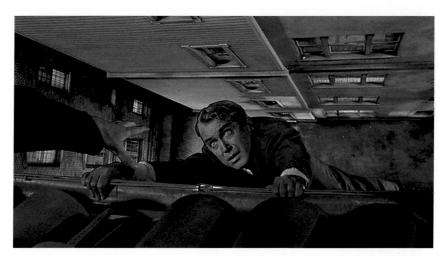

Plate 8. Police officer Scottie Ferguson (James Stewart) fights for his life as he hangs from a downtown San Francisco skyscraper in *Vertigo*. (Paramount Pictures)

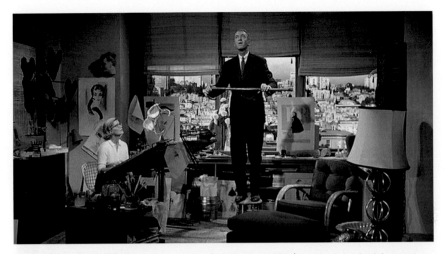

Plate 9. Fashion designer Marjorie "Midge" Wood (Barbara Bel Geddes) working in her feminine apartment interior, with a cantilevered pink bra, overlooking San Francisco in *Vertigo*. (Paramount Pictures)

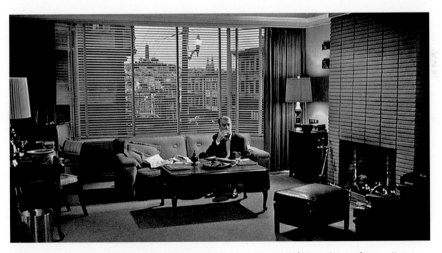

Plate 10. A view of the erect Coit Tower cresting the hill beyond Scottie's (James Stewart) masculine apartment interior, in *Vertigo*. (Paramount Pictures)

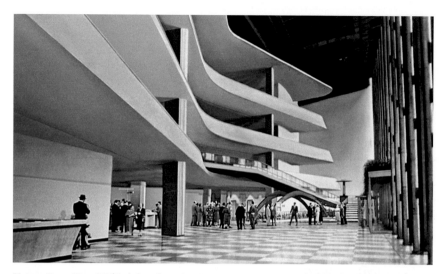

Plate 11. Roger Thornhill (Cary Grant) passing through the lobby of the United Nations headquarters, New York City, in *North by Northwest.* (Metro-Goldwyn-Mayer)

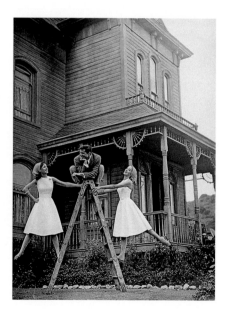

Plate 12. Actor Anthony Perkins posing with young fashion models in front of the Bates Mansion set for *Seventeen* magazine, May 1960. (Photograph by Francesco Scavullo, Hearst Magazine Media, Inc./New York Public Library/ProQuest)

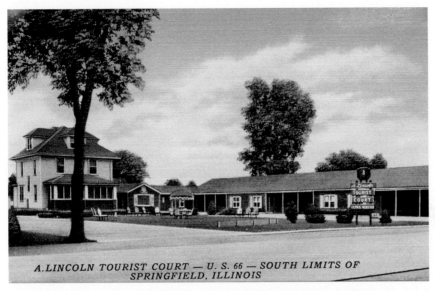

A. LINCOLN TOURIST COURT — U. S. 66 — SOUTH LIMITS OF
SPRINGFIELD, ILLINOIS

Plate 13. "New ultra modern" motel added to family home at A. Lincoln Tourist Court in Springfield, Illinois, ca. 1945. (The Tichnor Brothers Collection, Arts Department, Boston Public Library)

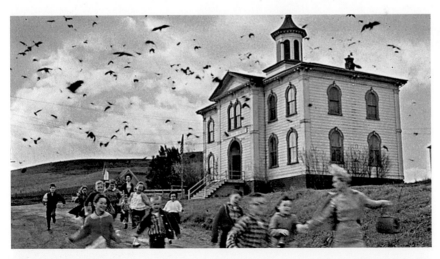

Plate 14. The Charles Potter School, built in 1873 in Bodega, California, saved from demolition after its star turn in *The Birds*. (Universal Pictures, 1963)

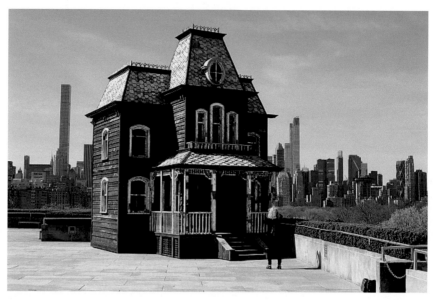

Plate 15. Cornelia Parker, *Transitional Object* (*PsychoBarn*), at a press preview in 2016. (Timothy A. Clary/ AFP via Getty Images)

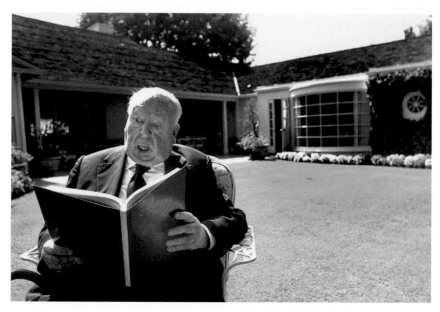

Plate 16. Alfred Hitchcock at his home at the Bel Air Country Club in Los Angeles, reading a script while reclining in a lawn chair 1978. (Photograph by Tom Nebbia/Corbis via Getty Images)

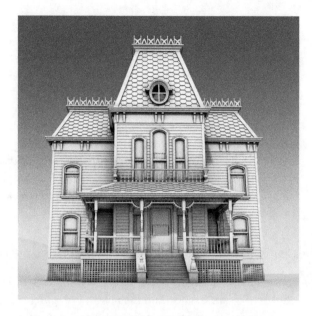

Figure 39. Rendering of the Bates Mansion, the Second Empire Revival–style Victorian house featured in *Psycho*. (Original 3D rendering, copyright Joshua Jaillet, all rights reserved, 2021)

In envisioning the reality of the Bates House, Hitchcock revealed his architectural thought process to his biographer Truffaut:

TRUFFAUT: In *Psycho* there's a whole arsenal of terror, which you generally avoid: the ghostly house.

HITCHCOCK: The mysterious atmosphere is, to some extent, quite accidental. For instance, the actual locale of the events is in northern California, where that type of house is very common. They're either called "California Gothic," or, when they're particularly awful, they're called "California Gingerbread." I did not set out to reconstruct an old-fashioned Universal [studio] horror-picture atmosphere. I simply wanted to be accurate. . . . I chose that house and motel because I realized that if I had taken an ordinary low bungalow the effect wouldn't have been the same.

TRUFFAUT: I must say that the architectural contrast between the vertical house and the horizontal motel is quite pleasing to the eye.

HITCHCOCK: Definitely, that's our composition: a vertical block and a horizontal block.[66]

The two buildings together formed more than just a graphical juxtaposition on film. The dead and dying character of the Bates Mansion not coincidentally expressed the ongoing fate of thousands of late nineteenth- and early twentieth-century Victorian-era homes across the country in the 1950s. By that time, people had grown frustrated with the style; the decorative elements were difficult to maintain, and the complicated interior floor plans were hard to renovate for new uses. The structures were further demeaned by architectural modernists as outdated and ready for replacement by contemporary designs that shed the dusty architectural baggage of bygone eras. To the 1950s public, the destruction of the traditional Victorian mansion, representing a solid and respectable past, embodied the uncertainty and chaos of change but also a necessary and welcome, though mildly distasteful, step toward a space-age future.

ARCHITECTURAL INSPIRATIONS FOR THE BATES MANSION

The architectural origin of the Bates Mansion is a hotly contested topic among scholars, film aficionados, and the public. Prevailing narratives are based on apocryphal stories, the reliance on visual connections between similarly styled Second Empire Revival houses in popular culture, art, and architecture, as well as Hitchcock's own words mixed with the recollections of production designers Joseph Hurley and Robert Clatworthy. Other problematic issues arise when investigating the birth of the house as a set piece, with multiple conflicting accounts from numerous sources. Hitchcock famously presented many stories about himself and his films, blending fact and fiction with an eye toward generating publicity and strengthening his claims to his own intellectual property. In addition, Hitchcock is often credited with the vision and the creation of the set (within the godlike role of auteur) without adequately acknowledging the contributions or possible origins of the mansion and the motel tableau under the creative eye of the screenwriter, production designer, and art director.

During the film's development phase, Clatworthy noted that Hitchcock did not give specific directions for the design of the mansion and motel: "Even though Hitchcock was an art director himself originally, he spoke only very generally. On the Bates house, he didn't say he wanted any particular look—which was one of the great things about him. He let you present your ideas." In many cases, including Hitchcock's *North by Northwest* and *Psycho,* it is often the production designer and art director rather than the director or screenwriter who chooses what type of

buildings best represent the people in the story. This methodology continues into the filmmaking process today. For example, production designer Jeannine Oppewall, a four-time Academy Award nominee (one shared with Jay Hart, set decorator, for her work on *L.A. Confidential,* directed by Curtis Hanson, 1997), prefers "complete freedom in that regard":

> I like a script that gives me zero information about the locations. *L.A. Confidential* was great because all of the information about the sets, except for the motel, had been taken out of the script and all I had to work with was what the action had to be, what kind of place did the actors need to move in to tell the story. . . . I like a director who comes and says here are my ideas, this is what's important to me, the rest is kind of up to you, we'll check back, we'll talk back and forth, you show me pictures, we'll pick it out together.[67]

The work of experienced production designers, whether for Hitchcock or for modern directors such as Hanson, draw from their own encyclopedic knowledge of cultural history, design, architecture, and film theory. Creating the sets and overall visual tone for *Psycho* was no exception; biographer Stephen Rebello wrote that the "designs of Hurley and Clatworthy were original," based on concepts that "sprang from solid backgrounds in art theory, history, and canny movie design."[68] The filmic mansion also satisfied a critical Hitchcock imperative: the set must represent the intensity of emotion, the history, and the motives of each of the characters. The Bates Mansion entraps people in a cage of their own making, such as in a key scene where Lila is hiding from the enraged Norman behind a jail cell–like balustrade, steps away from discovering Mother's desiccated corpse in the fruit cellar.

What types of existing buildings may have inspired Hurley and Clatworthy in the making of *Psycho?* Popular origin stories for the Bates Mansion frequently reference an Edward Hopper painting, *House by the Railroad* (1925). This work, one of the first paintings acquired by the New York Museum of Modern Art in 1930, depicts an isolated three-story, wood-framed mansion rendered in the Second Empire Revival style with mansard roof and central tower.[69] There is a strong resemblance to the resulting movie home of Norman Bates, particularly in the relationship of the building to the viewer; the perspective in both the painting and the film is set at a three-quarter view including the facade and one side of the house.

In *Footsteps in the Fog,* authors Jeff Draft and Aaron Leventhal note a number of visual similarities between the Bates Mansion and the Hotel McCray of Santa

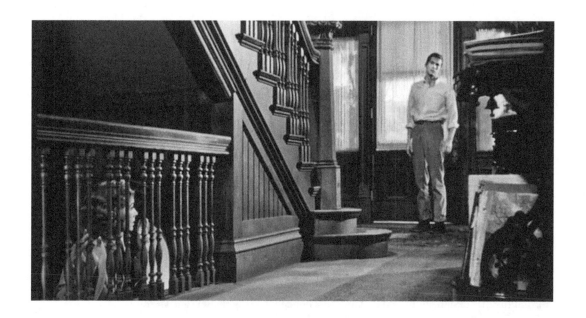

Cruz, an area frequently visited by Hitchcock on his sojourns to Northern California, or the Bernheim House, now demolished, in the same city.[70] No doubt the Victorian-era mansions of San Francisco made a cultural impact on the design of the building; the front doors of the Bates Mansion set were supposedly salvaged from the Crocker House, an enormous Second Empire Revival residence that was demolished.[71] Hitchcock and his designers were intimately familiar with the built landscape of San Francisco through his work on *Vertigo,* which featured visits to a number of iconic sites in the city and highlighted the skills of art directors Henry Bumstead and Hal Pereira. In that film, the mysterious figure of Madeleine visits a twenty-room, wood-frame mansion that played a role as the McKittrick Hotel. The building embodied the glorious excesses of the Victorian era, including an elaborately articulated stairway with a lamp-lit newel post. The tightly patterned floral wallpaper and dark wood interior resemble the entryway created later for the Bates Mansion. In *Vertigo,* Madeleine has taken a room in the Italianate Revival–style San Francisco building under the pseudonym Carlotta Valdez, the picturesque woman represented in a painting Madeleine visited on her pilgrimages across the region. The rooming inn was once the historic Valdez family home, according to the film story. The actual building at 1007 Gough Street, completed in 1890 as

a single-family home by Henry J. Portman, was demolished in 1959 after *Vertigo* wrapped filming.[72]

Film critics reviewing the movie *Psycho* at the time of its release reveal additional cultural touchstones that impacted the creation of the Bates Mansion. The house is described as "a gloomy haunted mansion back of the tourist cabins"[73] and alternately as a "Victorian house that is straight out of Charles Addams."[74] The filmic home of Norman Bates has a remarkable similarity to what later became known as the "Addams Family House." In one cartoon published in a Christmas edition of the *New Yorker*, illustrator Charles Addams depicts a family huddled at the top of a Victorian home ready to pour hot oil on a group of holiday carolers standing three stories below at the front door. The home in this 1946 illustration carries most of the hallmarks of what we now think of as a "haunted house" in the American Gothic and Hitchcockian tradition: the wood-framed Second Empire Revival–style building has two wings and other additions flanking a multistory tower, multiple mansard roofs, fish scale shingles, round-arched windows, gingerbread detailing in the form of brackets and dentils, a widow's walk along the sides of the tower, cast-iron railings defining the rooflines, and a porthole window in the attic for good measure, just like the architectural features that appear at the Bates Mansion.[75] The

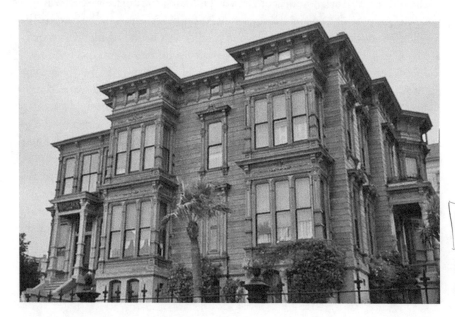

Figure 41. The "McKittrick Hotel," an Italianate Revival–style house, built in 1890 in San Francisco, as featured in *Vertigo*. (Paramount Pictures)

same house was repeated in other Addams cartoons over the years, making cover appearances for two of his books published in the 1950s, including *Monster Rally* (where the house is depicted high on a rise, similar to the Bates Mansion), and *Homebodies,* also a collection of his work that initially appeared in the *New Yorker.*

Interestingly, few historians have explored the landscapes of Southern California as the architectural legacy for this landmark film structure. The environment surrounding the studios served as home to both the director and the production designers, who lived and worked near downtown Los Angeles and were exposed daily to an eclectic collection of architecture. In the hills and valleys of Los Angeles, perhaps more than anyplace else in the world, is a cacophony of "conventionalized categories of dramatic expression," dating from the first "Golden Age" of Hollywood in the 1920s through the contemporary period. Theaters, bakeries, homes, commercial buildings, clubhouses, restaurants, and museums were created in the styles of the day—art deco and modernism—mixed among various manifestations of Egyptian, Gothic, Arabian, Asian, Russian, French Provincial, and English Cottage styles. In fact, Los Angeles and filmic architecture are so "symbiotically linked" that "they are difficult to separate, like Siamese twins," according to historian Juan Antonio Ramírez.[76]

The historic Victorian houses of Bunker Hill, on a rise adjacent to downtown Los Angeles, provided an architectural context for film creators of the period. The neighborhood was popular in Hollywood productions including film noir movies of the 1950s such as *Chicago Calling* (directed by John Reinhardt, 1951) and *Sudden Fear!* starring Joan Crawford (directed by David Miller, 1952), both featuring the work of production designer Boris Leven, and *Kiss Me Deadly* (directed by Robert Aldrich, 1955) with art direction by William Glasgow. During the writing and production of *Psycho,* the city was in the midst of planning the demolition of this once-elegant neighborhood as part of a massive redevelopment project. These structures included many historically and architecturally significant houses once owned by pioneers of industry, city leaders, and innovative entrepreneurs. There is a striking similarity between the history of these homes and the mansion's backstory in *Psycho.* In 1952, the *Los Angeles Times* described the neighborhood, capturing a poignant moment in the decline of the area: "Life is rich in the dozen square blocks atop Bunker Hill. It's rich in the things that artists and poets and writers call wealth. Things like picturesque old buildings, a romantic past and human interest drama. And it's a treasure chest of something else that appeals to a romantic soul— memories."[77]

The wholesale modernization of this 136-acre downtown area, pressed on two sides by new freeways, required the demolition of more than five thousand "substandard" buildings. The language of the city planners, developers, architects, and the press was largely the same: tear down the old and build up the new. One *Los Angeles Times* article, entitled "Blighted Bunker Hill Destined to Regain Old Majesty," noted that the leveled and rebuilt neighborhood would be a "sparkling jewel in the setting of the new Los Angeles," once the "passing of . . . Victorian relics" was completed. The "ancient buildings" located at downtown crossroads would soon be "replaced by modern office buildings, maybe of 20 stories, and apartments of Park Ave. type."[78] An established thirteen-story height limit for buildings in Los Angeles was swept away to allow for bigger and more financially lucrative development plans.

Mayor Norris Poulson celebrated the renewal program as "a new shot of life," for Los Angeles. The city moved forward aggressively in the late 1950s to finish these upgrades of the urban landscape after twelve years of planning, to create a "modern residential-commercial community" bounded by the freeway and busy downtown streets. The full-city evolution coincided with the successful signing of a baseball contract with the (former) Brooklyn Dodgers and the announcement of the construction of the "world's largest and finest zoo."[79] Leading modernist architects of the time also applauded the change. Charles Luckman, once called the "Boy Wonder of Business," by *Time* magazine and principal of the firm Pereira & Luckman with William Pereira (brother of production designer and frequent Hitchcock collaborator Hal Pereira), spoke in terms similar to those Louis Sullivan used at the birth of the skyscraper: "The skyline that will shoot up will not only be dramatic in itself but it will inspire and complement taller office and apartment buildings in areas surrounding it. There will be a resurgence . . . of the whole downtown district." Luckman, who served as supervising architect for the Los Angeles Community Redevelopment Agency during preparation of the plans, noted that "the view gets better the higher you go."[80]

Meanwhile, on the ground, reporter Wally Guenther observed the devastation and monumental loss of cultural heritage that the development represented: "Walk along the lonely sidewalks at this time, through block after deserted block, and soon you sense the memories pressing in around you . . . memories of past days . . . forgotten generations. Memories of a time when these blocks rang with a young vitality . . . of a time when this was the glittering heartbeat of a burgeoning metropolis, boastful, haughty, proud . . . memories of the mellow after years of aging . . . of lingering decay and disintegration. And, finally, oblivion."[81]

The Bunker Hill demolitions displaced more than eleven thousand mostly low-income residents who lived in this once-upscale residential neighborhood. Buildings such as the Melrose Hotel, located at 138 South Grand Avenue, counted "200 elderly tenants" and was known to house "ex-show people," and Hollywood industry retirees.[82] The Melrose started as a single-family Victorian mansion built in 1881. Eventually a second building was erected next door to accommodate more renters. Newspapers featured shocking photographs of the building as it was being demolished in 1957. In a scene not unlike the *Fall of the House of Usher*, the mansion was literally being torn apart at the seams to make way for new development, its decorative shingles, cupolas, and porches destroyed. Residents such as eighty-seven-year-old Lucy Davis were displaced in the urban revitalization. She lived in the hotel and made her home there for more than forty years. Pictured in the press as a lonely old woman holding court in a decaying mansion, she bears more than a passing resemblance to the elderly character of Norma Bates, Norman's dear departed mother.

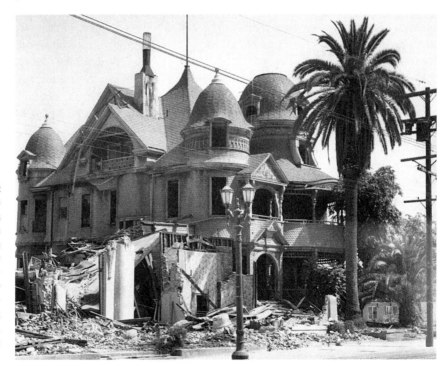

Figure 42. The last stand of the Melrose Hotel, built in 1883 on Bunker Hill in Los Angeles, being demolished for new downtown development, 1957. (Photo by Peter Anthell, Security Pacific National Bank Collection, Los Angeles Public Library)

THE ARCHITECTURE OF SUSPENSE

Figure 43. Resident Lucy Davis leaving the Melrose Hotel, her home of forty years, before it was demolished, Los Angeles, 1957. (Photograph by Gray, USC Digital Library, Los Angeles Examiner Photographs Collection)

The landscapes of Los Angeles also provided production designers the inspiration for the architectural pairing of an old tourist home surrounded by cabins or an adjacent motel building. This combination of structures was once common within the city limits and on the outskirts of this growing metropolis into the 1960s. Only a few holdouts remain in Southern California today. Places such as the Hollywood Center Motel located at 6720 West Sunset Boulevard, across the street from the noted Crossroads of the World development and a short drive away from the film studios, were in the daily path of Hitchcock's production designers and screenwriters. The motel, currently out of business (or at least out of the tourist trade), features a Queen Anne house built at the turn of the century surrounded by twenty-three motel units built in the early 1930s. The property was auctioned in 1954 but continued to function as place for lodging throughout the 1960s and 1970s. One

Figure 44. Postcard
advertising the Hol-
lywood Center Motel
on Sunset Boulevard,
Los Angeles, ca. 1945,
a local example of the
mansion and motel as
portrayed in *Psycho*.
(Universal Hotel
Service Company,
California State
Library)

resident described the motel in this period as "the beginning, the middle, and some-
times, the end of the road. More dreams began and ended there than any other
place in town." According to urban explorers, the motel is probably best known
as "a haven for hard drugs, prostitution, and other illicit activities."[83] Production
designer Jeannine Oppewall later featured this motel as the scene of a gangland
shoot-out in the movie *L.A. Confidential*.

THE BATES MANSION SET

The origin and history of the actual Bates Mansion set is also subject to interpre-
tation. Hilton A. Green, assistant director of *Psycho*, recalled: "The design of the
motel and the famous Psycho house . . . was supposed to be located somewhere in
Central California. There was never a town specifically named [in the script]. We
always felt it that it was up around Tulare. . . . The basic thing that we had to have

[was] the house had to stand above the motel. There had to be steps down to the motel, there had to be an angle from the motel that you could see from the window up to the house. These were all designed prior and then laid out [following] the script, of course." For the set, production designers Hurley and Clatworthy "constructed an original house, which unmistakably referred to a rich tradition of Folk Victorian houses and their associations in art and popular culture."[84]

On the studio backlot, only the front and left sides of the Bates Mansion were constructed (the facades propped up with a wood framework), as the filming angles required a ninety-degree view of the house primarily from the vantage point of the motel and garden stairway. Patrick McGilligan noted that on November 4, 1959, the film team "trooped over to Universal to look for the Psycho house among the standing sets, doctoring one into a blend of Charles Addams and Edward Hopper."[85] The Harvey House (also known as the Allison House) on Colonial Street at the Universal Studios lot is the most frequently cited progenitor of the Bates Mansion. The prevailing history is that this set piece was partially dismantled and reconstructed on the hill to create the Bates Mansion. The Harvey House, named for its starring role in *Harvey* (directed by Henry Koster, 1950) as the home of lead James Stewart and an invisible six-foot-tall talking rabbit, made frequent appearances in pictures long before and after *Psycho*. Likewise, the Bates Mansion set was employed in a number of television shows and films, including cameos in *Laredo, Night Gallery, Emergency!, Captains and the Kings, Wagon Train* and *The Hardy Boys* and feature parts in *Psycho II* and *Psycho III*. The studio likely disassembled the Harvey House to build the Bates Mansion, and then rebuilt the Harvey House from stock parts. Similarly, the Bates Mansion was repaired, reconstructed, and adapted over the years using stock architectural pieces.

As for the inside, *Psycho* scholar Stephen Rebello wrote that the interiors of the Bates Mansion were filmed on Stage 18-A at Universal, "as well as on the venerable 'Phantom' Stage," an older soundstage (also known as Stage 28) most noted as the location for a replica of the Paris Opera featured in *The Phantom of the Opera* (directed by Rupert Julian, 1925). Rebello noted that "several *Psycho* crew members said that Hitchcock took ghoulish delight in having the Bates stairwell built on the exact spot on which the chandelier plunged in *The Phantom of the Opera*."[86] The coincidence is apt. *The Phantom of the Opera* film promoted the set as spectacle, with the building rising above the status of background and into the role of the star. Of course, the source material again provided inspiration. French author Gaston

Leroux set his novel within the walls of the Palais Garnier, home to the Paris Opera, in 1909. Both stories, rendered in written and filmic forms, highlight architecture as central to the character's arc.

HISTORY OF THE AMERICAN MOTEL

The character of the motel in *Psycho* is best understood by first looking at the spectacular rise and desperate fall from grace of this roadside institution. The development of the motel, a uniquely American building, started on an optimistic note in the early years of the twentieth century. Roadside tourist accommodations grew along with the rise of the automobile, created to serve people who could not reliably plan on arriving at a downtown hotel as their end-of-the-day destination. In January 1925, the *Los Angeles Times* featured a profile and photographs of a model "hostelry chain for motorists" and unveiled the word "motel" (a contraction of "motor" and "hotel") as the name for the "New Caravansary System." The California Milestone Motel Company promoted "All the Comforts of Home in Modern Wayside Inns," with future plans to build sixteen motels along eight hundred miles of newly completed coastline highways running between San Diego to Seattle, each complex located "a normal day's auto ride apart" (about 150 miles).[87]

Milestone's modern lodging concept was inspired architecturally and geographically by the historic eighteenth-century Spanish missions lined up along the Pacific Coast. The mission chain included twenty-one buildings founded between 1769 and 1823 by Spanish Franciscan priests traveling north from Mexico, each site established a day's ride apart by horseback. Arthur S. Heineman, president of the California Milestone Motel Company and architect of the building, predicted that the innovative lodging, placed along new and expanding roads, would "democratize the highways and eliminate highway robbers." The motel provided family-friendly features not available in traditional multistory, downtown hotels, including a private garage attached to the cottage room, a private bath and shower, hot and cold water, and a "neatly arranged kitchenette."[88]

Milestone Interstate Corporation opened the first namesake "Mo-Tel" later that year in San Luis Obispo, California, the first recognized "motel" in the world. The building, located directly next to Highway 101, amplified its roadside presence with a three-tiered bell tower resembling the towers at Mission Santa Barbara, completed in 1820 about ninety miles south. The complex contained corridors of rooms, an enclosed courtyard, easy parking, and modern bathroom facilities. One

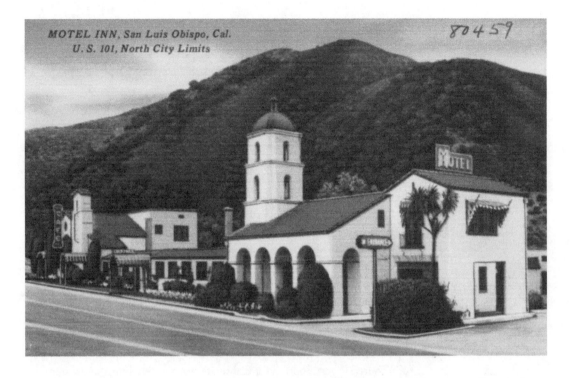

MOTEL INN, San Luis Obispo, Cal.
U. S. 101, North City Limits

news writer declared that the motel "breathe[d] an atmosphere of the old Spanish mission, of friendliness, warmth and comfort," and was certain to "be known up and down the coast as . . . the most comfortable, economical and hospitable inn that can be found anywhere in the country."[89] A red, white, and blue caravan of colorful Hudson and Essex cars arrived at the grand opening of the motel, part of a coordinated highway promotion by the Walter M. Murphy Motors Company.[90] A postcard promoting the establishment in the mid-twentieth century (with the new name "Motel Inn") advertised "Hoteldom in Bungalows," with "65 fully modern, nicely furnished units," a cocktail lounge and dining room, all under the supervision of Harold Spillers, on-site manager.[91]

The public took its time adopting to the name if not the building form of the motel. Two years after the Milestone Motel opened, a Wilkes Barre, Pennsylvania, journalist reported that "a member of the family returning from California brought back another word also recently coined, which seems to describe another new stunt in the motor world in a way that no present word of the language can

describe it. The word is 'mo-tel.'" Despite this skepticism, the author noted that "the motel idea" had gained steadily in popularity on the West Coast and predicted that the building type would no doubt spread across the United States: "The motel bids fair to become a permanent institution wherever the touring season is a year round affair."[92]

The concept took hold by the midcentury and proliferated along classic American roads, such as Route 66 and the Lincoln Highway. The buildings were easy to construct and represented investment opportunities for businessmen and families alike. Typically located on the outskirts of cities, motels replaced inconveniently located multistory, downtown hotels as well as aging and unsafe rustic car camps. The motels were also considered a step above the more common "tourist homes," frequently large, privately owned Victorian-style residences with rooms to let and shared bathrooms, similar to today's bed-and-breakfast establishments.[93] In the years following the introduction of the motel, small businesses and entrepreneurial families built thousands of small motels in their front yards as an adjunct to, or replacement of, their tourist home accommodations, much like the site written up by author Robert Bloch and followed in *Psycho*. Across the country, the convenient motel buildings featured eye-catching names, flashing neon signs, and modern amenities—such as a swimming pool or private bathroom—to attract car-bound tourists speeding from one destination to the next along the new highways. The A. Lincoln Tourist Court, located on Route 66 near the city limits of Springfield, Illinois, demonstrates the evolution of the type. A circa 1945 postcard advertises the property (close to Abraham Lincoln's home and tomb) as a "New ultra modern brick constructed court containing 24 units with tile bath," attached to the family home of "Mr. and Mrs. W. D. Posegate, Owners-Managers" (see color plate 13).[94]

For economy and maintenance, motels very quickly began a transformation from cabin camps (individual cottages set around a parking area), to connected cabins, and then to rows of individual rooms accessible by a common walkway. But the qualities that distinguished the motel as an easy rest stop on the highway soon became the reasons for its demise. Criminals and gangs found the lack of supervision appealing, with no doorman or front desk clerk to testify to coming and goings, as was found at downtown hotels. Patrons could pay at night when they arrived and then leave without checking out. The American Automobile Association made an earnest attempt to distinguish the best lodgings for its many tourist members, establishing guidelines and standards for "cleanliness and safety." The 1940 *Directory of Motor Courts and Cottages* listed 4,000 facilities that had been

personally inspected and graded from "fair," to "excellent." But of that number, "less than 1000 . . . were unreservedly recommended."[95] The rural locations along dark roads provided the perfect access and cover for illegal activities. Not to mention that motels quickly discovered a new population interested in their rooms: rent-by-the-hour couples. This new trade was often welcome to keep the profits rolling in.

By 1940, the problem of misconduct in motels and other roadside facilities had reached a peak. J. Edgar Hoover, "America's head G-Man," and chief of the Federal Bureau of Investigation from 1924 to 1972, addressed the "menace" in an article entitled "Camps of Crime." He unequivocally declared that "a majority of the 35,000 tourist camps" and motels throughout the United States threatened "the peace and welfare" of the community and were places from which "gangs of desperadoes prey upon the surrounding territory." Hoover besmirched roadside lodgings as "a new home of crime in America, a new home of disease, bribery, corruption, crookedness, rape, white slavery, thievery, and murder." He asserted that most of these sites purposely engaged in "loose registration regulations," with a long list of visitors using fake names to sign in for a stay, just as Marion Crane did when she signed the Bates Motel ledger under a pseudonym created from the first name of her boyfriend. Additionally, the popular "Dine-and-Dance" nightclubs that operated in conjunction with the camps, cabins, and motels were often "little more than camouflaged brothels, with prostitutes in the guise of entertainers, hostesses, or waitresses." He recommended that anyone considering roadside lodging first "make inquiries about available camps at recognized automobile associations, better business bureaus, and law-enforcement agencies along the route," not an easy task to accomplish if one is a single woman coming upon a rural motel late on a dark and rainy night, as in *Psycho*.[96]

Motels were particularly dangerous for women. In the 1940s and 1950s, stories abounded in the press about girls being kidnapped by or convinced to join criminals who were frequent guests of roadside lodgings and motels. Hoover himself shared a few stories in his essay. For example, Stella Mae Irwin, only fifteen years old, sped off with Bennie Dickson, ten years her senior, to become husband-and-wife bank robbers using tourist camps as their base of operations. A South Dakota robbery that netted fifty thousand dollars in cash financed their run across the country, stealing cars and engaging in gun battles with pursuers before being apprehended by the FBI in St. Louis, Missouri. Or consider the tale of Mary Sue (last name withheld), who at seventeen years old ran away from home and married twenty-seven-year-old William Taft Norris. The two joined his best friend, Emmett Eugene Cassady, on

a "five-state foray of car-theft and filling-station holdups," running from "tourist camp to tourist camp, where the incongruity of their ages apparently excited no curiosity whatever." The trio was finally captured by the FBI in Pensacola, Florida. The men went to prison, and the girl was released with only her "harrowing memories of her tourist-camp honeymoon."[97] And, of course, the famous crime couple Bonnie Parker and Clyde Champion Barrow frequented any number of motel cabins with their gang before being ambushed and killed in 1934 by a sheriff's posse.[98]

A decline in tourism during World War II further damaged the roadside hospitality industry. But the motels enjoyed one more rise in popularity as people took to the road for fun and misadventure after the war ended in 1945. More than thirty thousand motels were built between 1948 and 1960, with a total of sixty-one thousand motels serving more than twenty million vacationers.[99] But the boom years skidded to a stop when President Dwight D. Eisenhower approved the Federal Aid Highway Act of 1956, which authorized the construction of thousands of miles of interstate freeways to aid commerce and assist in national defense. Establishments such as Holiday Inn (started in 1952 near Memphis, Tennessee) and Howard Johnson's (with distinctive orange roofs and on-site restaurants) gained a foothold on the all-new superhighways, offering consistency, safety, and comfort. With the rise of new facilities, the once-modern "motel" of the 1920s through the 1940s, suffering from decades of deferred maintenance, became "a new primal scene for the American Gothic."[100] American newspapers across the country printed increasingly desperate pleas to off-load motels before the end of the era: "Widow Sacrifices Modern Motel, Only $5,000 Down . . . A real bargain at $37,500 full price," read one classified advertisement in the 1958 *Seattle Daily Times,* followed immediately by other listings promoting a "$26,000 Yr. Income," with your own "17 modern units," noting, of course, the clean, tiled showers.[101]

Other shocking motel incidents kept making the headlines in the years prior to the release of *Psycho,* emphasizing the bad patrons, quirky staff, and rural, isolated locales. In 1959, newspapers reported that police captured "three young California desperadoes" as they left their Apalachicola, Florida, motel room with three teenaged girls who were last seen getting into the men's stolen "rose pink" 1959 Pontiac sedan in Helena, Montana, after school. The young women were missing for four days until the criminals were apprehended, although the girls swore that they went willingly into the car for their wild road trip. The Montana sheriff described the men, two of whom had escaped from prison, as "armed, desperate and dangerous—as bad as they come." The crew had two rifles, a shotgun, and five sticks

of dynamite in their car. A motel owner named Tony Bates (coincidentally carrying the same surname as the fictional Norman) called in the tip after he read a newspaper story describing the missing Helena High School girls. The amateur group was not well skilled at staying under the radar. They paid with a one-hundred-dollar bill and put a "hand-numbered paper sign" on the distinctive, pink-colored car instead of a license plate.[102]

MOTELS IN THE MOVIES

By the late 1950s, the public vision of the motel had changed from a representation of modernity and personal comfort to a symbol of physical danger. Writer and director Orson Welles captured the popular zeitgeist of the motel as a sinister place in *Touch of Evil,* released in 1958, eighteen months before *Psycho* hit the screen. In the contemporary audience's eyes, these two movies played in sequence and were narratively connected. Some intersections are minor, such as the actor Mort Mills, who played both the assistant DA in Welles's film and the haunting policeman figure behind dark sunglasses in *Psycho.*[103] But there were more marked similarities as well: these two cinematic landmarks were created by the most recognized and accomplished directors of the age, and both were filmed in a black-and-white film noir style.

More significantly, the films are linked through the continuous narrative arc of the female lead character and her horrific experiences in a familiar architectural space: the roadside motel. Both films herald the downfall of a modern, headstrong woman, played with perfection by actress Janet Leigh. In *Touch of Evil,* Leigh played Susan, the newlywed American wife of Mexican drug-enforcement official Miguel "Mike" Vargas (played by Charlton Heston in brownface). While they are enjoying an evening in a border-straddling town called Los Robles (played by Venice Beach, California), a car from Mexico explodes with the body of a nightclub dancer inside. Susan is lured into Mexico by members of a Mexican gang while Vargas is kept busy. She is resistant and insulting during her visit with "Mr. Grande," who demands that her husband stop investigating his brother in Mexico City. Gang members follow her and harass her, but she stands up to them defiantly. The couple heads back to the United States to stay in an "American motel" for her safety while he meets with U.S. officials.

A fellow policeman takes Susan to the Mirador Motel, an isolated complex that is "mighty hard to find" and "in the middle of nowhere." Newer motels on the main

highway are closed for the season. The Mirador is run by a nervous proprietor, similar to Norman Bates, who is intimidated by her and stutters his way through their conversation. Susan is essentially abandoned by her husband as the only guest at the motel when the Mexican gang tracks her down and arrives in a fleet of jalopies. Unknowingly, she requests that the loud group be transferred to another "cabin." They chase away the manager and torment Susan in her room. High on narcotics, the hoodlums enter her room and inject her with drugs. When her husband arrives to rescue her, he finds no one listed in the register and her room ransacked. Susan was kidnapped by the gang, whose members are working with a morally conflicted, American investigator played by Orson Welles himself. He later threatens to kill the unconscious Susan before his double-crossing is exposed and he meets a tragic end.[104]

The Mirador Motel in *Touch of Evil* differs from the Bates Motel in setting and composition but architecturally arises from a similar period of construction and can be traced to the same art director: Robert Clatworthy. For Welles's movie, Clatworthy shared the billing with Andrew Golitzen. Golitzen, born in Russia and trained in architecture at the University of Washington, was nominated for an Academy Award for his work on Hitchcock's *Foreign Correspondent* (1940) and is

Figure 46. The lonely and dangerous Mirador Motel in *Touch of Evil*, 1958. (Universal International Pictures)

THE ARCHITECTURE OF SUSPENSE

perhaps best known for his Oscar-worthy role in designing *To Kill a Mockingbird* (directed by Robert Mulligan, 1962).[105] Clatworthy later paired with art director Joseph Hurley to create the iconic and deadly roadside motel in *Psycho*.

Set in a dismal landscape, the Mirador Motel is composed of separate, freestanding stucco-clad masonry cabins with low-slung, gabled roofs; each identical unit (containing two rooms) has a small outdoor porch tucked under the extended eave of the facade. A dusty, dirt parking lot surrounds the buildings, which are landscaped only with dead, stick-figure trees. The script for the film describes the motel further: "Dismal, indeed. Bypassed by the new highway, the 'Mirador Motel,' suggests the beached wreck of some disreputable pleasure ship—the Hudson Night Ferry, for instance—cast up on a strand from which the sea itself has long since receded—abandoned by everything but a fitful scattering of litter."[106] In a full shot at dusk, the surrounding landscape is revealed as a "desolute [*sic*] expanse stretching out on every side of the little motel. There is no distant house; not a flicker of light," playing upon the fear of isolation also leveraged by Hitchcock in his films.[107]

The Mirador Motel and the Bates Motel are not extraordinary as architectural statements. The significance of these structures arises from their commonality in the everyday environment. *Touch of Evil* and *Psycho* are populated with visual triggers, based on shocking public experiences and scandalous press reports, to generate an organic, nerve-tingling sensation of real fear. Welles's work is more defined by moving shadows and dark-alley conflicts, whereas Hitchcock relied on murky landscapes and small rooms reflected in mirrors. In any case, this pair of movies show that in your most vulnerable moments, alone in your pajamas or self-absorbed in the shower, you may be caught by surprise. The idea that these ordinary buildings could host horrific experiences was destabilizing for the audience and propelled the American roadside motel into the mythic realm. Hitchcock fully recognized the architectural power created by pairing this new iconic model with the well-established identity of the derelict mansion to generate an entirely new haunted landscape in the filmic universe.

CREATING THE BATES MOTEL

In *Psycho* the most pivotal scenes occur in tight spaces, leaving the characters, especially Marion, little room to escape awkward interactions and her own peril. The cheap hotel room where the couple meets illicitly, the airless real estate office in Phoenix where the buyer flashes his wad of cash, Marion's bedroom where she

chooses the wrong path, the bathroom at the car dealership that Marion uses as a retreat to count out the funds, and the interior of the car where she engages in a circular internal dialogue are all created as claustrophobic places that connote entrapment. Once Hitchcock has established this as a theme, he continues by leading the character into the last site she will ever visit: the Bates Motel. Here, the spaces reach a height in confinement, with an oppressive parlor decorated with stuffed birds and a faux-cozy motel room barely big enough for one.

Throughout the film, Hitchcock and his design team played upon the prevalent notions of the motel as dangerous, utilizing this identity to create fear when the audience faces the building on-screen. His narrative of the motel as a place to avoid rather than a place to find shelter impacted cultural history so completely that the Bates Motel was identified by historians as "a thing of evil" and "the most sinister motel of all" decades after the release of the film.[108] In 1986, at the release of *Psycho II* (directed by Richard Franklin), journalist Mickey Davis wrote that Norman Bates "did more to soil the reputation of the small motel than any frayed towels or unmade beds ever did. He even put a few of them out of business." Davis went so far as to call actor Anthony Perkins, who played Norman in *Psycho,* "Howard Johnson's favorite night light nemesis," referring to the popular motel chain.[109] One journalist warned that "young ladies may give up showering by themselves," an inclination felt by my own mother, Diane, after seeing the film on its first run in the theaters.[110]

Within the novel and the film, the architectural vision of the motel and the mansion are aligned. Yet screenwriter Stefano did not incorporate specific descriptions of the motel building or the mansion in his script. The motel office, porch, and individual rooms are not described at all, simply named as the locations for each scene, leaving space for a wide interpretation by the production designers. Only the first view of the motel from the car is described, as "a neon sign blurred by the rain-sheeted windshield," with "large letters which read 'Motel.'" The mansion is simply a "A Large Old House" from [Marion's] point of view.[111] Norman's parlor, however, receives detailed treatment in the script. This room in particular distinguishes the Bates Motel from your average roadside accommodation and adds context to the idea of the two buildings as analogous to the mother and son characters.

During the film, Marion agrees to share "sandwiches and milk" with Norman shortly after she arrives at the Bates Motel, as she does not want to go back out in the driving rain to reach the nearby diner. He invites her to come up to the house, but while she unpacks in her room she overhears Norman and his mother arguing over his gesture of hospitality, the voices arriving ghostlike through her window

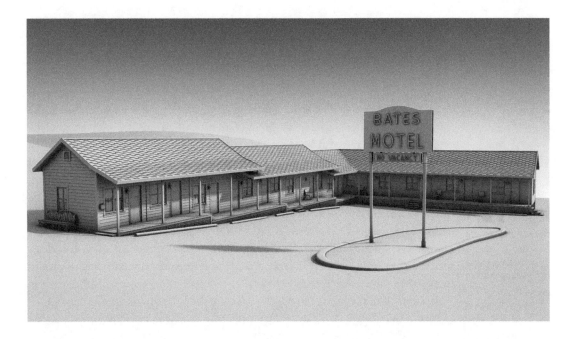

from the house on the hill. Mother demeans Norman vociferously, calling him "Boy" and accusing him of shameful and gutless behavior with the woman in the motel. Norman quickly leaves the house and arrives at Marion's room with the supper tray. She invites him into her room, but he hesitates, instead asking her to join him in the motel office instead. Once in the office, he stutters uncomfortably that "Eating in an office is just too officious. I have the parlor back here."[112] This proves to be the fatal step for Marion as she triggers Norman's conflicted feelings about his mother, his lust, and his identity during their intimate conversation.

The parlor represents more than a setting for the scene; the room is a physical manifestation of Mother within the realm of Norman. Stefano described the parlor as she enters the space in the script: "[Marion] is startled by the room. Even in the dimness of one lamp, the strange, extraordinary nature of the room rushes up at one. It is a room of birds. Stuffed birds, all over the room, on every available surface, one even clinging to the old fashioned fringed shade of the lamp. The birds are of many varieties, beautiful, grand, horrible, preying. [Marion] stares in awe and a certain fascinated horror." Norman admits his insecurities to her while the birds look down menacingly, delivering the famous line, "A boy's best friend is his mother."[113]

During their visit, Marion "briefly examines a bookcase stacked with books on the subject of 'Taxidermy,'" as well as "paintings on the wall; nudes, primarily, and many with a vaguely religious overtone."[114] In Hitchcock's realm, architectural spaces can protect you from danger or expose your private moments: the traditional paintings hide Norman's secret masturbatory peephole that provides a clandestine view into Cabin 1, the room he has assigned to Marion. In the finished film, the production designers selected a reproduction of a seventeenth-century painting by the Dutch artist Frans van Mieris the Elder to cover the rough hole in the wall. Even this small item adds depth to the story. The canvas depicts the tale of "Susanna and the Elders," from the book of Daniel in the Old Testament, with a nude woman being groped by two elderly men in a garden.[115] Norman's overdecorated parlor disoriented the audience and revealed the crushing presence of Mother by establishing a filial relationship between the mansion and the motel in its interior furnishings and gothic animal collection. If the motel ultimately represents Norman and his desperate yet futile fight for independence, then the parlor signifies the presence of his mother within the recesses of his mind.

Figure 48. Norman Bates (Anthony Perkins) surreptitiously peeking at Marion Crane through the peephole into Cabin 1 at the Bates Motel in *Psycho*. (Paramount Pictures)

In contrast to the unexpected nature of the parlor, the interior of the deadly motel room in *Psycho* is familiar to anyone who has stayed at a small, family-operated

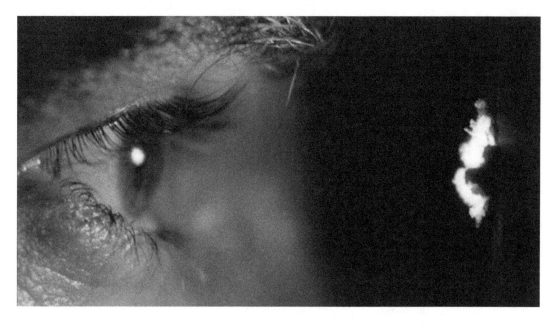

roadside lodging between 1930 and 1980. The room is cozy enough for a single night's stay but not somewhere you would want to linger: the walls are thin, and the furnishings are knockoffs of classic American styles. The bedside lamp features a shade painted with a tall ship at sea, and the walls are decorated with prints of birds and botanicals in cheap wood frames. The small closet does not have a door and is open to the room. The flowery wallpaper is outdated and in need of replacement, though it does conveniently hide Norman's peephole in its prolific blooms. The shower with its white square tiles, laid at an angle on the floor and in a box set across the walls, end in a bullnose just below the level of the erupting shower head. This style of bathroom design proliferated across the United States in middle-class homes and is common even today, seemingly impervious to shifting design tastes and destructive remodeling trends. The sink is dated by its separate faucets for hot and cold, rather than a modern single tap. The towel rack is rudimentary, made of a pipe clasped in place by screwed-in brackets, painted over with time.

The bathroom in Cabin 1, location of the iconic shower scene, is described in basic terms in the script as a room of "white brightness," that is "almost blinding." The murder is written simply as "THE SLASHING." The script reads: "An impression of a knife slashing, as if tearing at the very screen, ripping the film. Over it the brief gulps of screaming. And then silence. And then the dreadful thump as [Marion's] body falls in the tub."[116] Those thirty-eight words were turned into a three-minute sequence that became one of the most horrifying moments ever produced in film. Saul Bass, credited as "Pictorial Consultant" for the film, designed and laid out the graphic storyboard for "fast cut after fast cut in simulation of the frenzy of the act itself," to render "a violent bloody murder as a ritualized, near-bloodless, one," according to his daughter and biographer, Jennifer Bass. Bass himself said "As a title person, it was a very natural thing to use that quick cutting, montage technique to deliver what amounted to an impressionistic, rather than a linear, view of the murder."[117] Hitchcock did not originally plan a soundtrack for the murder scene, but he wisely revised his vision (with the prompting of Alma) to allow composer Bernard Herrmann leeway to create the discordant, screeching strings that send chills up the spine.[118] Marion's spectacular death is followed by an ignominious end: Norman wraps her body in the shower curtain, carries her to the trunk of her car, and sinks the woman, the Ford, and the stolen money to the bottom of a nearby swamp.

The film adaptation is based on Bloch's setting of the story, but it was the director and his production team who visually highlighted specific vernacular features, familiar to the public from circulating news stories, that alerted the audience to dan-

ger. The presence of these filmic architectural codes generated feelings of suspense, curiosity, and fear. For instance, unlike the new Holiday Inn or Howard Johnson's motels of the era, the filmic Bates Motel had no claim on 1950s modernity: no air-conditioning, no television, no cocktail lounge, and no connecting rooms for families. A small neon sign lacked any standard claims of comfort or trademark badges that indicated oversight of a trusted corporate entity such as the Automobile Club of America. This list of notable absences combined to form the image of a place to be avoided while on the road, much as J. Edgar Hoover had suggested decades earlier.

Early versions of the script for *Psycho* described the Bates Motel as a building with twenty-four rooms, but in Hitchcock's personal shooting copy of the script this number was crossed out and replaced by "12." The number of rooms is famously referenced by Norman Bates in his dialogue to both Marion and the private investigator Arbogast as "Twelve cabins, twelve vacancies," harkening back to that first era of car camps composed of linear arrangements of discrete cabins.[119] This small change in the script is significant as evidenced by a list of eighteen roadside motels compiled during the development of the film as the character of a large, twenty-four-room facility differs greatly from the stature of a lodging with only twelve rooms. A production note in the Alfred Hitchcock archives at the Margaret Herrick Library of the Academy of Motion Picture Arts and Sciences details motels near Redding and Red Bluff, located north of Sacramento, and Fairfield, northeast of San Francisco. The short list was compiled from the 1959–60 Automobile Club of Southern California's Southwest Tour Book by the "Research Dept." for *Psycho* (see appendix B).[120] The research team selected a number of establishments on Route 99, the main north-south highway running through the western states from Canada to Mexico that Marion travels during her ill-advised run from her current life.

The motels selected and likely visited and photographed by the research team include typical structures built between the 1930s and the late 1950s, with nightly rates ranging from five to twelve dollars. These lodgings would fit within the budget of a single working woman like Marion or may have been listed as possible set inspirations for the sites visited by the private detective Milton Arbogast during his search for the missing money and the errant woman. A few of the motels were no doubt too large and accommodating for the story, which called for a down-and-out establishment with few amenities. For example, the California Motel, "One of Redding's Finest," according to a period postcard, is a one-story building with twenty-three "modern air-conditioned and electrically heated units," arranged around a

center court in a U-shape.[121] The Crystal Motel and Coffee Shop outside of Red Bluff promoted its status as "new and modern" on a menu from the era and included a coffee shop and cocktail lounge on the property, far too luxurious a setting for this story of despair and desperation.[122]

One motel in particular, however, aligns with the finished Bates Motel in *Psycho* more than any other on the list: the El Rancho Motel near Shasta Dam, operated by Fred and Faun Gardner. A 1952 postcard promoted the motel in Project City (now incorporated within the limits of Shasta Lake City) as "The place to stop when you travel first class," and further adds that "distinctive designing and building by owner, former motion picture set builder."[123] In the 1940 U.S. Census, Fred Gardner (born in Texas) and his family resided on Siskiyou Street in Los Angeles.[124] His profession is listed at that time as a carpenter at a movie studio, but the studio is not named. Gardner later moved to Burbank (where many of the studio lots are located), and he is listed as a builder in the city directory for 1949.[125] Uncovering the connection between Gardner and a specific studio or person remains elusive. However, the

Figure 49. Postcard promoting the El Rancho Motel, Project City, California, 1952, visited by the production design team during field research for *Psycho*. (National Press, Inc.)

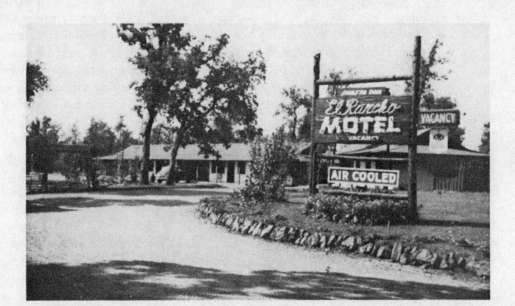

SHASTA DAM — EL RANCHO MOTEL — PROJECT CITY, CALIF.

building he constructed and the Bates Motel bear striking similarities in character and landscape, including the scale of the building, the linear range of rooms, the angle of the gable roof, the single pillars supporting the extended eave to provide a covered walkway to connect the rooms, and the location, immediately adjacent to Route 99. The route has long hosted roadside accommodations for travelers. The town of Corning on Highway 99 is credited with having the first auto camp in California, opened in 1900 in an olive grove.[126] That highway was decommissioned in 1972 and replaced in large part by Interstate 5, which now runs along the other side of the motel, trapping the building on its own private island, as Marion was seeking in her desperate escape from Phoenix. Of course, the Bates Motel is an amalgamation of many motel precedents from the era, but the El Rancho is the closest in structure and architectural appearance to its filmic look-alike from the examples listed by the studio Research Department.

THE LONG REACH OF *PSYCHO*

The Bates Motel and Mansion are not an unusual pair of buildings to encounter in the wilds of the American landscape. What is unlikely is the impact these two imaginary buildings made in cultural history. In the film, the audience makes the journey with Marion, from the reality of the outer world into the psychotic abnormality of Norman Bates's universe. Hitchcock relished re-creating this atmosphere for the audience, noting that "there is no question but that both the house and the motel are authentic reproductions of the real thing. . . . I felt that type of architecture would help the atmosphere of the yarn."[127]

At this point, there are dozens of books, documentaries, and fictionalized dramatic films examining every aspect of the writing, filming, editing, production, score, and history of *Psycho*. Principal works include (in order of publication), *Alfred Hitchcock and the Making of "Psycho"* (Stephen Rebello); *A Long Hard Look at "Psycho"* (Raymond Durgnat); *"Psycho": Behind the Scenes of the Classic Thriller* (Janet Leigh with Christopher Nickens); and *Alfred Hitchcock's "Psycho": A Casebook* (Robert Kolker, ed.). Historians, scholars, and fans have endlessly reviewed the lead-in, the event, and the long-term cultural impact of the now famous murder of Marion in the shower. Homages to the scene abound in popular culture, from the animated comedy *The Simpsons* to the recently televised horror series *Scream Queens*. The scene also received feature-length treatment in a documentary by director Alexandre O. Philippe entitled *78/52: Hitchcock's Shower Scene* (2017), focused

on a thorough examination of the seventy-eight camera setups and fifty-two cuts required for this one fragment of the film.[128] Gein's heinous acts, dramatized in *Psycho,* also inspired many notable authors and moviemakers in their own creations of iconic serial-killer characters. Gein appears in spirit as a series of serial killers: Leatherface in the *Texas Chainsaw Massacre* (directed by Tobe Hooper, 1974); Buffalo Bill in *The Silence of the Lambs* (directed by Jonathan Demme, 1991); and Dr. Oliver Thredson in *American Horror Story: Asylum* (2012–13).

Psycho as film, and as legend, has transcended the public consciousness to become timeless. The movie is referred to in reverential terms by any fan of Alfred Hitchcock: it is widely regarded as a "cinematic codex" that can be studied and obsessed over relentlessly with each viewing revealing new hints, new stories, and new avenues of interest.[129] William Rothman calls the film "the masterpiece that culminated the period in which Hitchcock and his public were in closest touch. . . . [I]ts astounding success capped the decade in which 'Hitchcock' was a household name."[130] *Variety* referred to the piece as "arguably the most revolutionary commercial movie ever made," as well as a work of "extraordinary *firstness.*"[131] Indeed, generation after generation continues to pass down stories drawn from this powerful film. In an interview for *78/52: Hitchcock's Shower Scene,* screenwriter and producer Daniel Noah recalled that his seven-year-old daughter once mimicked the stabbing motion and "eek-eek-eek" of the Bernard Herrmann score as a joke, even though she had never seen the film and "doesn't know where [the action] comes from." He described this powerful cultural ripple effect as "Evolutionary. It's like we are just born knowing the shower scene from *Psycho.*"[132]

The completed work became a filmic icon illustrating architectural, sexual, and Freudian themes that resonate more than six decades after the original release of the movie. Hitchcock biographer Patrick McGilligan summed it up when he wrote that the film was "a phantasmagoria with a scary mansion, stairwell, and dark basement; it was a Peeping Tom and a screaming Jane; it was the world's worst bathroom nightmare, mingling nudity and blood; it was a plunging knife in the muscled grip of a man dressed, bizarrely, as his own mother."[133] Critic Andrew Sarris, writing an opening review for New York's *Village Voice,* proclaimed that the movie was "overlaid with a richly symbolic commentary on the modern world as a public swamp in which human feelings and passions are flushed down the drain," not to mention "the grisliest murder scenes ever filmed." He noted that "such divergent American institutions as motherhood and motels [will] never seem quite the same again" and that the feature "should be seen at least three times by any discerning film-goer [to

uncover] all the hidden meanings and symbols lurking beneath the surface."[134] In 1995, lead actor Janet Leigh (who plays Marion Crane in the film) recalled that she had watched the movie at least fifteen times and still discovered new brilliant moments on each viewing.[135]

The persistent power of *Psycho* is also evidenced by the sheer number of sequels and remakes of this pivotal film. No other film by Hitchcock has received the same treatment. Anthony Perkins reprised his role as Norman in *Psycho II* (directed by Richard Franklin, 1983) and *Psycho III* (directed by Anthony Perkins, 1986). A made-for-television film entitled *Bates Motel* (directed by Richard Rothstein, 1987) continued the story line past Norman Bates's tenancy, and the subsequent release of *Psycho IV: The Beginning* (directed by Mick Garris, 1990) explored the events before the murder, in a prequel authored by Joseph Stefano, the screenwriter on the original *Psycho.* Eight years later director Gus Van Sant created a shot-by-shot remake of the Hitchcock original starring Vince Vaughan as Norman Bates and Anne Heche as Marion Crane (1998). In 2013, the A&E cable-channel television network released the wildly popular series *Bates Motel* featuring the backstory of Norma and Norman Bates but set in the present day rather than the mid-twentieth century.

In each of the *Psycho* sequels, the mansion and the motel make reappearances in close to their original form. Examining these modern-day reinterpretations of the motel and the mansion provides some insight as to the place of these structures in the cultural memory and exposes areas that today's creatives feel free to alter or expand on as part of this everlasting story. In *Psycho II,* screenwriter Tom Holland (also renowned as the writer and director of *Fright Night* in 1985 and *Child's Play* in 1988) worked with Hitchcock's production designer Robert Boyle to re-create the Bates Mansion for the film. During preproduction for this sequel, made twenty-three years after *Psycho,* Holland visited the Universal lot where Boyle "pulled out the plans to the original *Psycho* house, and we rebuilt that house according to [the] specifications of the original movie," to create "the same house," as Hitchcock intended. Holland ascribed the long popularity of the mansion and the motel in part to the spatial relationship between the buildings, with Mother Bates given oversight (from her second-story window) to watch "the evil" that happens in the motel.[136]

The Gus Van Sant 1998 version of *Psycho* made only minor changes to the script and score (which is credited to Joseph Stefano and Bernard Herrmann, as is the original film) but brought the characters and the buildings into a contemporary period. The motel appears to date from the 1950s (rather than the 1930s) and is composed of concrete block, colorfully painted yellow and coral with a large sign

on the roof reading "Motel" in neon-illuminated script and a backlit plastic sign along the highway. The mansion in this film, however, is completely transformed on the exterior. Created by art director Carlos Barbosa, the house on the hill is rendered as a Carpenter Gothic–style building. The concrete-and-brick building has a sharply gabled roof with a central entry capped by a transverse gable. Paired chimneys rise from the standing-seam metal roof. Shadow patterns on the facade appear to reference a porch that no longer exists, with a door opening onto thin air adjacent to the main entry. A brick extension, with chimney, projects from the front of the house. In this case, the architectural change detracted from the story and distracted the audience. These alterations of Hitchcock's "horror house," along with other issues, were exposed as weaknesses in the production, evidenced by the generally unfavorable reviews of the film. The *New York Times* simply asked, "Why copy a perfect movie?"[137]

The architectural identity and backstory of the buildings are further explored in the television series *Bates Motel*. This creatively revisionist series, promoted as a "contemporary prequel to the genre-defining film *Psycho,*" explores the deteriorating mental state of high-schooler Norman Bates (played by Freddie Highmore) and the developing dysfunctional relationship he has with his mother, Norma (played by Vera Farmiga).[138] The narrative begins with the mysterious death of Norman's father. Six months later, Norma and young Norman start their lives afresh by purchasing a worn-out but furnished mansion and old roadside motel at a foreclosure sale. The house and the motel are, of course, the same structures made famous by Hitchcock's film, but with the addition of a 1960s-era neon sign promoting the "Seafairer Motel" [*sic*], complete with overscaled captain's wheel erupting from a signature blue field with a sharp, but faded, red arrow pointing at the entrance. By the second episode, the "new," more familiar "Bates Motel" sign is in place, and Norma is getting the place fixed up.

The series narrative is based in the fictional coastal town of White Pine Bay, Oregon, rather than the central California location of the original, and was filmed in British Columbia, Canada. Both the house and the motel were reconstructed there for the filming. In the story, the drunk and enraged previous owner of the house and motel shows up, a Mr. Keith Summers, returning to berate Norma as the new resident of his century-old family property. Summers spits out that "my great-great grandfather built this house in 1912," and his "grandfather built that hotel in the '50s."[139] It is likely that the audience and the creator's didn't think twice about the dates, but character-defining features of the buildings, such as the Second Empire

Revival style mansard roof on the mansion, or the linked "cabins" of the one-story motel, are more accurately tied to the late nineteenth century and the late 1930s, respectively. In addition, a close reading of the source novel and analysis of the original movie reveal clues as to the original construction dates of the structures, if the buildings were real, that is.

The story in *Bates Motel* quickly turns dark and sinister: Norma kills Summers after he attacks her in the house. Rather than report the murder to the police, mother and son dispose of the body and hide the deed. The cover-up of the murder starts the downward spiral of the unfortunate paired destinies of both Norman and Norma and their mother-son buildings. Within a week, Norma finds out the city is building a highway bypass, marooning the structures (and the people) away from the eyes of the public. The story plays out over the five-season run of the series until the inevitable climax of the show, which ties back seamlessly with Hitchcock's film and Joseph Stefano's script. In "Marion" (season 5, episode 6), Norma is dead from an apparent suicide when wayward Marion Crane checks into the motel, now under the management of Norman. This pivotal episode is not scripted as a take-by-take replication of the classic Hitchcock movie but rather as a homage to a great moment in cinema, reinterpreted for the modern age.

No doubt in deference to rabid fans of *Psycho,* the team of production designers and art directors stayed largely true to the architectural details of the original filmic Bates Mansion. In the motel, however, they employed creative license in the interior design, changing Hitchcock's brilliant-white bathroom with a darker blue-on-blue tiled scheme. And, shockingly, the victim in the shower is a man rather than a woman. Nonetheless, the alteration in the set completely changes the mood of the scene, a remarkable contextual difference that illuminates the visual strength and genius of Hitchcock's minimalist, white-on-white approach in the original motel bathroom. Not to mention that the white tub and tile more effectively contrasted with the splashing and swirling blood of the murder in the high-contrast tone of the original film.[140]

There is another prevalent theme within *Psycho,* one that threads back to ancient traditions. The story of the Minotaur, captured within a labyrinth, is enmeshed within Western narratives and is a tale that still resonates. The image of the labyrinth—a mazelike construction of impenetrable walls arranged in a geometric configuration of openings, passageways, and dead-ends—impacted storytelling for thousands of years and permeates our culture today in books, films, and other artistic endeavors. The conceptual base of the story is interpreted by Hitchcock at

the Bates Mansion; by director Ridley Scott on the spaceship *Nostromo* in *Alien* (1979); and as the enormous, empty Overlook Hotel in Stanley Kubrick's *The Shining* (1980). Hitchcock and his fellow directors sought an archetypal counterbalance between mythology, cultural memory, and the collective unconscious, expressed through the architecture and characters in their films. The Minotaur was an unfathomable creature (a reflection of our worst selves) borne from illicit desires, the monstrous child of a sexual union between a woman and a bull. He is banished and forever trapped within a structure that embodies the concept of lostness: an inescapable and confusing maze. The tale of the Minotaur and the Labyrinth, first articulated in ancient Greek writings by Ovid, is explored in Metamorphoses. The relevant passage reads: "Minos resolved to remove this shame, the Minotaur, from his house, and hide it away in a labyrinth with blind passageways. Daedalus, celebrated for his skill in architecture, laid out the design, and confused the clues to direction, and led the eye into a tortuous maze, by the windings of alternating paths . . . so Daedalus made the endless pathways of the maze, and was scarcely able to recover the entrance himself: the building was as deceptive as that."[141]

Stanley Kubrick and Hitchcock shared similar proclivities in their approach to cinematic storytelling. There is an emphasis on the "grand-scale, inner struggle between darkness and light," and both confront the "Jungian duality of man."[142] *Psycho* and *The Shining* explore this theme in particular, although the vision pervades throughout other pictures including Kubrick's *2001: A Space Odyssey* (1968) and Hitchcock's *The Wrong Man* as well as *Vertigo*. The Bates Mansion and the Overlook Hotel are both metaphors for the "private island," the "traps" of our own making, and the internal damage incurred when a person is "cut off from the outside world entirely."[143] Additionally, both directors explore the "psychological underpinnings" of human emotions such as love and rage. Not surprisingly, Kubrick's co-scenarist was Diane Johnson, a novelist who was teaching a class in Gothic literature at UC Berkeley when she signed on for *The Shining,* her first screenplay. Incidentally, the movie was also Kubrick's first exploration in horror. He had previously declined requests to direct *The Exorcist* and *The Exorcist II.*[144]

Psycho captured the tenor of the times by featuring "icons of the new American vernacular landscape of the 1950s and 1960s, which found its cinematic expression in the genre of the road movie: highway patrol cops, car dealers, roadside billboards, neon signs, and motels," mixed with murder, fear, and overwhelming neuroses, as Steven Jacobs described.[145] Hitchcock admitted that it was "tremendously satisfying for us to be able to use the cinematic art to achieve something of a mass emotion.

And with *Psycho,* we most definitely achieved this. It wasn't a message that stirred the audiences, nor was it a great performance or their enjoyment of the novel. They were aroused by pure film."[146] Biographer Patrick McGilligan asserts that "it is no exaggeration to say that Hitchcock had been waiting for *Psycho*—working up to it—all his life."[147] In some analyses, critics "charge that there wouldn't be any 'slasher movies' today if *Psycho* hadn't laid the groundwork . . . in terms of the perverse sex and explicit scenes of violence."[148] The compelling characters of the motel and the mansion, as expressive as any actors of the period, drew from literary precedents and real-life examples but largely depended on the "analogy between the façade of a palace and the face of a man, between the house and the brain," inhabiting the building.[149] Now firmly established as architectural icons, these remnants of the American landscape continue to generate fear and serve as eternal warning signs: entering dark places can change your life, or end it.

5

ARCHITECTS AND THE ART
OF FILM

The exploration of buildings and film is incomplete without unearthing the critical role of architects in Hitchcock's landmark works. Architects changed the entire composition of the film industry, bringing with them methodologies utilized and perfected in design offices and studios. Many of Hitchcock's production designers, including Robert Boyle, Henry Bumstead, Hal Pereira, and Alexander Golitzen, formally trained as architects before working in Hollywood. Their collective credits on Hitchcock films included *Foreign Correspondent, North by Northwest, The Birds, The Man Who Knew Too Much, Vertigo, Topaz, Family Plot, Rear Window, To Catch a Thief,* and *The Trouble with Harry,* among other prominent movies. These design professionals and their architectural colleagues came to the set armed with the magic combination of three-dimensional thinking, a comprehensive knowledge of historic places, a pragmatic approach to construction, and an innate sense of bodies in motion that adapted perfectly to the requirements of the filmic art form. Once recruited to join the filmmaking team, the architects' impact then expanded into conversations regarding the visual mood of a film and manipulation of the set as a functional metaphor for real-life experiences. In time, the architects discovered that the film realm provided unprecedented opportunities for experimentation in design and a new pathway for introducing innovative ideas to the world.

FROM STAGEPLAY TO PHOTOPLAY

Creative, economic, and practical factors can be cited in the movement of architects into film. During the pioneering years of cinema, existing plays were simply rewritten and reproduced for the camera, as indicated by the name "photoplay." But unlike a play there was no audio dialogue, only music performed live in the theater, which led to the insertion of descriptive screen-sized title cards and exaggerated facial and bodily pantomime on the part of the actors. Without spoken lines to audibly express the action, filmmakers began to rely more heavily on the buildings and interior spaces framing the scene to carry the tone of the narrative. The use of new technology, in cameras and lighting, also called for new methods in storytelling.

In 1915, poet and cultural observer Vachel Lindsay argued for a complete evolution and departure from old traditions in the pursuit of film production. In his book *The Art of the Moving Picture,* he wrote: "In order to be real photoplays the stage dramas must be overhauled indeed, turned inside out and upside down. The successful motion picture expresses itself through mechanical devices that are being evolved every hour."[1] Creators quickly discovered that the movement of the "mechanical devices," specifically the camera, opened new frontiers by breaking the static relationship between the audience and the actors. Directors and cinematographers began to play with visual movement and the concept of scenic immersion through cuts and close-ups that transported the viewer out of their chair and into the action. In this way, a new power was conveyed to the storyteller, who compelled the audience to follow distinct narrative paths by manipulating the images on the screen.

Other critics called for a radical change in methodology and process by pointing to the transformation of the physical relationship between an audience member and the visual media. Rob Wagner, writing about the film industry for the "Palmer Plan" in 1920, noted that although the distance between a person and the live stage or movie screen is similar in scale, the perspectives are essentially different. Wagner likened the two connections to the shape and angle of a hand fan. In the playhouse, the fan handle is on the stage, "the ribs of which point toward the eyes of a thousand spectators distributed around the arc of a circular balcony." In film, however, this is reversed with "but a single eye to behold the picture, and the handle of the fan would be in the lens with the ribs pointing out from it."[2] He concluded that "it gradually was borne in upon the producers that the moving picture was not simply a translation of stage craft to the screen, and that the words 'canned drama' were

a misnomer," referring to the standard metal containers used to protect and ship films.[3] Decades later, director, writer, and actor Orson Welles aptly compared the two experiences by stating, "In the theatre there are 1,500 cameras rolling at the same time—in the cinema there is only one."[4]

Audience expectations of reality rose quickly as the public became comfortable with the new art form. Lindsay noted that "the camera has a kind of Hallowe'en witch-power" over the spectator, elevating their experience through photographic manipulations.[5] Wagner again noted the limitations of traditional stage design, writing that "what little manufactured scenery that was found necessary was made by scenic artists, which interested as a novelty, but was soon discovered to be totally inadequate to the purpose" of filmmaking. Additionally, he asserted that "the limitations of the playhouse also give rise to the necessity of painting interior sets in exaggerated perspective, and the men who had been trained in this kind of scenic representation found it difficult to adjust themselves to the building of sets in normal architectural proportions." The difference, he wrote, was that "the stage has always been regarded as an artifice, yet the public mind looked upon moving pictures as realism. And so, though vibrant cloth scenery was acceptable in the playhouse, it outraged the sense of propriety in a realistic presentation" when projected on-screen.[6]

In a search for innovative solutions, leaders in the nascent film industry began to assemble new types of teams to complete production. The precision of moviemaking called for a developed sense of space and the ability to conceptualize built environments (both realistic and fantastic) in an entirely different way. Architects were brought on board to fill this void in the process. They utilized their talents to author a more convincing set, or tableau, that accommodated multiple synchronized movements of both actors and the camera not necessary within the static set of the stage. By 1920, a line between the two types of performances was firmly established, compelling editors at the *American Architect* to credit architects' work at the studios as the determining factor between the definition of stage design as a "decorative art" and "motion picture design" as "one of the structural arts."[7]

A few architects had already attempted to interject more reality and perspective to stage sets, a movement that fit better with the process of set design for film. J. Andre Smith, a Cornell-trained architect who established an artist's studio in Maitland, Florida, authored a teaching guide for fellow architects and stage designers in 1926. He advocated for a three-dimensional approach to set design, a noted departure from the work of "the scene painter of yesterday, who tricked us rather convincingly with paint and canvas and amazing perspectives."[8]

Smith developed a volumetric approach combining the talents of the "scene architect and builder" and coined a new title: the scenewright. He noted the usefulness of architects in the field, considering that both the designer and the scenewright "must consider their finished creation as a tangible form existing in space." This articulation of immersive set pieces called for a "painter-architect, a dreamer with the ability to make his dreams come true and as big as life," someone with "the color sense of the painter and with some of his technical skill; he has to know enough about architecture to keep from going historically astray; and he has to be enough of a draftsman to enable him to transfer his pictorial designs into practical working drawings and structural details from which the stage carpenter and scene builder can create the finished set." Smith concluded that the scene designer should have "the qualifications of the painter as well as those of the architect."[9] His descriptions of the role of the scenewright are closely aligned with the responsibilities later articulated under the film titles of production designer and art director, incorporating a unique set of well-developed visual and technical talents.

This type of thinking was adopted by filmmakers themselves as the industry matured. Luis Buñuel, a Spanish filmmaker, recognized the power of architects after watching *Metropolis* in 1927, a science-fiction, architecturally focused film set in the dystopian future of the 2000s. This gothic-modernist extravaganza compelled him to proclaim: "Now and forever the architect is going to replace the set designer. The movies will be the faithful translator of the architect's boldest dreams."[10] Through film, architects expanded the impact of their ideas exponentially and internationally, realizing higher visibility than a single building or even a body of work could ever accomplish.

ARCHITECTS IN HOLLYWOOD

Visionaries such as Vachel Lindsay called for architects to change the world through film; Lindsay dedicated a chapter in his 1915 book to "Architects as Crusaders." Indeed, he was one of the first to recognize the increased prominence of the architect as a cultural harbinger. He also predicted the rise of Hollywood's impact when he wrote that "California, as the natural moving picture playground, has the possibility of developing a unique cultural leverage upon America."[11] He saw film as an instrument for communication, a new method of exchange that quickly surpassed other types of interactions with the public.

At that time, the film industry was the fourth-largest in the United States,

"attended daily by ten million people," Lindsay wrote, "and in ten days by a hundred million, capable of interpreting the largest conceivable ideas that come within the range of the plastic arts."[12] He encouraged the architectural profession to "take over the films bodily" by creating a leadership board "who make it their business to eat dinner with the scenario writers, producers, and owners, conspiring with them in some practical way."[13] Using film as a communicative media, architects could help America reclaim its architectural greatness and spread the country's conceptual design theories across the globe. He wrote in bold statements and declarations about modern opportunities for the profession, stating, "I bring forward the proposition that the photoplay is such a good natural medium for architectural propaganda that architects could use it to stimulate the rebuilding of America into a sort of perpetual World's Fair, if they had the courage of such persons as Alexander, Julius Caesar, or Napoleon." He referred to this ideal environment as "An Architect's America."[14]

By the 1930s, the explosion of population and the arts that brought Hitchcock to Southern California not surprisingly also attracted the "nation's best architects" to this "breeding ground for new architectural ideas," as noted by the *Los Angeles Times.* According to the paper, the city grew into a "distinctive art center" that influenced "the nation's taste in dress, building and way of living," an influence that spread internationally, in part due to the movies.[15] The immense popularity of the new cinematic art form also fostered an employment and opportunity boom for adventurous architects as "millions of architectural sets required for thousands of films needing yet more memorable sequences kept countless imaginative designers gainfully employed."[16]

The economic depression of the 1920s and 1930s forced the issue further. Architects faced unemployment nationwide as the construction and design fields floundered. In New York the "Architects' Emergency Committee" launched "Manhattan landcruises" in 1933. The tours were "personally conducted and explained by unemployed architects" and featured landmarks such as the Rockefeller Center and a peek at Diego Rivera completing the murals at Radio City Music Hall.[17] In Hollywood, architects repositioned themselves as creatives working behind the scenes at the studios: as draftsmen, builders, and eventually art directors and production designers. Trained architects such as Joseph Urban, born in Vienna in 1872, paved the way for others in their field to join the film industry by hammering out newly emerging job titles and responsibilities on the set, at times a rocky process. Urban repeatedly clashed with directors at Cosmopolitan studios (owned by William

Randolph Hearst) over the limits of his position as set designer or art director, resulting in the establishment of procedures and a better delineation of above-the-line titles.[18]

As the industry matured, a league of architects worked the halls of the major studios in a cartel of sorts. Even architect Lloyd Wright, son of world-renowned architect Frank Lloyd Wright, worked as a designer for Famous Players-Lasky, the same studio where Alfred Hitchcock got his start in film.[19] By 1940, a film writer noted that "motion pictures are almost solely dominated by the architectural mind or the architecturally trained mind," with "hierarchical and specialized work methods" similar to the practices "already established in major American architectural studios by the first decades of the twentieth century."[20] During the "Golden Age" of Hollywood, between the 1920s and late 1950s, architects ran the art departments at Paramount and Metro-Goldwyn-Mayer, for example. The budgets for sets and the personnel needed to create the distinctive look of the films coming from each of these studios were a major expense in the production, accounting for about 12 percent of the total and exceeded only by the 30 percent set aside for stars salaries.[21] The studios likely recruited from the local architecture schools, particularly the University of Southern California (USC), which birthed an unusual number of art directors and production designers. One of those students, Robert Boyle, noted that the distinctive look for the movies, or "the stamp," from each studio originated with the supervising art directors and the art department team, composed primarily of trained architects.[22]

Hans Dreier, an architect from Germany, served as head of the art department at Paramount studios from 1927 until 1950, and brought his expressionist tone to works such as *Sunset Boulevard* (directed by Billy Wilder, 1950). He studied architecture in Munich and began his career in 1919 with UFA (Universum-Film Aktiengesellschaft), a German production company, before moving to Paramount in 1923. Dreier ran the art department with methods similar to those employed in an architectural studio or an atelier, occupying one floor of the production building with a drafting area for the assistants, or "draftsmen."[23] They were kept busy during the 1930s, when Paramount ran "three eight-hours shifts of set builders" on their soundstages and produced about forty films per year.[24]

Architects such as Dreier proved "to exercise as substantial an influence on Hollywood's set design as . . . architectural emigres like Richard Neutra, Walter Gropius, and Mies van der Rohe were to have on American architecture," according to Albrecht.[25] The "Bauhaus-like workshop" under Dreier was populated with "local

architectural school graduates and fellow emigres," including Jock Peters and Kem Weber. Peters trained in the Berlin office of Peter Behrens, also known as a training ground for modernist architects Walter Gropius and Mies van der Rohe. He returned to architecture and was known for his luxurious art deco interior design, including the landmark Bullocks-Wilshire Department Store completed in 1929 in Los Angeles. Weber was also from Berlin and first arrived in the United States as part of the crew overseeing the German exhibition at the Panama-Pacific Exposition of 1915.[26]

Dreier's team also included Henry Bumstead, who graduated from the architecture program at USC, a second-choice career after he was injured playing football. "Bummy," as he was known, was recruited by RKO for a summer term as an "apprentice draughtsman," which he later referred to as his "first big break." Bumstead appreciated his educational training in Los Angeles and noted the close connection between USC and Hollywood, saying "God bless them: if I had not gone to USC, I would probably never have become an art director in the film industry."[27] A few years later, Bumstead moved to Paramount to work with Dreier. He has nearly one hundred films to his credit, including Academy Award wins for *To Kill a Mockingbird* (directed by Robert Mulligan, 1962) and *The Sting* (directed by George Roy Hill, 1973). He was nominated for an Oscar for many other creations including *Vertigo* and received a Lifetime Achievement Award from the Art Directors Guild in 1998.[28] He also worked with Hitchcock on *The Man Who Knew Too Much, Topaz,* and *Family Plot.*

At Paramount, Dreier was followed by Harold "Hal" Pereira, an architect from Illinois. Hal, born in 1905, worked on multiple pictures with Hitchcock: *Vertigo, To Catch a Thief, The Trouble with Harry* (1955), and *The Man Who Knew Too Much,* all luxuriously filmed projects for Paramount featuring dozens of landmark locations. Hal's studio career officially began in 1942, when he started at Paramount as unit art director.[29] He worked as supervising art director for two years at the studio.[30] He then stepped into the shoes of Hans Dreier in 1950, heading the art department at Paramount until it closed in 1967–68.[31] He contributed to or oversaw the completion of 287 films as art director during his long career in Hollywood, dating from his first art department credit for *China* (directed by John Farrow, 1943) through *The Odd Couple* (directed by Gene Saks, 1968). He was nominated for an Oscar twenty-three times, including for his work on *Vertigo* and *To Catch a Thief,* and came away with one win, for *The Rose Tattoo* (directed by Daniel Mann, 1955). His brother William had a bigger profile in architecture as designer of the

1969 Transamerica Pyramid in San Francisco among other notable works and as a principal in the firm Pereira and Luckman.

Hal and William Pereira showed promise as architects even in high school. The brothers attended the University of Illinois, William graduating in 1930. William then began his professional career with Holabird & Root, a landmark Chicago firm established in 1880, and later formed Pereira & Pereira with his brother Hal in 1933.[32] William first came to Hollywood in 1933 to "get into the designing end of the movie business," but "he couldn't even get inside a studio to arrange an interview."[33] Returning to Chicago, he continued his work renovating movie theaters with his brother and completing large-scale commercial works. In 1934, William married Margaret McConnell, a well-known "cigarette ad girl" and model who signed a seven-year contract with Metro-Goldwyn-Mayer, forging a more solid connection between the family and the Hollywood studio network.[34] She starred in two pictures before they married and she left the business: *Million Dollar Haul* (directed by Al Herman, 1935), and *Crashin' thru Danger* (directed by Sam Newfield, 1936). That same year, Pereira noted the "paucity of films" as the primary driver behind the firm's bustling business remodeling movie palaces, a specialty of the firm, then known as Pereira, Senseney & Pereira.[35]

William finally headed to Los Angeles in 1939, winning the commission to design a $12 million studio for Paramount working with T. Keith Glennan, operations manager. Construction plans were "subsequently dropped," but William remained at Paramount "designing sets, costumes, making tests and writing," working with David O. Selznick, the producer who brought Hitchcock to the United States for *Rebecca.*[36] Pereira continued to work in architecture, remodeling the elegant El Capitan theater in downtown Los Angeles with the notable addition of "love seats" in the balcony "whose arms can be folded away" so that couples could cuddle up closer during the movie. The building was renamed the Paramount Hollywood to reflect its new ownership during that period.[37] That same year he also donated his services to the creation of a new Motion Picture Relief Fund country home for retired actors.[38] One of William's most notable contributions in film was the completion of a "series of 485 drawings, in sequence" to storyboard the movie *Jane Eyre* (directed by Robert Stevenson, 1943), starring Joan Fontaine and Orson Welles.[39] His work on that movie earned him the title of director himself.[40] William contributed his talents to Hitchcock's *Rear Window,* as well as ten other films, and received an Oscar for Best Effects/Special Effects in *Reap the Wild Wind* (1942) for director Cecil B. DeMille.[41] This one-man "phenomenon in two different fields:

architecture and movies" excelled because, according to him, "both begin with an idea on paper."[42]

Cedric Gibbons, the head of the art department at MGM, grew up in design; his father, Patrick Gibbons, was an architect in New York, and his grandfather was also an architect. Instead of following in their footsteps, Cedric moved to California after World War I and put his skills toward set design for Samuel Goldwyn. When MGM formed in 1924, he was installed as the first head of the art department at what was then the "world's largest film studio." Historian Donald Albrecht attributed Gibbons's single-minded determination and Los Angeles's "lack of cultural inhibitions" as inspiration for Gibbons to be "daringly inventive" and innovative in set design. Gibbons viewed himself "as an equal partner in the promulgation of modern architecture in the United States," keeping pace with Neutra, Schindler, and other contemporary architects of the day.[43] At one point, Gibbons had more pull in the public eye than any practicing architect at the time with the possible exception of Frank Lloyd Wright.

Gibbons structured his department at the studio within the same format as an architectural office and brought in other architects to work with him including Van Nest Polglase (art director for *Citizen Kane* and Hitchcock's *Suspicion;* he was also head of the art department at RKO from 1932 to 1942), and Merrill Pye (art director for *Ziegfeld Follies* and Hitchcock's *North by Northwest*). The *Los Angeles Times* recognized Gibbons widespread cultural impact when a writer noted that "motion-picture art directors like Cedric Gibbons, Max Parker, Richard Day, Gordon Wiles, Anton Grot and others, do more than produce beautiful settings for a motion picture—they give to the world, through the screen, new ideas for architecture and interior decoration which are often adopted by the public."[44] Gibbons designed his own modernist house, a romantic getaway for himself and his actress wife, Dolores del Río. Designed with architect Douglas Honnold (who also worked at MGM), the Gibbons residence in Santa Monica Canyon embodied all the dramatic Hollywood touches of a film set including a scenic grand stairway, a fireplace of black terrazzo and silver nickel, water sprinklers on the roof to create the impression of rain, and light projectors to illuminate the sensuous shapes of the interior.[45]

Gibbons created a massive workforce to complete the glittering productions under his watch. For the preparation of *Romeo and Juliet* (directed by George Cukor, 1936), for example, Gibbons used a "small army of artists to prepare sets and costumes," including nine chief assistants and forty architectural draftsmen, creating "hundreds of rough sketches, detail drawings, and . . . miniature sets." The pro-

duction required more than two years of background research into the buildings, clothes, and cultural climate of the Renaissance era.[46] Creating an environment that comprehensive required the "ability to merge metaphors with filmic content" and depended on "experience and technical expertise that create reality out of the lyricism of ideas," according to writer and film editor Vincent LoBrutto.[47] This area of film design, first referred to as art direction, eventually morphed into the realm of production design. Historian Juan Ramírez identified Anton Grot, supervising art director at Warner Brothers from 1927 through 1948, as "the first real production designer in the history of American cinematography," pointing to his thousands of illustrations in which "he worked out not only various overall views of a given architectural set but also all the individual shots, human figures included, composing the film."[48]

By most accounts, the actual title of production designer came into fruition during the filming of *Gone with the Wind* in 1939. William Cameron Menzies invented the term for himself to describe his far-reaching role in establishing the design, character, and overall image of the film, a position title later confirmed by director David O. Selznick in the credits for the movie. Interestingly, Menzies began his career working for Grot at Fort Lee studios in New Jersey, an early-emerging epicenter for making movies.[49] In 1932, Grot completed art direction for *Doctor X* (directed by Michael Curtiz, 1932), the "first of the 'thrillers' to be filmed in full color." In promoting the film, Grot spoke of his goal to "build menace into the sets." For *Doctor X,* he noted that the "criss-cross attic beams . . . give a cramped sensation even before you know that beneath them a man is to be choked to death. The sagging roof line, too is most suggestive." For mystery, he would "design a set that imitates as closely as possible a bird of prey about to swoop down upon its victim, trying to incorporate in the whole thing a sense of impending calamity, of overwhelming danger. We put this into the design of the rooms, the furniture in the rooms and even into the gables." Grot himself talked about the set as "like a frame for a picture," one which needs to "blend harmoniously with the story being told." He elaborated the overall approach in a 1934 news story: "Few people realize the direct connection between backgrounds and action. Love scenes are more romantic when played in a garden . . . crime incidents belong in shaded corners . . . suggestive of shadow and heaviness . . . the siren secures best results in boudoir intimacies. . . . [P]roviding the backgrounds are a real part of the tension, emotion and suspense that must be details of such a twist to the story if it is to prove effective."[50] Production designers therefore created more than a set; they were charged with envision-

ing "the world in which the film takes place to capture a sense of authenticity and render the director's vision to celluloid reality." This process includes "translating the script into visual metaphors, creating a color palette, establishing architectural and period details, selecting locations, designing and decorating sets," and ultimately defining the "pictorial scheme" of the entire film, as noted by LoBrutto.[51]

In a 1963 interview with *Cinema* (a journal for "the intelligent motion picturegoer"), Hitchcock described his understanding of the difference between a production designer and an art director, two critical positions in filmmaking that are often occupied by professional architects:

> Art director is not a correct term. You see an art director, as we know it in the studios, is a man who designs a set. The art director seems to leave the set before it's dressed and a new man comes on the set called the set dresser. Now there is another function which goes a little further beyond the art director and it is almost in a different realm. That is the production designer. Now a production designer is a man usually who designs angles and sometimes production ideas. . . . The art direction is set designing. Production design is definitely taking a sequence and laying it out in sketches.[52]

The layout of sketches to which Hitchcock referred is a process called storyboarding, a method of deconstructing the narrative and shooting sequence before filming begins, similar to the drawing of a blueprint preceding the construction of a building. Each shot of the film is laid out, as in a graphic novel, to guide the continuity of narrative and image throughout. The storyboard not only illuminates the story but may include visual aspects, such as suggested camera angles and notes for the color tone of the film. In some cases, surprisingly, the architects laid out the look and graphic thrust of a film before a director even signed on to the project.

Turning "poetic ideas into reality on the screen" did require a comprehensive understanding of the period, the script, and the best way to inform the story through architectural form. Production designer Paul Sylbert, who worked with Hitchcock on *The Wrong Man,* referenced "books, diaries, letters, all kinds of things" but particularly relied on architectural research. He noted that a deep knowledge of architecture was "absolutely necessary; you can't invent that. . . . You've always got to start with something real and shape it to suit the needs of a particular script."[53] As an innovative creator, Hitchcock encouraged his production designers to dream up buildings that were "freed from the constraints of actual construction." allowing for

fantastical designs that may, or may not, stand up in the real world, such as Robert Boyle's design of the Vandamm House in *North by Northwest.*[54]

FILM AND ARCHITECTURE AT THE UNIVERSITY OF SOUTHERN CALIFORNIA

In 1929, two years after the initial feature "talkie" emerged, the University of Southern California (USC) founded the world's first film school in Los Angeles. The School of Cinematic Arts began as a joint venture with the Academy of Motion Picture Arts and Sciences. Noted contemporary alumni of the school include award-winning directors George Lucas and Ron Howard. Although the widespread cultural impact of the film school at USC is well known, the contribution of the School of Architecture is not as readily acknowledged.

The architecture program at USC birthed a number of award-winning professionals in the film industry. Of the 139 graduates between 1931 and 1938, twelve students pursued a career in film rather than practice with an architectural firm. In fact, 30 percent of the USC School of Architecture class of 1933 ended up in the film industry; three of these graduates eventually worked with Alfred Hitchcock on some of his most pivotal American works, including *Saboteur, The Paradine Case* (1947), *Rear Window, To Catch a Thief, The Man Who Knew Too Much, North by Northwest, The Birds, Vertigo, Topaz,* and *Family Plot.*

The list of notable graduates from this period included: Walter Harry Tyler (1931); Edward Charles Carfagno and John Francis Meehan (1932); Albert R. Nozaki, Robert Francis Boyle, Boris Robert Leven, and Edward Willens (1933); Marvin Aubrey Davis (1935), Marvin Summerfield (1936), Joseph McMillan Johnson (1937); and Hilyard Morris Brown (1938). Two notable additions to this list include Dorothea Holt Redmund and Henry Bumstead, who graduated with a bachelor of fine arts from USC in 1933 and 1937, respectively. During their cinematic careers (which extended into the 1970s), these USC graduates collectively earned 908 screen credits as art directors, 145 as production designers, 66 Academy Award nominations and 15 winning efforts that received an Oscar. The films they "built" established the tone and tenor of architecture on film in the mid-twentieth century. This venerable cinematic list includes *Fiddler on the Roof* (directed by Norman Jewison, 1971); *West Wide Story* (directed by Jerome Robbins, 1961); *Giant* (directed by George Stevens, 1956); and *The Sound of Music* (directed by Robert Wise, 1965). The creative journey from the university into the studios was firmly established by

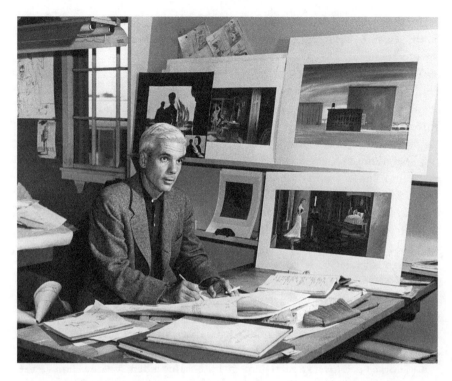

Figure 50. Alfred
Hitchcock's
production designer
and architect Robert
Boyle at work, ca.
1955. (Photofest)

1936, when USC incorporated courses on production design in the curriculum, including "The Technique of the Art Director," taught by Dr. Eugene G. Steinhof.[55]

One of Hitchcock's most notable production designers, Robert Boyle, represents the path of architects graduating into the profession in the early years of the 1930s, when "not only was the pay at the studios traditionally better than at architectural offices, but during the darkest days of the Depression, it was the *only* pay available."[56] Boyle was a member of the Delta Sigma Phi fraternity as a junior at USC and considered an "outstanding campus leader" at his election as president of the class.[57] After graduating from USC, Boyle immediately obtained a position with an architectural firm. When that firm went bankrupt after a month, he began work with another firm, and then another. He "worked for three architects in a period of about three months, all of whom went broke." In need of ready money, Boyle picked up parts as "bit players and extras in films" to make ends meet. While wait-

ing for his screen time at RKO, he realized the studios might need people to sketch up the sets surrounding him. According to Boyle, he went directly to the office of the supervising art director, Van Nest Polglase, who sent him to Wiard Ihnen at Paramount to look for work. Interestingly, in 1940 Ihnen married costume designer Edith Head, who worked closely with Hitchcock on eleven of his American films and famously dressed leading ladies Grace Kelly, Kim Novak, and Tippi Hedren. Three days after their meeting, Boyle reported to Paramount to work under Ihnen and supervising art director Hans Dreier.[58] In Boyle's own words, "I went to work, and I never looked back." As for Dreier, Boyle noted: "We had a wonderful intellectual in [him], more so than Cedric Gibbons and all the rest of them in town. Hans Dreier was more of a realist. He was a strong force who gathered together some oddball characters for art directors. A lot of his people at Paramount were architects like Wiard himself and Robert Odell, but some of the best ones were fine artists like Robert Usher."[59]

Boyle collaborated with Hitchcock on several of his midcentury films, including *Saboteur, Shadow of a Doubt, The Birds,* and *Marnie,* and stated that "my most productive years in film were with Hitchcock." During his work with Hitchcock, Boyle was not restricted to one role and was able to bring a range of talents to the production; he illustrated, drafted, and supervised on set. Hitchcock also asked Boyle to complete storyboards.[60]

Boyle developed his own methodology for creating a film, looking through the lens of an architect turned production designer and art director. He started with a focused analysis of the script, writing, "I read the script and very often make quick studies—little sketches—sometimes on the page opposite the one I'm reading." He then imagined bodies in motion inside the filmic space, paired with an observation of the tone of the scene. He referred to this practice as an "italicized" treatment, such as "italicized loneliness." This was a direct reference to the "parenthetical" or "action" lines in a screenplay that clue in actors to the emotion of a scene and assist in the language of the film.[61] Boyle also used art as a touchstone during his creative process. In his designs for *The Birds,* he kept a vision of *The Scream* in mind, a surrealist icon of modern art depicting a distorted figure experiencing a mental schism, completed in 1893 by Edvard Munch.[62]

After Boyle's sketches were completed, the illustrators and set designers went to work, laying out graphics, miniatures, and matte paintings. Albert Whitlock, a master matte painter, elaborated on architectural concepts first imagined by Boyle

and prepared the scene for film. In one example, Boyle mentioned that the set designer constructed only the door of a mansion, a building that would be too expensive to build in its entirety, and then Whitlock added "his own special flavor to it," improving the appearance of the overall building as an illustrated set piece.[63] In the finished film, the set and illustration merge as one image for the audience.

Despite the number of architects in the studios, Boyle believed that his training as an architect did not impact his career as a production designer. In an interview, he maintained:

> Except for a basic sense of structure, there's nothing you find in school that really prepares you for production design any more than studying a course in literature is exactly what you need to become a screenwriter. You have to take the skills you collect along the way and adapt them to the whole collaborative art of filmmaking, which is all dependent upon one thing: that script. We're creating a physical environment. I have to say physical environment rather than architecture or background or sets; it's a total physical environment that interprets the script. What you're doing is designing spaces for action; that's what we're really trying to do.[64]

In a similarly toned discussion, Boyle drove home the point: "There really is nothing that you're going to learn in a school to prepare you to build a cardboard shack under an overpass in a modern urban setting. You don't learn that in school, but you learn it because you go to see how the homeless live." But, he continued, "even in a homeless cardboard carton there's a sense of structure, so your architectural background plays on that."[65]

Architects working as art directors in film were not only design masters in their industry. They also maintained a firm grasp on the concepts of storytelling, depicting details of personality, character arcs, and layers of a story in a visual medium. Boyle asserted that the environment of the scene "has to indicate the kind of world" the character is in, "whatever that world is depends on the script," he noted. Boyle plotted out the sequences and then worked closely with the director to fulfill the overall vision for the movie, noting the collaborative nature of creating a film: "I don't care how many auteurs there are around. Let them try it on their own; they can't. You need a space that's designed for this particular project," a task particularly suited to architects.[66]

HITCHCOCK AS ARCHITECT

Hitchcock's mid-twentieth-century films invite repeated viewing and analysis as part of a course of discovery, providing a path for deconstructing architectural relationships and exposing visual metaphors between humans and design. In *The Wrong House: The Architecture of Alfred Hitchcock,* author Steven Jacobs posits the "absurd premise that all the important buildings in his films are designed by one and the same architect," who is Hitchcock himself. He describes the director as a "chameleon who excelled in a wide variety of architectural styles" within the position of master planner for a universe of stories.[67] Hitchcock did have experience with drafting and blueprints, working briefly "as a draughtsman in an engineer's office" before his movie career, but he was never formally trained in crafting buildings for occupancy.[68] Yet Hitchcock developed into a creative architectural designer on film, bringing buildings, cities, landmarks, and landscapes to life for an eager worldwide audience. Through creative production design, lighting, cinematography, and storytelling, Hitchcock highlighted the innate and subconscious "personalities" of buildings as effectively as any architect. Under Hitchcock, the parts of a building represent humanity and all its complications: windows are the eyes into the soul, a stairway is a connecting spine, the basement is a place to hide secrets, and a door permits entry into the subconscious mind. He translated the subtle meanings inherent in our interpretations of architecture and the built environment, a language that we use as a daily part of our vocabulary and interactions but only tacitly acknowledge. Or maybe the perception is solely a product of our imagination. As author Joel Gunz noted, in Hitchcock films "a cup of coffee, a glass of milk, a compass, a cigarette lighter, and especially the camera itself can be just as much a character in a scene as an actor," or a building.[69]

Much of Hitchcock's approach to architecture and film arose from his early work on German silent films during the 1920s. One of his earliest jobs was working as a screenwriter and art director (with Alma Reville advising and Graham Cutts directing) for Universum-Film Aktiengesellschaft (UFA) in Berlin. At that time, the city was heralded as one of the foremost leaders in architectural design in the world, hosting the pioneering work of the Bauhaus design school under the leadership of architect Walter Gropius. Later, Hitchcock earned his first credit as director for *The Pleasure Garden* (1925), a Gainsborough Pictures and Emelka coproduction filmed in Munich.[70] During this period, Hitchcock was "swept away by the controlling style and pictorial mood of German expressionism," as well as the "visual

influence of the Germans." According to Hitchcock biographer Patrick McGilligan, their overall approach was "more architectural, more painstakingly designed, more concerned with atmosphere," with more "shadows and glare, bizarre angles, extreme close-ups, and mobile camera work." When questioned about mentors for the visual style of his work, Hitchcock replied, "The Germans. The Germans."[71] Examining Hitchcock's movies at midcentury through this lens reveals the graphic nature of his approach, one that emphasized architecture by bringing the building dramatically into the scene and most often in conflict with the characters.

The marriage of these inherently creative professions began as a practical exercise but then matured into an impactful process directing the art of storytelling on film. Hitchcock empowered the trained designers on his team to create immersive, building-centric filmic environments. In his cinematic landscapes, architects could release themselves from expectations of designs that worked purely in a practical sense and experiment in hybridizing a fictional environment. An unexpected result of that freedom was an existential circling back in the design world: real-life structures inspired production designers, whose works then spurred the development of new building forms and finishes as the public "increasingly desired to live in a universe just like the one they saw invented for the silver screen."[72]

One of Hitchcock's true contributions as an architect can be attributed to the longevity of the buildings in his films. Buildings in the movies, whether constructed as a studio set, depicted as a matte painting, or recorded on location, are preserved in perpetuity. Rather than falling to the wrecking ball as the result of age or disuse, architecture captured on film perseveres and continues for as long as the movie or series is in circulation. The film director is therefore a type of architect for the people, one who can reach large audiences over successive generations, thereby playing a more comprehensive role "in the reception, criticism and dissemination of architectural ideas" than the more traditional interpretation of the building designer's role.[73]

Uncovering the origin stories of the places represented in Hitchcock's films—including a modernist aerie in a national park, a dilapidated Victorian-era mansion, a worn-out roadside motel, a gleaming downtown skyscraper, and an urban courtyard apartment complex—reveals the key position of buildings and the environment in storytelling traditions, a cinematic screen capture that still resonates today. Hitchcock himself knowingly used film as a communicative device, saying: "One doesn't make a picture . . . merely for the first row in the balcony or for the few seats on the aisle. It would have to be geared toward two thousand seats in the theater.

Because cinema is the greatest known mass medium there is in the world and the most powerful."[74] The goal is to have all people, from around the world, gasp at the same moment, laugh together with the comedy, and follow the narrative whether the spoken language is understood or not. That is the place of architecture within film: as the connective tissue of cultures and of generations.

CONCLUSION

German architect Hugo Häring asserted that "space in film only needs to be unique, singular, designed for one event only, one instance of joyful bliss, one moment of horror."[1] Hitchcock created sets that lasted only a few months and buildings that appeared on-screen for mere moments. Yet he, his architects, and his production designers impacted our cultural landscape as much as any creator of a "real" structure. In the last seventy years, millions of people across the world have experienced Hitchcock's collection of landmark American buildings and absorbed the structures, complete with their own origin stories and histories, into their cultural memory. The buildings never die, speaking from beyond the filmic grave with the same impact as Mrs. Bates in *Psycho* or Madeleine in *Vertigo*. Collectively, Hitchcock's buildings continue to inspire and provide an organic measure of the constantly shifting connection between architectural intent, public reception, and the wider impact of design as a tool for narrators.

The stories that Hitchcock brought to the screen are so powerful and penetrating that succeeding generations are compelled to delve further into these memories, lodged deeply in their psyche, by revisiting actual sites or reinterpreting the cinematic narrative. The Charles Potter School, now famous from its star turn in *The Birds*, was condemned and slated to be demolished before Hitchcock's production team discovered it. Albert Whitlock and Robert Boyle found the boarded-up Italianate structure in Bodega (five miles inland from Bodega Bay where the story is

set) and added the iconic metal jungle gym to host a murder of lurking crows.[2] The birds boldly attacked a group of children as they ran screaming down the hill (see color plate 14). The resulting popularity of the movie saved the distinctive green-and-white painted redwood building, which was originally opened on Halloween night in 1873 and is reputed to be haunted. In 1966, Tom and Mary Taylor purchased the dilapidated building for $10,500 with the intent of making a home and art gallery.[3] The "Bodega Bay School" (as the building was named in *The Birds*) is now a pilgrimage site for fans of the film. In this age of photo sharing, people recreate the terror of a bird attack on the street in front of the building and post the images to their social media accounts.[4] "You are here" they say, or more accurately, you are here with Hitchcock.

The form of and story behind the Bates Mansion is the most frequently interpreted Hitchcock icon, more than sixty years since the release of *Psycho.* The Imagineers at Disneyland Paris styled the "Phantom Manor" (a spookier 1992 version of the original Haunted Mansion at the Anaheim theme park) as a Victorian-era house with a striking resemblance to the home of Norman Bates. And, in 2016, British artist Cornelia Parker used salvaged wood as the primary material of *Transitional Object (PsychoBarn),* a contemporary good-versus-evil artistic statement inspired by noted American architectural idols, including Edward Hopper's *House by the Railroad,* homey red barns, and the Bates Mansion. Parker created the large-scale sculpture for the fourth annual installation of site-specific works commissioned for the Metropolitan Museum of Art's Iris and B. Gerald Cantor Roof Garden in Manhattan. The 30-foot-tall art piece is a scale-model Bates Mansion completed in a three-quarters view, similar to the set constructed at the Universal lot in Southern California, to deliberately reveal the scaffold structure supporting the facade. The model was featured on the museum's roof garden for the summer and then set off for a tour of the globe. A *Los Angeles Times* critic noted that the artwork "evokes the creepiness of the 'Psycho' movie while nodding to a symbol of corn-fed Americana." She acknowledged that "Art may be weird. But it's hard to outweird Hollywood—Hitchcock—on this one."[5] The faded red Bates Mansion, set against the dramatic backdrop of skyscrapers in Manhattan or the neoclassical elegance of the Royal Academy of Arts' Annenberg Courtyard in London, brings the study of Hitchcock's architecture full circle (see color plate 15).

Defining the audience reaction to and absorption of an architectural trigger point is difficult to articulate. What is happening in your mind when you experience a building on film? When you watch a movie, your perception of the images

on the screen are immediate, but your interpretation is based on an amalgamation of personal experiences, sensory cues, memories, and impressions. In *Welcome to Your World: How the Built Environment Shapes Our Lives,* Sarah Williams Goldhagen compares the subliminal effect of architecture (whether experienced in person or in the cinema) to "blindsight," in which the viewer is impacted by something but remains consciously unknowing as to the larger impact. She further classifies the built environment as a "never-ending concatenation" of "primes," or "nonconsciously perceived environmental stimulus that can influence a person's subsequent thoughts, feelings, and responses by activating memories, emotions, and other kinds of cognitive associations."[6]

For example, Hitchcock's frequent focus on windows, doors, hallways, knobs, and hands in his films recall "organism-environment interactions" that our minds rely on to "rapidly and without conscious effort, to navigate, interpret, and make sense of our physical environments and the objects they contain."[7] Hitchcock frequently incorporated architectural elements as metaphors, as in the door-opening sequence in *Spellbound,* inserted at the moment that Dr. Constance Petersen (played by Ingrid Bergman), characterized as a "human glacier," realizes she is in love with the mysterious imposter John Ballantyne (played by Gregory Peck). Literally, her mind is opening as her frigidity thaws; unlocking memories through the science of psychoanalysis is the very foundation of the story.[8] In theory, any filmmaker can reach below this level of our conscious awareness, but a master director (aided by a skilled production team) can propel the audience into a deeper-level experience by relying heavily on our innate tendency to identify schemas and associate those patterns with certain moods and feelings. Who among us has not felt fear when reaching for a doorknob not knowing what might be waiting on the other side of the door? Successful connections and characterizations that resonate with large audiences are eagerly repeated by subsequent filmmakers. This circular confirmation of identity cements a link in our minds between a building type, an associated action, and a conjured sensation.

Architectural memories are further strengthened when paired with real human emotions of love, disgust, happiness, and fear. There is a key difference between interpreting buildings in static arts, such as paintings, and understanding how the public views a building on film, which is more akin to a whole-body experience. Hitchcock's horror movies compel us to viscerally feel the thrill of goosebumps and the terror of an adrenaline-fueled heartbeat even though we know intellectually that we are not in immediate, physical danger. This brush with real fear, followed

quickly by the fresh breath of survival, is energizing. Hence the refrain "let's do it again!" heard so often in amusement parks and movie palaces. Writers often note with astonishment the photographs showing people laughing as they leave the theater after watching *Psycho*. Hitchcock frequently referred to this compulsion in his many press and magazine interviews, noting that "people enjoy danger when they have the subconscious realization that it is only temporary." But the director knew exactly how much an audience could take, adding that "at the end you have to relieve them of the fear and suspense. That is absolutely essential."[9] This blood-rush of living through a terrifying experience brought people back to the theater again and again, alternately screaming and laughing.

Analyzing building histories and the larger meanings implied and stated within film is a relatively recent endeavor. Spanish historian Juan Antonio Ramírez was one of the first to develop a new method of architectural analysis in his 1986 book *La arquitectura en el cine: Hollywood, la Edad de Oro:* "I proclaim that no longer may the historian treat movie architecture, itself the inanimate vehicle of symbolic cultural messages, as something of only marginal or secondary interest. Even though gloriously 'fictitious,' far from being a mere curiosity, movie architecture proves absolutely fundamental for an understanding of just what has transpired (and continues to happen) in contemporary design—even within contemporary life itself."[10] Writing from Spain, Ramirez observed that our modern world "is not that of the Roman aqueducts or medieval cathedrals: for us, nothing is solid; nothing endures." He cites American cycles of erection and demolition in a culture that "change[s] their buildings like seasonal fashions." In the United States, "where a bookstore or church once stood, a parking lot or skyscraper is erected. A rundown street is transformed into a shopping center overnight." Rather than express shock, however, Ramírez instead acknowledges the place of Hollywood and film, an industry "in a perpetual process of transformation" that anticipated this cycle of building up and tearing down "long ago in the back lots of film studios, with their multitude of fragmentary buildings, half-constructed and half-ruined." In life as in film, the only thing that remains is a "visual memory of things once seen and [that] have the evocative power of the experiences perhaps once actually lived there."[11]

Ramírez classified his approach as "a sort of cultural revisionism" at that time. His work investigated architectural manipulation as a purposeful endeavor, a methodology that contrasted with previous studies that treated filmic settings as an "inanimate vehicle of symbolic cultural messages." He identified film images of buildings and landscapes accompanied by the "complex and disparate emotions" of

the accompanying cinematic narrative as uniquely capable of working "powerfully in our collective unconscious."[12] Filmic architecture, more fully preserved than real-life counterparts in many cases, "carries the present into the past—and vice versa," transcending "historical trends and styles, nicely destroying any linear conception of history."[13]

Architectural impressions are indeed persistent, penetrating, and can be passed from one generation to the next. Understanding this communal reaction to architecture, and the embrace or rejection of certain types of structures, can enhance how we interpret and understand buildings and their intersections with the art of film. Deconstructing these singular moments when a building is portrayed in a powerful film leads to a more informed, contextual understanding of the metaphysical structure of architecture, human motivation, and the people themselves.[14] Studying architecture within popular films can also serve as "a gateway to our understanding the interweaving of the multivariate histories," or better yet as a "Portal of the Past" that enhances our perceptions of both the story and the setting, as noted by Hitchcock historian Douglas Cunningham.[15] In the simplest sense, the film industry and its "architecture" embody the idea of "physical impermanence and emotional transience," which relates to the wave of change as generation after generation makes their own mark on the cultural landscape.

These perceptions are constantly shifting, particularly with access to video-on-demand or "streaming" (introduced by Amazon in 2006), which allows for multiple viewings and provides an unending flow of interpretive tributaries. Streaming accommodates the rerelease of any number of classic films that were previously held in the archival vaults of major studios and shown rarely after their debut year. For example, Robin Wood, author of *Hitchcock's Films Revisited,* included an apologia in his 1989 book that "at the time of writing no copy of *Rear Window* is available in this country, either for public or private viewing." Wood was limited to basing his observations on a "three-year old memory and a few notes scribbled in the cinema."[16] Thankfully, those boundaries no longer restrict our study and enjoyment of significant cinematic works.

Alfred Hitchcock predicted his own cultural longevity when he said, "I warn you, I mean to go on forever."[17] Hitchcock was a master, a "complete film-maker," and "all-round specialist, who excels at every image, each shot, and every scene." He was one of those rare filmmakers who masterminded "the construction of the screenplay as well as the photography, the cutting, and the sound track," and, basically, could figure out and handle anything and everything in the realm of film

creation.[18] Even with all that in hand, he still found time to read scripts and pose for photographs at his home at the Bel Air Country Club, a quiet and serene architectural getaway from the buildings he featured in his films (see color plate 16). At his death in April 1980, Hitchcock had completed fifty-four films in fifty-one years, a remarkable accomplishment. His creative period spanned from 1925 through 1976, beginning in the silent-film era and crossing boldly into the space age.[19]

The impact of Hitchcock's work is visibly imprinted within the creative approach of many notable writers, directors, and producers. The better question might be, Where do we not see the impact of Hitchcock? Homages to his method, his visual style, and the cumulative talents of his team (including lighting, cinematography, scoring, and screenwriting) abound in television and film through a long line of productions—from television to "B" movies to summer blockbusters—more than forty years after his last film was released. New biographical books and films about Hitchcock's work continue to emerge. Hitchcock, like novelist Edgar Allan Poe or entrepreneur storyteller Walt Disney, is one of those rare creators whose work overflows with narrative complexities that engage and fascinate audiences for generations.

Hitchcock did develop at least one storytelling concept that was never executed during his lifetime. This documentary concept captures his unique vision of the world and life within it. He described the project at length to biographer Truffaut:

> One idea, for instance, is that I'd like to do twenty-four hours in the life of a city, and I can see the whole picture from beginning to end. It's full of incidents, full of backgrounds, a complete cyclic movement. It starts out at five A.M., at daybreak, with a fly crawling on the nose of a tramp lying in a doorway. Then, the early stirrings of life in the city. I'd like to try to do an anthology on food, showing its arrival in the city, its distribution, the selling, buying by people, the cooking, the various ways in which it's consumed. What happens to it in various hotels; how it's fixed up and absorbed. And, gradually, the end of the film would show the sewers, and the garbage being dumped out into the ocean. So there's a cycle, beginning with the gleaming fresh vegetables and ending with the mess that's poured into the sewers. Thematically, the cycle would show what people do to good things. Your theme might almost be the rottenness of humanity. You could take it through the whole city. Look at everything, film everything, and show all of that.[20]

THE ARCHITECTURE OF SUSPENSE

Truffaut wrapped up the story of Hitchcock's life after Alfred's burial on May 2, 1980. He noted the long-term impact of cinema, and of Hitchcock's legacy: "The man was dead, but not the film-maker. For his pictures, made with loving care, an exclusive passion, and deep emotions concealed by exceptional technical mastery, are destined to circulate throughout the world, competing with newer productions, defying the test of time, and confirming Jean Cocteau's image of Marcel Proust: 'His work kept on living, like the watches on the wrists of dead soldiers.'"[21]

Luckily, my own life and Hitchcock's overlapped by a decade. I rediscovered my fascination with his work at a pivotal moment in my professional development and followed a new, unexplored path into history. Repeated viewings of his movies helped me recognize this ability to pair a building with an emotional response, a distinctive approach for discovering and interpreting American architecture. This intellectual epiphany also released ideas and stories that had circulated in my mind for years. With that, I was compelled to also pursue screenwriting as another creative way to express my ideas about architecture, life, and the way that buildings can hold memories, carry on traditions, and tie generations together.

As a historic preservationist and architectural historian, I mourn the buildings that we have lost. Rest in peace for these significant structures that are gone forever, including Pennsylvania Station in New York City designed by McKim, Mead, and White (1910–63) and featured in Hitchcock's *Strangers on a Train;* the Prentice Women's Hospital Building by Bertrand Goldberg & Associates (1975–2014); and the Gettysburg National Military Park Cyclorama and Visitor Center in Pennsylvania by Richard Neutra (1962–2013), which I defended passionately for fifteen years before its demolition. I felt physical pain watching the erasure of other structures that represented the life and love of incredible people, such as Ray Bradbury's house in Cheviot Hills, California, demolished without regret by the current owner of the property. I interviewed Mr. Bradbury there in 2010 and listened intently as he explained his concept of "lostness," or the art of intentional exploring without a map or a guide to lead you. He helped me see how the application of that philosophy, paired with fearless curiosity and a sense of adventure, could lead to the discovery of new worlds, places, and ideas, even in my own backyard or within my own mind.

There remain many areas to explore regarding Hitchcock's immediate influence and long-term impact in filmic and cultural contexts including the role of African Americans (and their notable absence) in his works, and the prominence of women and the LGBTQ community in his successful career. So, we continue our

intellectual excavations. Each subsequent generation must return to his films and watch them from their own perspective, guided perhaps by our books and articles, but always with fresh eyes. These queries and observations bring more intelligent analysis to the table and add to the cinematic lore of the director's oeuvre. In this way, we can watch as his stories shift and develop through time. It is an honor to participate in this lineage of interpretations.

I want to end this book with a celebration of victories, when people came together to protect and save a building that represents community in all its manifestations, whether in real life or on film. There is so much to be thankful for, such as the moving and restoration of the historic Capen House in Winter Park, Florida; the relocation of gracious old mansions from throughout the city to Heritage Square in Los Angeles; the salvation of the modernist Santa Fe Bank in Palm Springs, California, renewed and reopened as the Palm Springs Architecture and Design Center Edwards Harris Pavilion; and the preservation of Richard Neutra's Painted Desert Community Complex and visitor center at Petrified Forest National Park in Arizona, the sister building to the Cyclorama at Gettysburg. In these movements, and in the movies, I discovered the spirit of architecture—a spirit that is hopeful, energized, and emblematic of our common human experience.

APPENDIX A

Table of Motels Listed in Research Notes for
Psycho, 1959

Preproduction for *Psycho* included the identification of stylistic models for the Bates Motel. These eighteen sites in California, with room rates between five and twelve dollars per night, represent the type of establishment that Marion would encounter during her run from the law (Research Department, "For PSYCHO, Hotels near Redding, Red Bluff, and Fairfield, California from Automobile Club of Southern California's Southwest Tour Book. 1959–60," Margaret Herrick Library of the Academy of Motion Picture Arts and Sciences, Beverly Hills, CA).

REDDING

California Motel, 2.5 miles S on U.S. 99
Capri Motel, 2.5 miles S on U.S. 99
Cascade Motel, 2 miles S on U.S. 99
English Villa Motel, 1 mile S on U.S. 99
Hacienda Motel, 0.5 mile S on U.S. 99
Manhattan Motel, 0.75 mile S. on U.S. 99
Mark's Motel, 1.5 miles S on U.S. 99
Monterey Motel, 1 mile S on U.S. 99
North Gate Lodge, North edge of town on U.S. 99

Shasta Dam El Rancho Motel, 7 miles N on U.S. 99
Town House Lodge, 1 mile S on U.S. 99

RED BLUFF

Crystal Motel, 1 mile S on U.S. 99
Mount Lassen Motel, Edge of town on U.S. 99
Red Bluff Travelodge, N edge of town on U.S. 99
Sky Terrace Motel, 0.5 mile S on U.S. 99
Triangle Motel, 1.5 mile S on U.S. 99

FAIRFIELD

Fairfield Motor Inn, 1120 Texas Street.
New Solano Motel, 1700 N. Texas Street. Now known as the Solano Lodge
 Motel and Mobile Park

APPENDIX B

Alfred Hitchcock's Thirty Major American Films

1940: *Rebecca* (Selznick International Pictures, United Artists); *Foreign Correspondent* (Walter Wanger Productions, United Artists)

1941: *Mr. & Mrs. Smith* (RKO Radio Pictures); *Suspicion* (RKO Radio Pictures)

1942: *Saboteur* (Frank Lloyd Productions, Universal Pictures)

1943: *Shadow of a Doubt* (Universal Pictures)

1944: *Lifeboat* (Twentieth Century Fox)

1945: *Spellbound* (Selznick International Pictures, Vanguard Films, United Artists)

1946: *Notorious* (Vanguard Films, RKO Radio Pictures)

1947: *The Paradine Case* (Vanguard Films, Selznick International Pictures)

1948: *Rope* (Transatlantic Pictures, Warner Brothers)

1949: *Under Capricorn* (Transatlantic Pictures, Warner Brothers)

1950: *Stage Fright* (Warner Brothers)

1951: *Strangers on a Train* (Warner Brothers)

1953: *I Confess* (Warner Brothers)

1954: *Dial M for Murder* (Warner Brothers); *Rear Window* (Alfred J. Hitchcock Productions, Paramount Pictures)

1955: *To Catch a Thief* (Paramount Pictures); *The Trouble with Harry* (Alfred J. Hitchcock Productions, Paramount Pictures)

1956: *The Man Who Knew Too Much* (Filwite Productions, Paramount Pictures); *The Wrong Man* (Warner Brothers)

1958: *Vertigo* (Paramount Pictures)

1959: *North by Northwest* (Metro-Goldwyn-Mayer)

1960: *Psycho* (Shamley Productions, Paramount, filmed at Universal Pictures)

1963: *The Birds* (Alfred J. Hitchcock Productions, Universal Pictures)

1964: *Marnie* (Alfred J. Hitchcock Productions, Universal Pictures)

1966: *Torn Curtain* (Alfred J. Hitchcock Productions, Universal Pictures)

1969: *Topaz* (Alfred J. Hitchcock Productions, Universal Pictures)

1972: *Frenzy* (Alfred J. Hitchcock Productions, Universal Pictures)

1976: *Family Plot* (Alfred J. Hitchcock Productions, Universal Pictures)

APPENDIX C

Fifty Films to Watch

The following is a list of films that portrayed buildings and places as characters or served as sources for this study of architecture and film. These movies range from 1925 through 2021, from small stories to spectacular Hollywood productions with a heavy dose of horror and haunted houses. Each film is listed by title, director, production company or distributor, and year of release. There are many more wonderful works on my personal list, but this is a good place to start the journey. For fun, I have included *Two Weeks Notice,* a historic preservation love story.

Alien, directed by Ridley Scott. Los Angeles: Brandywine Productions, 1979.

The Amityville Horror, directed by Stuart Rosenberg. Beverly Hills: Metro-Goldwyn-Mayer (MGM), 1979.

The Babadook, directed by Jennifer Kent. Ultimo, NSW, Australia: Screen Australia, 2014.

The Big Lebowski, directed by Joel Coen. Los Angeles: Polygram Filmed Entertainment, 1998.

The Black Cat, directed by Edgar G. Ulmer. Universal City, CA: Universal Pictures, 1934.

Blade Runner, directed by Ridley Scott. Los Angeles: Warner Brothers, 1982.

Body Double, directed by Brian De Palma. Los Angeles: Columbia Pictures, 1984.

Candyman, directed by Bernard Rose. Los Angeles: TriStar Pictures, 1992.

Catch Me If You Can, directed by Steven Spielberg. Los Angeles: Dream-Works, 2002.

Charlie's Angels, directed by McG. Los Angeles: Columbia Pictures, 2000.

The Conjuring, directed by James Wan. Los Angeles: New Line Cinema, 2013.

Crimson Peak, directed by Guillermo del Toro. Universal City, CA: Universal Pictures, 2015.

Dawn of the Dead, directed by George A. Romero. Los Angeles: Laurel Group, 1978.

Diabolique, directed by Henri-Georges Clouzot. Paris, France: Filmsonor, 1955.

Dracula, directed by Tod Browning. Universal City, CA: Universal Pictures, 1931.

The Evil Dead, directed by Sam Raimi. Beverly Hills: Renaissance Pictures, 1981.

The Fountainhead, directed by King Vidor. Los Angeles: Warner Brothers, 1949.

Get Out, directed by Jordan Peele. Universal City, CA: Universal Pictures, 2017.

Ghost in the Shell, directed by Mamoru Oshii. Tokyo: Kôdansha, 1995.

Gonjiam: Haunted Asylum, directed by Beom-sik Jeong. Seoul, South Korea: Hive Media Corp., 2018.

The Grand Budapest Hotel, directed by Wes Anderson. Century City, CA: Fox Searchlight Pictures, 2014.

The Haunting, directed by Robert Wise. United Kingdom: Argyle Enterprises, 1963.

Hereditary, directed by Ari Aster. New York: A24, 2018.

High-Rise, directed by Ben Wheatley. London: HanWay Films, 2015.

Horror Castle, directed by Antonio Margheriti. Rome, Italy: Atlantica Cinematografica Produzione Films, 1963.

House on Haunted Hill, directed by William Castle. Los Angeles: William Castle Productions, 1959.

Koyaanisqatsi, directed by Godfrey Reggio. San Francisco: American Zoetrope, 1982.

L.A. Confidential, directed by Curtis Hanson. Los Angeles: Regency Enterprises, Warner Brothers, 1997.

The Lighthouse, directed by Robert Eggers. New York: A24, 2019.

Los Angeles Plays Itself, directed by Thom Andersen. New York: Thom Andersen Productions, 2003.

Metropolis, directed by Fritz Lang. Berlin: Universum-Film, 1927.

Neutra: Survival through Design, directed by P. J. Letofsky. Los Angeles: Newcastle Productions, 2019.

The Old Dark House, directed by James Whale. Los Angeles: Universal Studios, 1932.

The Others, directed by Alejandro Amenábar. Los Angeles: Miramax, 2001.

Parasite (original title *Gisaengchung*), directed by Bong Joon Ho. Seoul, South Korea: CJ Entertainment, 2019.

The Phantom of the Opera, directed by Rupert Julian. University City, CA: Universal Studios, 1925.

Poltergeist, directed by Tobe Hooper. Beverly Hills: Metro-Goldwyn-Mayer (MGM), 1982.

Psycho II, directed by Richard Franklin. University City, CA: Universal Pictures, 1983.

Rec, directed by Jaume Balagueró and Paco Plaza. Barcelona, Spain: Castelao Producciones, 2007.

Rosemary's Baby, directed by Roman Polanski. Los Angeles: William Castle Productions, 1968.

The Shining, directed by Stanley Kubrick. Los Angeles: Warner Brothers, 1980.

78/52: Hitchcock's Shower Scene, directed by Alexandre O. Philippe. New York: Exhibit A Pictures, 2017.

Suspiria, directed by Dario Argento. Rome, Italy: Produzioni Atlas Consorziate (PAC), 1977.

A Tale of Two Sisters (original title *Janghwa, Hongryeon*), directed by Jee-woon Kim. Seoul, South Korea: B.O.M. Film Productions Co., 2003.

The Texas Chainsaw Massacre, directed by Tobe Hooper. Los Angeles: Vortex, 1974.

Touch of Evil, directed by Orson Welles. University City, CA: Universal International Pictures, 1958.

2001: A Space Odyssey, directed by Stanley Kubrick. Beverly Hills: Metro-Goldwyn-Mayer, (MGM), 1968.

Two Weeks Notice, directed by Marc Lawrence. Los Angeles: Castle Rock Entertainment, 2002.

Visual Acoustics, directed by Eric Bricker. New York: Arthouse Films, 2008.

The Wailing (original title *Gokseong*), directed by Na Hong-jin. Los Angeles: 20th Century Fox, 2016.

NOTES

INTRODUCTION

1. Jonathan Freedman and Richard H. Millington, *Hitchcock's America* (New York: Oxford University Press, 1999), 6.

2. Dietrich Neumann, *Film Architecture: Set Designs from "Metropolis" to "Blade Runner"* (New York: Prestel, 1999), 7.

3. Neumann, *Film Architecture,* 8.

4. Alfred Hitchcock, quoted in Truffaut, *Hitchcock,* 123.

5. William Rothman, *Hitchcock: The Murderous Gaze* (Cambridge, MA: Harvard University Press, 1982), 248.

6. Reyner Banham, *Age of the Masters: A Personal View of Modern Architecture* (1962; repr., New York: Harper and Row, 1975), 3.

7. Paul Goldberger, *Why Architecture Matters* (New Haven, CT: Yale University Press, 2009), 159.

8. Freedman and Millington, *Hitchcock's America,* 10.

9. Steven Jacobs, *The Wrong House: The Architecture of Alfred Hitchcock* (Rotterdam: Nai010, 2013), 15, 41.

10. Douglas A. Cunningham, ed., *Critical Insights: Alfred Hitchcock* (Ipswich, MA: Salem, 2016), vii.

11. The Internet Movie Database (IMDb) operates as a subsidiary of Amazon. *IMDb,* http://www.imdb.com.

12. Stanley Kubrick, quoted in Alison Castle, *The Stanley Kubrick Archives* (Cologne, Germany: Taschen, 2008), 344.

1. ALFRED HITCHCOCK'S AMERICAN EXPERIENCE

1. "U.S. Prize for a British Film," *Observer* (London), January 8, 1939, 9.

2. François Truffaut, *Hitchcock* (New York: Simon and Schuster, 1983), 121.

3. "Hitchcock Coming for Hollywood Job," *Brooklyn Daily Eagle,* March 6, 1939, 9.

4. Patrick McGilligan, *Alfred Hitchcock: A Life in Darkness and Light* (New York: Harper Perennial, 2003), 234.

5. Geoffrey T. Hellman, "Alfred Hitchcock: England's Best and Biggest Director Goes to Hollywood," *Life,* November 20, 1939, 33, 38. Joan Harrison also produced Hitchcock's later television series *Alfred Hitchcock Presents* from 1955 to 1962.

6. Hitchcock, quoted in Truffaut, *Hitchcock,* 125.

7. Vachel Lindsay, *The Art of the Moving Picture* (New York: Macmillan, 1915), 223.

8. Lindsay, *The Art of the Moving Picture,* 218.

9. McGilligan, *Alfred Hitchcock,* 7.

10. McGilligan, *Alfred Hitchcock,* 15.

11. McGilligan, *Alfred Hitchcock,* 16.

12. Hitchcock, quoted in Truffaut, *Hitchcock*, 125.

13. McGilligan, *Alfred Hitchcock,* 25.

14. McGilligan, *Alfred Hitchcock,* 27.

15. McGilligan, *Alfred Hitchcock,* 50–51.

16. Donald Spoto, *The Dark Side of Genius: The Life of Alfred Hitchcock* (Boston: Little, Brown, 1983), 65.

17. McGilligan, *Alfred Hitchcock,* 58.

18. McGilligan, *Alfred Hitchcock,* 69, 81.

19. Alfred Hitchcock, quoted in Stephen Witty, *The Alfred Hitchcock Encyclopedia* (New York: Rowman and Littlefield, 2016), 363.

20. Edwin Schallert, "'Jazz Singer' Is Landmark," *Los Angeles Times,* December 30, 1927, 11.

21. Louella O. Parsons, "Jolson's 'Jazz Singer' Blends Film and Voice to Suit Severest Critic," *San Francisco Examiner,* February 12, 1928, 6E.

22. Robert F. Sisk, "Jazz Singer Effective, Says Critic," *Baltimore Sun,* October 16, 1927, 54.

23. "New Year to Bring Progress," *Los Angeles Times,* January 22, 1928, 53.

24. McGilligan, *Alfred Hitchcock,* 131.

25. Peter Ackroyd, *Alfred Hitchcock: A Brief Life* (New York: Doubleday, 2015), 46.

26. McGilligan, *Alfred Hitchcock,* 148.

27. McGilligan, *Alfred Hitchcock,* 149.

28. Edwin Schallert, "World Celebrities Start New Surge to Southland," *Los Angeles Times,* August 6, 1933, pt. 2, pp. 1–2.

29. Paul Jordan-Smith, "New Forces Lure Working Writers," *Los Angeles Times,* August 6, 1933, pt. 2, p. 2.

30. McGilligan, *Alfred Hitchcock,* 150.

31. Hellman, "Alfred Hitchcock: England's Best and Biggest Director Goes to Hollywood," 43–44.

32. McGilligan, *Alfred Hitchcock,* 4.

33. "Latest Murder Pitch from Hitch," *Life,* July 13, 1959, 70.

34. Martin Kane, "Film Director's Diet Purely for Enjoyment," *San Bernardino County Sun,* March 11, 1939, 4.

35. Ackroyd, *Alfred Hitchcock: A Brief Life,* 74.

36. "Alfred Hitchcock Presents: The Great Hitchcock Murder Mystery," *This Week Magazine, Des Moines Register,* August 4, 1957, 8–9.

37. *Life* magazine advertisement, *Detroit Free Press,* June 7, 1960, 20.

38. "Through His Eyes," *Newsday* (New York), March 8, 2006, A34.

39. "Phantom Face in the Foliage," *Life,* July 11, 1960, 54.

40. "How Hitchcock Lives (a Surprise)," *Wisconsin State Journal,* September 25, 1960, 69.

41. Peter J. Boyer, "Master of Film Suspense Dies Peacefully at 80," *Santa Cruz Sentinel,* April 30, 1980, 40.

42. McGilligan, *Alfred Hitchcock,* 234.

43. Hitchcock, quoted in Truffaut, *Hitchcock,* 102.

44. Will Schmenner and Corinne Granof, *Casting a Shadow: Creating the Alfred Hitchcock Film* (Evanston, IL: Northwestern University Press, 2007), 17.

45. Luis Buñuel, "Metropolis," 1927, in *Metropolis, un film de Fritz Lang* (Paris: Cinémathèque Française, 1985), 15, quoted in Dietrich Neumann, *Film Architecture: Set Designs from Metropolis to Blade Runner* (New York: Prestel, 1999), 8.

46. Vincent LoBrutto, *By Design: Interviews with Film Production Designers* (London: Praeger, 1992), 12.

47. Schmenner and Granof, *Casting a Shadow,* 17.

48. Steven DeRosa, *Writing with Hitchcock* (New York: Faber and Faber, 2001; CineScribe Media, 2011), 6.

49. Sidney Gottlieb, *Hitchcock on Hitchcock: Selected Writings and Interviews* (Berkeley: University of California Press, 1995), xiii.

50. Gottlieb, *Hitchcock on Hitchcock,* xiii–xiv.

51. Gottlieb, *Hitchcock on Hitchcock,* xv.

52. Hitchcock, quoted in Truffaut, *Hitchcock,* 195.

53. Henry Fonda, quoted in Boyer, "Master of Film Suspense."

54. LoBrutto, *By Design,* 11.

55. Rita Riggs, quoted in Stephen Rebello, *Alfred Hitchcock and the Making of "Psycho"* (New York: Dembner, 1990), 99.

56. Truffaut, *Hitchcock,* 17.

57. Hitchcock, quoted in Truffaut, *Hitchcock,* 87.

58. Truffaut, *Hitchcock,* 15.

59. Alison Castle, *The Stanley Kubrick Archives* (Cologne, Germany: Taschen, 2008), 288.

60. Spoto, *The Dark Side of Genius,* 573–78.

61. Colin Bennett, "At the Cinema: Welcome Return to Vintage Hitchcock," *The Age* (Melbourne, Australia), December 5, 1959, 19.

62. Boyer, "Master of Film Suspense."

63. Ackroyd, *Alfred Hitchcock: A Brief Life,* 88.

64. Martin Kane, "Film Director's Diet Purely for Enjoyment," *San Bernardino County Sun,* March 11, 1939, 4.

65. Truffaut, *Hitchcock,* 61.

66. Lindsay, *The Art of the Moving Picture,* 161.

67. Rothman, *Hitchcock: The Murderous Gaze,* 6–7.

68. Geoffrey T. Hellman, "Alfred Hitchcock: England's Best and Biggest Director Goes to Hollywood," *Life,* November 20, 1939, 39.

69. "$5,000 Production: Hitchcock Makes Thriller under WPB Order on New Sets," *Life,* January 25, 1943, 70–78.

70. Hitchcock, quoted in Lawrence Howe, "Through the Looking Glass: Reflexivity, Reciprocality, and Defenestration in Hitchcock's 'Rear Window,'" *College Literature* 35, no. 1 (2008): 16–37, http://www.jstor.org/stable/25115476.

71. Rothman, *Hitchcock: The Murderous Gaze,* 13.

72. George Tomasini, "Biography," http://www.imdb.com/name/nm0866462/; Robert Burks, "Biography," https://www.imdb.com/name/nm0122079/?ref_=fn_al_nm_1.

73. Rothman, *Hitchcock: The Murderous Gaze,* 6–7.

74. Rothman, Hitchcock: *The Murderous Gaze,* 6.

75. Truffaut, *Hitchcock,* 319.

76. Truffaut, *Hitchcock,* 15.

77. Hitchcock, quoted in Truffaut, *Hitchcock,* 260.

78. Rothman, *Hitchcock: The Murderous Gaze,* 35.

79. Truffaut, *Hitchcock,* 20.

80. Ackroyd, *Alfred Hitchcock: A Brief Life,* 88.

81. Rothman, *Hitchcock: The Murderous Gaze,* 35.

82. Alfred Hitchcock, quoted in McGilligan, *Alfred Hitchcock,* 86.

83. Hitchcock, quoted in Truffaut, *Hitchcock,* 48.

84. Truffaut, *Hitchcock,* 158.

85. Boyer, "Master of Film Suspense," 40.

86. Spoto, *The Dark Side of Genius,* 370.

87. Robert Phillip Kolker, *Alfred Hitchcock's Psycho: A Casebook* (Oxford: Oxford University Press, 2004), 31–32.

88. McGilligan, *Alfred Hitchcock,* 581.

89. Boyer, "Master of Film Suspense."

90. Spoto, *The Dark Side of Genius,* 373.

91. Spoto, *The Dark Side of Genius,* 370.

92. Boyer, "Master of Film Suspense."

93. Truffaut, *Hitchcock,* 11, 15.

94. Stanley Kauffmann, "North by Northwest," *New Republic,* August 10, 1959, 23.

95. Kauffmann, "North by Northwest."

96. Whitney Balliett, "Hitchcock on Hitchcock," *New Yorker,* August 8, 1959, http://www .newyorker.com/magazine/1959/08/15/hitchcock-on-hitchcock.

97. Vernon Young, *On Film: Unpopular Essays on a Popular Art* (Chicago: Quadrangle, 1972), 261, 293.

98. Marc Shapiro, "The Potential Bomb That Became 'Psycho,'" *St. Louis Post-Dispatch,* July 8, 1990, 3C, 13C.

99. Truffaut, *Hitchcock,* 247.

100. "*Vertigo* Edges out *Kane,*" *Los Angeles Times,* August 2, 2012, D2; "The 100 Greatest Films of All Time," Sight and Sound Contributors, *Sight and Sound,* British Film Institute, September 8, 2020, https://www2.bfi.org.uk/greatest-films-all-time.

101. Herbert Brean, "Master of Suspense Explains His Art," *Life,* July 13, 1959, 72.

102. Gottlieb, *Hitchcock on Hitchcock,* xvi.

103. Stephen King, *Danse Macabre* (New York: Gallery, 1981), 148.

104. Eric Rohmer and Claude Chabrol, quoted in Truffaut, *Hitchcock,* 17.

105. Hitchcock, quoted in Truffaut, *Hitchcock,* 85.

106. Hitchcock, quoted in Truffaut, *Hitchcock,* 103.

2. THE VILLAIN'S LAIR

1. Beverly Heisner, *Hollywood Art: Art Direction in the Days of the Great Studios* (London: McFarland, 1990), 287.

2. "Charles D. Hall," http://www.imdb.com/name/nm0355405/.

3. Donald Albrecht, *Designing Dreams: Modern Architecture in the Movies* (New York: Harper and Row in collaboration with the Museum of Modern Art, 1986), 102.

4. "Filmsite Movie Review: *The Black Cat* (1934)," *Filmsite,* n.d., https://www.filmsite.org /blac.html.

5. Heisner, *Hollywood Art,* 287.

6. Albrecht, *Designing Dreams,* 100.

7. Edgar G. Ulmer quoted by Peter Bogdanovich, in "Edgar G. Ulmer," in *Kings of the Bs: Working within the Hollywood System,* ed. Todd McCarthy and Charles Flynn (New York: Dutton, 1975), 389, quoted in Albrecht, *Designing Dreams,* 101.

8. Albrecht, *Designing Dreams,* 101.

9. François Truffaut, *Hitchcock* (New York: Simon and Schuster, 1983), 107.

10. AMPAS Hitchcock f. 544: manuscript draft of an article by Herbert Brean for *Life,* n.d., quoted in James Chapman, *Hitchcock and the Spy Film* (London: I. B. Tauris, 2018), 221.

11. Ernst Lehman, *North by Northwest* shooting script, as quoted in Chapman, *Hitchcock and the Spy Film,* 219–20.

12. Hitchcock, quoted in Truffaut, *Hitchcock,* 107.

13. Patrick McGilligan, *Alfred Hitchcock: A Life in Darkness and Light* (New York: Harper Perennial, 2003), 568.

14. McGilligan, *Alfred Hitchcock,* 529.

15. Hal Boyle, "I Can't Stand Suspense in My Own Life," *Petersburg (VA) Progress-Index,* March 13, 1956, 4.

16. Bob Thomas, "Hitch Enters Black Hills?," *Omaha World Herald,* June 8, 1958, 9F.

17. Peter Ackroyd, *Alfred Hitchcock: A Brief Life* (New York: Doubleday, 2015), 49.

18. Hitchcock quoted in Truffaut, *Hitchcock,* 150.

19. William A. Payne, "Hitchcock—U.S. Tangle," *Dallas Morning News,* August 9, 1959, sec. 5, p. 1.

20. Incensed, "Voice of the People," letter to the editor, *Chicago Daily Tribune,* September 10, 1958, 20.

21. Christine Madrid French, "The Visitor Center as Monument: Recontextualizing Richard Neutra's 1962 Cyclorama Center within the Commemorative Landscape of the Gettysburg Battlefield," in *Public Nature: Scenery, History, and Park Design,* ed. Ethan Carr, Shaun Eyring, and Richard Guy Wilson (Charlottesville: University of Virginia Press, 2013), 234.

22. Murray M. Moler, "National Shrine Is Explained to Its Visitors," *Marietta (GA) Daily Journal,* September 26, 1958, 7.

23. Vincent LoBrutto, *By Design: Interviews with Film Production Designers* (London: Praeger, 1992), 9; Phil Davis, "Matt Yuricich: Visual Effects Artist Who Won an Oscar for 'Logan's Run,'" *Independent,* June 12, 2012, http://www.independent.co.uk/news/obituaries/matt-yuricich-visual-effects-artist-who-won-an-oscar-for-logans-run-7836842.html.

24. Reyner Banham, *Age of the Masters: A Personal View of Modern Architecture* (New York: Harper and Row, 1975), 3.

25. Anthony DeFeo, "Compression and Release," *The Writing Cooperative,* November 12, 2016, https://writingcooperative.com/compression-and-release-ca222264905.

26. Lehman, *North by Northwest,* 149.

27. Lehman, *North by Northwest,* 151.

28. Steven Jacobs, *The Wrong House: The Architecture of Alfred Hitchcock* (Rotterdam: Nai010, 2013), 312.

29. Lehman, *North by Northwest,* 150.

30. Lehman, *North by Northwest,* 9.

31. Lisa Rosen, "A Touch of Modern Evil: Sinister but Stylish," *LA Architect,* 2001, 9.

32. Kenneth Frampton, *Modern Architecture: A Critical History* (London: Thames and Hudson, 1992), 128.

33. Henry-Russell Hitchcock and Arthur Drexler, *Built in USA: Post-war Architecture* (New York: Simon and Schuster, 1952), 21.

34. Louis H. Sullivan, "A Tall Office Building Artistically Considered," *Lippincott's Monthly Magazine,* March 1896, 408.

35. Frampton, *Modern Architecture,* 129.

36. Jacobs, *The Wrong House,* 303.

37. John Peter, *The Oral History of Modern Architecture* (New York: Harry N. Abrams, 1994), 114.

38. Susan Vaughn, "Taking a Spin around the Concrete Block," *Los Angeles Times,* May 12, 1991, E6.

39. Anne Baxter, "Biography," https://www.imdb.com/name/nm0000879/?ref_=tt_cl_t_2.

40. Arthur Millier, "Building for Our Age," *Los Angeles Times,* April 27, 1930, 45.

41. Lewis Mumford, "What Wright Hath Wrought," *New Yorker,* December 5, 1959, http://www.newyorker.com/magazine/1959/12/05/what-wright-hath-wrought.

42. Hitchcock and Drexler, *Built in USA,* 28.

43. "Frank Lloyd Wright's Arch Oboler Complex Appears Gutted by California Fire," November 28, 2018, https://franklloydwright.org/frank-lloyd-wrights-arch-oboler-complex-appears-gutted-by-california-fire/.

44. Truffaut, *Hitchcock,* 254.

45. Alfred Hitchcock to Sol Siegel, Inter-Office Communication, Metro-Goldwyn-Mayer Pictures, December 16, 1958, Margaret Herrick Library of the Academy of Motion Picture Arts and Sciences, Beverly Hills, CA.

46. Jacobs, *The Wrong House,* 296.

47. LoBrutto, *By Design,* 16.

48. LoBrutto, *By Design,* 9.

49. Peter Blake, *The Master Builders* (1960; repr., New York: Norton, 1976), 380.

50. Frampton, *Modern Architecture,* 189.

51. Frank Lloyd Wright, "Nature as Architect," in *Roots of Contemporary American Architecture,* ed. Lewis Mumford (1952; repr., New York: Dover, 1972), 134, 136.

52. Vaughn, "Taking a Spin around the Concrete Block," E6.

53. "History of the Spring House," *Spring House Institute,* http://www.preservespringhouse.org/history.html.

54. LoBrutto, *By Design,* 170.

55. LoBrutto, *By Design,* 171.

56. LoBrutto, *By Design,* 37.

57. Jonathan Glancey, "Ken Adam," *175 Years of Architectural Education at UCL,* Bartlett School of Architecture, February 6, 2017, http://issuu.com/bartlettarchucl/docs/bartlett_175_lo/98, 98.

58. LoBrutto, *By Design,* 35.

59. Glancey, "Ken Adam."

60. "Ken Adam," *IMDb,* https://www.imdb.com/name/nm0010553/awards?ref_=nm_awd.

61. LoBrutto, *By Design,* 35–36.

62. Alison Castle, *The Stanley Kubrick Archives* (Cologne, Germany: Taschen, 2008), 312.

63. Home Furnishings Daily, "California Go-Round: The Arthur Elrod Palm Springs Home," *Chicago Tribune,* January 27, 1969, sec. 2, p. 4.

64. Richard J. Williams, *Sex and Buildings: Modern Architecture and the Sexual Revolution* (London: Reaktion, 2013), 108.

65. Williams, *Sex and Buildings,* 114.

66. John Lautner quoted in Williams, *Sex and Buildings,* 115.

67. Williams, *Sex and Buildings,* 118.

68. Williams, *Sex and Buildings,* 109.

69. "A Fish Called Selma," directed by Mark Kirkland, *The Simpsons,* 20th Century Fox Television, season 7, episode 19, March 24, 1996.

70. "LACMA Announces Landmark Promised Gift of the James Goldstein House," press release, Los Angeles County Museum of Art, February 17, 2016.

71. Williams, *Sex and Buildings,* 31, 38.

72. Philip M. Lovell, "Care of the Body," *Los Angeles Times Sunday Magazine,* December 15, 1929, 26–27.

73. Barbara Mac Lamprecht, *Richard Neutra: Complete Works* (New York: Taschen, 2000), 91.

74. Lovell, "Care of the Body," 26–27.

75. Arthur Millier, "Building for Our Age," *Los Angeles Times,* April 27, 1930, 45.

76. "What Will the Neighbors Think?," *Time,* August 15, 1949, 60.

77. Carter B. Horsley, "Realty News," *New York Times,* March 27, 1977, 293.

78. Richard Neutra, "Homes and Housing," in *Los Angeles: Preface to a Master Plan,* ed. George W. Robbins and L. Deming Tilton (Los Angeles: Pacific Southwest Academy, 1941), 196, quoted in Albrecht, *Designing Dreams,* 84.

79. Millier, "Building for Our Age."

80. Jeannine Oppewall, interview by Christine Madrid French, Los Angeles, March 24, 2020.

81. John Horn, "Set Designers Re-Create 'Real' World," *Johnson City (TN) Press,* March 21, 1998, 18.

82. Oppewall interview.

83. Rosen, "A Touch of Modern Evil."

84. Eleanor Sprawson, "Sydney Home in Dynasty Film," *Daily Telegraph* (Sydney), November 3, 2004, 21.

85. Graham Quint, "Mirrabooka: National Trust Register Listing Report," The National Trust of Australia (New South Wales), n.d., 1–2.

86. Sprawson, "Sydney Home in Dynasty Film."

87. Jacobs, *The Wrong House,* 307.

88. Jacobs, *The Wrong House,* 302–3.

89. Goldberger, *Why Architecture Matters,* 159.

90. Rosen, "A Touch of Modern Evil."

91. Lamprecht, *Neutra,* 10.

3. URBAN HONEYCOMBS

1. Richard J. Williams, *Sex and Buildings: Modern Architecture and the Sexual Revolution* (London: Reaktion, 2013), 87.

2. John Russell, "When Bad Art Can Be Good and Good Art Bad," *Sydney Morning Herald,* October 2, 1982, 37.

3. *Metropolis: The Story of the Film,* a program produced for the London premiere of the film at the Marble Arch Pavilion, March 21, 1927, https://socks-studio.com/2012/08/15/about-metropolis/.

4. "Among the Stars," *Montgomery (AL) Weekly Advertiser* 18, no. 14 (February 5, 1884): 1; H. B. Kelly, untitled article, *McPherson (KS) Freeman* 5, no. 40 (May 4, 1883): 2; "The Champions Beaten at Home," *St. Louis Daily Globe-Democrat,* May 6, 1883, 11.

5. Winston Weisman, "New York and the Problem of the First Skyscraper," *Journal of the Society of Architectural Historians* 12, no. 1 (1953): 13–21.

6. "Colossal Architecture," *Stockton [CA] Mail* 11, no. 33 (March 19, 1885): 1.

7. Albert Bush-Brown, *Louis Sullivan* (New York: George Braziller, 1960), 22

8. Bush-Brown, *Louis Sullivan,* 7.

9. Frank Lloyd Wright, "The Tyranny of the Skyscraper," *Modern Architecture: Being the Kahn Lectures for 1930,* (1931; repr., Princeton, NJ: Princeton University Press, 2008), 85.

10. Louis Sullivan, "A Tall Office Building Artistically Considered," *Lippincott's Monthly Magazine,* March 1896, reprinted in *Western Architect* 31, no. 1 (January 1922): 3.

11. Sullivan, "A Tall Office Building," 4.

12. Sullivan, "A Tall Office Building," 4.

13. Eric Bunge and Juan Antonio Ramirez, "Bee Modern: An Interview with Juan Antonio Ramirez," *Cabinet Magazine,* Fall 2001, http://www.cabinetmagazine.org/issues/4/bunge.php.

14. Sarah Williams Goldhagen, *Welcome to Your World: How the Built Environment Shapes Our Lives* (New York: HarperCollins, 2017), 14.

15. Wright, *Modern Architecture,* 88.

16. Wright, *Modern Architecture,* 97.

17. Wright, *Modern Architecture,* 98.

18. Williams, *Sex and Buildings,* 88.

19. Steven Jacobs, *The Wrong House: The Architecture of Alfred Hitchcock* (Rotterdam: Nai010, 2013), 309.

20. King Vidor, dir., *The Fountainhead* (Los Angeles: Warner Brothers, 1949).

21. Henry-Russell Hitchcock and Arthur Drexler, eds., *Built in USA: Post-war Architecture* (New York: Simon and Schuster, 1952), 8.

22. Hitchcock and Drexler, *Built in USA,* 11.

23. Hitchcock and Drexler, *Built in USA,* 10.

24. Margaret Illington, "In Pictures," *Fresno Morning Republican,* January 7, 1917, 10.

25. François Truffaut, *Hitchcock* (New York: Simon and Schuster, 1983), 180.

26. Hitchcock, quoted in Truffaut, *Hitchcock,* 181–83.

27. "Movie Review: *Rope,*" *Look* 12, no. 19 (September 14, 1948): 92–93.

28. "Movie Review: *Rope,*" 92, 93.

29. Jacobs, *The Wrong House,* 274.

30. Hume Cronyn, Arthur Laurents and Ben Hecht, *Rope,* January 13, 1948, 2, http://cinephiliabeyond.org/alfred-hitchcocks-rope.

31. Cronyn, Laurents, and Hecht, *Rope,* 2.

32. Jacobs, *The Wrong House,* 270.

33. Jacobs, *The Wrong House,* 268

34. Jacobs, *The Wrong House,* 272, 274.

35. Hitchcock, quoted in Truffaut, *Hitchcock,* 102; Cronyn, Laurents, and Hecht, *Rope,* 5.

36. Cronyn, Laurents, and Hecht, *Rope,* 95.

37. Jacobs, *The Wrong House,* 276.

38. "Rope," *IMDBPro,* http://pro.imdb.com/title/tt0040746/filmmakers.

39. Jacobs, *The Wrong House,* 277.

40. Hitchcock, quoted in Truffaut, *Hitchcock,* 210.

41. Donald Spoto, *The Dark Side of Genius: The Life of Alfred Hitchcock* (Boston: Little, Brown, 1983), 344.

42. The story was first published in the February 1942 issue of *Dime Detective* and later retitled "Rear Window" when reprinted in *After Dinner Story,* a 1944 collection of Woolrich-

authored stories that was submitted to Paramount Pictures by Woolrich's publisher (Steven DeRosa, *Writing with Hitchcock* [New York: Faber and Faber, 2001; CineScribe Media, 2011], 11, 14).

43. Robin Wood, *Hitchcock's Films Revisited* (1989; rev. ed., New York: Columbia University Press, 2002), 103.

44. Hitchcock, quoted in Truffaut, 222.

45. Truffaut, *Hitchcock,* 214.

46. Truffaut, *Hitchcock,* 11.

47. Wood, *Hitchcock's Films Revisited,* 211.

48. DeRosa, *Writing with Hitchcock,* 16.

49. DeRosa, *Writing with Hitchcock,* 17.

50. DeRosa, *Writing with Hitchcock,* 19.

51. Jacobs, *The Wrong House,* 282.

52. Thomas W. Ennis, "H. I. Feldman, Head of Architecture Concern, Dies," *New York Times,* January 27, 1981, B19.

53. Jay Shockley, "Greenwich Village Historic District Extension Designation Report," New York City Landmarks Preservation Commission, May 2, 2006, 16.

54. "Peeping Tom Spots a Killer," *Life,* August 16, 1954, 89.

55. Patrick McGilligan, *Alfred Hitchcock: A Life in Darkness and Light* (New York: Harper Perennial, 2003), 482.

56. Truffaut, *Hitchcock,* 223.

57. Wood, *Hitchcock's Films Revisited,* 210.

58. Truffaut, *Hitchcock,* 216.

59. DeRosa, *Writing with Hitchcock,* 21.

60. DeRosa, *Writing with Hitchcock,* 49.

61. John McCarten, "The Current Cinema," *New Yorker,* August 7, 1954, 51.

62. Marjory Adams, "'Rear Window' at Met, Slick Hitchcock Drama," *Boston Daily Globe,* August 27, 1954, 6.

63. Spoto, *The Dark Side of Genius,* 347.

64. Grace Kelly, quoted in Spoto, *The Dark Side of Genius,* 344–45.

65. Paramount Advance Campaign document as quoted in Jacobs, *The Wrong House,* 285.

66. Jacobs, *The Wrong House,* 284.

67. McGilligan, *Alfred Hitchcock,* 484.

68. Jacobs, *The Wrong House,* 285.

69. Jeff Kraft and Aaron Leventhal, *Footsteps in the Fog: Alfred Hitchcock's San Francisco* (Santa Monica, CA: Santa Monica Press, 2002), 73–74.

70. Douglas A. Cunningham, *The San Francisco of Alfred Hitchcock's "Vertigo": Place, Pilgrimage, and Commemoration* (Lanham, MD: Scarecrow, 2012), 281.

71. McGilligan, *Alfred Hitchcock,* 553, 555.

72. Saul Bass, quoted in Jennifer Bass and Pat Kirkham, *Saul Bass: A Life in Film and Design* (London: Laurence King, 2011), 180.

73. Kraft and Leventhal, *Footsteps in the Fog,* 130.

74. "Vertigo—Scottie's House," *Reel SF,* April 26, 2011, http://reelsf.com/reelsf/vertigo-scotties-house.

75. "Sutter Street, San Francisco, California," *The Alfred Hitchcock Wiki,* https://the.hitchcock.zone/wiki/Sutter_Street,_San_Francisco,_California.

76. William Helbing or the Helbing Company is credited with the design and construction of the Hotel Rich (1010 Bush Street, 1906), the Curtaz Apartments (839 Leavenworth Street, 1910), the Domo Apartments (920 Leavenworth Street, 1912), Apartment Building (921 Leavenworth Street, 1919), Hotel Glen Royal (940 Sutter Street, 1925), and the Langham Apartments (555 Taylor Street, 1922) ("Lower Nob Hill Apartment Hotel District, National Register of Historic Places Registration Form," U.S. Department of the Interior, National Park Service, June 24, 1991).

77. "Uptown Tenderloin Historic District, National Register of Historic Places Continuation Sheet," U.S. Department of the Interior: National Park Service, NRIS Reference No. 08001407, February 5, 2009, sec. 8, p. 32.

78. "Hotel Glen Royal, 940 Sutter Street," *San Francisco Examiner,* November 28, 1925, 5.

79. "Hotel Glen Royal," *San Francisco Examiner,* March 31, 1926, 22.

80. "H. C. Muddox Buys San Francisco Hotel," *Sacramento Bee,* June 11, 1927, 7; "Hotel Deals Here Involve over $750,000," *San Francisco Examiner,* November 5, 1938, 9; "15 Story Hotel El Cortez Is Sold to Fritz," *San Francisco Examiner,* May 17, 1941, CCCC.

81. Advertisements in the *San Francisco Examiner* for "940 Sutter Street" are listed as the "Empire Lodge," until January 23, 1957, and then changed to the "Empire Hotel," in a February 21, 1957, classified advertisement ("$17.50 WEEK," *San Francisco Examiner,* February 21, 1957, sec. 2, p. 18).

82. "Empire Hotel Leased for SPARS," *San Francisco Examiner,* October 17, 1943, 2.

83. "Coast Guard Now Ready to Enlist SPARS," *Minneapolis Star,* November 29, 1943, 25.

84. "Coast Guard Spars Take over Hotel Which Becomes Official S.F. Barracks," *San Francisco Examiner,* November 13, 1943, 10.

85. "Ross Sisters Lease One Hotel and Sell 2d," *San Francisco Examiner,* May 21, 1959, 1.

86. "Opening To-Night!," *San Francisco Examiner,* June 5, 1950, 38; "Sandro's," *San Francisco Examiner,* December 19, 1952, 21.

87. "Come to the Cabaret," *San Francisco Examiner,* January 9, 2008, A19.

88. "6-Story Leap Kills Woman," *San Francisco Examiner,* August 28, 1957, 5.

89. "Hotel Vertigo," *Atlas Obscura,* n.d., http://www.atlasobscura.com/places/hotel-vertigo.

90. Truffaut, *Hitchcock,* 20.

91. Earle Shultz and Walter Simmons, *Offices in the Sky* (New York: Bobbs-Merrill, 1959), 275.

92. Wright, *Modern Architecture,* 87.

93. Banham, *Age of the Masters,* 50–51.

94. Bennett, "At the Cinema."

95. Don Quigg, "Blind Newsboy's Shack Designed by Architects," *Brownsville (TX) Herald,* November 22, 1957, 5; Colin Bennett, "At the Cinema: Welcome Return to Vintage Hitchcock," *The Age* (Melbourne, Australia), December 5, 1959, 19.

96. Saul Bass, quoted in Myrna Oliver, "Saul Bass; Innovative Film Title Designer," *Los Angeles Times,* April 27, 1996, A30.

97. Hitchcock and Drexler, *Built in USA,* 20–21.

98. Hitchcock and Drexler, *Built in USA,* 23.

99. Victoria Newhouse, *Wallace K. Harrison, Architect* (New York: Rizzoli, 1989), 143.

100. Lewis Mumford, quoted in Newhouse, *Wallace K. Harrison,* 143.

101. Dana Brand, "Rear-View Mirror: Hitchcock, Poe, and the Flaneur in America," in *Hitchcock's America,* ed. Jonathan Freedman and Richard H. Millington (New York: Oxford University Press, 1999), 126.

102. Lewis Mumford, quoted in Mark Lamster, ed., *Architecture and Film* (New York: Princeton Architectural Press, 2000), 132.

103. "The Glass Wall," IMDb, http://www.imdb.com/title/tt0045824.

104. "The Glass Wall," http://www.scripts.com/script/the_glass_wall_20322.

105. Brian Camp, "42nd Street and Times Square Theaters: The Glass Wall (1953)," Brian Camps Film and Anime Blog, http://briandanacamp.wordpress.com/2012/05/05/42nd-street-and-times-square-theaters-the-glass-wall-1953.

106. Hitchcock, quoted in Truffaut, *Hitchcock,* 252.

107. Whitney Balliet, "Hitchcock on Hitchcock," *New Yorker,* August 15, 1959, http://www.newyorker.com/magazine/1959/08/15/hitchcock-on-hitchcock.

108. Williams, *Sex and Buildings,* 128–29.

109. Joseph Stefano, *Psycho,* revised December 1, 1959, 1, http://www.horrorlair.com/scripts/psycho.pdf.

110. Stefano, *Psycho,* 1.

111. William Rothman, *Hitchcock: The Murderous Gaze* (Cambridge, MA: Harvard University Press, 1982), 251.

112. Stefano, *Psycho,* 5.

113. McGilligan, *Alfred Hitchcock,* 589.

114. "Like Fairy Tale Reads Story of Life of Salim Ackel Who Erected the Building," *Arizona Republican,* July 15, 1915, 2.

115. "Hotel Company Incorporated," *Arizona Republican,* February 5, 1915, 10.

116. "Like Fairy Tale," 2.

117. "Police Interrupt Meal, Halt Beating, Robbery," *Arizona Republic,* January 28, 1959, 13.

118. Brenna Goth, "Phoenix Approves Sale of Historic Downtown 'Psycho' Building," *Arizona Republic,* June 22, 2016, http://www.azcentral.com/story/news/local/phoenix/2016/06/22/phoenix-psycho-building-sale-approved-condos-barrister-building/86207788.

4. AMERICAN ROADSIDE

1. Steven Jacobs, *The Wrong House: The Architecture of Alfred Hitchcock* (Rotterdam: Nai010, 2013), 122.

2. Stephen King, *Danse Macabre* (New York: Gallery, 1981), 235.

3. *Psycho* screenwriter Joseph Stefano incorporated numerous references to hiding, or escapism, in the script. Marion Crane stops at the Bates Motel on her way to her own "private island," and Detective Arbogast, at his first meeting with Norman Bates, notes that the motel "is the first one that looked like it was hiding from the world at large" (Joseph Stefano, *Psycho,* revised December 1, 1959, 70, http://www.horrorlair.com/scripts/psycho.pdf).

4. Patrick McGilligan, *Alfred Hitchcock: A Life in Darkness and Light* (New York: Harper Perennial, 2003), 590.

5. Stephen Rebello, *Alfred Hitchcock and the Making of "Psycho"* (New York: Dembner, 1990), 51.

6. "Missing from Store, Widow Found Dead," *Milwaukee Journal,* November 17, 1957, 1.

7. Rebello, *Alfred Hitchcock and the Making of "Psycho,"* 25.

8. Rebello, *Alfred Hitchcock and the Making of "Psycho,"* 27.

9. McGilligan, *Alfred Hitchcock,* 580–81.

10. McGilligan, *Alfred Hitchcock,* 56.

11. McGilligan, *Alfred Hitchcock,* 583.

12. McGilligan, *Alfred Hitchcock,* 64.

13. Janet Leigh, *"Psycho": Behind the Scenes of the Classic Thriller* (New York: Harmony, 1995), 62.

14. Luigi Luraschi, Paramount Pictures Corporation, West Coast Studios, to Mr. Hitchcock, "Inter-Office Communication RE: Psycho," November 24, 1959, copy of letter in the hands of the author.

15. McGilligan, *Alfred Hitchcock,* 584.

16. McGilligan, *Alfred Hitchcock,* 580.

17. Owen Gleiberman, "Film Review: *78/52: Hitchcock's Shower Scene," Variety,* January 24, 2017, http://variety.com/2017/film/reviews/7852-review-psycho-1201966555.

18. McGilligan, *Alfred Hitchcock,* 600.

19. Alfred Hitchcock, quoted in Rebello, *Alfred Hitchcock and the Making of "Psycho,"* 199.

20. "Mr. Hitchcock and Psychiatry," *The Age* (Melbourne, Australia), October 24, 1960, 3.

21. Jim Phillips, "'Alfie' Goes Berserk with His Newest Film," *Arlington Heights (IL) Herald,* July 7, 1960, 21.

22. "Hitchcock Shocker in *Psycho,*" *Des Moines (IA) Tribune,* August, 4, 1960, 14.

23. Danton Walker, "Broadway: Manhattan Memoranda," *New York Daily News,* April 26, 1960, 51.

24. Carol McMurtry, "Hitch Abandons Suspense for Horror," *Amarillo (TX) Globe-Tim*es, August 12, 1960, 19.

25. Mrs. R. W. Collins (Texas) to Mr. Alfred Hitchcock, Hollywood, CA, September 27, 1960, copy in the hands of the author.

26. Dudley M. Cobb Jr., M.D., Vice-Chairman Physicians Advisory Committee on Television, Radio and Motion Pictures, to Mr. Alfred Hitchcock, Revue Studios, Universal City, CA, August 29, 1960, copy in the hands of the author.

27. Mildred Martin, "Hitchcock Delivers Quota of Shocks in Eerie 'Psycho,'" *Philadelphia Inquirer,* June 19, 1960, D1.

28. Bosley Crowther, "An Answer to Those Filmgoers Who Think *Psycho* Should Be Banned," *New York Times,* 28 August 1960.

29. Hitchcock, quoted in François Truffaut, *Hitchcock* (New York: Simon and Schuster, 1983), 268.

30. Dennis R. Perry and Carl H. Sederholm, *Poe, "The House of Usher," and the American Gothic* (New York: Palgrave Macmillan, 2009), 6.

31. Hitchcock, quoted in Truffaut, *Hitchcock,* 1, 12.

32. Richard Leonard, "Murder Farm Horror Grows," *Milwaukee Journal,* November 18, 1957, 1; "Plainfield Slayer Arrives in Madison for a Lie Test," *Capital Times* (Madison, WI), November 19, 1957, 1.

33. "'Strange Sex Complex' Led to Sadistic Killings," *Oshkosh (WI) Daily Northwestern,* November 21, 1957, 13.

34. "House of Horror Stuns the Nation," *Life,* December 2, 1957, 24–31.

35. "Ed Gein House Burns," *Capital Journal* (Salem, OR), March 20, 1958, 6.

36. "Ed Gein: 50 Years Later," *Marshfield (WI) News-Herald,* November 16, 2007, 71.

37. Rebello, *Alfred Hitchcock and the Making of "Psycho,"* 20–21.

38. Robert Bloch, *Psycho* (New York: Overlook, 2010), 20.

39. Bloch, *Psycho,* 12.

40. Bloch, *Psycho,* 28.

41. Bloch, *Psycho,* 57, 147.

42. Bloch, *Psycho,* 32.

43. Bloch, *Psycho,* 153, 155–56, 158, 165.

44. Anthony Boucher, "Criminals at Large," *New York Times Book Review,* April 19, 1959, quoted in Rebello, *Alfred Hitchcock and the Making of "Psycho,"* 24.

45. Perry and Sederholm, *Poe,* 34.

46. Perry and Sederholm, *Poe,* 113.

47. Perry and Sederholm, *Poe,* 4.

48. Edgar Allan Poe, *Edgar Allan Poe Stories* (New York: Platt and Munk, 1961), 84.

49. Poe, *Edgar Allan Poe Stories,* 86.

50. R. Barton Palmer, "The Metafictional Hitchcock: The Experience of Viewing and the Viewing of Experience in *Rear Window* and *Psycho,*" *Cinema Journal,* Winter 1986, 14.

51. Bloch, *Psycho,* 9.

52. Cleanth Brooks and Robert Penn Warren, "View Points," in *Twentieth Century Interpretations of "The Fall of the House of Usher": A Collection of Critical Essays,* ed. Thomas Woodson (Hoboken, NJ: Prentice-Hall, 1969), 24.

53. Palmer, "The Metafictional Hitchcock," 17.

54. Perry and Sederholm, *Poe,* 129.

55. "Meet Your Favorite Hollywood Stars," *Seventeen* 19, no. 5 (May 1960): 118–19.

56. Bob Greer, "Clutter Family Slayings Shock, Mystify Area," *Garden City (KS) Telegram,* November 16, 1959, 1.

57. McGilligan, *Alfred Hitchcock,* 534.

58. Hitchcock, quoted in Truffaut, *Hitchcock,* 237.

59. "A Nightmare Lived Again," *Life,* May 12, 1967, 99, 104A.

60. Crystal K. Wiebe, "In the End, Just a Home: A House with a History of Murder Finds New Life," *Lawrence (KS) Journal-World,* April 6, 2005, http://www2.ljworld.com/news/2005/apr/06/in_the_end.

61. Hitchcock, quoted in Truffaut, *Hitchcock,* 242–43.

62. Hitchcock, quoted in Truffaut, *Hitchcock,* 131.

63. Hitchcock, quoted in Truffaut, *Hitchcock,* 132.

64. Jacobs, *The Wrong House,* 122.

65. Ward Bucher, ed., *Dictionary of Building Preservation* (New York: John Wiley and Sons, 1996), 283, 409.

66. Hitchcock, quoted in Truffaut, *Hitchcock,* 269.

67. Jeannine Oppewall, "Buildings on Film: Bridging Art and Architecture," interview by Christine Madrid French on behalf of the California Preservation Foundation, April 23, 2020, http://www.facebook.com/113918040943/videos/700600657348700.

68. Robert Clatworthy, quoted in Rebello, *Alfred Hitchcock and the Making of "Psycho,"* 93.

69. Rebello, *Alfred Hitchcock and the Making of "Psycho,"* 94; "Edward Hopper. *House by the Railroad.* 1925," Museum of Modern Art, New York, http://www.moma.org/audio/playlist/1/132?high_contrast=false.

70. Jeff Kraft and Aaron Leventhal, *Footsteps in the Fog: Alfred Hitchcock's San Francisco* (Santa Monica, CA: Santa Monica Press, 2002), 238.

71. Kraft, *Footsteps in the Fog,* 240.

72. Kraft, *Footsteps in the Fog,* 105.

73. Arthur Darack, "*Psycho* Analysis," *Cincinnati Enquirer,* September 4, 1960, 31.

74. Carol McMurtry, "Hitch Abandons Suspense for Horror," *Amarillo (TX) Globe-Time*s, August 12, 1960, 19.

75. Charles Addams, Untitled cartoon, *New Yorker,* December 21, 1946, 30.

76. Juan Antonio Ramírez, *Architecture for the Screen: A Critical Study of Set Design in Hollywood's Golden Age,* trans. J. Moffitt (Jefferson, NC: McFarland, 2004), 9.

77. Harry Nelson, "Romance Dwells atop Bunker Hill, City's Treasure Chest of Yesterday," *Los Angeles Times,* April 27, 1952, 63.

78. "Blighted Bunker Hill Destined to Regain Old Majesty," *Los Angeles Times,* April 28, 1958, 3.

79. Charles M. Weisenberg, "Bunker Hill, Zoo, Baseball Top News from City Hall," *Van Nuys News,* December 29, 1959, 17.

80. William Pereira is the brother of Hal Pereira, an architect and art director/production designer who worked for Hitchcock on a number of his films (Ray Hebert, "Bunker Hill Project to Give City New Skyline," *Los Angeles Times,* April 1, 1959, 1–2).

81. Wally Guenther, "Bunker Hill: The End of an Era," *Los Angeles Times,* May 19, 1957, 408.

82. "Councilman Raps Claims of Skid Row Cleanup Savings," *Valley News* (Van Nuys), February 19, 1957, 17.

83. Mark Amans, quoted in Rachel Kafka and Nate Hennagin, "The Hollywood Center Motel," *Finding Lost Angeles,* http://www.findinglostangeles.com/all-content/2018/9/11/the-hollywood-center-motel.

84. Jacobs, *The Wrong House,* 127.

85. McGilligan, *Alfred Hitchcock,* 589.

86. Rebello, *Alfred Hitchcock and the Making of "Psycho,"* 96.

87. James Warnack, "Hostelry Chain for Motorists," *Los Angeles Times,* January 18, 1925, pt. 2, p. 7.

88. Warnack, "Hostelry Chain for Motorists."

89. Jakle, Sculle, and Rogers, *The Motel in America,* 1.

90. Staff writer, "New System Aids Tourists," *Los Angeles Times,* February 7, 1926, pt. 6, p. 6.

91. "Motel Inn, San Luis Obispo, California," postcard, Elmo B. Sellers, Los Angeles California, n.d., The Tichnor Brothers Collection, Arts Department, Boston Public Library, https://www.digitalcommonwealth.org/search/commonwealth:x920g395b.

92. "Parting Shots," *Wilkes Barre (PA) Times-Leader,* June 25, 1927, 25.

93. John Margolies, *Home Away from Home: Motels in America* (Boston: Little, Brown, 1995), 29.

94. "A. Lincoln Tourist Court, 2927 South Sixth Street, Springfield, Illinois," postcard, National Advertising Specialty Co., Tyler, Texas, n.d., The Tichnor Brothers Collection,

Arts Department, Boston Public Library. https://www.digitalcommonwealth.org/search
/commonwealth:wh246w27h.

95. Edgar J. Hoover and Courtney Ryley Cooper, "Camps of Crime," *American Magazine* 129,
no. 2 (February 1940): 15.

96. Hoover, "Camps of Crime," 13.

97. Hoover, "Camps of Crime," 15.

98. "Bonnie and Clyde," Federal Bureau of Investigation: History, https://www.fbi.gov
/history/famous-cases/bonnie-and-clyde.

99. Margolies, *Home Away from Home,* 90.

100. Jonathan Freedman and Richard H. Millington, *Hitchcock's America* (New York: Oxford
University Press, 1999), 5.

101. Classified advertisements listed in the *Seattle Times,* September 20, 1958, 15.

102. "Police Nab 3 Escapees in Florida," *Spokane (WA) Semi-Weekly Spokesman-Review,*
October 9, 1959, 6.

103. Robert Phillip Kolker, *The Extraordinary Image: Orson Welles, Alfred Hitchcock, Stan-
ley Kubrick, and the Reimagining of Cinema* (New Brunswick, NJ: Rutgers University Press,
2017), 108.

104. *Touch of Evil,* directed by Orson Welles (Universal International Pictures, 1958).

105. "Alexander Golitzen," IMDb, https://www.imdb.com/name/nm0326529/?ref_=ttfc_fc
_cr10.

106. Orson Welles, *Badge of Evil: "Touch of Evil,"* revised final screenplay, February 5, 1957,
39, http://www.cinephiliabeyond.org/wp-content/uploads/2014/12/touch_of_evil
.compressed.pdf.

107. Welles, *Badge of Evil: "Touch of Evil,"* 84.

108. Jakle, Sculle, and Rogers, *The Motel in America,* 17.

109. Mickey Davis, "Roadside Motel a Little Fishy, but (Whew!) No Bates," *Dayton (OH)
Journal Herald,* April 13, 1983, 21.

110. Darack, "*Psycho* Analysis," 31.

111. Joseph Stefano, *Psycho,* revised December 1, 1959, 34–35, http://www.horrorlair.com
/scripts/psycho.pdf.

112. *Psycho,* directed by Alfred Hitchcock (Los Angeles: Paramount Pictures), 1960.

113. Stefano, *Psycho,* 45.

114. Stefano, *Psycho,* 43.

115. "Let's Figure It Out: What Pictures Did Alfred Hitchcock's *Psycho* feature?," *Artsmarts,*
https://arthive.com/publications/2863~Lets_figure_it_out_what_pictures_did_Alfred
_Hitchcocks_Psycho_feature. The original painting *Suzanne et le vieillards* is held at the Hy-
acinthe Rigaud Museum, Perpignan, France (https://www.photo.rmn.fr/archive/72-006690
-2C6NU0SI06UP.html).

116. Stefano, *Psycho,* 51.

117. Jennifer Bass and Pat Kirkham, *Saul Bass: A Life in Film and Design* (London: Laurence King, 2011), 185.

118. Rebello, *Alfred Hitchcock and the Making of Psycho,* 101.

119. "*Psycho* Mr. Hitchcock's Original Work Copy," Alfred Hitchcock Collection, Folder 566, 37, dated 11-10-1959, Margaret Herrick Library of the Academy of Motion Picture Arts and Sciences; *Psycho,* directed by Alfred Hitchcock (Los Angeles: Paramount Pictures), 1960.

120. Research Department, "For PSYCHO, Hotels near Redding, Red Bluff, and Fairfield, California from Automobile Club of Southern California's Southwest Tour Book. 1959–60," Margaret Herrick Library of the Academy of Motion Picture Arts and Sciences, Beverly Hills, CA.

121. "California Motel," postcard, Nationwide Advertising Specialty Co., Tyler, TX, postcard in the hands of the author.

122. "Crystal Motel and Coffee Shop," menu, printed by Green's Chico, menu in the hands of the author.

123. "Shasta Dam El Rancho Motel," postcard, National Press, Inc., North Chicago, post-marked October 25, 1952.

124. Ancestry.com, "Population Schedule," *Sixteenth Census of the United States: 1940,* April 11, 1940, S.D. No. 13, E.D. No. 60–719, Sheet No. 9A, [database online]. Provo, UT, USA: Ancestry.com Operations, Inc., 2012.

125. Ancestry.com, *U.S. City Directories, 1822–1995* [database online], Provo, UT, USA: Ancestry.com Operations, Inc., 2011.

126. Jill Livingston and Kathryn Golden Maloof, *That Ribbon of Highway I: Highway 99 from the Oregon Border to Sacramento* (Klamath River, CA: Living Gold, 2016), n.p.

127. Hitchcock, quoted in Truffaut, *Hitchcock,* 269.

128. Owen Gleiberman, "Film Review: *78/52: Hitchcock's Shower Scene,*" *Variety,* January 24, 2017, http://variety.com/2017/film/reviews/7852-review-psycho-1201966555.

129. Gleiberman, "Film Review: *78/52.*"

130. Rothman, *Hitchcock: The Murderous Gaze,* 248.

131. Gleiberman, "Film Review: '78/52.'"

132. Alexandre O. Philippe, director, *78/52: Hitchcock's Shower Scene* (Los Angeles: Exhibit A Pictures), 2017.

133. McGilligan, *Alfred Hitchcock,* 579.

134. Andrew Sarris, quoted in J. Hoberman, "*Psycho* Is 50: Remembering Its Impact and the Andrew Sarris Review," *Village Voice,* June 15, 2010, http://www.villagevoice.com/2010/06/15/psycho-is-50-remembering-its-impact-and-the-andrew-sarris-review.

135. Bernard Weinraub, "*Psycho* in Janet Leigh's Psyche," *New York Times,* May 1, 1995, 41–46.

136. Tom Holland, interview by author, November 18, 2021, Los Angeles, California.

137. RJ Smith, "Has Gus Van Sant Gone Psycho?," *New York Times Magazine,* November 29, 1998, sec. 6, p. 104.

138. "Bates Motel," IMDbPro, http://pro.imdb.com/title/tt2188671/details.

139. *Bates Motel,* episode 1, season 1.

140. Production designers credited on the series included Mark S. Freeborn, Tony Wohlgemuth, and Peter Bodnarus. Credited art directors included David Hadaway, Tony Wohlgemuth, Margot Ready, and Peter Bodnarus ("Bates Motel," IMDbPro, http://pro.imdb.com/title/tt2188671/filmmakers).

141. Ovid, *Metamorphoses,* trans. Anthony S. Kline (Charlottesville: University Press of Virginia, 2000), bk. VIII: 152–82, http://ovid.lib.virginia.edu/trans/Metamorph8.htm.

142. Alison Castle, *The Stanley Kubrick Archives* (Cologne, Germany: Taschen, 2005), 627.

143. Castle, *The Stanley Kubrick Archives,* 627.

144. Castle, *The Stanley Kubrick Archives,* 630.

145. Jacobs, *The Wrong House,* 121.

146. Hitchcock, quoted in Truffaut, *Hitchcock,* 282.

147. McGilligan, *Alfred Hitchcock,* 579.

148. Stanley Wiater, *Dark Visions: Conversations with the Master of the Horror Film* (New York: Avon, 1992), n.p.

149. Harry Levin, "View Points," in *Twentieth Century Interpretations of "The Fall of the House of Usher": A Collection of Critical Essays,* ed. Thomas Woodson (Hoboken, NJ: Prentice-Hall, 1969), 31.

5. ARCHITECTS AND THE ART OF FILM

1. Vachel Lindsay, *The Art of the Moving Picture* (New York: Macmillan, 1915), 158.

2. Rob Wagner, *Picture Values from an Artist's Viewpoint* (Los Angeles: Palmer Photoplay Corporation, Department of Education, 1920), 4.

3. Wagner, *Picture Values from an Artist's Viewpoint,* 5.

4. Andrew Sarris, *Interviews with Film Directors* (Indianapolis: Bobbs-Merrill, 1967), 458, quoted in Beverly Heisner, *Hollywood Art: Art Direction in the Days of the Great Studios* (London: McFarland, 1990), 2.

5. Lindsay, *The Art of the Moving Picture,* 31.

6. Wagner, *Picture Values from an Artist's Viewpoint,* 4.

7. Juan Antonio Ramírez, *Architecture for the Screen: A Critical Study of Set Design in Hollywood's Golden Age* (London: McFarland, 2004), 27.

8. J. Andre Smith, *The Scenewright: The Making of Stage Models and Settings* (New York: Macmillan, 1926), 1–2.

9. Smith, *The Scenewright,* 1–2.

10. Buñuel, quoted in Dietrich Neumann, *Film Architecture: Set Designs from "Metropolis" to "Blade Runner"* (New York: Prestel, 1999), 9.

11. Lindsay, *The Art of the Moving Picture,* 6.

12. Lindsay, *The Art of the Moving Picture,* 249–50.

13. Lindsay, *The Art of the Moving Picture,* 247.

14. Lindsay, *The Art of the Moving Picture,* 6, 248.

15. Arthur Millier, "Our Art Influence Felt Everywhere," *Los Angeles Times,* August 6, 1933, pt. 2, p. 2.

16. Ramírez, *Architecture for the Screen,* 8.

17. Julia Blanshard, "In New York," *Franklin (PA) News-Herald,* April 11, 1933, 4.

18. Ramírez, *Architecture for the Screen,* 31–32.

19. Donald Albrecht, *Designing Dreams: Modern Architecture in the Movies* (New York: Harper and Row in collaboration with the Museum of Modern Art, 1986), 79.

20. Raymond Myerscough-Walker, *Stage and Film Décor,* quoted in Ramírez, *Architecture for the Screen,* 38.

21. Albrecht, *Designing Dreams,* 78.

22. Vincent LoBrutto, *By Design: Interviews with Film Production Designers* (London: Praeger, 1992), 6.

23. LoBrutto, *By Design,* 7. Production designer Robert Boyle noted that all of the assistants in the art department at Paramount were called "draftsmen," because, with the exception of Dorothea Holt, all of the employees were men.

24. Albrecht, *Designing Dreams,* 78.

25. Albrecht, *Designing Dreams,* 79.

26. Albrecht, *Designing Dreams,* 79.

27. Tom Vallance, "Henry Bumstead: Hitchcock's Production Designer," *Independent,* May 31, 2006, https://www.independent.co.uk/news/obituaries/henry-bumstead-480402.html.

28. "Henry Bumstead," IMDb, https://www.imdb.com/name/nm0120317/?ref_=fn_al_nm_1.

29. Heisner, *Hollywood Art,* 185.

30. "Hal Pereira, Art Director for Paramount Studios, Dies at 78," *Los Angeles Times,* December 24, 1983, 53.

31. Heisner, *Hollywood Art,* 185.

32. Heisner, *Hollywood Art,* 185.

33. William Pereira, quoted in Paul Harrison, "In Hollywood," *Frederick (MD) News,* February 16, 1942, 9.

34. "Bride at Crown Point," *Chicago Tribune,* June 24, 1934, 3.

35. "What Modernization Can Do for a Movie," *Chicago Tribune,* December 23, 1934, 22.

36. Edwin Schallert, "Broadway Sells Tenth of Product to Movies," *Los Angeles Times,* January 22, 1942, 32.

37. John Chapman, "Looking at Hollywood," *Chicago Daily Tribune,* March 23, 1942, 14.

38. Hedda Hopper, "Looking at Hollywood," *Chicago Daily Tribune,* September 26, 1942.

39. Robbin Coons, "There's Class in *Jane Eyre*," *Hackensack (NJ) Record,* February 26, 1943, 13.

40. Hedda Hopper, "Hollywood," *Pittsburgh Press,* March 27, 1943, 6.

41. "Hal Pereira," IMDb, https://www.imdb.com/name/nm0673134/?ref_=fn_al_nm_1; "William L. Pereira," IMDb, https://www.imdb.com/name/nm0673233/?ref_=nv_sr_1?ref_=nv_sr_1.

42. "Architect of Success," *Time* magazine, October 14, 1946, n.p., http://content.time.com/time/subscriber/article/0,33009,934088,00.html.

43. Albrecht, *Designing Dreams,* 89.

44. Millier, "Our Art Influence Felt Everywhere," 2.

45. Albrecht, *Designing Dreams,* 91–92.

46. "Fifty Artists Made Sketches for 'Romeo,'" *Los Angeles Times,* October 4, 1936, pt. 3, p. 4.

47. LoBrutto, *By Design,* 73.

48. Ramírez, *Architecture for the Screen,* 33.

49. Ramírez, *Architecture for the Screen,* 34.

50. Ella H. McCormick, "Movie Art Director Fails If His Work Gets Praise," *Detroit Free Press,* June 10, 1934, 12.

51. LoBrutto, *By Design,* xi.

52. "Hitchcock on Style: An Interview with Alfred Hitchcock," *Cinema (US)* 5, no. 1 (August–September 1963): 4–8, 34–35.

53. LoBrutto, *By Design,* 85.

54. Neumann, *Film Architecture,* 8.

55. Arthur Millier, "Brush Strokes," *Los Angeles Times,* October 4, 1936, pt. 3, p. 4.

56. Albrecht, *Designing Dreams,* 78.

57. "U.S., School Yearbooks, 1880–2012"; University of Southern California; 1932 (Provo, UT: Ancestry.com Operations, 2010).

58. LoBrutto, *By Design,* 4.

59. LoBrutto, *By Design,* 5.

60. LoBrutto, *By Design,* 5, 7.

61. LoBrutto, *By Design,* 12.

62. Pete Collard, "From *Vertigo* to *Psycho,* How Hitchcock Changed the Role of Architecture in Film," Wallpaper, n.d., https://www.wallpaper.com/art/hitchcock-architecture-in-film-vertigo-psycho.

63. LoBrutto, *By Design,* 13.

64. LoBrutto, *By Design,* 16.

65. LoBrutto, *By Design,* 16.

66. LoBrutto, *By Design,* 12

67. Jacobs, *The Wrong House*, 12.

68. Alfred Hitchcock, "My Screen Memories," *Film Weekly*, May 2, 1936, 16–18, quoted in Sidney Gottlieb, *Hitchcock on Hitchcock*, vol. 2: *Selected Writings and Interviews* (Berkeley: University of California Press, 2015), 6.

69. Joel Gunz. "Hitch Puts a Bird on It: Paul Klee's Influence on the Master of Suspense," in *Critical Insights: Alfred Hitchcock*, ed. Douglas A. Cunningham (Ipswich, MA: Salem, 2017), 248.

70. Patrick McGilligan, *Alfred Hitchcock: A Life in Darkness and Light* (New York: Harper Perennial, 2003), 63, 67.

71. McGilligan, *Alfred Hitchcock*, 64.

72. Ramírez, *Architecture for the Screen*, 7.

73. Neumann, *Film Architecture*, 8.

74. Hitchcock, quoted in François Truffaut, *Hitchcock* (New York: Simon and Schuster, 1983), 320.

CONCLUSION

1. Hugo Häring, "Filmbauen," *Der Neubau: Halbmonatsschrift für Baukunst* 6 (June 10, 1924): 117–18, quoted in Dietrich Neumann, *Film Architecture: Set Designs from "Metropolis" to "Blade Runner"* (New York: Prestel, 1999), 9.

2. Camille Paglia, *The Birds* (London: British Film Institute, 1998), 18–19.

3. Meg McConahey, "Happy Haunting at Historic Schoolhouse," *Santa Rosa (CA) Press Democrat*, October 24, 2013, https://www.pressdemocrat.com/article/news/happy-haunting-at-historic-schoolhouse.

4. "Alfred Hitchcock's Birds Still Flutter around Bodega," Sonoma County Tourism, Santa Rosa, CA, 2021, https://www.sonomacounty.com/articles/alfred-hitchcocks-birds-still-flutter-around-bodega.

5. Carolina A. Miranda, "Nice Try, but Hitch Still Holds the Title," *Los Angeles Times*, May 1, 2016, F2.

6. Sarah Williams Goldhagen, *Welcome to Your World: How the Built Environment Shapes Our Lives* (New York: HarperCollins, 2017), 59.

7. Goldhagen, *Welcome to Your World*, 50–51.

8. *Spellbound*, dir. Alfred Hitchcock (Los Angeles: Selznick International Pictures, 1945).

9. Hal Boyle, "I Can't Stand Suspense in My Own Life," *Petersburg (VA) Progress-Index*, March 13, 1956, 4.

10. Juan Antonio Ramírez, *Architecture for the Screen: A Critical Study of Set Design in Hollywood's Golden Age* (London: McFarland, 2004), 5.

11. Ramírez, *Architecture for the Screen*, 8.

12. Ramírez, *Architecture for the Screen,* 5.

13. Ramírez, *Architecture for the Screen,* 9.

14. Richard A. Etlin, *Symbolic Space: French Enlightenment Architecture and Its Legacy* (Chicago: University of Chicago Press, 1994), xix.

15. Douglas A. Cunningham, *Critical Insights: Alfred Hitchcock* (Ipswich, MA: Salem, 2016), 286.

16. Robin Wood, *Hitchcock's Films Revisited* (1989; rev. ed., New York: Columbia University Press, 2002), 100.

17. Sidney Gottlieb, *Hitchcock on Hitchcock: Selected Writings and Interviews* (Berkeley: University of California Press, 2015), 6.

18. François Truffaut, *Hitchcock* (New York: Simon and Schuster, 1983), 18.

19. Peter J. Boyer, "Master of Film Suspense Dies Peacefully at 80," *Santa Cruz Sentinel,* April 30, 1980, 40.

20. Hitchcock, quoted in Truffaut, *Hitchcock,* 320.

21. Truffaut, *Hitchcock,* 12.

BIBLIOGRAPHY

Ackroyd, Peter. *Alfred Hitchcock: A Brief Life.* New York: Doubleday, 2015.

Albrecht, Donald. *Designing Dreams: Modern Architecture in the Movies.* New York: Harper and Row in collaboration with the Museum of Modern Art, 1986.

Anson, Jay. *The Amityville Horror.* New York: Prentice-Hall, 1977.

Banham, Reyner. *Age of the Masters: A Personal View of Modern Architecture.* 1962. Reprint, New York: Harper and Row, 1975.

Bass, Jennifer, and Pat Kirkham. *Saul Bass: A Life in Film and Design.* London: Laurence King, 2011.

Blake, Peter. *Form Follows Fiasco: Why Modern Architecture Hasn't Worked.* 1974. Reprint, Boston: Little, Brown, 1977.

———. *The Master Builders: Le Corbusier, Mies van der Rohe, Frank Lloyd Wright.* New York: Norton, 1976.

Bloch, Robert. *Psycho.* New York: Overlook, 2010.

Boyle, Hal. "Hitchcock, Master of Film Suspense, Confesses Fear." *Sacramento Bee,* March 13, 1956, 26.

Brill, Lesley. *The Hitchcock Romance: Love and Irony in Hitchcock's Films.* Princeton, NJ: Princeton University Press, 1988.

Bucher, Ward, ed. *Dictionary of Building Preservation.* New York: John Wiley, 1996.

Bush-Brown, Albert. *Louis Sullivan.* New York: George Braziller, 1960.

Castle, Alison, ed. *The Stanley Kubrick Archives.* Cologne, Germany: Taschen, 2005.

Chapman, James. *Hitchcock and the Spy Film.* London: I. B. Tauris, 2018.

Cunningham, Douglas A., ed. *Critical Insights: Alfred Hitchcock.* Ipswich, MA: Salem, 2016.
——, ed. *The San Francisco of Alfred Hitchcock's "Vertigo": Place, Pilgrimage, and Commemoration.* Lanham, MD: Scarecrow, 2011.
DeRosa, Steven. *Writing with Hitchcock: The Collaboration of Alfred Hitchcock and John Michael Hayes.* New York: Faber and Faber, 2001; CineScribe Media, 2011.
Dickey, Colin. *Ghostland: An American History in Haunted Places.* New York: Penguin, 2016.
Droste, Magdalena. *Bauhaus.* Los Angeles: Taschen, 2006.
du Maurier, Daphne. "The Birds." In *The Apple Tree: A Short Novel, and Some Stories.* London: Victor Gollancz 1952.
Durgnat, Raymond. *A Long Hard Look at "Psycho."* London: British Film Institute, 2002.
Eco, Umberto. *Travels in Hyperreality.* Translated by William Weaver. New York: Harcourt Brace, 1973.
Escher, Frank. *John Lautner, Architect.* New York: Princeton Architectural Press, 1998.
Etlin, Richard A. *Symbolic Space: French Enlightenment Architecture and Its Legacy.* Chicago: University of Chicago Press, 1994.
Frampton, Kenneth. *A Genealogy of Modern Architecture: Comparative Critical Analysis of Built Form.* Zurich: Lars Muller, 2015.
——. *Modern Architecture: A Critical History.* London: Thames and Hudson, 1992.
Freedman, Jonathan, and Richard H. Millington, eds. *Hitchcock's America.* New York: Oxford University Press, 1999.
Goldberger, Paul. *Why Architecture Matters.* New Haven, CT: Yale University Press, 2009.
Goldhagen, Sarah Williams. *Welcome to Your World: How the Built Environment Shapes Our Lives.* New York: HarperCollins, 2017.
Gottlieb, Sidney, ed. *Hitchcock on Hitchcock: Selected Writings and Interviews.* Berkeley: University of California Press, 1995.
——, ed. *Hitchcock on Hitchcock.* Vol. 2: *Selected Writings and Interviews.* Berkeley: University of California Press, 2015.
Hedren, Tippi. *Tippi.* New York: William Morrow, 2016.
Heisner, Beverly. *Hollywood Art: Art Direction in the Days of the Great Studios.* London: McFarland, 1990.
Hess, Alan. *Frank Lloyd Wright: Mid-Century Modern.* New York: Rizzoli International, 2007.
——. *Googie: Fifties Coffee Shop Architecture.* San Francisco: Chronicle, 1986.
——. *The Ranch House.* New York: Henry N. Abrams, 2004.
Hitchcock, Henry-Russell, and Arthur Drexler, eds. *Built in U.S.A.: Post-War Architecture.* New York: Simon and Schuster, 1952.
Hitchcock, Henry-Russell, and Philip Johnson. *The International Style.* New York: Norton, 1966.
Hoover, J. Edgar, and Courtney Ryley Cooper. "Camps of Crime." *American Magazine* 129, no. 2 (February 1940): 14–15, 130–32.

Jacobs, Steven. *The Wrong House: The Architecture of Alfred Hitchcock.* Rotterdam: Nai010, 2013.

Jackson, Shirley. *The Haunting of Hill House.* New York: Viking, 1959.

Jakle, John A., Keith A. Sculle, and Jefferson S. Rogers. *The Motel in America.* Baltimore: Johns Hopkins University Press, 1996.

Kendall, Elizabeth. *The Runaway Bride: Hollywood Romantic Comedy of the 1930s.* New York: Knopf, 1990.

King, Stephen. *Christine.* New York: Viking, 1983.

———. *Danse Macabre.* New York: Gallery, 1981.

———. *The Shining.* New York: Doubleday, 1977.

Kolker, Robert Philip. *Alfred Hitchcock's "Psycho": A Casebook.* Oxford: Oxford University Press, 2004.

———. *The Extraordinary Image: Orson Welles, Alfred Hitchcock, Stanley Kubrick, and the Reimagining of Cinema.* New Brunswick, NJ: Rutgers University Press, 2017.

Kraft, Jeff, and Aaron Leventhal. *Footsteps in the Fog: Alfred Hitchcock's San Francisco.* Santa Monica, CA: Santa Monica Press, 2007.

Lamprecht, Barbara Mac. *Richard Neutra: Complete Works.* New York: Taschen, 2000.

Lamster, Mark, ed. *Architecture and Film.* New York: Princeton Architectural Press, 2000.

Langman, Larry. *Destination Hollywood: The Influence of Europeans on American Filmmaking.* London: McFarland, 2000.

Lavin, Sylvia. *Form Follows Libido: Architecture and Richard Neutra in a Psychoanalytic Culture.* Cambridge, MA: MIT Press, 2004.

Leigh, Janet. *"Psycho": Behind the Scenes of the Classic Thriller.* New York: Harmony, 1995.

Lindsay, Vachel. *The Art of the Moving Picture.* New York: Macmillan, 1915.

Livingston, Jill, and Kathryn Golden Maloof. *That Ribbon of Highway I: Highway 99 from the Oregon Border to Sacramento.* Klamath River, CA: Living Gold, 2016.

LoBrutto, Vincent. *By Design: Interviews with Film Production Designers.* London: Praeger, 1992.

Longstreth, Richard. *The Buildings of Main Street: A Guide to American Commercial Architecture.* Walnut Creek, CA: AltaMira, 2000.

———. *Road Trip: Roadside America, From Custard's Last Stand to the Wigwam Restaurant.* New York: Rizzoli, 2017.

Mackendrick, Alexander. *On Film-Making: An Introduction to the Craft of the Director.* New York: Farrar, Straus and Giroux. 2004.

Margolies, John. *Home Away from Home: Motels in America.* Boston: Little, Brown, 1995.

McGilligan, Patrick. *Alfred Hitchcock: A Life in Darkness and Light.* New York: Harper Perennial, 2003.

"Motel Opens for Service to Motor Public." *San Luis Obispo (CA) Daily Telegram,* December 12, 1925, 1+.

Mumford, Lewis, ed. *Roots of Contemporary American Architecture.* 1952. Reprint, New York: Dover, 1972.

Neumann, Dietrich, ed. *Film Architecture: Set Designs from "Metropolis" to "Blade Runner."* New York: Prestel, 1999.

Newhouse, Victoria. *Wallace K. Harrison, Architect.* New York: Rizzoli, 1989.

Oppenheim, Chad, Andrea Gollin, Iona Oppenheim, and Carlos Fueyo. *Lair: Radical Homes and Hideouts of Movie Villains.* Miami, FL: Tra, 2019.

Paglia, Camille. *The Birds.* London: British Film Institute, 1998.

Palmer, R. Barton. "The Metafictional Hitchcock: The Experience of Viewing and the Viewing of Experience in *Rear Window* and *Psycho.*" *Cinema Journal,* Winter 1986.

Payne, William A. "Hitchcock—U.S. Tangle." *Dallas (TX) Morning News,* August 9, 1959, sec. 5, p. 1.

Perry, Dennis R., and Carl H. Sederholm. *Poe, "The House of Usher," and the American Gothic.* New York: Palgrave Macmillan, 2009.

Peter, John. *The Oral History of Modern Architecture.* New York: Harry N. Abrams, 1994.

Poe, Edgar Allan. *Edgar Allan Poe Stories.* New York: Platt and Munk, 1961.

———. *The Fall of the House of Usher.* Columbus, OH: Merrill, 1971.

Ramírez, Juan Antonio. *Architecture for the Screen: A Critical Study of Set Design in Hollywood's Golden Age.* London: McFarland, 2004.

Rand, Ayn. *The Fountainhead.* New York: Plume, 2005.

Raubicheck, Walter, and Walter Srebnick. *Hitchcock's Rereleased Films: From "Rope" to "Vertigo."* Detroit: Wayne State University Press, 1991.

———. *Scripting Hitchcock: "Psycho," "The Birds," and "Marnie."* Urbana: University of Illinois Press, 2017.

Rebello, Stephen. *Alfred Hitchcock and the Making of "Psycho."* New York: Dembner, 1990.

Rothman, William. *Hitchcock: The Murderous Gaze.* Cambridge, MA: Harvard University Press, 1982.

Salas, Charles G., and Michael S. Roth, eds. *Looking for Los Angeles: Architecture, Film, Photography, and the Urban Landscape.* Los Angeles: Getty Research Institute, 2001.

Schmenner, Will, and Corinne Granof, eds. *Casting a Shadow: Creating the Alfred Hitchcock Film.* Evanston, IL: Northwestern University Press, 2007.

Serraino, Pierluigi. *The Creative Architect: Inside the Great Midcentury Personality Study.* New York: Monacelli, 2016.

Shockley, Jay. *Greenwich Village Historic District Extension Designation Report.* New York City Landmarks Preservation Commission, May 2, 2006.

Shultz, Earle, and Walter Simmons. *Offices in the Sky.* New York: Bobbs-Merrill, 1959.

Smith, Andre. *The Scenewright: The Making of Stage Models and Settings.* New York: Macmillan, 1926.

Spoto, Donald. *The Dark Side of Genius: The Life of Alfred Hitchcock*. Boston: Little, Brown, 1983.

Stephens, Michael L. *Art Directors in Cinema: A Worldwide Biographical Dictionary*. 1998. Jefferson, NC: McFarland, 2008.

Strauss, Marc. *Hitchcock's Objects as Subjects: The Significance of Things on Screen*. Jefferson, NC: McFarland, 2016.

Sullivan, Louis H. "A Tall Office Building Artistically Considered." *Lippincott's Monthly Magazine,* March 1896. Reprinted in *Western Architect* 31, no. 1 (January 1922).

Toker, Franklin. *Fallingwater Rising: Frank Lloyd Wright, E. J. Kaufmann, and America's Most Extraordinary House*. New York: Knopf, 2003.

Truffaut, François. *Hitchcock*. New York: Simon and Schuster, 1983.

Tschumi, Bernard. *The Manhattan Transcripts*. 2nd ed. New York: Academy Editions, 1994.

Venturi, Robert, Denise Scott Brown, and Steven Izenour. *Learning from Las Vegas*. 1972. Cambridge, MA: MIT Press, 1996.

"What Will the Neighbors Think?" *Time* 54 (August 15, 1949).

Whitty, Stephen. *The Alfred Hitchcock Encyclopedia*. London: Rowman and Littlefield, 2016.

Wiater, Stanley. *Dark Visions: Conversation with the Masters of the Horror Film*. New York: Avon, 1992.

Williams, Richard J. *Sex and Buildings: Modern Architecture and the Sexual Revolution*. London: Reaktion, 2013.

Williamson, Roxanne Kuter. *American Architects and the Mechanics of Fame*. Austin: University of Texas Press, 1991.

Wojtowicz, Robert, and Bruce Brooks Pfeiffer, eds. *Frank Lloyd Wright & Lewis Mumford: Thirty Years of Correspondence*. New York: Princeton Architectural Press, 2001.

Wood, Robin. *Hitchcock's Films Revisited*. 1989. Rev. ed. New York: Columbia University Press, 2002.

Woodson, Thomas, ed. *Twentieth Century Interpretations of "The Fall of the House of Usher": A Collection of Critical Essays*. Hoboken, NJ: Prentice-Hall, 1969.

Wright, Frank Lloyd. *Modern Architecture: Being the Kahn Lectures for 1930*. 1931. Reprint, with new introduction, Princeton, NJ: Princeton University Press, 2008.

Young, Vernon. *On Film: Unpopular Essays on a Popular Art*. Chicago: Quadrangle, 1972.

INDEX

Italicized page numbers refer to illustrations.

Hurst, F. C. (architect), *96, 98*
hypotrochoids, 83

I Confess (1953, film, dir. Hitchcock), 21, 43, 97
identity, 21, 53, 63, 65, 69, 82, 92; American, 33, 76; architectural, 36, 57, 71, 113, 137, 138, 147; Norman Bates's, *115,* 139; filmic, 3, 171; Alfred Hitchcock's, 23; of place, 2, 5; villain's, 43
Ihnen, Wiard, 164
Illinois, 132, 157
Imagineers, The Walt Disney Company, 170
I. Magnin & Company, 88
IMDb (Internet Movie Database), 6
impersonator, 84, 86
In Cold Blood (1966, book, Capote; 1967, film, dir. Brooks), 116–17, *117*
Indigenous sites, 33
International Style, 45
Internet Movie Database. *See* IMDb
Interpreter, The (2005, film, dir. Pollack), 94
Interstate 5 (U.S.), 144
interstates, 101, 111, 134
Invisible Man, The (1933, film, dir. Whale), 28
Irwin, Stella Mae, 133
island, private, 101, 114, 144, 149, 198n3
Islington, London, 10
Italianate Revival, 122–23, *123,* 169
Italian neorealism movement, in film, 116
Italian Renaissance Revival, 87

Jackson, Shirley, 113
Jacobs, Jane, 78
Jacobs, Steven (*The Wrong House*), 4, 70, 101, 166; *North by Northwest,* 60; *Psycho,* 101, 149; *Rope,* 74–75
Jaillet, Joshua, *119, 139*
Jamaica Inn (1939, film, dir. Hitchcock), 7, 12

Jane Eyre (1943, film, dir. Stevenson), 158
Jazz Singer, The (1927, film, dir. Crosland), 11
Jefferson, Thomas, 33
Jefferson Hotel (Phoenix, AZ), *96, 98*
Jeffries, L. B. "Jeff" (*Rear Window*), 77. *See also* Stewart, James "Jimmy"
Jenkins, Mary, 88
Jenney, William LeBaron, 65
Jewison, Norman, 162
Jobs, Steve, 14
Johnson, Diane, 149
Johnson, Joseph "J" McMillan, 81, 162
Johnson, Philip, 38, 70
Jolson, Al, 11
Julian, Rupert, 28, 129
jungle gyms, 41, 170
Juno and the Paycock (1930, film, dir. Hitchcock), 12

Kanievska, Marek, 54
Kansas, 116–17, *117*
Kaplan, George (*North by Northwest*), 32. *See also* Grant, Cary
Karloff, Boris, 28–29, *31,* 55
Karoly, Grosz, 73
Kauffmann, Stanley, 24
Kaufmann, Liliane and Edgar J., 46
Kelly, Grace, 77–78, 80, 100, 164, 195
Kendall, Eve (*North by Northwest*), 33, 39–40, 43
Kettelhut, Erich, 65
Keystone (SD), *35*
Kinematograph Weekly (magazine), 10
King, Stephen, 25, 101
Kiss Me Deadly (1955, film, dir. Aldrich), 124
Kolker, Robert, 144
Korda, Vincent, 49
Koster, Henry, 129

Poelzig, Hans (architect), 31

Poelzig, Hjalmar (*The Black Cat*), 29–31. *See also* Karloff, Boris

Poelzig Mansion (*The Black Cat*), *30–31*

Polaroid, 75

Polglase, Van Nest, 159, 164

Pollack, Sydney, 94

pornographers, 54

"pornomodernism," 53

"Portal of the Past," 173

porte cochere, 40

Portman, Henry J. (architect), *123*

Posegate, Mr. and Mrs. W. D., 132

Post, George B., 65

Poulson, Norris, 125

pranks, 12

Prentice Women's Hospital Building (Chicago), 175

Price, Vincent, 49

Princeton University (NJ), 66

producers, 155

Production Code Administration, 104

production design, 165: architecture in, 161; versus art director, 161; origin, 160; USC, 163

production designers, 94, 138, 140, *143,* 148, 167, 169; Academy Awards, 162; architects as, 5, 151, 154–56; role of, 2–3, 5, 40, 120–21, 124, 127, *163;* villain's lairs, 28, 32, 37, 43, 45, 49, 53–54, 58. *See also* Adam, Ken; Boyle, Robert Francis; Clatworthy, Robert; Hurley, Joseph; Oppewall, Jeannine; Pereira, Harold

Project City (CA), *143*

Proust, Marcel, 175

Psycho (1959, book, Bloch), 16, 103, 107, 111–12, 132, 141; inspired by Edgar Allan Poe, 113–14

Psycho (1960, film, dir. Hitchcock), 116, 149, 172; architectural precedents, 120–24, 128, *131,* 142–44, *143;* art, 170, *plate 15;* Bates Mansion rendering, *119;* Bates Motel rendering, *139;* Ed Gein's House of Horror, 108–10, *109, 110;* peephole in, *140;* Phoenix (AZ), *96, 97, 98;* and Edgar Allan Poe, 113; promotion, *plate 1;* relationship to *Touch of Evil,* 135–37; release, 105; Research Department, 142, 144; reviews, 106–7, 123; sequels, 144–48; set, *102, 115, 122,* 128–29; *Seventeen* (magazine), 115, *plate 12;* shower scene, 2, 104, 106–7, 111, 138, 141, 144–45, 148; slasher movies, 150; source novel (Bloch), 111–13; trailer, 105–6. *See also* Bates Mansion; Bates Motel; island, private; Perkins, Anthony; Leigh, Janet

Psycho (1998, film, dir. Van Sant), 146

psychoanalysis, 5, 103, 171

PsychoBarn. See Transitional Object/Psycho-Barn

"Psycho Building," Phoenix, Arizona, *96, 98,* 99

Psycho House, 128, 129, 146. *See also* Bates Mansion

Psycho II (1983, film, dir. Franklin), 129, 138, 146

Psycho III (1986, film, dir. Perkins), 129, 146

Psycho IV: The Beginning (1990, film, dir. Garris), 146

Pye, Merrill, 45, 159

Quebec (Canada), 97

Queen Anne Revival, 127

Queen Mary, RMS, *7–8*

racism, 21

Radio City Music Hall (New York), 155

Ramírez, Juan Antonio, 68, 124, 160, 172

Ramses the Great, 34

McKittrick Hotel, 122–23, *123;* production team, 21; reviews, 25, 90; skyscrapers, 63, *plate 8;* source novel, 82; stairway, 21, *84;* USC, 162

vertigo, sensation, 21, 69, 83–85

VHS tapes, 2

Victoria (queen), 34

Victorian Revival (houses), 100–101, 167, 170; Charles Addams, 123; Bates Mansion, 119; Bunker Hill (Los Angeles), 124–27, *126–27;* demolition, 120, 122, *126;* Folk, 129; Phantom Manor (Disneyland Paris), 170; *Psycho* (Bloch), 111; tourist homes, 132; *Vertigo,* 122–23, *123*

video-on-demand, 173

Vidor, King, 69

Vienna (Austria), 31, 155

villains: architects as, 28; architectural identity, 43, 53, 60–61; James Mason, 32; modern, 27; *North by Northwest,* 32; *The Secret Agent,* 32

villain's lairs, 3, 4, 32, 54, 62; *The Black Cat,* 31; Lovell "Health" House, 58

violence, 23

visitor centers, 34–35, *36,* 39, 175

Vitaphone, 11

Vollbrecht, Karl, 65

voyeurism, 22, 39, 53, 76–77, 96

Wagner, Rob, 152

Wainwright Building (St. Louis, MO), 66–66, *67*

walls: glass curtain, 63, 92; movable, *52,* 72–73; window, 36, 61

Warner Brothers, 18, 69, 71, 74, 160

War Production Board, 19

Washington, George, 33, *35,* 94

Watson, Tiny, 88

Wayman, George, 49

Weber, Kem, 157

Wegener, Paul, 32

Welles, Orson, 25, 75, 135–37, 153, 158

Werdegast, Dr. Vitus (*The Black Cat*), 29–30. *See also* Lugosi, Bela

Western Union Telegraph Building (New York), 65

West Wide Story (1961, film, dir. Robbins), 162

Weyauwega (WI), 103

Whale, James, 28

Whitlock, Albert, 164–65, 169

Wilder, Billy, 156

Wilder, Thornton, 16

Wiles, Gordon, 159

Wilkes Barre (PA), 131, 201

Willens, Edward, 162

Williams, Richard J., 53, 64, 95

Wilshire Palms (Los Angeles), 13

Wilson, Scott, *117*

windows, *87. See* glass

Winter Park (FL), 176

Wisconsin, 43–44, 55, 103, 108–9, *109, 110*

Wise, Robert, 162

Woman to Woman (1923, film, dir. Cutts), 10

Wood, Marjorie "Midge" (*Vertigo*), 84–86, *86, plate 9. See also* Bel Geddes, Barbara

Wood, Robin, 173

wood, salvaged, 170

Woolrich, Cornell, 16, 76

Worden, Bernice, 108

Worden Hardware & Implement (Plainfield, WI), 108

World's Fair, 155

World War I, 29–30, *30,* 159

World War II, 19, 35, 50, 69, 82, 88, 101, 134

wrecking balls, 99, 167

Wright, Catherine, 43

Wright, Frank Lloyd, 15, 28, 51, 55, 62, 92; Adler & Sullivan, 66; Fallingwater, *47, plate 3; The Fountainhead,* 69–70; Kaufmann House, 58*; North by Northwest* (Vandamm House), 38–39; Sturges House, *48,* 48–49; Usonion, 60; Lloyd Wright, son of, 156

Wright, Lloyd, 43, 49, 156

Wright, Teresa, *20*

Wrong Man, The (1956, film, dir. Hitchcock), 4, 17, 21–22, 25, 33, 116, 149, 161

W. T. Henley's Telegraph Works, 10

Wyler, William, 105

Yale School of Architecture, 78

Yale University (CT), 7

York Hotel (San Francisco), *87, 88–89*

Young, Terence, 50

Young, Vernon, 25

You Only Live Twice (1967, film, dir. Gilbert), 50

Yuricich, Matthew, *38*

Zacherly, John (also known as Zacherle), 106

Ziegfeld Follies (1945, film, dir. Ayers, Del Ruth, and Lewis), 159

Zurflua, Helen (also known as Zurfluh, Helen), 88–89, *89*

Midcentury: Architecture, Landscape, Urbanism, and Design